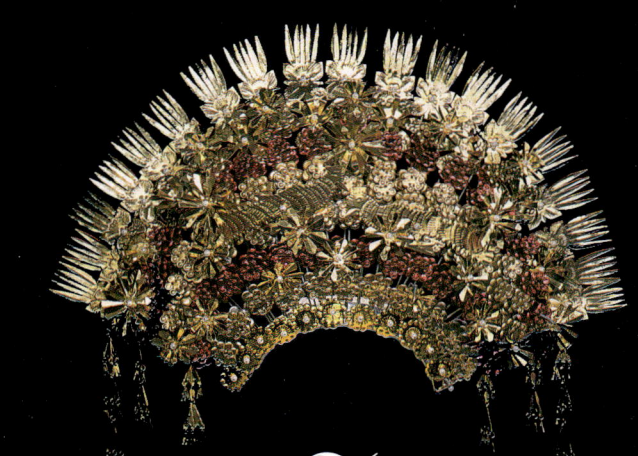

Walk in Splendor

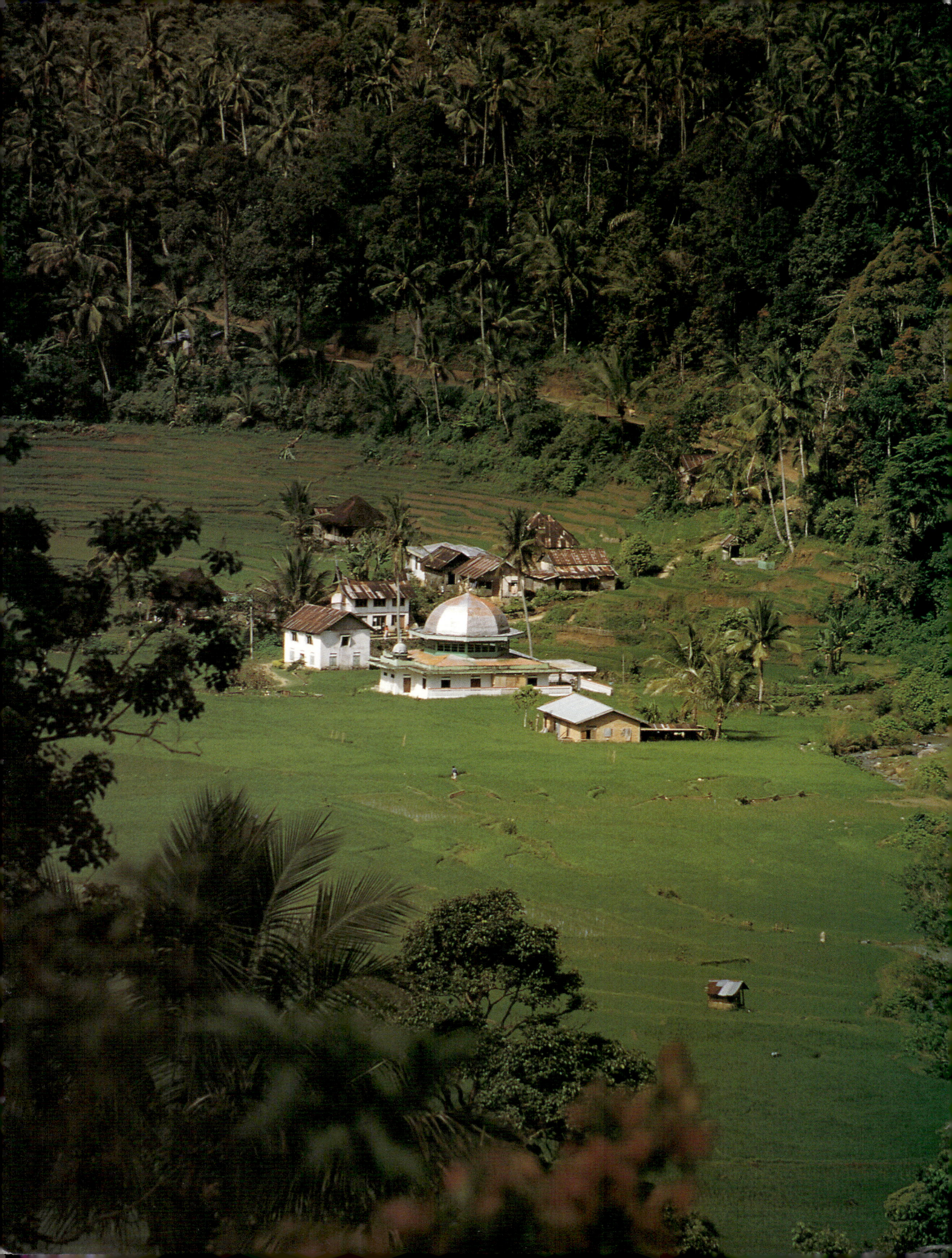

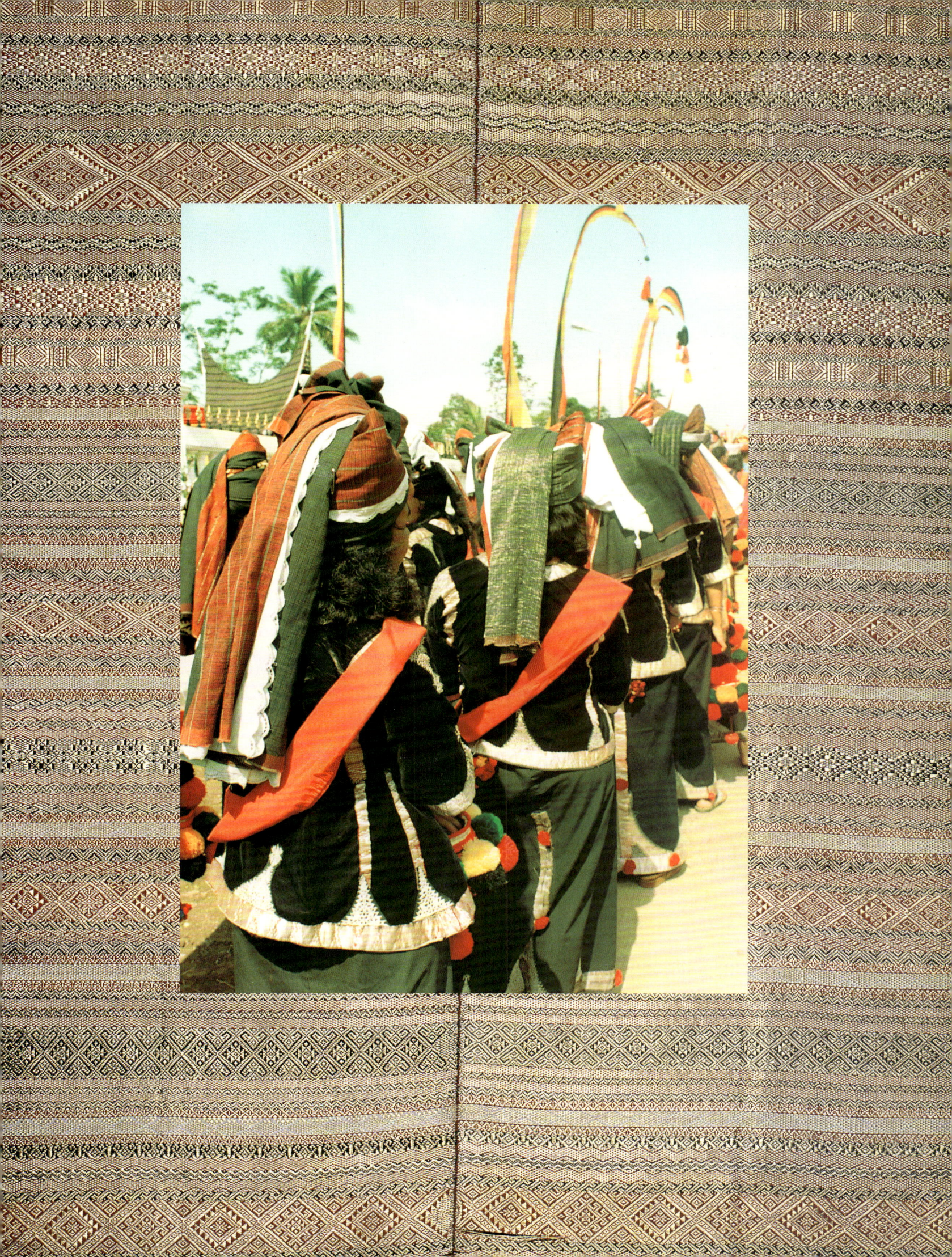

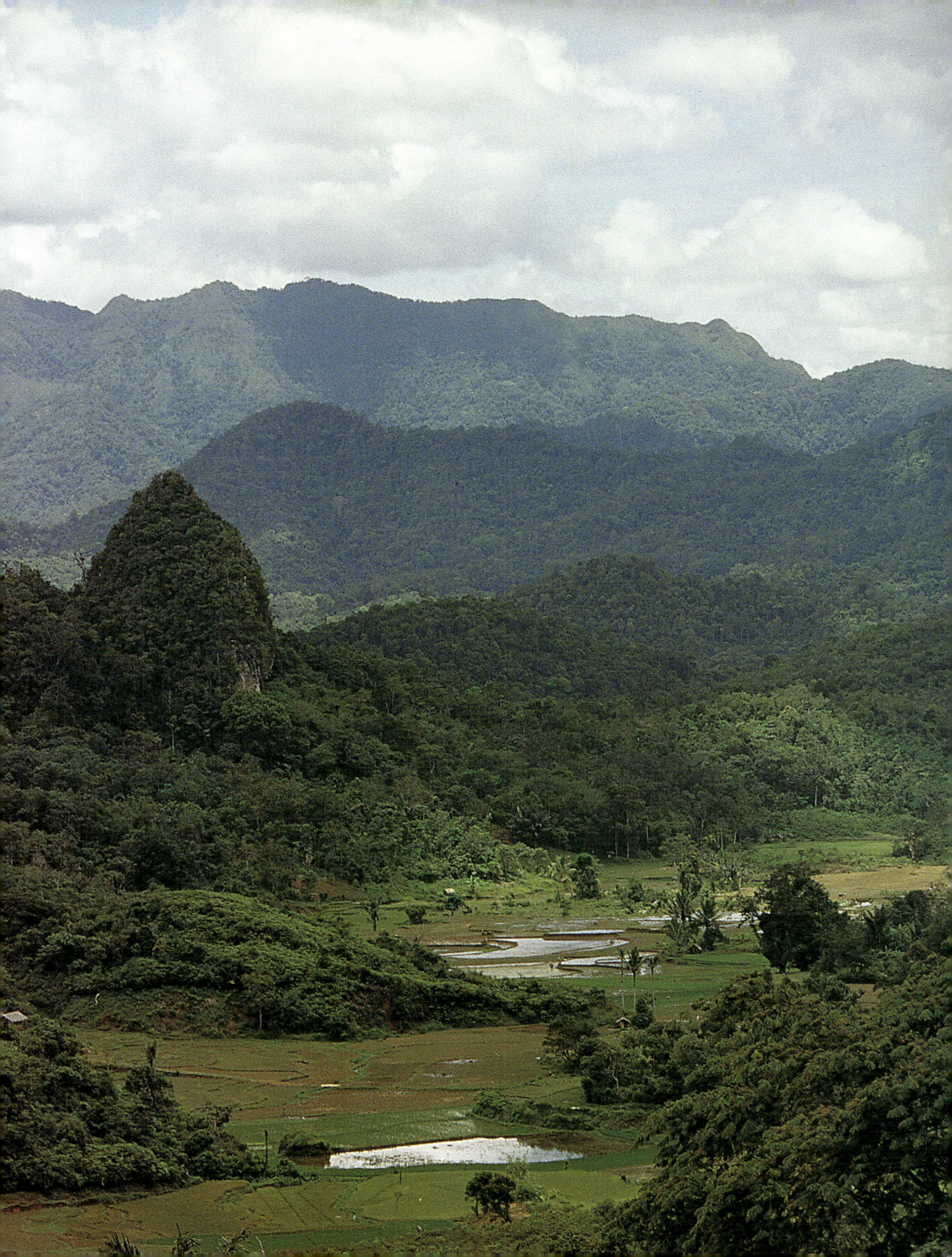

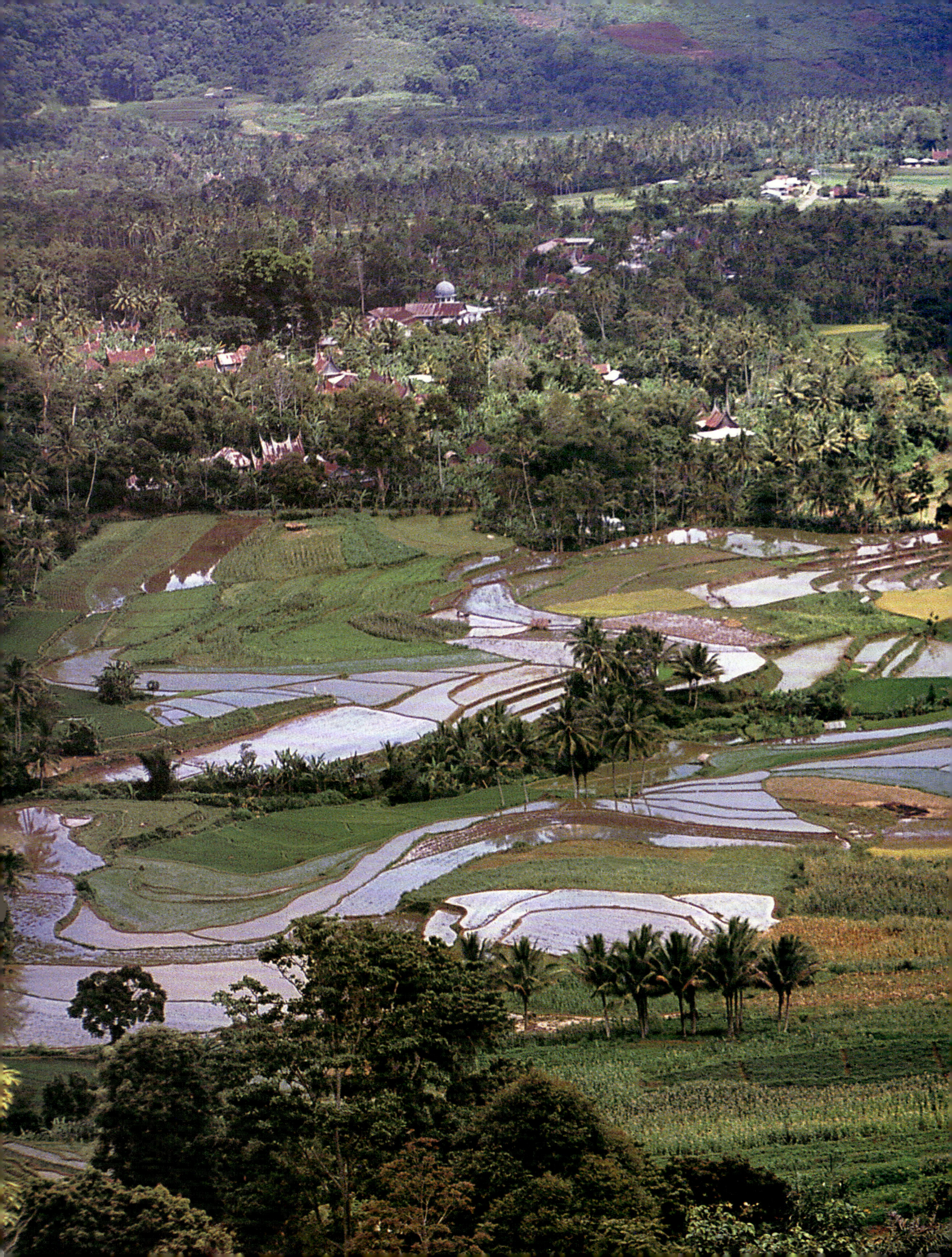

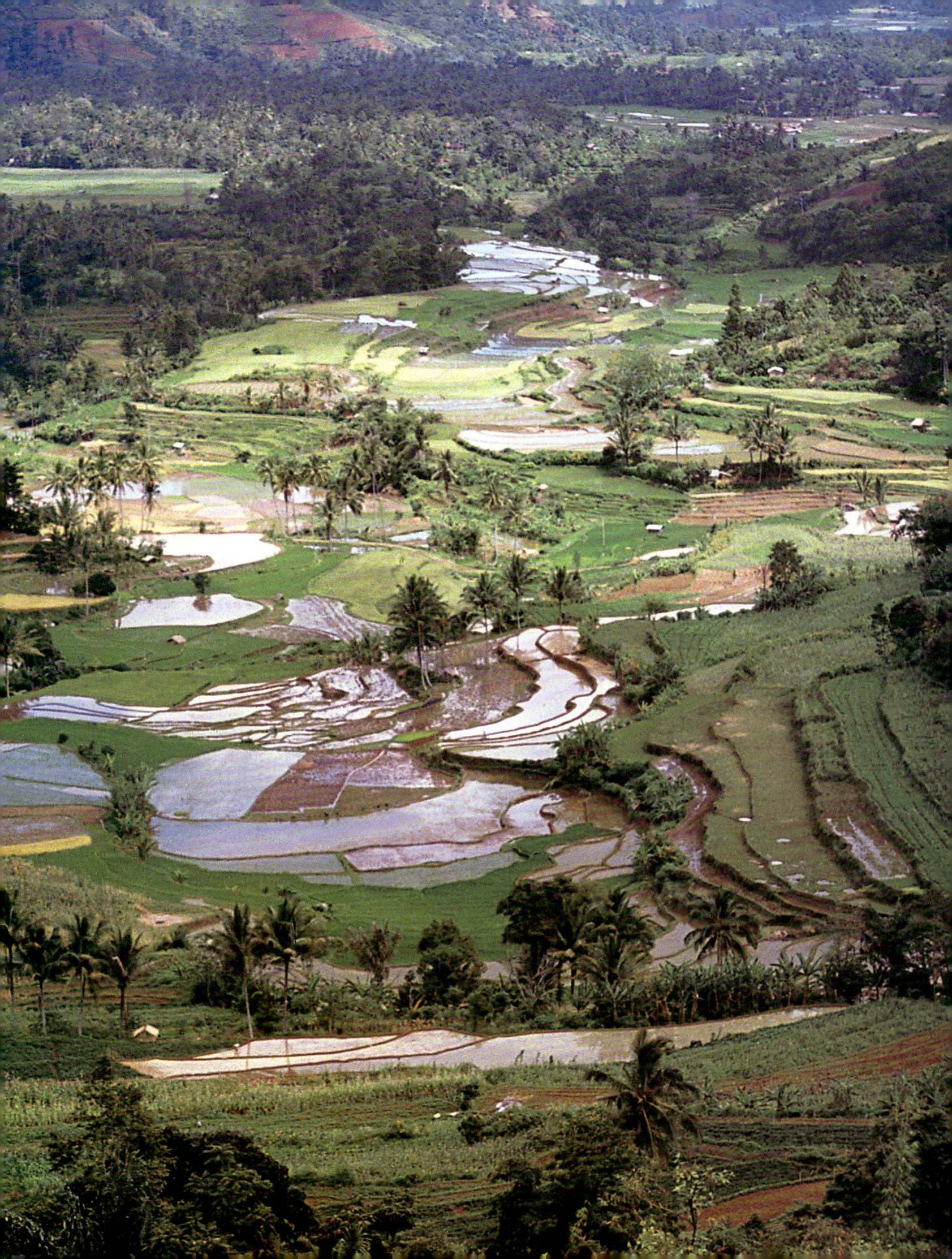

Walk in Splendor

Ceremonial Dress and the Minangkabau

UCLA Fowler Museum of Cultural History Textile Series, No. 4
Published with the assistance of the Getty Grant Program

TEXTILE SERIES
EDITORIAL BOARD

Doran H. Ross
Patricia Rieff Anawalt
Roy W. Hamilton
Betsy D. Quick
Lynne Kostman
Daniel R. Brauer

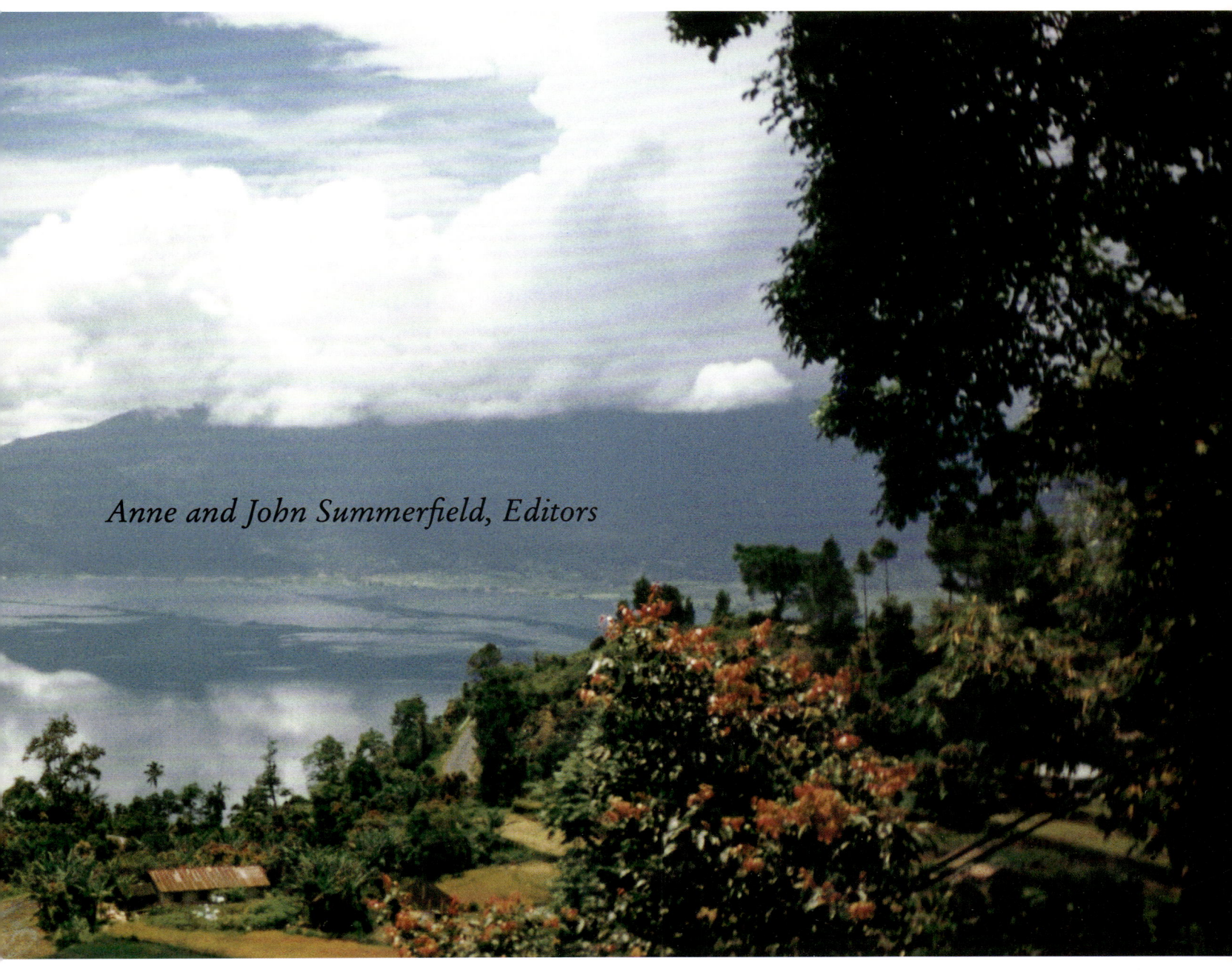

Anne and John Summerfield, Editors

UCLA FOWLER MUSEUM OF CULTURAL HISTORY
LOS ANGELES

WITH CONTRIBUTIONS BY

Taufik Abdullah
Khaidir Anwar
Redjeki Arifin
Hanefi
Norman Indictor
Lisa Klopfer
H. A. Sutan Madjo Indo

Imran Manan
Anas Nafis
David and Vicki Salisbury
Anne Summerfield
John Summerfield
Ibenzani Usman
Indra Utama

Major funding for this publication has been provided by
The Getty Grant Program

Major funding for this exhibition and its publication has been provided by
Private donors
The National Endowment for the Arts

The Ahmanson Foundation
The Times-Mirror Foundation
Manus, the support group of the UCLA Fowler Museum of Cultural History

The Fowler Museum is part of UCLA's School of the Arts and Architecture

Lynne Kostman, Managing Editor
Karen Jacobson, Manuscript Editor
Sandy Bell, Designer
Don Cole, Principal Photographer
Daniel R. Brauer, Production Manager

©1999 Regents of the University of California.
All rights reserved.

UCLA Fowler Museum of Cultural History
Box 951549
Los Angeles, California 90095-1549

Map (pp. 22–23): © David L. Fuller

Requests for permission to reproduce material from this catalog should be sent to the UCLA Fowler Museum Publications Department at the above address.

Printed and bound in Hong Kong by South Sea International Press, Ltd.

Library of Congress Cataloging-in-Publication Data

Walk in splendor : ceremonial dress and the Minangkabau / Anne and John Summerfield, editors : with contributions by Taufik Abdullah . . . [et al.].
 p. cm. — (UCLA Fowler Museum of Cultural History textile series ; no. 4)
 Catalog of an exhibition of the same name held at the UCLA Fowler Museum of Cultural History.
 Includes bibliographical references.
 ISBN 0-930741-72-2 (hard). —
 ISBN 0-930741-73-0 (soft)
 1. Minangkabau (Indonesian people)—Costume—Exhibitions. 2. Textile fabrics, Minangkabau—Exhibitions. 3. Minangkabau (Indonesian people)—Rites and ceremonies—Exhibitions.
 I. Summerfield, Anne, 1917– . II. Summerfield, John, 1917– . III. Abdullah, Taufik. IV. University of California, Los Angeles. Fowler Museum of Cultural History. V. Series.
GT1539.S854W35 1999
391'.0089'9922—dc21 99-13749
 CIP

FRONT COVER: Detail of fig. 6.88
BACK COVER: Ceremonial shoulder cloth. Koto Gadang. FMCH X97.50.74; private gift.
COVER FLAPS (SOFTCOVER VERSION): Detail of fig. 6.22
ENDSHEETS (HARDCOVER VERSION): Detail of fig. 6.22
PAGE 1: Fig. 6.67
PAGE 2: Village and mosque. Near Palembayan.
PAGE 3: Background, detail of fig. 6.96. Inset, ceremonial procession. Limo Puluah Koto.
PAGES 4–5: Rain forest. Limo Puluah Koto.
PAGES 6–7: Rice paddies. Near Batu Sangkar.
PAGES 8–9: Cloud reflections on Lake Maninjau. Near Bukittinggi.
PAGE 11: Alfred Russel Wallace, *The Malay Achipelago* (1902).
PAGE 21: Merchant. Bukittinggi market.
PAGES 24–25: Harvesting Rice. Tanah Datar.
PAGE 27: Dedication of a palace. Limo Puluah Koto.
PAGES 74–75: Dedication of a palace. Limo Puluah Koto.
PAGES 238-239: Musical ensemble at a ceremony. West Sumatran highlands.
PAGE 363: (Top) woman selling a dish known as *tape*. Bukittinggi. (Bottom) woman selling *krupuak*, a cracker painted with chile paste. Bukittinggi.
PAGE 364: (Left) fly-shuttle loom weaver. Village of Kubang. (Right) H. A. Sutan Madjo Indo inspecting a textile at his antique shop. Bukittinggi.
PAGE 365: Fly-shuttle loom weaver. Village of Kubang.
PAGE 366: (Left) late wife of the chieftain of the village of Minangkabau wearing a headdress unique to the Tanah Datar region. (Top right) young woman in the market. Bukittinggi. (Bottom right) Ibu Arimi. Village of Alang Laweh.
PAGE 367: Woman carrying tray of food to a ceremony. Tanjung Sungayang.
PAGE 368: Woman wearing headdress unique to Padang Magek.

This book is dedicated to

J. Daniel and Gerdy Ungerer
H. Elly Azhar and H. A. Sutan Madjo Indo

without whose generous and unstinting assistance
neither this book nor the accompanying exhibition
could have come into being.

CONTENTS

	14	Forewords
	16	Preface
	18	Acknowledgments

	25	**Part 1 The Minangkabau**
CHAPTER 1	29	Introduction *Anne and John Summerfield*
CHAPTER 2	45	A Short History of the Minangkabau *Imran Manan*
CHAPTER 3	55	The Minangkabau and Their Culture *Khaidir Anwar*
CHAPTER 4	65	Traditional Minangkabau Ceremonies *David and Vicki Salisbury*

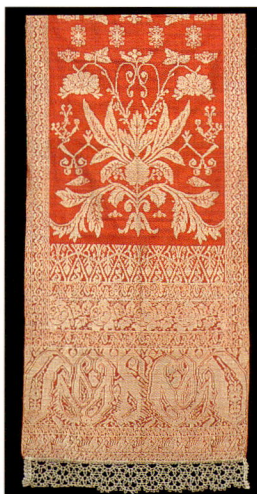

	75	**Part 2 Ceremonial Textiles**
CHAPTER 5	79	Men's Ceremonial Dress *John Summerfield*
CHAPTER 6	105	Women's Ceremonial Dress and Related Ceremonial Textiles *Anne Summerfield*
CHAPTER 7	171	Motifs and Their Meaning *Anne Summerfield and H. A. Sutan Madjo Indo*
CHAPTER 8	201	Fibers and Patterning Techniques *John Summerfield*
CHAPTER 9	225	Metallic Threads in Minangkabau Textiles *Norman Indictor*

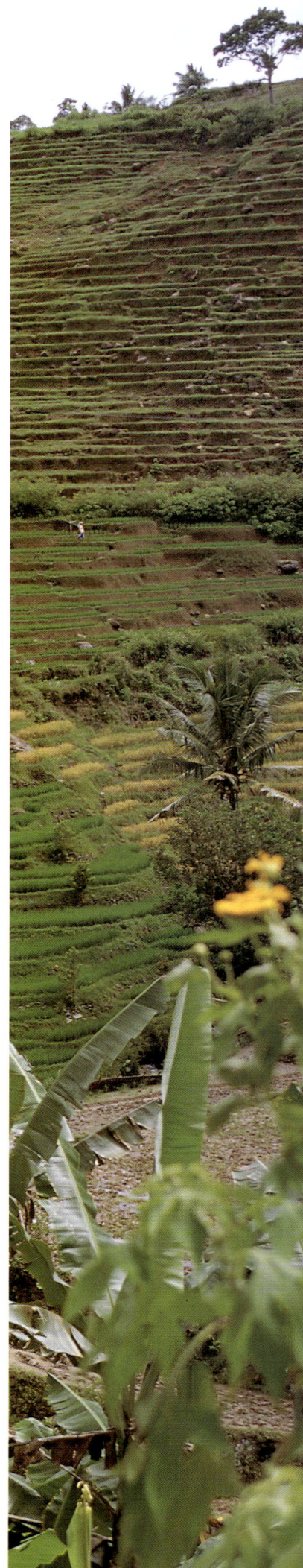

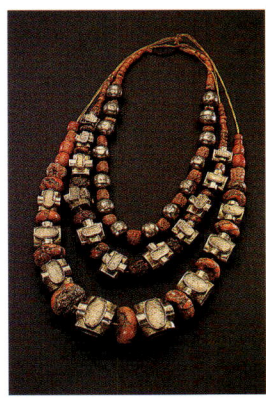

239 Part 3 Related Ceremonial Arts

CHAPTER 10 243 The Traditional Adat House and Its Carving
Ibenzani Usman

CHAPTER 11 257 Ceremonial Foods for the Celebration of Marriage
Lisa Klopfer

CHAPTER 12 271 Minangkabau Ceremonial Jewelry
Redjeki Arifin

CHAPTER 13 297 Traditional Minangkabau Music
Hanefi

CHAPTER 14 313 Traditional Dance in Minangkabau: Its Roots and Its Future
Indra Utama

CHAPTER 15 324 *Pidato Adat* and Minangkabau Proverbs
Anas Nafis

CHAPTER 16 334 *Tambo, Kaba,* and History: Tradition and the Historical Consciousness of the Minangkabau
Taufik Abdullah

340 Notes to the Text
344 Glossary
347 Bibliography
357 Illustration Credits
361 Contributors

FOREWORDS

PRIOR TO THE MID-1980s only five textiles representative of the Minangkabau people of Sumatra were included among the Indonesian collections at the UCLA Fowler Museum of Cultural History. Of these five, three were purchased in the Netherlands in 1969 by our former associate director George Ellis, who did much to foster the Fowler Museum's nascent interest in Indonesian culture. The other two examples were gifts from Mrs. Rosa Covarrubias, the widow of Miguel Covarrubias, and were presumably acquired by the famed Mexican painter during his residence in Bali in the 1930s.

The museum's interest in the Minangkabau began to rise sharply after Anne and John Summerfield first became involved as volunteers in 1986. In the intervening years, the Summerfields have consistently demonstrated their devotion to the study of Minangkabau culture and textiles: they have overseen the growth of the Fowler Museum's Minangkabau textile collection to over two hundred pieces, and, along the way, richly deserved their titles as "visiting curators." If that weren't enough, this remarkable couple has undertaken the immense task of organizing this publication and its companion exhibition in their supposed "retirement."

The Summerfields have made over a dozen trips to Sumatra and have developed close friendships with many Minangkabau. Two of these friends are H. Elly Azhar and H. A. Sutan Madjo Indo, residents of the Minangkabau cultural "capital" of Bukittinggi and, like the Summerfields, passionate students of Minangkabau culture. Together the Summerfields and the Madjo Indos made the arrangements that led to the Fowler Museum developing perhaps the most comprehensive collection of Minangkabau textiles in the world.

Minangkabau textiles are known primarily for their intricate geometric motifs worked in metallic threads on a silk ground. Because many textile scholars have had a bias favoring the more fluid motifs of the resist-dyed textiles (batiks and ikats) made by other Indonesian groups, Minangkabau textiles have consistently been underrated. What the growing Minangkabau collections at the Fowler Museum have made abundantly clear is that Minangkabau weavers have been second to none in the archipelago in their technical skills as weavers. We are extremely pleased to be able to present a thorough treatment of these remarkably fine and beautiful textiles, and the society from which they have sprung, to an international audience.

This book is the fourth volume of the UCLA Fowler Museum of Cultural History Textile Series, published with the support of the Getty Grant Program, and also our fourth foray into the field of Southeast Asian textile studies in the past five years. It provides a particularly interesting counterpoint to our book *The Women's Warpath: Iban Ritual Fabrics from Borneo* (1996) by Traude Gavin. Gavin discussed the various ways in which textiles are named by the Iban and the limitations of trying to "read" interpretive messages into motifs in a literal manner. The Minangkabau, on the other hand, seem to almost obsessively attach and annunciate meanings for every minute part of a textile's design. A closer reading of the two cases, how-

ever, reveals that they have more in common than in opposition. In both cases, the meaning of the textile pattern is related to oral literature—in the Iban case through literary references to epic legends and praise poems and in the Minangkabau through the fostering of a multitude of aphorisms defining what it means to be a "good" Minangkabau. While textiles are not "read" like alphabets, they do draw meaning through a rich interplay with the other leading form of artistic expression in Southeast Asian society, the recitation of oral literature. It is our hope that this book, like Gavin's, will continue to foster debate about the naming and meaning of textiles in Southeast Asia.

DORAN H. ROSS, Director
ROY W. HAMILTON, Curator of Southeast Asian and Oceanic Collections

ON BEHALF OF THE GOVERNMENT of the province of West Sumatra and the Minangkabau people, and in my role as chairman of the Adat Council of the Minangkabau World, I extend my highest appreciation to Anne and John Summerfield, the editors of *Walk in Splendor: Ceremonial Dress and the Minangkabau*. This magnificent volume is a truly comprehensive introduction to the people and culture of the Minangkabau.

For more than a decade the Summerfields have collected materials and amassed knowledge that have made them experts in the fields of ceremonial textiles and traditional arts and that have, perhaps more importantly, enabled them to comprehend the Minangkabau adat, or culture. In producing this book, they have brought together more than a dozen scholars—all experts in their respective fields—to examine various aspects of this, one of the largest matrilineal societies in the world. Their untiring efforts have resulted in an invaluable contribution to the understanding of the Minangkabau in particular and of human culture in general.

Our deepest gratitude must go to Anne and John Summerfield and to the contributors to this important volume, all of whom have helped to disseminate the precious treasure of the Minangkabau and to promote cultural appreciation and understanding among the citizens of our "global village."

H. HASAN BASRI DURIN, Minister of Land Reform, Jakarta; former Governor, Province of West Sumatra; and Chairman of the Adat Council of the Minangkabau World

PREFACE

OUR INTEREST IN INDONESIAN textiles was stimulated by a visit made in 1977 to the eastern portion of the Indonesian Archipelago where we watched women on several different islands weaving the boldly patterned warp-ikat textiles for which the region is justly known. In the course of our subsequent textile studies, we had an opportunity to examine three weavings from the province of West Sumatra, near the western end of the archipelago. What had been a wide-ranging interest encompassing all Indonesian weavings thereafter became concentrated on the ceremonial textiles of the Minangkabau. We were struck by the exquisite beauty of the refined, sophisticated, gold and silver patterning of Minangkabau silk ceremonial textiles, and we became determined to locate more Minangkabau weavings for examination and analysis.

As we perused the literature on Indonesian textiles and visited museums in the United States and Europe looking for examples of Minangkabau weaving, we found that with the exception of a very few European museums, substantial collections of Minangkabau ceremonial textiles were nonexistent in public institutions and that large, clear illustrations of Minangkabau textiles rarely appeared in scholarly publications. It was the skillfully dyed ikat cloths of eastern Indonesia, the ceremonial cloths from Sumatra's Lampung area, and the batiks from central and north coast Java that were attractive to the textile arts community of the Western world in the 1970s and 1980s. Even the groundbreaking Indonesian textile exhibitions and accompanying publications by Mary Hunt Kahlenberg at the Los Angeles County Museum of Art in 1977 and Mattiebelle Gittinger at the Textile Museum in 1979 paid scant attention to Minangkabau cloths, perhaps because they were largely unavailable at that time.

Lack of study of the material culture of the Minangkabau by most Western anthropologists or by other scholars visiting West Sumatra and the consequent lack of publication of images of Minangkabau ceremonial weavings are partly responsible for a scarcity of reports in English dealing with these remarkable cloths. Collections of Minangkabau weavings had been assembled by museums in the Netherlands and by a few institutions in Germany, but the pieces were generally not well documented. If published, they usually appeared in the back sections of books among small black-and-white photographic displays of cataloged collections.

By 1990 only two articles in English had discussed Minangkabau's ceremonial textiles in any depth, and these, regrettably, suffered from somewhat limited distribution. The first report was presented by Suwati Kartiwa as part of the Emery Roundtable on Indonesian Textiles held at the Textile Museum, Washington, D.C., in 1979. The second, by Peggy Sanday and Suwati Kartiwa, appeared in the University of Pennsylvania journal *Expeditions* five years later. Cecelia Ng's doctoral thesis of 1987, a detailed report on mostly contemporary textiles from a relatively small group of villages in the West Sumatran regency of Limo Puluah Koto, is not readily available in the United States. Although many museums in the United States have one or more Minangkabau textiles, some are undocumented or are misattributed. One Minangkabau collection we examined contains only one ceremonial cloth in extremely fragile condition, while the remainder of pieces in the collection are examples of everyday wear. In some other collections we have found Minangkabau textiles erroneously described or labeled as originating from other cultures, while textiles from other cultures are, in turn, labeled as Minangkabau.

In an attempt to help ameliorate this state of affairs, we curated two exhibitions of fewer than one hundred Minangkabau ceremonial textiles in 1990 and 1991, the first at the Textile Museum in

Washington, D.C., and the second at the Santa Barbara Museum of Art. The latter exhibition was accompanied by a small, illustrated publication, which was well received by museums, collectors, and an international public, indicating that there existed an audience for more information written in English about Minangkabau textiles. The present volume, consequently, greatly expands the descriptions and analyses of these intricately woven cloths. The cloths are often of such complexity that skilled weavers could complete only a few centimeters in a day at the loom. The book also presents a brief survey of Minangkabau history and cultural values and discusses the interrelatedness of ceremonial textiles and other ceremonial arts, thus providing a much wider context in which to view the textiles and to assess their importance.

We have been extremely fortunate to enlist as contributing authors nine native Minangkabau scholars to survey Minangkabau history and culture, to describe textile motifs, and to introduce the traditional arts of architecture and carving, jewelry, music, dance, ceremonial oratory, the *tambo* (tales of Minangkabau origins) and *kaba* (parable-like stories of ideal behavior). The contributions by the Minangkabau scholars have been augmented by those of four American scholars. We, in turn, have written four of the five chapters that constitute the discussion of ceremonial textiles, part 2 of this book. In the introductory chapter we posit an explanation as to why the Minangkabau assigned names and meanings to the hundreds of abstract motifs they use to richly embellish their ceremonial textiles and their great houses.

Over the years we have made some fourteen visits to West Sumatra, and we have been privileged to become close friends with many Minangkabau who have guided, advised, educated, and supported us in our endeavors. With their help and with careful examination and analyses of hundreds of Minangkabau ceremonial textiles, old and new, including the more than two hundred in the collections of the UCLA Fowler Museum of Cultural History, we have been able to assemble the materials that constitute this book. We hope that it will serve as a reference and that it will assist museums and collectors in identifying Minangkabau weavings in their collections. We hope, above all, that the book will provide the English-reading audience with important and telling insights into the arts of a unique culture that has heretofore been studied in the West for aspects of its history and social structure and only now for the great strength and enduring beauty of its magnificent traditional art.

ANNE AND JOHN SUMMERFIELD

ACKNOWLEDGMENTS

THIS BOOK AND THE EXHIBITION that it accompanies would not have been possible without the unstinting and enthusiastic support and knowledgeable assistance of Daniel and Gerdy Ungerer of Vista, California, and of H. A. Sutan Madjo Indo and his wife, H. Elly Azhar, of Bukittinggi and Balingka, West Sumatra. Over the course of more than a decade, they have helped us find sources, including textiles to study; explained customs and traditions; and taught us the meanings of motifs in textiles and carvings.

We are also extremely grateful for the financial support provided to the exhibition and book by a group of private donors including Margaret Mahoney of New York City with matching grants from the Commonwealth Fund and the John D. and Catherine T. MacArthur Foundation; Mien Soedarpo and Soedarpo Sastrosatomo of Jakarta; Karen Friedmann of Santa Fe; Kirsten Combs of Los Angeles; Norman and Rina Indictor of New York City; and two very generous donors who have elected to remain anonymous. Additional major contributions were made by the Getty Grant Program for the publication and by the National Endowment for the Arts.

We are indebted to many individuals who have generously shared their expertise with us and have thus contributed significantly to our education in the textile arts, as well as to the exhibition and its accompanying volume. Notable among these are Mary Jane Leland of Los Angeles and Mary Hunt Kahlenberg of Santa Fe. Mattiebelle Gittinger of Washington, D. C., has supported us in important ways. Not only did she arrange for us to analyze the pieces in Alice Sheldon's gift of Minangkabau textiles to the Textile Museum, it was at her instigation that we curated at the Textile Museum the first exhibition in the United States devoted soley to the Minangkabau. Brian Morehouse generously shared his collection of rugs, his library, and his extensive knowledge of motifs in Middle Eastern textiles. Our thanks must also go to Garrett and Bronwen Solyom in the United States; Zulkifli, the late Saifoed'din and his wife, Adelena, Anis and Anneka Salim, Akmar Muchtar, Nuran Effendi, and especially the Madjo Indo family in West Sumatra. A number of Minangkabau weavers have also patiently demonstrated their expertise for us, including Rohanyi in Tanjung Sungayang, Sanuar and Rosamun in Pandai Sikek, and a number of weavers in Balai Cacang, Silungkang, and Sijunjung. Special thanks are due to Suwati Kartiwa, the director of the Museum Nasional in Jakarta, who has served as a consultant on this project. Her pioneering work on the meanings of motifs in Minangkabau textiles and her advice and counsel on our planning of the exhibition have proved invaluable.

Our thanks go also to the many museums and members of their staffs who have permitted us to examine Minangkabau textiles in their collections, including Erman Makmur, Usriah Dhavida (Ms. Dhavida supplied us with many museum documents and helped us to meet Minangkabau scholars who in turn assisted us), Darman Moenir, and Akmar Muchtar at the Museum Adityawarman in Padang; Suwati Kartiwa at the Museum Nasional and Puspita Wibisona at the Museum Tekstil in Jakarta; Rita Bolland and Etie van Hout at the Royal Tropical Institute/Tropenmuseum in Amsterdam; Julie Jones, William Gunn, and Christine Gentini at the Metropolitan Museum of Art in New York; Peggy Sanday at the University Museum in Philadelphia; Carol Bier at the Textile Museum in Washington, D. C.; Susan Hay at the Museum of Art at the Rhode Island School of Design in Providence; Niloo Paydar at the Indianapolis Museum of Art; Bennet Bronson at the Field Museum in Chicago; Nora Fisher at the International Folk Art Museum in Santa Fe; and

Audrey Hozack and Lynne Milgram at the Museum for Textiles in Toronto, Canada. To the best of our knowledge, the UCLA Fowler Museum of Cultural History has the largest and most comprehensive collection of Minangkabau ceremonial textiles in the United States. We are greatly indebted to the former director of the Fowler Museum, Christopher Donnan, and to the present director, Doran Ross, for making that collection available for the exhibition and for giving us the opportunity to publish the results of our Minangkabau studies.

In connection with our earlier exhibitions of Minangkabau textiles, we wish to express our gratitude for the help of Carol Bier, Sara Wolf, Virginia Delfico, Carolyn Reagan, and Barbara Warren at the Textile Museum in Washington, D. C., Marilee Peebles, Susan Tai, and Cathy Pollock at the Santa Barbara Museum of Art, Hazel Koenig and Susan Sagawa at the Bellevue Museum of Art, and Susan Rodgers and Ellen Lawrence at the Iris and B. Gerald Cantor Gallery at the College of the Holy Cross, Worcester.

As for our outstanding coauthors, Imran Manan went well beyond what we might rightfully have expected in the way of help. Not only did he contribute the chapter on Minangkabau history, he assisted Ibenzani Usman with the chapter on Minangkabau houses and their carvings, and he edited the informal draft of Khaidir Anwar's chapter on Minangkabau cultural values after Anwar's untimely death. He also arranged to have the manuscript of the chapter on *pidato adat* (ceremonial speech) translated into English. David and Vicki Salisbury, H. A. Sutan Madjo Indo, Norman Indictor, the late Ibenzani Usman, Lisa Klopfer, Redjeki Arifin, Hanefi, Indra Utama, Anas Nafis, and Taufik Abdullah are all recognized experts in their fields. It has been a sincere pleasure for us to have had this opportunity to collaborate with them.

We also want to thank a number of indirect but very important contributors to the text of this book. These include Amin Sweeney for his elucidation of the significance of the oral culture of the Minangkabau in his book *A Full Hearing: Orality and Literacy in the Malay World* (1987); the staff of the library of Andalas University in Padang for translation of the *pidato adat* section of chapter 15, Lukman Ali of the University of Indonesia in Jakarta for checking that translation, and Consul J. S. Philliang at the Consulate of the Republic of Indonesia, Los Angeles, for further elucidating parts of the translation; Dahnil Adnani in Kuala Lampur, Malaysia, for the translation of the *Peribahasa* section of chapter 15; Endo and Marjie Suanda in Bandung for translations of chapters 13 and 14; Nina Capistrano-Baker for her generously shared insights on Minangkabau houses for chapter 10; and Gérard Moussay for his encyclopedic *Dictionnaire Minangkabau* (1995), a Minangkabau/French dictionary that has helped us to unravel many of the mysteries of the Minangkabau language. During most of our years spent preparing for this book and its companion exhibition, we were encouraged and strongly supported by H. Hasan Basri Durin, Minister of Land Reform, Jakarta, formerly the governor of the province of West Sumatra. His assistant in West Sumatra, Hawari Siddik, was also always available to help when we were in the capital city, Padang.

We would never have met many of the very helpful Indonesians mentioned here were it not for the persistent efforts of our friends the late Aswar Hamid, his wife, Noor, and their daughter Tisnawati; Muslim A. Nathin and his wife, Upik; Gunarijah Kartasasmita; Imran Manan and his wife, Nan; Poppy Zalnofri as Ibu Bupati of Sijunjung; the late Ellysa Noorhan, an expert on textiles from the regency of Limo Puluah Koto; and Ridwan of the Hotel Minang who took us to his village, Minangkabau (Minang

Raya), and introduced us to the local *pangulu* who in turn regaled us with stories of his village's participation in a legendary buffalo fight that supposedly gave the Minangkabau their name.

Others in Indonesia who have assisted in very special ways include Mien Soedarpo and her husband, Soedarpo Sastrosatomo, Nelly Malik, the late Bambang Sumadio, Rahmad Adenan, Djoko Soejono, Judi Achjadi, Nasroel Chas, Boestanil Arifin, Devi Meidya Azhar, Edy Utama, and Desi Anwar. A succession of consuls general of the Republic of Indonesia in Los Angeles and their staffs have always been ready to help us over the years that we have been working toward this exhibition and book.

Four outstanding conservators have contributed to preparing the textiles for the exhibition and for photographs in the book: Jo Hill, the director of conservation at the UCLA Fowler Museum of Cultural History, Sara Wolf at the Textile Museum, Washington, D. C., Edith Dietz at the Smithsonian Institution, and Sharon Shore of Caring for Textiles, Los Angeles. The outstanding photographs of textiles in this book are mostly the caring, patient, and highly skilled work of the Fowler Museum's talented photographer, Don Cole. These gold- and silver-embellished textiles are extremely difficult to photograph well. The metal surfaces reflect so much light that, in the hands of less talented photographers, the details of the design are almost obliterated by the reflections. A few of the textile photographs included in the volume were the work of another excellent photographer, Gene Akers of Santa Fe.

Finally, we are indebted to the entire staff of the Fowler Museum of Cultural History for welcoming us into their midst and helping to make the exhibition and book possible. Among those who have not been already mentioned we want especially to thank: Senior Editor Lynne Kostman for her remarkable thoroughness and her unwavering patience both in overseeing the editing of this book and in dealing with other institutions from whom we needed to borrow photographs; freelance editor Karen Jacobson for her efforts in assuring the consistency and readability of this text; Collections Manager Fran Krystock for her shepherding of the fragile weavings and her concern that they receive the best possible care in storage; Registrar Sarah Kennington and her assistant, Farida Sunada, for efficiently attending to accessioning objects for the exhibition and to the voluminous detail that attended the borrowing of artifacts for the exhibition; Exhibition Designer David Mayo and his staff for design and installation of the exhibition and for advice about many aspects of curating the exhibition; Curator Roy Hamilton for his careful reading and intelligent criticisms of the manuscript of the book; Director of Publications Danny Brauer for monitoring and overall supervision of the publication of the book including the excellent choice of Sandy Bell as designer; Director of Education Betsy Quick, who generously shared her expertise in presenting information to museum visitors to help us prepare text panels and labels; and Director of Public Relations Christine Sellin for effectively making the public aware of this book and the exhibition it accompanies.

ANNE AND JOHN SUMMERFIELD

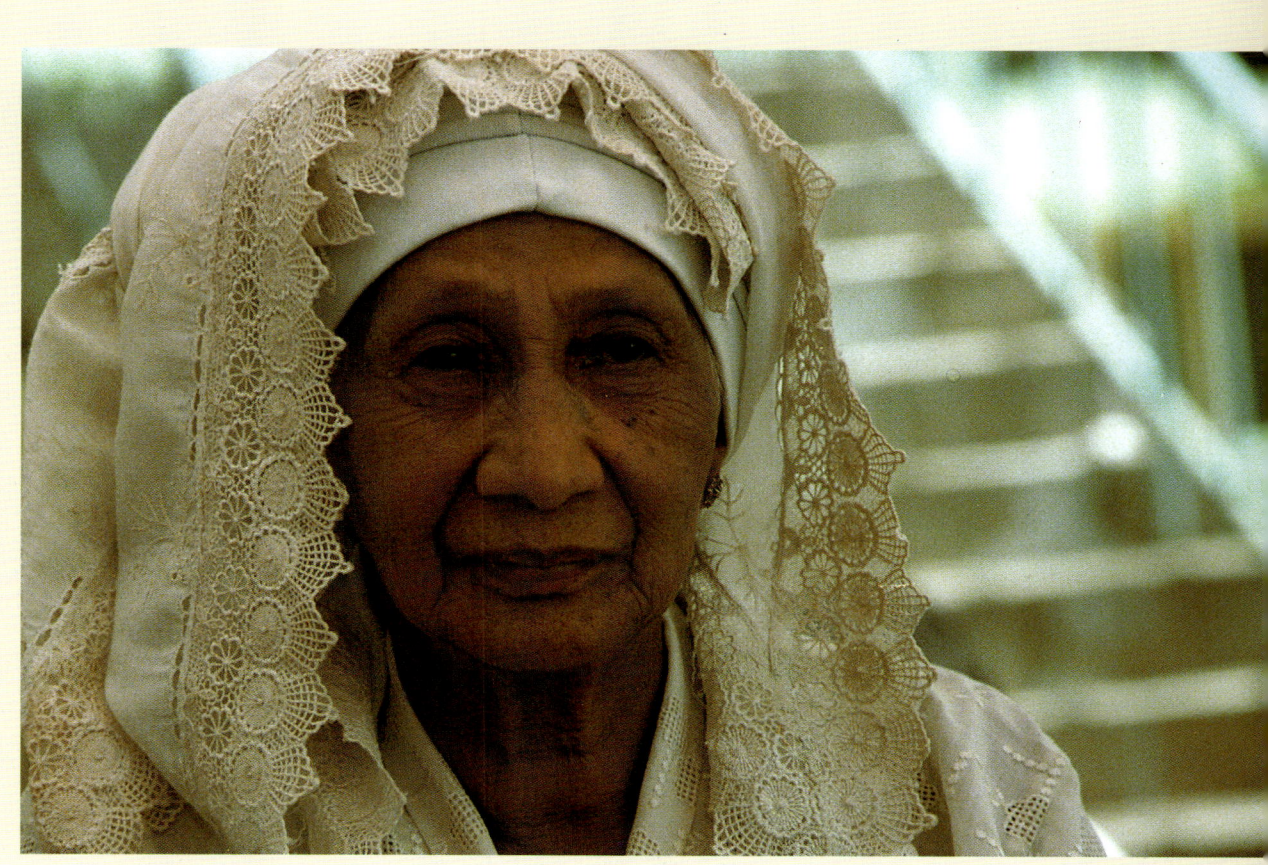

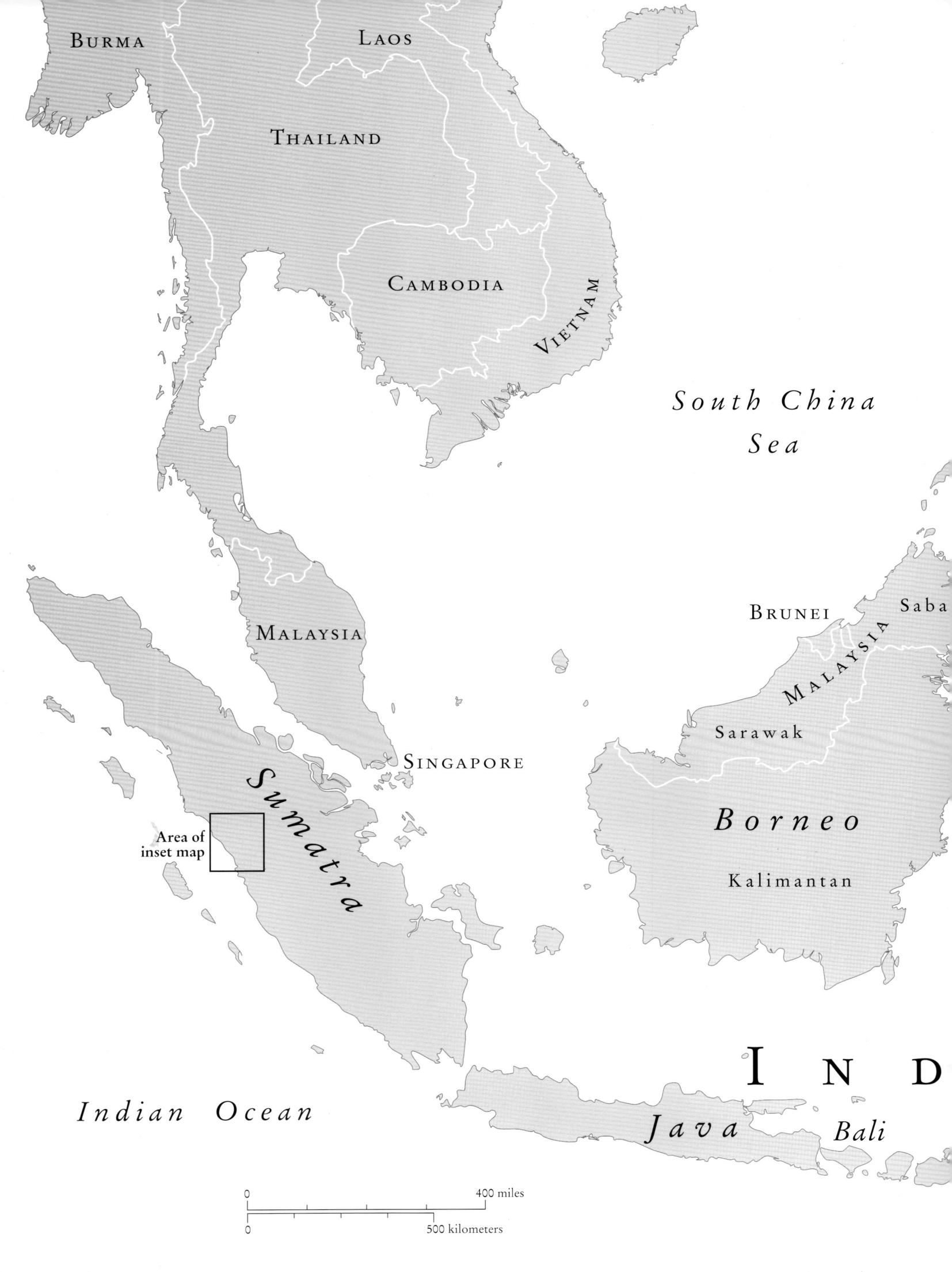

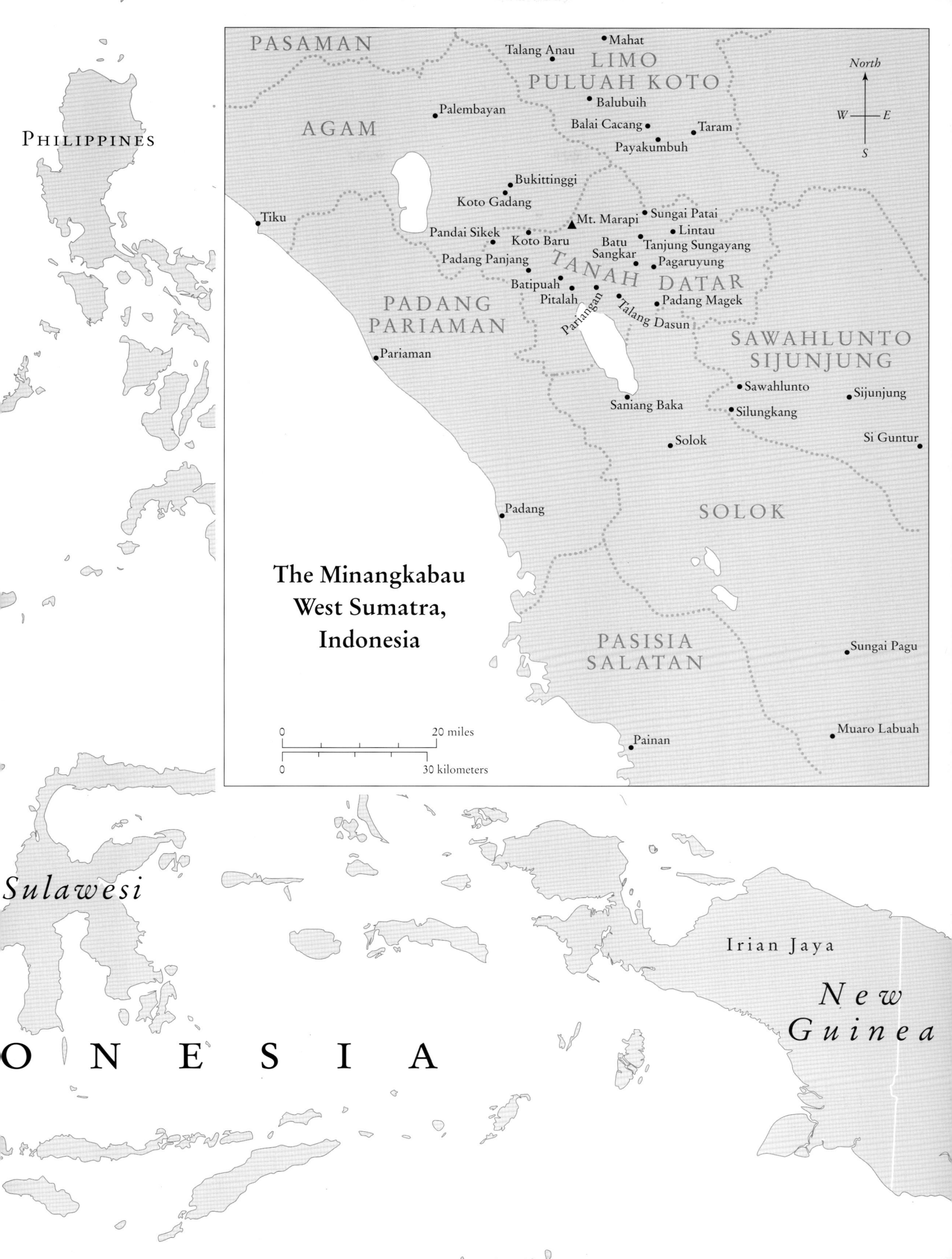

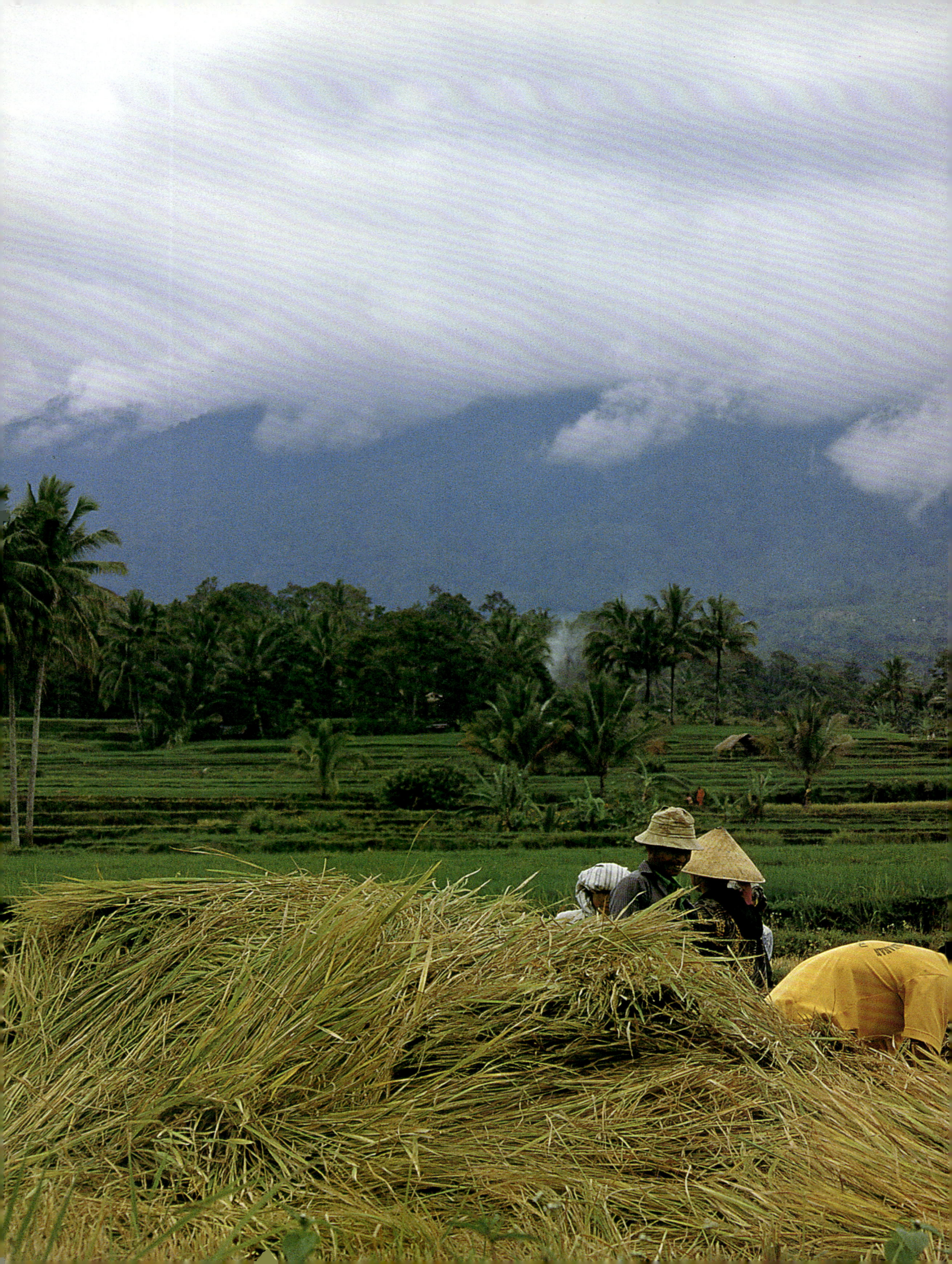

Part 1
THE MINANGKABAU

We are the people of the adat.

—MINANGKABAU SAYING

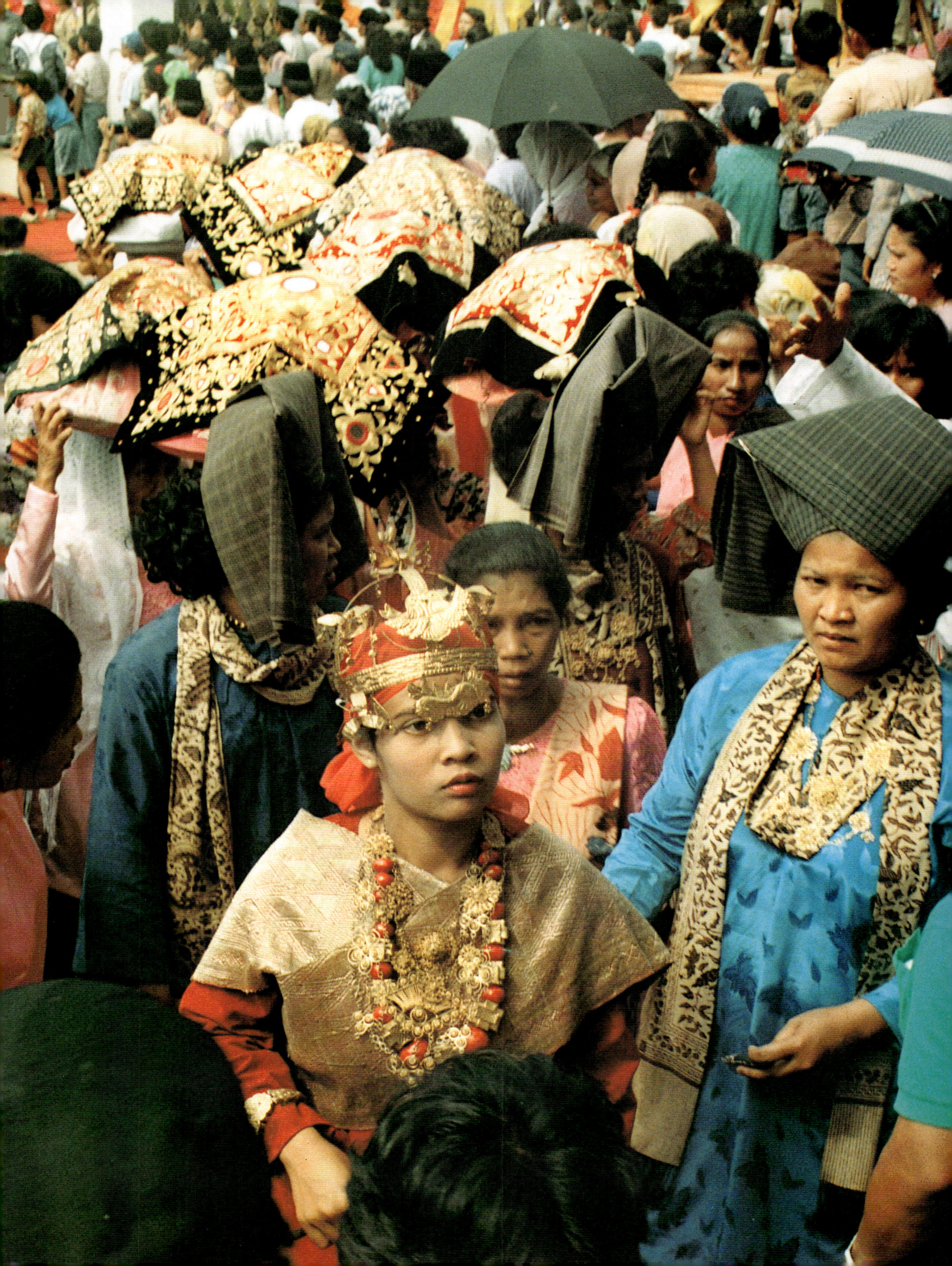

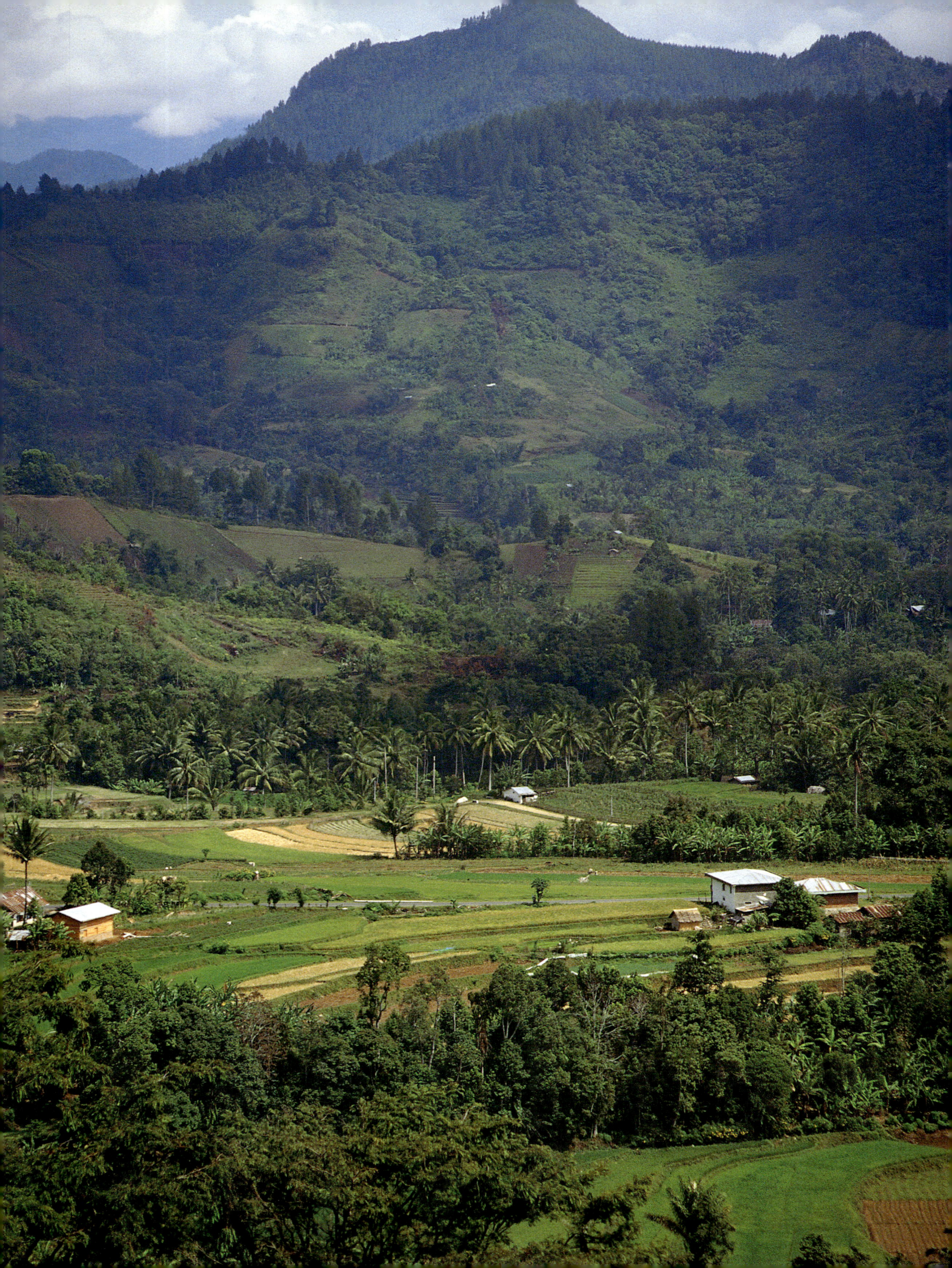

Anne and John Summerfield

INTRODUCTION

The homeland of the Minangkabau is on the tropical Indonesian island of Sumatra, the world's fourth-largest island. Sumatra, which straddles the equator at the western end of the seventeen-thousand-island Republic of Indonesia, has long been known as the island of gold. The literature of India from the first century C.E. refers to the area as Yavadvipa or Suvarnadvipa, the "golden island" or "golden peninsula." Writing in the second century C.E., Ptolemy also referred to the island as Yavadvipa (Hall 1981, 121–23).

The Minangkabau heartland occupies a series of valleys in the highlands of the Barisan Mountains, a range that runs like a spine along the length of Sumatra. The area of the highlands originally settled by the Minangkabau consists of fertile valleys and rough, mountainous terrain (fig. 1.1), including three volcanoes: Mounts Marapi, Singgalang, and Sago. Only Marapi is still active (fig. 1.2). The scenery is spectacularly beautiful, with many long vistas of planted fields leading to steep mountain slopes and lakes reflecting cloud-strewn skies (fig. 1.3).

According to legend, the first Minangkabau settlement was on the high slopes of Mount Marapi. From there the population spread into immediately surrounding areas, eventually occupying three major regions that came to be called the Minangkabau heartland. These regions, known as the *luhak nan tigo* (three regions)—Tanah Datar, Agam, and Limo Puluah Koto—are now incorporated (with the same names) as three regencies, or *kabupatan*, of the province of West Sumatra. Emigration from the heartland *luhak* to frontier, or *rantau*, areas first took place to neighboring highland regions. Later some highland dwellers moved to more distant places, including the western coastal plains along the Indian Ocean. Gradually the Minangkabau community was distributed throughout central Sumatra. Major west coast settlements were at Tiku and Pariaman, two important early trading ports, and at Padang, now the capital of the province of West Sumatra.

EARLY INHABITANTS

It is not clear when the ancestors of the Minangkabau arrived in what is now the Indonesian province of West Sumatra. Megaliths in a field at Mahat and in neighboring areas in the regency of Limo Puluah Koto (figs. 1.4–1.6) are said to be four to five thousand years old (Bahar 1993, 14). Some are in the form of snakes or other animals; many are carved with abstract motifs. Nearly all stones at Mahat face toward Mount Sago, whose former name was Surga, believed to mean "heaven." Other megaliths found at Balubuih, in Limo Puluah Koto, are also carved (fig. 1.7), some with motifs also found in woven ceremonial textiles of the Minangkabau.

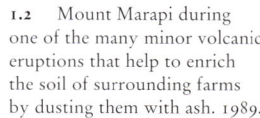

Arguing largely from archaeological and linguistic evidence, Peter Bellwood (1985) has traced the flow of human migration into the western part of Indonesia from South China through Taiwan and thence south to the Philippines and Indonesia. There is some interesting linguistic and other evidence that suggests possible common early origins of the Minangkabau and the Laotian Lao Tai. For example, in the Lao Tai language *minan kabo* means "honorable mother of water buffalo,"[1]

1.1 Part of a panorama of fields and mountains on the road from Bukittinggi to Batu Sangkar. 1996.

1.2 Mount Marapi during one of the many minor volcanic eruptions that help to enrich the soil of surrounding farms by dusting them with ash. 1989.

1.3 Clouds reflected in the mirrorlike surface of the crater lake Maninjau, near Bukittinggi. 1995.

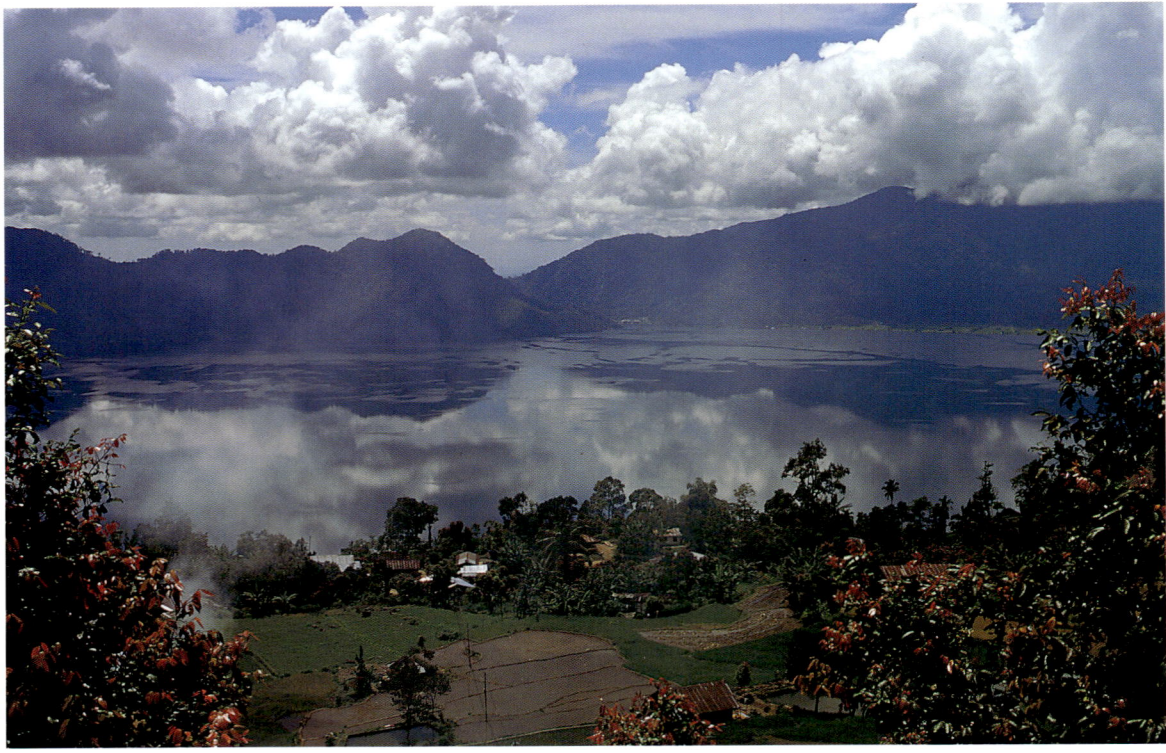

1.4 The Mahat field of megaliths, said to date from four to five thousand years ago. Nearly all stones face toward Mount Sago. The reason why is not known. 1997.

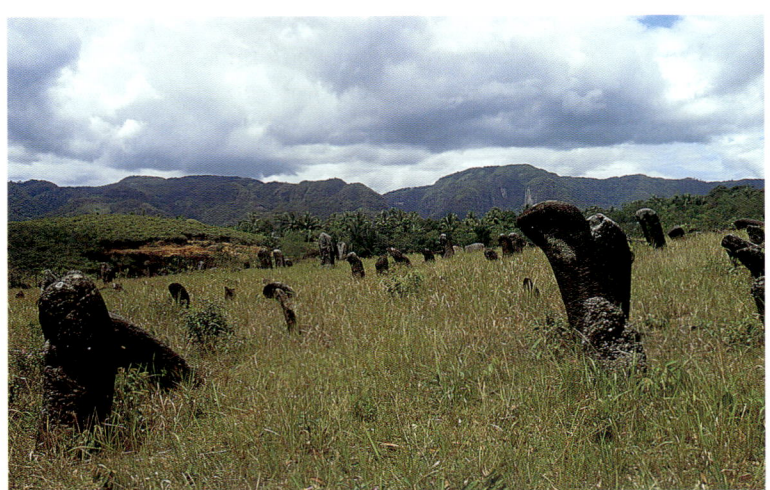

1.5 Detail of motifs carved on a Mahat megalith. 1997.

1.6 Megalith in the form of a snake's head in the village of Talang Anau, near where six large granite boulders were excavated. These boulders, when struck with a fist-sized stone, resonate with the five tones of the Minangkabau musical scale. Legend has it that the stones were the origin of the musical scale in this culture. 1995.

1.7 A small megalith from the field at Balubuih. The spiral shape carved into this stone appears as a significant motif in Minangkabau carvings and ceremonial textiles. Burials have been found under some of the Balubuih stones. 1994.

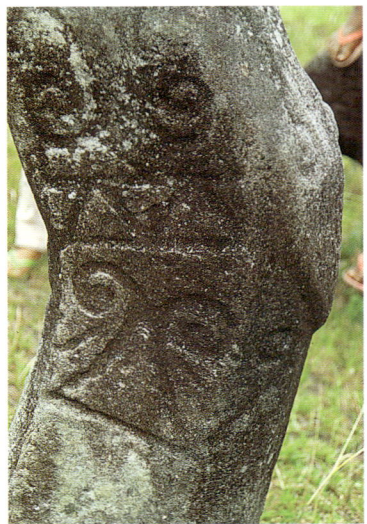
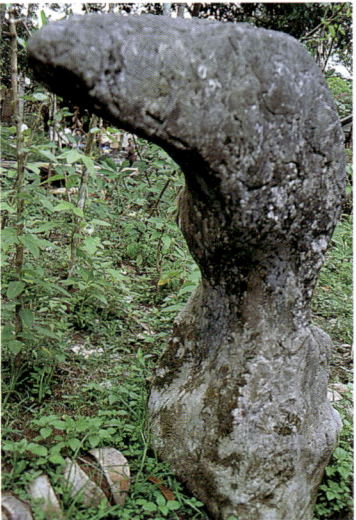
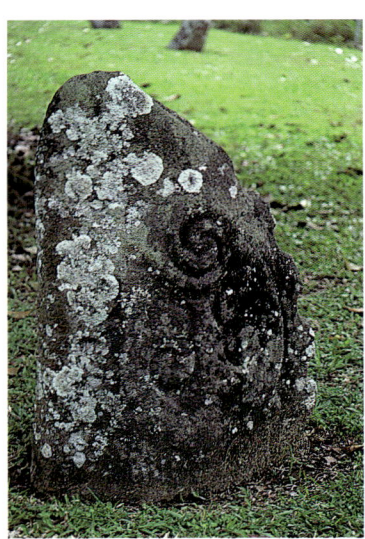

30 THE MINANGKABAU

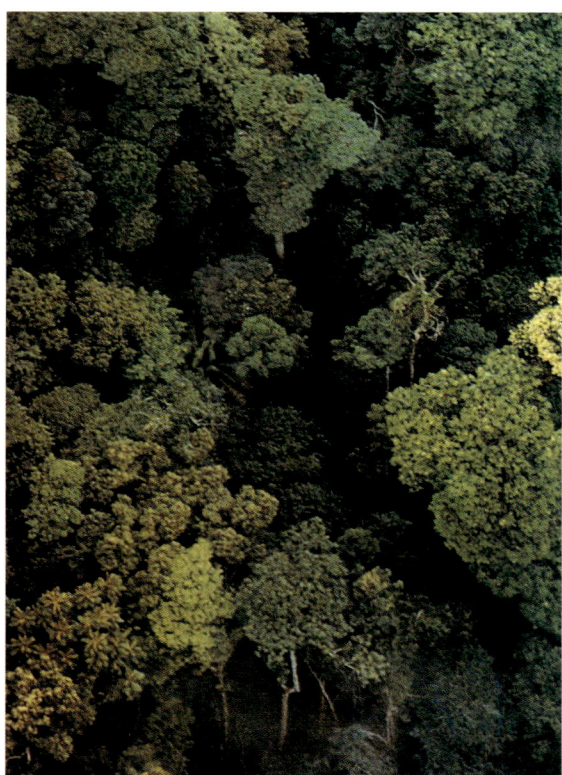

a plausible source of the name Minangkabau. (For a popular legend explaining the origins of the name, see chapter 2.)

Early Trade

In part because of its rich natural resources and in part because of its strategic location along the ocean trade route connecting the Middle East and India with China, Sumatra has been subject to influences of many cultures: Arab, Persian, Indian, Chinese, Javanese, and later Portuguese, English, and Dutch. After the Chinese lost access to their land routes across Asia in the fourth century (Hall 1981, 128), sea passages assumed ever greater importance in the trade connecting China with India and the Middle East. Although the Minangkabau dwelt for the most part in the mountainous inland terrain of Sumatra, they were avid traders with merchants from far distant cultures. In the early days Minangkabau traveled by river to the eastern shores of Sumatra to meet seagoing traders along the Straits of Malacca at Jambi and at Palembang. The trading route was not easy. Sometimes it required journeying on foot for as long as three weeks to reach tributaries of the rivers that flowed down to the straits. Small boats laden with gold, gambir, and pepper started down the tributaries of the Kampar and Inderagiri or later down the Batang Hari, joining other Minangkabau trading groups along the way at entrepôts. There the cargo was transferred to larger vessels and eventually reached the straits. The trip back was more difficult as the vessels, laden with Indian cloths and other trade goods, mostly had to be poled back up the rivers.

Steep, mountainous terrain and rain forest jungle (fig. 1.8) made the shorter trip from the Sumatran highlands to the west coast extremely difficult. It was not until the nineteenth century that the Dutch, with forced Minangkabau labor, managed to construct a road and a railroad from the highlands to the west coast port of Padang (fig. 1.9).

Foreign Influences

Early trade brought the Minangkabau into contact with Arab, Chinese, Indian, and Javanese traders and thus into contact with Islam, Hinduism, and Buddhism. Some elements of Minangkabau men's ceremonial dress are today acknowledged to be derived from Hindu garments (see chapter 5). By the twelfth or thirteenth century, trade with India was of sufficient magnitude that Indian traders had established themselves in the Tanah Datar region of the Minangkabau highlands to maintain oversight (Dobbin 1983, 61).

In the fourteenth century the arrival of Adityawarman, a prince from the Javanese kingdom of Majapahit who established courts both in Jambi and in Minangkabau, introduced in the Minangkabau heartland a Tantric form of demonic Buddhism that included the concept of a divine ruler. Adityawarman established a royal court, called Pagaruyung, and a continuous line of royal authority extended from his time until

1.8 The rain forest jungle en route to Anai. During the nineteenth century traders had to traverse this terrain in order to reach the west coast and the Indian Ocean. 1995.

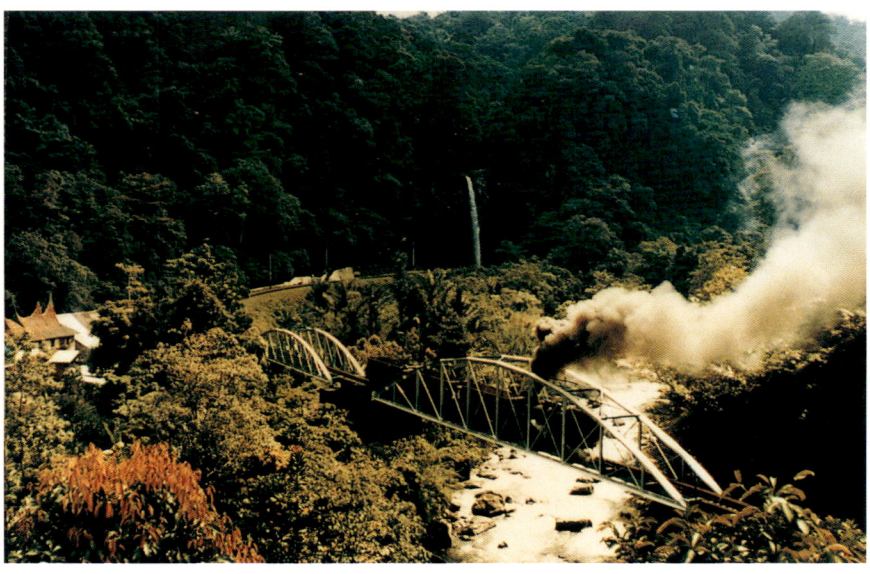

1.9 A coal train crossing the Anai River. Coal could not be moved from the rich Ombilin coal field to the west coast port at Padang until a road and railroad tracks were constructed under Dutch administration in the nineteenth century.

INTRODUCTION 31

1.10 The current raja at Si Guntur, which was once a palace but is now a residence-museum in the regency of Sawahlunto/Sijunjung. Although long stripped of all political power, this raja still represents the line of authority established in the fourteenth century to administer areas of the highlands that were not part of the original three settlement areas. His grandson will succeed him. 1996.

1.11 Cultivated rice paddies near Palembayan, in Agam, stretch up the lower slopes of the mountains surrounding the valley. 1995.

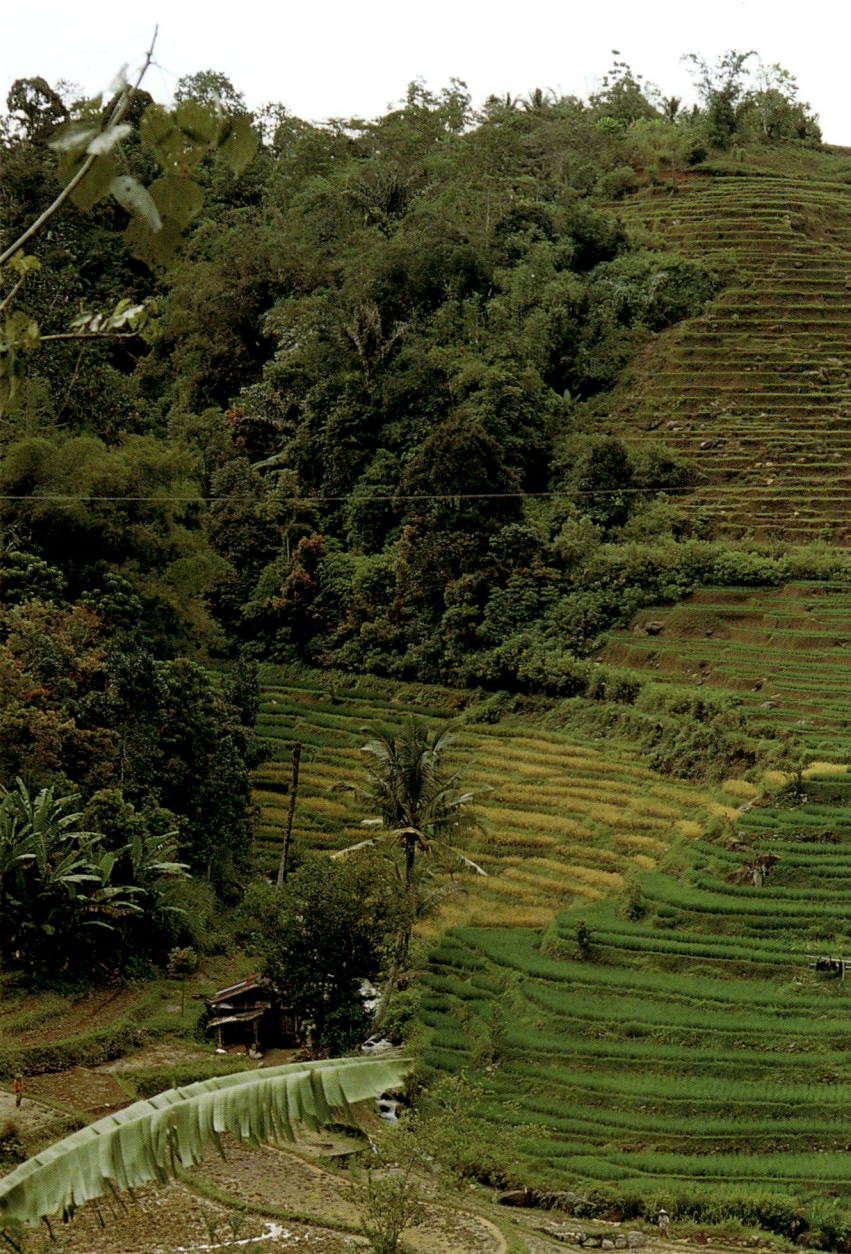

a few years after the Dutch took control of the highlands in the mid-nineteenth century. The king was basically a figurehead in the heartland villages. Village chieftains (*pangulu*), through actions of village councils, continued to lead their people. In the *rantau*, areas outside the heartland, however, villages were ruled by rajas (fig. 1.10), supported by Pagaruyung.

By the first quarter of the sixteenth century, Islam had taken hold among the tradespeople of the coastal area of Sumatra. Certain areas of the highlands had been converted to Islam by the mid-seventeenth century.[2] By the second quarter of the nineteenth century, the Dutch had acquired control of the Minangkabau territory, then known as Central Sumatra.

At the end of World War II Indonesia declared its independence, but the Dutch, eager to regain control after the defeat of the Japanese occupiers, resisted fiercely, finally capitulating in 1949. At that time the territory that had been known as Minangkabau became the Indonesian national province of West Sumatra. (See chapter 16 for a discussion of how Minangkabau ideology influenced the form of the new nation.)

The Contemporary Minangkabau Economy

The valleys and lower slopes of the mountains in the Minangkabau heartland are devoted largely to wet rice cultivation (fig. 1.11), with fruit trees and vegetables grown on much of the remaining land. Heavy work such as plowing rice paddies in preparation for planting is accomplished with the aid of water buffalo pulling plows through muddy, water-soaked fields. Planting, harvesting, winnowing, drying, and packaging are all carried out manually (figs. 1.12, 1.13).

A rich variety of tropical fruit is available in the region (figs. 1.14–1.16). In addition to rice, fine arabica coffee, cinnamon, pepper, and gambir are among the most productive crops of the Minangkabau heartland. Some cotton is grown in the coastal areas to supply raw materials for heartland weavers. Home-grown fruits and vegetables are distributed largely through open-air village markets (fig. 1.17), to which growers bring their produce on weekly or semiweekly market days. Small shops in most villages are open daily for sale of other necessities, such as cooking utensils, clothing, hardware items, and now antiques.

Rice flour, a common cooking ingredient now available commercially in Indonesia, was at

THE MINANGKABAU

1.12 Woman sowing rice in a nursery bed, where the young sprouts will be tended until they are ready to be transplanted into the larger paddy. Between Bukittinggi and Batu Sangkar. 1989.

1.13 Men transplanting rice from the nursery to the paddies. These two have built raft-like sleds to carry sizable amounts of the young rice plants along with them as they plant in the flooded field, thus speeding up a long and laborious project. Between Bukittinggi and Batu Sangkar. 1989.

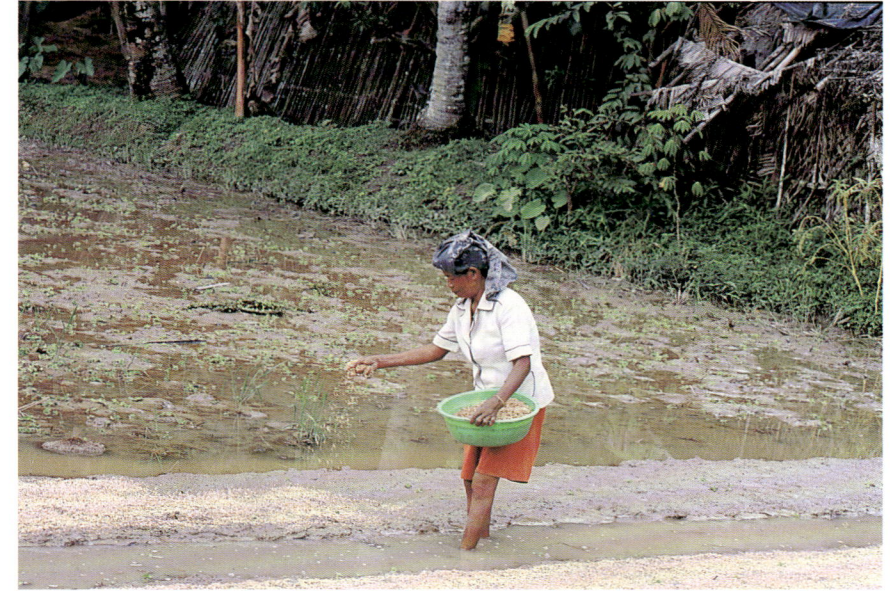

1.12

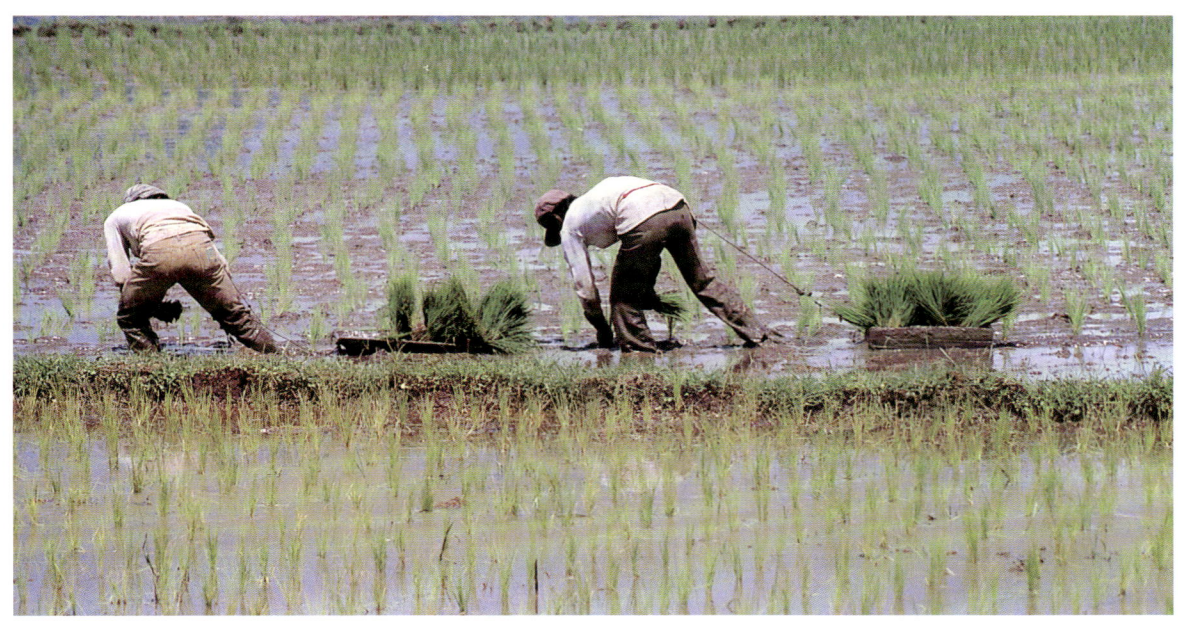

1.13

1.14 A display of several different types of bananas for sale in the market at Bukittinggi. 1994.

1.15 The edible portion of this fruit, mangosteen, is a delicious sphere of small white segments encased in a hard, woody red shell. The number of white sections in the interior is the same as the number of rectangular growths found on the bottom of the fruit. The piece illustrated has seven edible white sections. Bukittinggi. 1989.

1.16 The fruit called salak is sometimes also called snake fruit because of the scaly appearance of its thin skin. The edible portion of the fruit is light beige, crisp, and waxy. Bukittinggi. 1985.

1.14

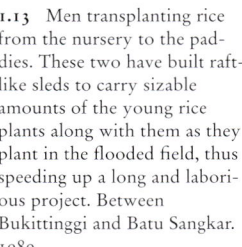

1.15

1.16

INTRODUCTION 33

1.17 The view from the upper market at Bukittinggi toward the lower market. 1994.

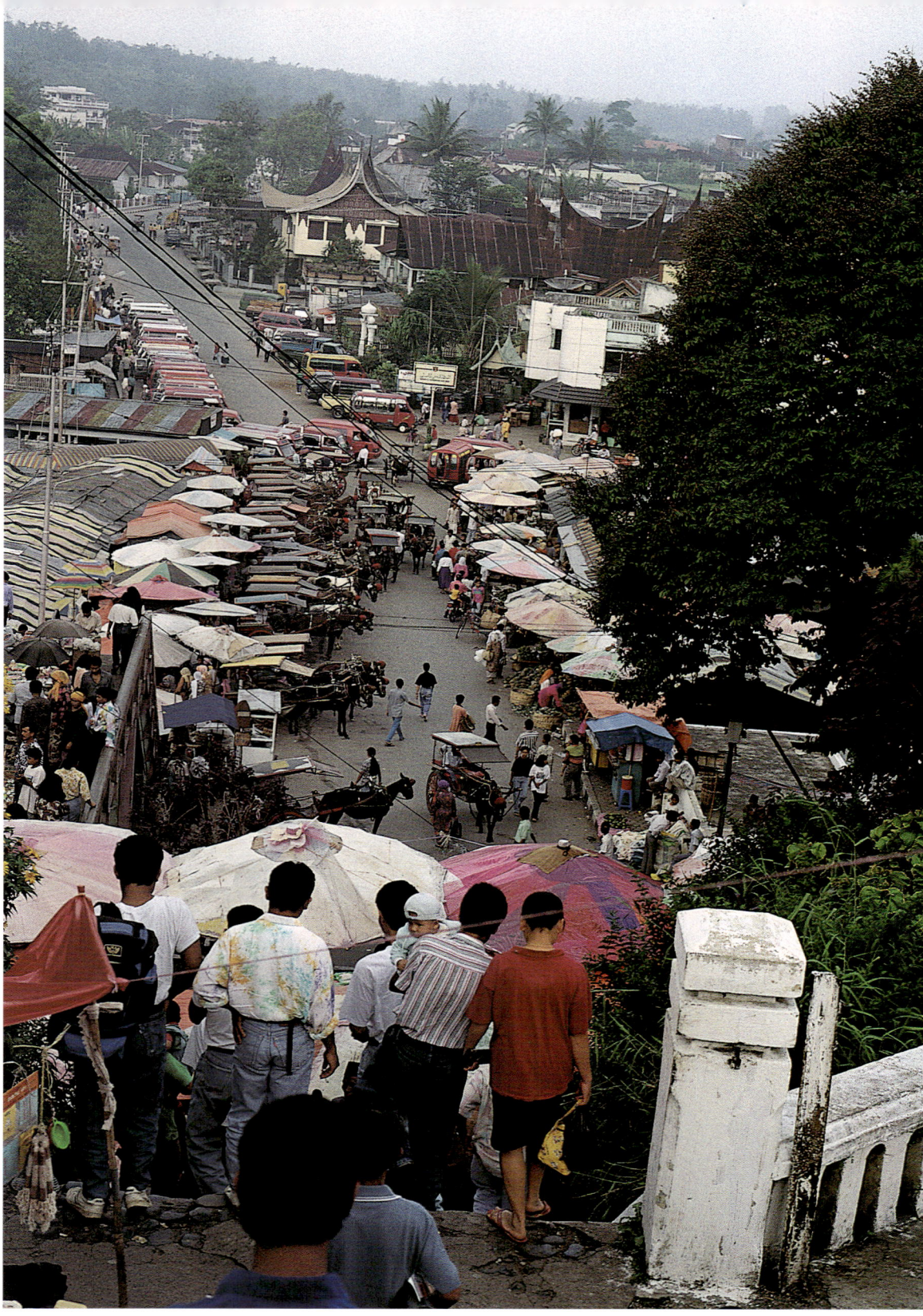

one time produced by hand-pounding dry rice in a huge stone mortar (fig. 1.18). This technique was supplanted by simple mechanical pounders, driven by water power (fig. 1.19), which were considerably more efficient. Similar waterwheel-driven pounding machines are still used commercially for grinding coffee (figs. 1.20, 1.21), and waterwheels are also used to lift water from flowing streams to high troughs that feed irrigation systems for rice paddies (fig. 1.22).

Minangkabau food, often called Padang food,[3] is notorious for its extensive use of hot chili peppers (fig. 1.23). So-called Padang restaurants, which have spread through much of Indonesia, feature a unique style of "fast food" service. No sooner has one been seated at one of these restaurants than a waiter arrives with as many as a dozen dishes stacked along his arm (fig. 1.24). He places them on the dining table along with large bowls of rice. Each dish

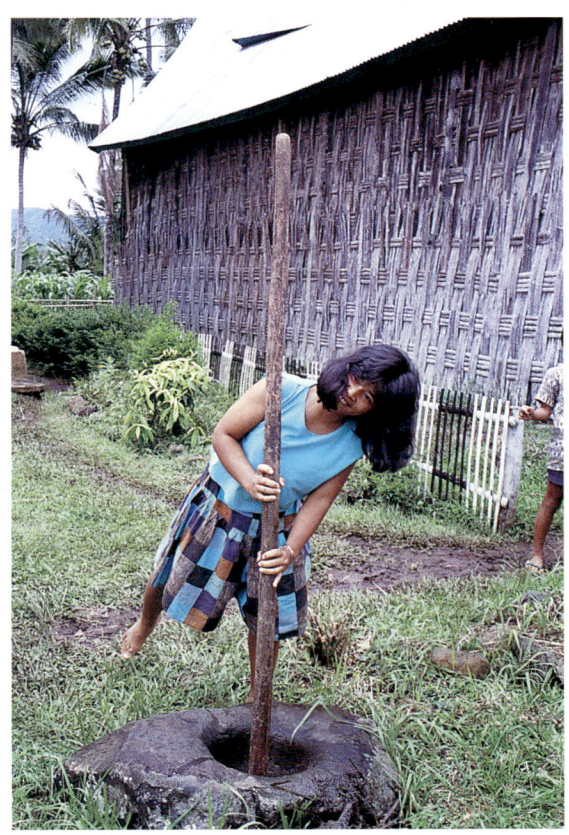

1.18 A woman pounding rice in a mortar to make rice flour for cooking. Padang Magek. 1989.

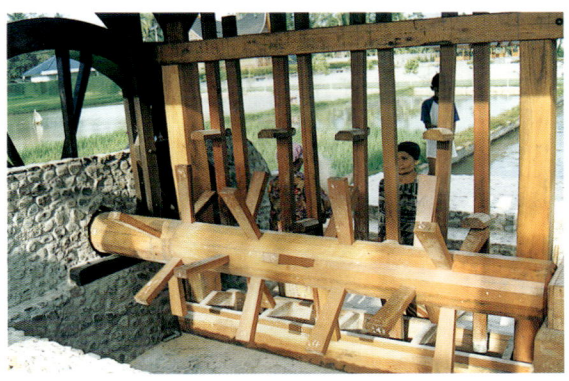

1.19 A mechanical rice pounder actuated by a waterwheel. Note how the arms on the large wooden axle lift the pounders and then disengage so that the pounder falls under its own weight and pulverizes the rice grains into fine flour. This contemporary example was built as one of a series of demonstrations of indigenous Minangkabau production techniques at the Rumah Godang, an unusually informative tourist attraction in Limo Puluah Koto. 1995.

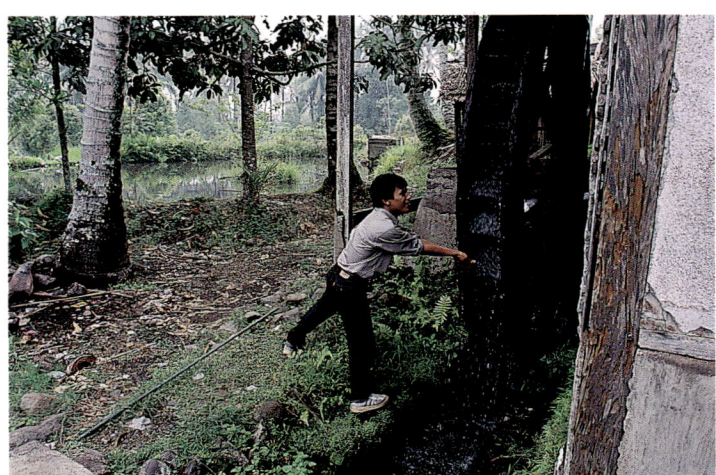

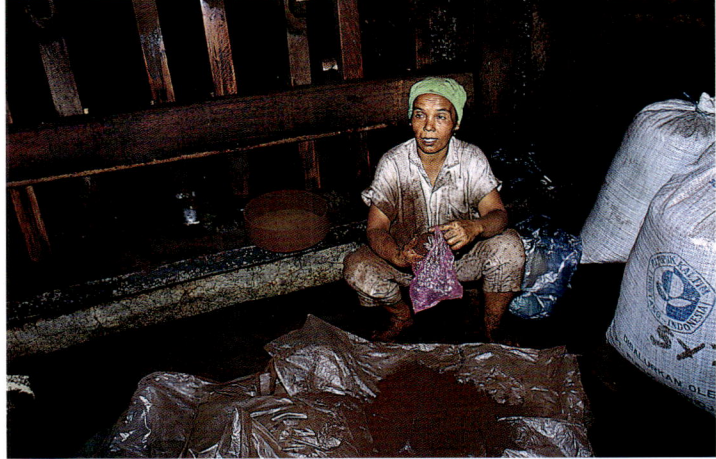

1.20 The waterwheel of a coffee-pounding mill still commercially active in the village of Sungai Tarab, in the regency of Tanah Datar. 1994.

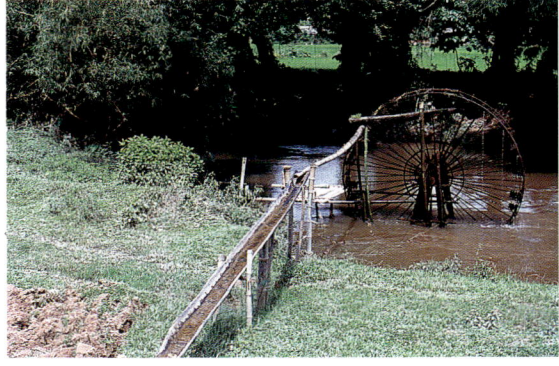

1.21 Interior of the coffee mill showing the waterwheel–activated pounders that pulverize the coffee beans. The mechanism is the same as that of the demonstration rice pounder shown in figure 1.19. Sungai Tarab. 1994.

1.22 A waterwheel used to lift water from a stream and distribute it to crops in nearby fields. Near Mungo. 1989.

INTRODUCTION

1.23 A market display. From the top: chili pepper paste, chilies, and shallots. The tropical climate is not well suited to growing onions, so shallots replace them in everyday foods. Sawahlunto. 1994.

1.24 A waiter in a "Padang" restaurant delivering twelve different dishes and rice to a customer's table. West Sumatra.

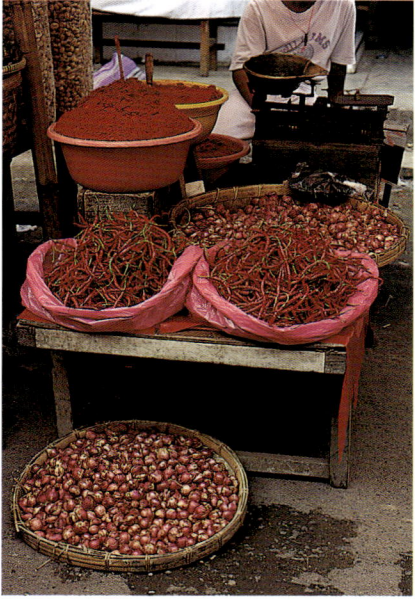
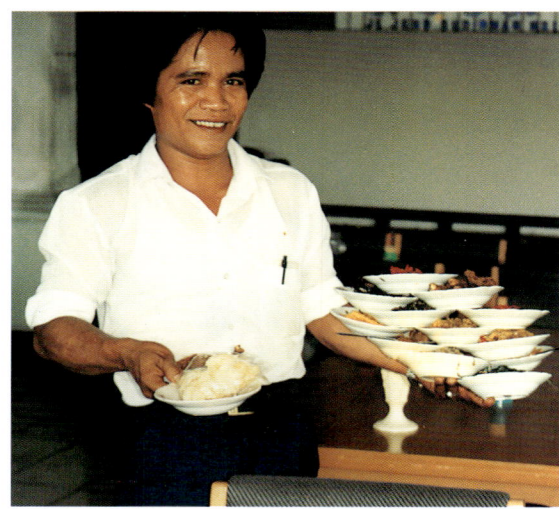

OPPOSITE:
1.25 Headdress textile from the village of Pariangan. Silk, cotton, silver-wrapped thread. To create the village-specific headdress, this textile is first arranged to form two conical "horns" at the sides of the wearer's head. Then the ends, lavishly embellished with motifs in silver thread, are arranged to fall behind the shoulders to make an elaborate frame for the face. (See chapter 6 for illustrations of Minangkabau women's headdresses.) 273 x 71 cm, including trim. FMCH X93.25.45; collection of H. Elly Azhar and H. A. Sutan Madjo Indo.

contains a different food: fish, eel, buffalo, beef, goat, eggs, liver, lung, brains, vegetables, pickles, fruit, and a variety of *karupuak* (the omnipresent Indonesian flour, nut, or fish and flour deep-fried variants on chips). Diners select and eat only what they wish.

Agriculture is not the only industry of the Minangkabau. They are especially noted for the superb quality of their handwoven ceremonial textiles, often richly embellished with gold- or silver-wrapped thread (fig. 1.25). Before World War II women in most Minangkabau villages produced these sumptuous textiles for their own and their extended family's ceremonial use. Textile design and format tended to be village-specific. Today the villages of Pandai Sikek and Silungkang are major production centers for ceremonial clothing. Although weaving of ceremonial cloth still continues in a few other villages, notably Tanjung Sungayang and Balai Cacang, it is on a considerably smaller scale.

The village of Silungkang, surrounded by land that is only marginally suitable for agriculture, has developed a specialized industry that supplies warped looms for the entire Minangkabau heartland (fig. 1.26) and also ties, dyes, and weaves ikat textiles of contemporary design (fig. 1.27). Silungkung is also a source of nationally distributed commercial cloth yardage and sarongs for everyday wear, produced in this case by men, not women.

In the sixteenth century a Turkish sultan sent a variety of craftsmen to Aceh, in Northern Sumatra, primarily to help the Acehnese develop military hardware (Reid 1969). It is believed that the Turkish-inspired jewelry-making techniques of filigree and granulation, now found throughout Indonesia, date to that period. The Minangkabau village of Koto Gadang in Agam is home to a number of expert silversmiths and goldsmiths who produce exquisite jewelry with outstanding filigree and granulation work (fig. 1.28).[4]

West Sumatra also boasts other metalworking industries, especially the making of hand-forged tools. It is a large producer of coal and cement. Mining the gold that brought early traders and raiders to Minangkabau is no longer commercially profitable, although it is not uncommon to see individuals panning for gold along the banks of the Ombilin River in Tanah Datar.

THE MINANGKABAU

At the heart of this beauty and productive activity is one of the world's most remarkable cultures: the Islamic, matrilineal Minangkabau. Prehistoric Minangkabau society was governed by a multifaceted *adat*,[5] which made lineage, property, and inheritance the responsibility of senior women but entrusted maintenance of the adat, the smooth running of the society, and resolution of its disputes to senior men and their adat councils of *pangulu*. When the Minangkabau converted to Islam, they retained their basic adat beliefs and their matrilineal social organization, yet they became (and remain) strongly Muslim. By adopting from Islam the broad outlines of proper behavior, and by relying on their age-old adat to tell them in detail how to fill out those outlines, the Minangkabau have been able to blend two systems that, on the surface, appear to be conflicting (fig. 1.29).

1.26 Colorful threads being unreeled from a bank of spools in a workshop in the town of Silungkang. The threads are directed onto a warp drum, which will be attached to the foot of a loom in Pandai Sikek for weaving colorful everyday sarongs. 1995.

1.27 This three-piece ensemble with traditional motifs of metallic thread and black and white ikat patterning won first prize in an Indonesian national competition held to promote weaving as a national art form. The designer and model is Poppy Zalnofri, wife of the *bupati*, or head officer, of the regency of Sawahlunto/Sijunjung. The costume was woven in the town of Silungkang, the only Minangkabau region known to have produced ikat cloths with complex patterns. The photograph was taken in front of the *bupati*'s residence in Sijunjung in 1994.

1.28 Detail of a necklace with peacock motifs executed in filigree and granulation techniques, which were introduced to Sumatran jewelers by Turkish goldsmiths. Use of these techniques eventually spread from Sumatra throughout the western half of the archipelago. Bukittinggi. 1991.

1.29 The roof of an Islamic mosque in Batu Sangkar is topped with a small structure reminiscent of the roofs on traditional Minangkabau adat houses. Such conjunctions of symbols of Islam and adat are metaphors for the uniquely Minangkabau blending of these two belief systems.

Many events in Minangkabau daily life call for ceremonies: birth, circumcision of a young male, learning to recite the Quran (Koran), planting or harvesting of rice, marriage, the elevation of a man to the role of clan chieftain. The scale of the event varies from a simple *salamatan*, an offering of thanks, to a multiday wedding ceremony. At its most lavish, a ceremony calls for both men and women to wear sumptuous heirloom textiles of silk or cotton, woven with motifs in gold- or silver-wrapped thread, garments that are part of the long Minangkabau tradition (fig. 1.30).

Although this is a matrilineal society, senior males (*niniak mamak*) play the most prominent role in ceremonies. The society has a long oral tradition, and the *niniak mamak* display their knowledge of this tradition with lengthy speeches, often in the form of a mock debate to inquire if the ceremony about to take place is in proper adat form. Different ceremonies call for different ceremonial foods, and some involve music, dance, and drama performances that last through the night.

The Minangkabau highly value democracy, education, social justice, success, and individual freedom within the confines of adat. They were quick to take advantage of the school system that the Dutch introduced after acquiring control of the area. This early exposure to, and enthusiasm for, education has helped make the Minangkabau major contributors to contemporary Indonesian literature and has enabled them to play important roles in Indonesian government and industry.

The Minangkabau Adat

No introduction to the Minangkabau would be complete without some preliminary discussion of their adat, the indigenous ideology that guides them in all activities, religious and secular. In most Indonesian cultures adat encompasses a body of traditional practices and conventions, but the Minangkabau adat is much more pervasive. It is "the whole body of standards and rules used by Minangkabau to guide their lives, to structure social groups and social

relations, to determine the rights and obligations of individuals and groups, to select meaningful words to be used in speaking, and to face foreign ideologies" (Manan 1984, 4).

There are four aspects of Minangkabau adat. The first-known as "the adat that is truly adat," or *adat nan sabana adat*—is said to have existed even before the world existed and "neither cracks in the sun nor rots in the rain." It contains statements of the laws of nature, of the way nature behaves (for example, "water wets"). This adat has been expanded to include rules for the Minangkabau matrilineal system of inheritance, the role and responsibilities of *pangulu*, the division of villages into clans, and so forth.

A second aspect of adat is known as "the adat which was developed into adat" (*adat taradat*). It consists of rules for ideal social conduct and includes standards that form the basis of a constitution and the laws that enforce it. This form of adat allows the making of rules for conduct that may be less than ideal but that offers the best practical way to approach the ideal.

The third aspect of adat is *adat nan diadatkan*. This consists of adat that has been created by consensual decisions of the *pangulu* members of a village adat council. Such adat may differ markedly from village to village. The ability to incorporate new rules into an existing corpus provides the adat with great flexibility and ensures its currency. *Diadatkan* rules may regulate what kind of food is served at ceremonies (fig. 1.31) as well as appropriate ceremonial costumes (fig. 1.32). A recent example of change to ceremonial procedure decreed by a village council of *pangulu* in the 1970s was imposition of a restriction that limited the amount of food that could be served at ceremonies. Wealthy participants were apparently becoming inappropriately ostentatious with lavish outlays of food, to the dismay of less affluent participants, who felt demeaned. In the late 1980s *pangulu* in a different village limited the number of textiles that could be displayed at ceremonies because differences between rich and poor were becoming distressingly apparent in a society that prides itself on its social democracy.

The fourth aspect of adat—the *adat nan istiadat*, or general customs—contains rules for the use of words to address other persons: parent to child, peer to peer, wife to husband, and so on. It is also the adat that governs games, permitting those that are generally accepted as good and dismissing those that are considered by the society to be bad, such as gambling and cock fighting. *Istiadat* also acts as a guide for the creation

1.30 This spectacular, sophisticated headdress textile from the village of Pitalah is unusual because all of the warp threads are made of the very fine bast fiber *ramin*, the inner bark of a type of *Boehmeria*. Silk, *ramin*, gold-wrapped thread; motifs woven of gold-wrapped thread along the selvage are so placed that the red silk background material also forms motifs. 280 x 75 cm including fringe. Private collection.

INTRODUCTION 39

1.31 "Table" for a ceremonial feast set on the floor of the room where the ceremony will take place. The cake in the center of the table is made of cardboard and is for decoration only. Bukittinggi. 1995.

of certain art forms, such as dance (see chapter 14), which is classified as a form of recreation, albeit a very serious one.

Ceremonial Arts and the Adat

Visitors to the Minangkabau heartland are struck by the profusion of elaborate patterns decorating ceremonial weavings and the façades and interiors of the traditional houses known as *rumah gadang*, or big houses (figs. 1.33, 1.34). These patterns or motifs are related to adat.

Investigation into their nature yields the surprising information that literally hundreds of these motifs are known to the community. They have names, often taken from nature, which not only relate to images in carvings and in weavings but are also found in poetry, in traditional speech, and in the thousands of adat sayings known as *kato adat* (see chapters 7 and 15).

A deeper probe into the significance of motifs shows that there are also meanings associated with their names. These meanings relate to adat teachings and spell out what is ideal behavior for a "good" and wise Minangkabau. Adat-related meaning is also assigned to structures and to shapes of ceremonial garments (see chapter 5) and, in fact, to many items in the Minangkabau environment (fig. 1.35).

For what purpose, if any, did the Minangkabau undertake the monumental task of developing this complex system of adat-related names and meanings to be superimposed on the motifs of weavings and carvings? There is currently no recorded answer to this question, and we can only speculate about why such activity took place. To construct a plausible explanation, we look not only to the Minangkabau's all-encompassing adat but also to the persistent orality of the culture.

Minangkabau as an Oral Culture

Amin Sweeney (1987) has described how longstanding oral tradition in the Minangkabau heartland changed after the Dutch took over administration of the area. Until the coming of

1.32 Part of a ceremonial procession at the dedication of a palace in Limo Puluah Koto in 1989.

THE MINANGKABAU

1.33 Carving on the outer walls of the traditional house of the weaver Sanuar and her family in the village of Pandai Sikek. 1989.

the Dutch, all Minangkabau, in addition to honoring the social prescriptions of adat, were amateur adat jurists. They participated eagerly, if vicariously, in their *pangulu* councils' decisions. The decisions, a result of deliberations conducted in open-sided and therefore public council halls (*balai*), were reached by consensus and were made according to adat law (*hukum adat*). With the arrival of the Dutch, all Minangkabau were completely excluded from decision making in areas defined by the Dutch as constitutional law and criminal law. Legal areas of oral tradition were thus displaced, but vast areas of oral tradition dealing with "what it means to be a Minangkabau" were retained.

> The wisdom of oral society was consequently encapsulated in adat sayings [*kata adat*]. This area of the oral enclave of contrived speech with its short, relatively fixed, self-contained units was so designed that it could easily be drawn upon by the vernacular for use in dialogue.... The *kata adat* were, in fact, the repository of all knowledge that depended for its validity and force upon a specific word choice. Obviously, if such sayings were to possess any authority and have the weight of public opinion behind them, it was necessary that they should be known and accepted by all members of a community, and this was possible only if the sayings were in relatively fixed form. (Sweeney 1987, 122–23)

Given this large body of relatively fixed short sayings encapsulating the wisdom of the society, combined with an awareness that "matters of the most central concern to Minang society as a whole continued to be preserved, retrieved, and communicated orally in spite of the presence of writing" (Sweeney 1987, 118), we are in a position to speculate about why the Minangkabau might have found it useful to develop an enduring system associating adat-related names and meanings with motifs in their carvings and on their ceremonial textiles. First, consider that an overwhelming number of the *kata adat* refer to some aspect of nature. Frederick K. Errington (1984, 93) has gone to great lengths to elucidate the Minangkabau belief that "natural events and *adat* are of the same order

1.34 One of the exquisitely carved teakwood posts in the interior of the Rumah Godang in Limo Puluah Koto. 1995.

INTRODUCTION 41

1.35 The upswept roof finials of Minangkabau matrilineage adat houses are said by many highland Minangkabau to represent the horns of the water buffalo, or *kabau*. Most women's ceremonial headdresses also are shaped like horns, suggesting a link to the matrilineage house and emphasizing the important role of women in the culture. Batu Sangkar. 1986.

of reality"—that is, natural events and social order follow the same form. He gives as one example a Minangkabau saying that makes an analogy between water and the role of the *pangulu*: Water first exists in the earth. It is drawn up by the sun and later returns to earth as rain. So the *pangulu*, chosen from the people (by the people), is raised up (inaugurated) and then returns to the people to work for them.

Adat rules of propriety and cultural wisdom also are expressed in terms of natural occurrences. The Minangkabau acknowledge their debt to nature in the expression "nature is our teacher" (*alam takambang jadi guru*). In the *kata adat* natural occurrences are used as parallels or metaphors, both for human behavior and for other aspects of humanity that the wise should comprehend. Take, for example, the adat saying "*Indak tinggi gunuang dek kabuik*." It translates as "a mountain does not become higher just because the top is covered with fog." A Minangkabau interpretation of this saying is that one's high position does not add to one's true character (Anwar 1988, 75).

Second, it is a basic principle of the Minangkabau adat that one may *not* express oneself directly. So the Minangkabau speak metaphorically both in traditional speech and in everyday conversation, sometimes through the use of riddles. They may also converse using a type of poetry known as *pantun*, a verse of four, six, eight, ten, or twelve lines. The most common form of *pantun*, the quatrain, starts with two lines that either are present only for their rhymes or that constitute a riddle. The *pantun* concludes with two expressive lines that either explain the riddle or that otherwise communicate a message. The Minangkabau have developed the art of indirection in oral communication to a high state, and they are well known for it throughout Indonesia.

Finally, consider the vast extent of the Minangkabau adat and the literally thousands of *kata adat* that encapsulate in pithy fixed oral statements the wisdom and teachings of that adat. How should the ordinary Minangkabau, in a basically oral society that provided no handy written reference, be kept aware of the bewildering array of adat rules to be followed and adat wisdom to be absorbed? Again, according to Sweeney (1987), the way to ensure awareness was to repeat the things one should know. The *kata adat*, which were easily memorized and repeated in everyday speech, provided one mechanism. An additional way to provide repetition would be to augment the system of verbal images with a like system of visual images: the motifs and images in carvings and weavings.

By selecting names from nature for these images and by using those names as signs pointing to *kata adat* centered on the named natural object, the Minangkabau could become immersed visually as well as orally in the adat. One of the old instructional stories, the *kaba Malin Kanduang*, states that "textiles are the skin of adat," the visual manifestation of adat. We conclude that a reason for naming motifs and, indirectly, for investing meaning in them could well have been mnemonic, a means of recalling the *kata adat* and so reinforcing teachings of the adat.

It is consistent with the assignment of meaning to motifs that the Minangkabau would extend the scope of such a mnemonic system to include other aspects of ceremonial garments. And they have indeed given importance to the seams and structures of a chieftain's ceremonial garments by making them emblematic of the responsibilities of male leadership in the society (see chapter 5). For example, the sleeve-to-shoulder seam is not visible in the chieftain's ceremonial black shirt because it is covered with gold braid. Minangkabau *pangulu* say that this trim stands for the *pangulu*'s ability to resolve family disputes so that no party is displeased with the resolution and the family is again

THE MINANGKABAU

joined. So skillfully joined, in fact, that the mended family breach, or "seam," does not show (fig. 1.36).

The role of visual manifestations of adat in the Minangkabau culture should not be minimized. The importance of such matters in general has been well expressed by Sherry Orthner (1973, 1339–40): "Key symbols ... are seen as summing up, expressing, representing for the participants in an emotionally powerful and relatively undifferentiated way, what the system means to them.... The body of summarizing symbols ... operates to compound and synthesize a complex system of ideas, to 'summarize' them under a unitary form which, in an old-fashioned way, 'stands for' the system as a whole."

The remaining chapters in this book expand on the material presented in this introduction. Part 1 provides a more detailed introduction to the Minangkabau, addressing history, culture, and the ceremonies for which magnificent textiles were woven. Part 2 deals in depth with the art of weaving, discussing men's ceremonial costumes, women's ceremonial costumes, woven motifs and adat, fibers and patterning techniques, and analyses of the metallic threads used to create the exquisite patterns found in Minangkabau ceremonial textiles. Part 3 is an introduction to other ceremonial arts that, through adat, are related to ceremonial weaving. These chapters provide the larger context within which to view weaving as a ceremonial art. They clearly show the vast extent to which adat pervades the Minangkabau culture. The sum of these three parts is an overview of the culture and ceremonial arts of a great Sumatran people who heretofore have been little known to America and the West, a people whose arts and culture deserve much closer scrutiny.

1.36 A chieftain's black ceremonial shirt, with the sleeve-to-shoulder seam covered with braid. This concealed seam is symbolic of the chieftain's ability to resolve familial disputes so that there is no evidence of a rupture. Velveteen, gold-colored metallic-wrapped thread, gold-colored metal ornaments. Length (collar to hem) 71 cm. FMCH X97.50.34a; private gift.

INTRODUCTION

Imran Manan

A SHORT HISTORY OF THE MINANGKABAU

For a variety of reasons, the Minangkabau have interested social scientists since the beginning of the Dutch colonization of West Sumatra. Their matrilineal system, which dates to their earliest history, was largely unaffected by conversion to Islam in the sixteenth century. Foreign influence began to be felt in the fourteenth century, when the ruler of the Darmasyraya Hindu kingdom of Jambi, the Majapahit prince Adityawarman, conquered the Minangkabau heartland and founded the Minangkabau kingdom (fig. 2.2). The Minangkabau began trading with the Dutch in the seventeenth century and were subject to Dutch colonial domination from the second quarter of the nineteenth century until 1942. During World War II Indonesia, including the Minangkabau area, was occupied by the Japanese. With the declaration of Indonesian independence in 1945, the Minangkabau, along with other ethnic groups of Indonesia, were incorporated into a unified nation.

Not only are the Minangkabau people well known as members of one of the largest societies that still preserves its matrilineal identity; they are also famous as devout Muslims. To foreigners, this might be puzzling. How could a matrilineal society such as the Minangkabau become one of the most thoroughly Islamized societies? The Minangkabau explain it with an expression: "Adat (custom) is based on *syarak* (Islam); *syarak* is based on *Kitabullah* (Quran)," meaning that their adat, which defines their ideal culture, is based on Islamic tenets and the Islamic tenets are based on the Quran (fig. 2.3). What the Minangkabau mean by adat is really synonymous with the anthropological concept of culture. According to Taufik Abdullah (1966), adat, on the one hand, refers to local customs but, on the other, is conceived as the whole structural system of the society, of which local customs are only a component. Adat includes the entire value system; it is the basis of all ethical and legal judgments and the source of social expectations. It represents the ideal pattern of behavior shared by the Minangkabau. Abdullah reminds us of P. E. Josselin de Jong's (1960) concept of adat as denoting "the whole complex of custom, rules, beliefs, and etiquette handed down by tradition from immemorial times."

An adat theoretician (Nasrun 1957) has argued that Islam is the perfection of adat, but only in its religious aspects; the formulation of adat itself is consistent with Islamic principles of reasoning. The philosophical basis of the Minangkabau adat is natural law. According to adat, nature is the teacher. In the Quran there is a passage in which God indicates that he reveals some of his secrets through nature to those who can interpret nature properly. Abdullah (1966) states that in the latest adat codification a new dimension is added to the "adat that is truly adat": that of supernatural law. Although Islamic doctrine was not intended to replace local practices, it is an outside ideology that has been put into the highest category of adat.

2.1 Adat house in the village of Padang Magek, built in the Koto Piliang style, with the end sections (*anjuang*) raised above the level of the central section of the house, representing the hierarchical social system. That system, also known as Koto Piliang, exists in parallel with the egalitarian Bodi Caniago social system. 1989.

2.2 Large standing stone near the village of Lima Kaum bearing an inscription attributed to the fourteenth-century ruler Adityawarman. The inscription is carved in a mixture of Sanskrit and an ancient Minangkabau language. 1989.

2.3 Mosque in the village of Koto Baru. To the left of the mosque is a small traditional Minangkabau adat house, the *surau*, or prayer house. The juxtaposition of the two is one indication of the successful blending of Islam with the Minangkabau adat. 1989.

2.4 Old house in the village of Sijunjung, in the area southeast of the Minangkabau heartland. Areas outside the heartland to which the Minangkabau migrated are referred to as *rantau*, the outside or foreign world. 1994.

The Quran and Hadith (the prophetic tradition) and the natural laws are viewed, accordingly, as the eternal principles that guide human spiritual and secular activities and from which actual practices and lesser values should emanate. Hamka (1968)—a great Islamic leader of Indonesia, a Minangkabau *pangulu andiko* (clan chieftain), and a novelist and historian—has stated that adat is synonymous with culture, a way of life, norms, and philosophy. It consists of all the efforts of the Minangkabau to adapt themselves to their environment.

The Minangkabau are also known as one of the most mobile people in Indonesia, and they have institutionalized outmigration (*marantau*), making it an integral part of their cultural system (Naim 1972, Kato 1977, Pelly 1983; fig. 2.4). According to adat, *rantau* (the outside world) is the source of wealth, knowledge, and innovation, and Minangkabau culture extends beyond the island of Sumatra. For example, a large-scale settlement was established by the Minangkabau in the state of Negeri Sembilan in Western Malaysia. The exact date of Minangkabau immigration into the area is still debated; some scholars put it in the fifteenth century, and others put it in the first half of the sixteenth century. The people of Negeri Sembilan developed the matrilineal system as the principle of their social organization, and they invited a king from Minangkabau to be their ruler from sometime in the eighteenth century until the first quarter of the nineteenth century (Josselin de Jong 1960). Today most people in Negeri Sembilan claim to be descendents of the Minangkabau, and there remains a close relationship between the two cultures.

The Minangkabau are also known for being very open to new ideas. When the Dutch colonial government introduced a modern school system, the Minangkabau soon adopted it. Their educational achievement led them to play a very active role in the movement for national independence in the first half of the twentieth century. Many Minangkabau leaders became national leaders during the early decades of Indonesian independence (Graves 1971, Ricklefs 1993; see also chapter 16).

The Minangkabau are also known for their consensual village democracy. Their egalitarian principle is expressed in the following adat saying: "If sitting, equally low; if standing, equally high." Decisions are made through deliberation to achieve consensus. In the village (*nagari*) community, a village being the highest settlement recognized by adat, the ultimate authority rests in the hands of the village council, whose members are the chieftains of the matrilineages. The title of the chieftain of the matrilineal group is *pangulu andiko*, which literally means the chieftain who has the authority over a corporate group (fig. 2.5).

According to early Minangkabau chronicles, the name Minangkabau originated from a historical event, a buffalo fight that took place when a prince from Java came to West Sumatra to expand his political authority. Because the people of this area did not have a strong army to fight this king, they proposed a buffalo fight to determine who would rule. The prince agreed with the proposal and found a big, strong buffalo. The Minangkabau chose a baby buffalo, which they did not feed the day before the contest. Before the contest the Minangkabau tied sharp iron spikes to the baby buffalo's nose. When the buffalo encountered each other, the

2.5 Ancient meeting place for chieftains (*pangulu*) to convene and resolve important issues. This site is adjacent to the Adityawarman stone illustrated in figure 2.2. Near Lima Kaum. 1989.

baby buffalo ran to the big buffalo, thinking it was its mother. Trying to nurse, it slashed the belly of the big buffalo with the iron spikes. The big buffalo died; the prince from Java lost the contest and withdrew. The name Minangkabau consists of two words, *minang* and *kabau*. *Minang* is derived from *menang*, which means victorious; *kabau* means buffalo. The remnants of the body of the big buffalo were kept in various villages surrounding the arena of the buffalo fight. The village where the fight took place and where the horn (*tanduak*) was kept was called Minangkabau (fig. 2.6). The village where the skin (*jangek*) was kept was called Sijangek, and the village where the intestines (*perut*) were kept was called Simpurut. All these villages are located in the northern part of the regency of Tanah Datar. This is the most popular legend explaining the origin of the name of the Minangkabau (Zain 1960, Diradjo 1919, Radjo Panghoeloe 1971).

Minangkabau history can be studied through indigenous chronicles and epics, which may be considered a kind of "folk memory." As sources of history, however, these accounts lack precision; they are a mixture of myth and reality. Another way of studying history is through analysis of historical facts. In order to give a comprehensive history, both approaches will be presented here.

2.6 A village chieftain holding the buffalo horn that is said to be from the losing water buffalo in the traditional story of how the Minangkabau got their name. Village of Minangkabau. 1989.

2.7 Water buffalo are important in Minangkabau society not only for their role in the origin story but also for plowing the rice paddies and their use as a local source of milk and meat. Tahah Datar. 1989.

The Indigenous Account of Minangkabau History

The traditional historiography of the Minangkabau is known as *tambo*. Various versions of *tambo* record tales of Minangkabau origins and early development, which were transmitted orally over the centuries before the Minangkabau had a written language. According to *tambo*, their land is called the Minangkabau World (Alam Minangkabau), one of the three worlds they had known. The other two worlds were the Land of Sunset (possibly the eastern Roman Empire) and the Land of Sunrise (possibly China and Japan).

Tambo also claims that the Minangkabau originated with Adam. One of Adam's descendants, Iskandar (Alexander the Great), had three sons: Maharaja Alif, Maharaja Dipang, and Maharaja Diraja. After the death of Iskandar the three sons sailed to the Land of Sunrise. On their journey to the east, near Langkapuri (Sri Lanka), they lost the only crown left by their father. One of Maharaja Diraja's followers made a duplicate of the crown and gave it to his master, asking him to claim superiority over his brothers. After the acceptance of Maharaja Diraja's superiority, the three brothers parted; Maharaja Alif returned to the Land of Sunset, Maharaja Dipang went to the Land of Sunrise, and Maharaja Diraja went to the Land between the Sunset and the Sunrise. There he landed at the top of Mount Marapi, on the island of Sumatra (Sango 1955, Abdullah 1972). When he arrived, Mount Marapi was surrounded by water. After the water subsided, the face of the earth expanded, and the number of people increased. The first settlement at the southern slope of Mount Marapi, Pariangan Padang Panjang, became the first *nagari* (village) of the Minangkabau World.

A king from the southern part of Sumatra, Sang Sapurba, came to Pariangan Padang Panjang. Datuak Suri Dirajo, a direct descendant of Maharaja Diraja, welcomed Sang Sapurba, took him as the husband of his sister, and acknowledged him as the new king. To help the new king govern the people, the first four *pangulu* were installed and the first council hall was built.

Sang Sapurba had a son, Sutan Paduko Basa. After the death of Sang Sapurba, his widow married a sage, and from this marriage Sutan Balun was born. When the two half brothers were grown, they were appointed leaders of their people, bearing the titles Datuak Katumangguangan and Datuak Parpatiah Nan Sabatang. These legendary cultural heroes of the Minangkabau formulated the foundations of the Minangkabau adat and transformed various large settlements into *nagari*. Each *nagari* had its own council hall, and each was divided into clans led by its own *pangulu*, whose authority was derived from the consensus of clan members.

According to *tambo*, on one occasion Datuak Parpatiah Nan Sabatang wanted to travel abroad. He went to Pariaman, a coastal town, and met a nobleman there. This man was building a boat, but when it was finished, he was not able to launch it. He asked Datuak Parpatiah Nan Sabatang to help; Datuak Parpatiah agreed, but on the condition that he be allowed to do it himself. He cast a spell, but the boat did not move. He needed a male to sleep in front of it. The nobleman asked his son to do this, but his son refused. Then he asked one of his sister's children to sleep in front of the boat, and his sister's child did so. Datuak Parpatiah read a magic formula, and the boat was launched to the sea without touching the child who slept in front of it. Since that time, because only the sister's child was willing to sacrifice for his uncle, the inheritance of a man has been given to his sister's children. This is the story of the origin of the matrilineal system of the Minangkabau. Datuak Parpatiah made several trips abroad, to Sri Lanka, Burma, Thailand, China, and other places. During his travels he observed the clan system, which he introduced to the Minangkabau people upon his return (Batuah and Madjoindo 1956, Abdullah 1972).

Later Adityawarman, a prince from the Darmasyraya kingdom who was raised in the Javanese kingdom of Majapahit, came to Minangkabau. Datuak Parpatiah and Datuak Katumangguangan had different opinions about the status of this nobleman. The former regarded him as a minister, while the latter regarded him as king. As a result of this difference of opinion, Minangkabau villages were divided into those that accepted the kingship system (Datuak Katumangguangan's followers) and those that did not (Datuak Parpatiah's followers). According to *tambo*, civil war between the followers of these two cultural heroes ensued. To end the war, Datuak Parpatiah challenged Datuak Katumangguangan to a duel. Rather than attacking Datuak Katumangguangan directly, Datuak Parpatiah thrust his kris into a large stone. In response, Datuak Katumangguangan thrust a wooden stick into another large stone, nearly penetrating it and thereby establishing his superiority. A stabbed stone in the regency of Tanah Datar is said to bear witness to this encounter (fig. 2.8).

Despite Datuak Katumangguangan's victory, the villages that followed the ideas of Datuak Parpatiah were allowed to practice their more democratic system, in which all *pangulu* (clan chieftains) were equal. Villages that followed the ideas of Datuak Katumangguangan used a more aristocratic system, in which there was a hierarchy of *pangulu*. This was the origin of the two political traditions of the Minangkabau. The egalitarian tradition is called Bodi Caniago (valued character), and the hierarchical tradition (fig. 2.1) is called Koto Piliang (chosen words). Those two traditions were called the two *lareh* (harmonies), signifying that although the people follow different political traditions, they should nonetheless try to live in harmony. According to Minangkabau chronicles, before these two cultural heroes died, they instructed their followers to intermarry and consider themselves part of a united whole.

Although Adityawarman was installed as the first king of the Minangkabau kingdom, the institution of kingship did not change the existing political system. Each village, as an autonomous "republic," continued to be governed by the *pangulu andiko* and the village council, and each village could choose between the two traditions. When there was no agreement as to this choice, a third tradition, that of the village of Pariangan Padang Panjang, was followed. According to the sayings, this tradition follows neither the political tradition of Datuak Katumangguangan nor that of Datuak Parpatiah Nan Sabatang. It is neither Koto Piliang nor Bodi Caniago. The chieftain of this third tradition became mediator in case there was conflict between the Bodi Caniago and Koto Piliang traditions. The king remained outside the system, although he was henceforth considered to be an integral part of the Minangkabau World.

When the heartland of Minangkabau was well settled, the people continued their exploration, and new settlements outside the three original *luhak* (regions) were developed. These new territories, which were called *rantau* (Batuah and Madjoindo 1956), were not ruled by *pangulu andiko*, but by rajas, who were representatives of the king and who followed the Koto Piliang political tradition (fig. 2.9). Their authority was the same as that of the *pangulu andiko* in the three *luhak* in the heartland. The king was accepted in the new territories, thus helping to legitimize his position; the *rantau* also became the source of revenue for the royal family. Through the *rantau* the Minangkabau gained access to new ideas, which they actively sought and selectively incorporated into their adat.

The Historical Account of the Minangkabau

Having learned the indigenous account of the history of the Minangkabau, it is worthwhile to look at the Minangkabau in light of the historical record of Indonesia and Southeast Asia. According to Harry Benda (1962), the classical era of Southeast Asia lasted from the fourth century B.C.E. until the fourteenth century C.E. During this period contact with Indian and Chinese cultures brought significant changes to Southeast Asia, including the emergence of Indianized and Sinicized states. During the postclassical era, from the fourteenth until the sixteenth century, the influence of Theravada Buddhism, Islam, and Christianity brought further changes. The colonial era lasted from the sixteenth century until World War II and was followed by independence.

The prehistory of the Minangkabau is still largely unexplored. We do not know how earlier peoples migrated to what is now regarded as the Minangkabau homeland, whether there were any tribes native to the area who mixed with the immigrants, or how the matrilineal system developed.

2.8 According to Minangkabau legend, Datuak Katumangguangan pierced this stone with a wooden stick, thereby establishing his supremacy over his brother, Datuak Parpatiah Nan Sabatang. Lima Kaum. 1989.

2.9 The son of the present raja of the village of Si Guntur, dressed in some of the ceremonial attire he will wear when he succeeds his father as raja. 1994.

The prehistory of Indonesia ends with the beginning of the Hindu (classical) period. South Indian merchants brought a South Indian version of Hinduism to the Malay Peninsula and the Indonesian archipelago in the third and fourth centuries C.E. (Koentjaraningrat 1975, 13). According to M. D. Mansoer (1970), during the classical period in the southern and eastern Minangkabau regions, the following kingdoms had established commercial, diplomatic, and religious contact with the outside world: the old Melayu kingdom at Muara Tembesi and the old Srivijaya kingdom at Muara Sabak (sixth and seventh centuries C.E., both practicing Hinayana Buddhism); the Srivijaya kingdom at Palembang, practicing Mahayana Buddhism (end of the seventh century C.E. to the beginning of the eleventh century), whose realm was also extended to East Minangkabau; the Kuntu sultanate, a Shiite Islamic realm at Kampar (fourteenth century C.E.); the Melayu or Darmasyraya kingdom in Jambi, practicing Tantric Buddhism (twelfth century to fourteenth century C.E.), whose center was finally moved to the highland Minangkabau court, Pagaruyung, by Adityawarman, the founder of the first Minangkabau kingdom, which lasted from 1347 C.E. until 1809. We have no historical record of any kingdom in the inte-

50 THE MINANGKABAU

rior of Minangkabau prior to the fourteenth century. It is probable that the Minangkabau matrilineal system and the system of village administration were highly developed prior to the fourteenth century, for these systems are clearly recognized in the earliest recorded history.

The creation of a Minangkabau kingdom by Adityawarman was a turning point in Minangkabau history; it marked the first attempt to establish a system of authority superseding that of the village-level republics. In Pagaruyung, Saruaso, Bukit Gombak, and Lima Kaum several stone inscriptions have been found which attest to Adityawarman's grandeur and authority as the king of the Minangkabau (Suleiman 1977; see fig. 2.2). These inscriptions provide preliminary information concerning the classical Minangkabau kingdom. After studying the inscriptions, R. P. Hardjowardo (1966) concluded that Adityawarman lived in the fourteenth century and was a follower of Tantric Buddhism (fig. 2.10). He was related to the royalty of the Singosari and Majapahit kingdoms of Java. During his reign in Minangkabau he established a strong central authority and supported a flourishing of the arts. The center of his kingdom was the court of Pagaruyung.

We have no other information about Adityawarman's administration and statecraft. It is possible that both of the Minangkabau cultural heroes served Adityawarman. Hardjowardo (1966, 13) considers Datuak Parpatiah Nan Sabatang the prime minister of Adityawarman. Mansoer et al. (1970) speculate that Datuak Parpatiah Nan Sabatang and Datuak Katumangguangan were the prime minister and commander of the army, respectively (cf. Hamka 1951, 16).

Ancient Southeast Asian rulers often solidified alliances and established their control over subjugated peoples by intermarrying or appointing local chiefs to administrative positions (Hall 1976). From this tradition we can infer that Datuak Parpatiah Nan Sabatang and Datuak Katumangguangan may have been local chieftains who were incorporated into Adityawarman's administration. The Minangkabau chronicles mention that Adityawarman married the sister of one of these local cultural heroes, which conforms to the pattern of traditional alliance. The chronicles, as discussed before, attributed the division of the traditional Minangkabau system of village administration into Bodi Caniago and Koto Piliang to the disagreement over Adityawarman's right to rule.

Most early accounts of the Minangkabau kingdom after the death of Adityawarman come from Western sources, some of whom gained audiences with one of the Minangkabau kings. Tomé Pires, a Portuguese who studied various kingdoms in the Indonesian archipelago at the beginning of the sixteenth century, mentioned that the Minangkabau king and about one hundred of his people had become Muslim, while the rest of the people were not (Cortesão 1944). The Minangkabau Islamic scholars Hamka (1951) and Mahmud Yunus (1960) and the historian Mansoer (1970) recognized Sultan Alif, who ruled in the middle of the sixteenth century and died in about 1580, as the first Minangkabau king who was a Muslim. The next king known to be a Muslim was Sultan Ahmad Syah (1650–1680); we do not know who reigned between these two kings.

As the process of Islamization continued, a small number of the Minangkabau who could not accept this religion fled to the regions of Jambi and Riau. They become isolated tribes in jungle areas of these regions and are known as *orang Kubull* and *orang Talang Mamak* (Usman 1985).

Contact between the Minangkabau and Western nations—namely, the Dutch, Portuguese, and British—began in the early seventeenth century. On their way to Batavia (present-day Jakarta) and the Moluccas, the

2.10 A statue of Adityawarman as a Buddhist bodhisattva. The original is in the National Museum in Jakarta. The copy illustrated here is in the Museum Adityawarman in Padang, capital of West Sumatra. There is another copy in the Provincial Museum in Jambi, where Adityawarman also established a court. 1997.

A SHORT HISTORY OF THE MINANGKABAU

Dutch could sail either through the Straits of Malacca or along the west coast of Sumatra. The Dutch and the British East India Company found sources of pepper and gold in the coastal villages of West Sumatra. All these villages and ports had once belonged to the Minangkabau kingdom but were conquered by the Acehnese in the sixteenth century (Mansoer 1970, Wells 1976, Dobbin 1977). In some important coastal trading centers the Acehnese appointed vassals, with whom the Dutch and the British made commercial contacts. Gold was first acquired officially on behalf of the Dutch East India Company (Vereenigde Oost-Indische Compagnie, or VOC) in 1651 at Pariaman, an important Minangkabau port, but Acehnese insistence on maintaining a monopoly at these ports pushed the Dutch farther south, to Padang.

Meanwhile, a federation of villages known as Banda Sapuluah (the ten ports), in the southern part of Padang, asked the VOC to protect and liberate them from Acehnese power. The VOC used this opportunity to join with the village federation to sign a treaty that gave the Dutch a monopoly without tax in return for protection but required that they pay tribute to the local rulers. Thus the Dutch built their trading posts in Padang and Painan. In 1665 they sent two native dignitaries to meet the Minangkabau king in the highlands in an effort to encourage gold trade between the highlands and Padang. Because the Acehnese had been expelled by the Dutch and the Minangkabau king felt that his authority was respected, he promised to direct the gold trade to Padang. In 1667 a treaty between the Minangkabau king and the governor general of the VOC was signed in Batavia. The chief representative of the VOC in Padang was appointed viceroy of the Minangkabau king, having secured the right to a monopoly over trade in the coastal areas by agreeing to pay tribute to the king. Until the end of the eighteenth century the VOC maintained its trade monopoly in the coastal areas of Minangkabau, with Padang as its trade base, but had no interest in visiting the interior of the kingdom. Rather, the highland traders brought their gold and produce to Padang.

In 1795 the British occupied Padang, a repercussion of the Napoleonic Wars in Europe. When the king of the Netherlands fled to England, he instructed the Dutch company to surrender its territories in Indonesia to the British in order to keep them out of the hands of the French. Padang and other commercial posts of the Dutch company were then supervised by the British company. Sir Thomas Stamford Raffles, the British lieutenant governor of Bengkulu (Bengkulen) in Sumatra, traveled to the interior of Minangkabau in 1818 to visit the capital of the kingdom. Raffles (1835) was impressed by the agricultural potential of the area and the manufacturing of iron and pottery. He also recognized that there were political advantages to be gained by reestablishing the sovereignty of the Minangkabau under British influence. Raffles's intention to make Sumatra a part of the British empire had to be abandoned when all territories in the Indonesian archipelago were returned to the Dutch government in 1819. Dutch officials in Batavia planned to revive monopoly trading contracts with the local raja but limited operation to four important ports of Minangkabau, with Padang as its center.

In the highlands, the center of the Minangkabau kingdom, an elaborate system of governance evolved, featuring three kings: the King of Adat, the King of Religion, and the King of the World. They were supported by the Great Men of the Four Council Halls, who acted as ministers. Two of these ministers served the King of Adat and the King of Religion. The two pillars of the Minangkabau identity, adat and Islam, were in effect institutionalized.

Until the end of the eighteenth century the integration of Islam into Minangkabau society was peaceful. The Minangkabau World had come to be seen as a harmonious world containing both adat and Islam. This harmony was expressed by the existence of the King of Adat and the King of Religion, the *pangulu andiko* and the *ulama* (head of religion), the adat council hall and mosque. This harmony was formalized in the adat aphorism "Adat is based on *syarak* (Islam); *syarak* is based on adat." Ideally adat maintained the harmony of society, while *syarak* worked to achieve harmony between the self and the cosmic order (Abdullah 1972).

This peaceful religious movement changed its course in 1803, when three new hajis returned from Mecca. There they had observed a religious movement dedicated to purifying Islamic doctrine, returning to the Quran and to prophetic tradition. When these hajis came back to West Sumatra, they attempted to introduce the ideas they had encountered in Mecca. Minangkabau society was soon split into two factions: those who accepted the purification and those who opposed it. The returning hajis were regarded as opponents of the adat group.

The religious reformers were called the Padri group, after Pedir, the port from which pilgrims from Sumatra journeyed to Mecca.

After seizing power in almost all of the Minangkabau heartland, the Padri intensified their reforms, attempting to eliminate all syncretic aspects of Islam and all practices that were not in line with Islamic teaching. It was probably during this period that the basis for the aphorism "adat (custom) is based on *syarak* (Islam); *syarak* is based on *Kitabullah* (Quran)" was established.[1] In terms of political power, the Padri movement was never able to present itself as a united front or to create a single center of authority capable of displacing the indigenous system of authority. The kings and *pangulu andiko* who had managed to escape to Padang, where the Dutch had established a trading post with the permission of a Minangkabau king, asked the Dutch to help them fight the Padri.

Colonial domination of the Minangkabau began when the then-current Minangkabau king and about twenty *pangulu* from fourteen villages, acting on behalf of about one hundred other *pangulu*, agreed to cede to the Dutch the capital of the Minangkabau kingdom, Pagaruyung, and other areas under the influence of the Minangkabau king in return for Dutch assistance in fighting the Padri. The agreement was signed on February 10, 1821 (Amran 1981). After the Padri War had gone on for several years, the two opposing factions detected the Dutch intention to colonize the Minangkabau area and realized that they had endangered the existence of the Minangkabau World. They held a secret meeting and reached an agreement to fight the Dutch together, but their united effort was unsuccessful. From 1837 until World War II the Minangkabau area and other areas of Indonesia were Dutch colonies.

During the colonial period the Dutch administration improved the transportation system, constructing a road network, a railway system, and a seaport. The development of colonial administration and the intensification of economic exploitation created demand for people qualified to occupy the new offices in administrative and economic institutions. For that purpose some new forms of education were introduced. Through education the Minangkabau realized that Dutch power was based on superiority in knowledge and science. Their adat taught them to "take example from the victorious, and learn from the clever." The Minangkabau soon adopted a modern educational system, opening the door to modernization and increased awareness of humanistic values.

The experience of being colonized and exploited led to the desire to be free. The first decade of the twentieth century marked the rise of cultural nationalism, followed by political nationalism in the second decade (Kahin 1952). Social, cultural, and political organizations flourished, promoting interest in progress and demanding greater participation in government affairs, which culminated in the demand for Indonesian independence. The Minangkabau and the Javanese played special roles in the anticolonial and reform movements in Indonesia (Ricklefs 1993). During World War II the Minangkabau area, like other areas of Indonesia, was occupied by the Japanese. After the Japanese capitulation on August 17, 1945, Indonesia proclaimed independence. The Dutch tried to regain control of the area but were defeated, and some four years later Minangkabau became an integral part of the nation as the province of West Sumatra.

This brief account of Minangkabau history reveals the extensive and widely varying cultural contacts experienced by the Minangkabau since the beginning of their history. These contacts have brought changes in their way of life, but the Minangkabau are still able to preserve and use their core values and symbols in facing the challenge of modern life. Two key statements of the Minangkabau adat—namely, "nature is the teacher" and "adat is based on *syarak*; *syarak* is based on *Kitabullah*"—have been preserved and used by the Minangkabau to guide their way of life. Nature is the main source from which they draw their metaphors for being, by which they externalize their moral values. References to nature pervade the main tenets of adat as expressed in proverbs, maxims, aphorisms, house carving (see chapter 10), the motifs woven into ceremonial textiles (see chapter 7), and other arts.

Khaidir Anwar

THE MINANGKABAU AND THEIR CULTURE

People of the Adat

Minangkabau life is centered around a traditional belief system, adat (from the Arabic word '*adah*), which is usually translated as "custom" or "tradition." As used by the Minangkabau, the word has a special significance, and it has, in fact, become a key word in the Minangkabau value system. Adat in its broadest sense refers to a whole body of standards and rules used by the Minangkabau to guide their lives, to structure social groups and social relations, to determine the rights and obligations of individuals and of groups, to select meaningful words to be used in speaking, and to face foreign ideologies (Manan 1984, 4). Adat is the whole complex of customs, rules, beliefs, and etiquette handed down by tradition from time immemorial (Josselin de Jong 1952, 87).

The historian Taufik Abdullah (1978), a Minangkabau by birth, looks upon adat as the collective identity of the Minangkabau, the pillar of the sacred notion of the Minangkabau World, or Alam Minangkabau. Core to this belief system, referred to as "the adat that is not made fragile by rain and is not scorched by the heat of the sun," are principles specifying ownership by the matrilineage of house and lands (fig. 3.2), matrilineal inheritance, and decision making by consensus.

The Minangkabau regard themselves as people of the adat. As a culture-conscious people, they take it as an insult if they are accused of having no adat. To be without adat means to be barbaric, to live as animals. The Minangkabau believe that their strength as a people lies in their adat. An old adat maxim says that the Dutch fortress is made of iron, but the Minangkabau fortress is made of adat, implying that adat is stronger than iron. The Minangkabau people of Negeri Sembilan, a province in Malaysia founded by the Minangkabau, have a saying: "It is all right if one's children die as long as the adat does not die."

Minangkabau Characteristics and Social Values

Minangkabau adat regards verbal proficiency as a central precept. The adat elite is an articulate group, especially adept in using and manipulating words. Eloquence is highly appreciated by all Minangkabau. Even ordinary people enjoy talking in riddles, making jokes, discussing, explaining, and arguing. On the whole, the Minangkabau are not reserved, and a few are blatantly boastful. Many are frank, although they would not admit that they are so, because they like to be regarded as modest and refined. The Minangkabau hate stupidity and simple-mindedness; they appreciate shrewdness and tend to tolerate cunning. They condemn hypocrisy in others but tend to tell white lies. Appearances are as important to them as are realities. They insist that justice be done and appear to be done. The Minangkabau tend to be impatient; they refuse to stomach insult but are not vindictive. They are not skeptical but not credulous either. They may believe

3.1 Group of chieftains at a ceremony. Limo Puluah Koto. 1994.

3.2 The house of a matrilineage near the village of Lima Kaum. This traditional style of house is called an adat house or a *rumah gadang* (big house). 1986.

3.3 An old traditional house in the *rantau* village of Sijunjung. 1994.

their friends but distrust human nature in general. An adat maxim says, "The bridge tends to be fragile, and promises tend to be broken."

The Minangkabau applaud success and look down on failure. A successful Minangkabau tends to have many persons who declare themselves his relatives, whereas an unsuccessful person tends to be left alone. This attitude has been instrumental in causing Minangkabau youth to work hard to achieve success. In traditional stories a man returning home a failure from the *rantau* (any area outside the Minangkabau heartland) or from carrying out a task was given dog food served in a coconut shell for his meal.

This aspect of Minangkabau culture has not brought much change in Minangkabau life. Some people have been successful in the *rantau*, but many have not, and both tend to continue living in the *rantau* (fig. 3.3). Successful families in the *rantau* feel a need to let their fellow countrymen know of their success. They are not pleased if their success is recognized only by other Indonesians. At the same time, however, the Minangkabau tend not to recognize the achievement of their fellow Minangkabau until it is appreciated by other Indonesians.

The Minangkabau admire riches both in private and in public. A rich person has high social prestige. Everyone is encouraged to work hard in order to earn as much as possible. A successful merchant is an important member of society. The Minangkabau are materialistic in this sense. When one is poor, one has little or no prestige, but not every rich person has high prestige. In order to be respected, one has to be generous and be prepared to spread largesse. If one is rich but miserly, one loses or reduces one's high social status. The ideal is to be both wealthy and generous. Money, though extremely important, is not an end in itself; it is only a means to an end. On the whole, the Minangkabau tend to blame the poor for their poverty. Socialism is not popular among the Minangkabau masses.

With the introduction of Islam into Minangkabau culture, the idea of an egalitarian society

3.4 Vista of the lush Minangkabau heartland near Palembayan. 1994.

THE MINANGKABAU

was strengthened. Each Minangkabau believes that he is as good as anyone else. He bows to no man; he bows only to God. When an ordinary Minangkabau knows that he has been slighted, even by somebody important, his typical reaction is: "What did he take me for? Even if he may be rich, I am not begging from him. If he is clever, I am not asking for his advice. If he is brave, I am not going to fight him."

The Minangkabau have a strong sense of justice and fair play as they understand it. They will obey the ruler only if he is a just ruler and will oppose him if he is unjust. But when a Minangkabau sees injustice in society and is powerless to do anything about it, he will save his own skin first. He will try to cheat if necessary. He becomes cynical. The Minangkabau tend to show their good character when society is open and free, when foul play is not acceptable. But bad character tends to come out when there is no freedom of expression, when foul play has been used to dominate society.

The Minangkabau are not racist; their society is open, and their culture is receptive to innovation and foreign influence. Minangkabau culture is established on the basis not of superstition, but of human experiences. An adat maxim says: "The expanding world, or nature, is our teacher" (fig. 3.4). The Minangkabau believe that the essence of their adat has universal applicability because it is learned from nature and not from unknowable things—thus the Minangkabau attitude to *tuah*, the supreme quality of a thing, an animal, or a human. *Tuah* depends solely on reality, not on assigned attributes. A maxim says, "To find out where the *tuah* lies in a cockfight, look at the winning rooster." Another saying is, "You lose your color because of illness; you lose your *tuah* because you have gone bankrupt."

The Minangkabau as Part of Indonesia

The Minangkabau regard their land, West Sumatra, as the *alam*, or the world. Although it is the world to the Minangkabau, it is only one of twenty-seven provinces of the Indonesian republic. About 3 percent of the population of Indonesia are Minangkabau. Today the Minangkabau regard themselves as both Minangkabau and Indonesian. They are bilingual, speaking both the Minangkabau language and the Indonesian language. Their patterns of behavior have been greatly influenced by the process of Indonesianization, which has been effectively carried out by intensive use of the mass media—newspapers, radio, and television.

Because of the strong push for uniformity in thought and action in Indonesia, the significance of ethnicity has been diminishing. Nevertheless, the Minangkabau tend to think that they are different in several respects from other ethnic groups in Indonesia. Their social system, based on adat, is different; their kinship system, based on matriliny, is uncommon in the country. Even Minangkabau who live outside their homeland maintain a strong attachment to matriliny, although some no longer observe its precepts, especially when dealing with inheritance. Today the Minangkabau are perhaps the most urbanized group in Indonesia; approximately half the people of Minangkabau descent live in towns outside their Sumatran homeland. More than half a million live in the capital city of Indonesia, Jakarta.

Nagari the Physical Center of Minangkabau Life

The word *nagari*, derived from a Sanskrit word for "town," was employed by Hindu-Javanese invaders of Sumatra around the end of the thirteenth century to denote a village state (Oki 1977). It is understood by many scholars to mean a village republic, because of the autonomous character of early Minangkabau villages. Prior to the fourteenth-century formation of the first Minangkabau kingdom (the first supravillage authority known in the history of the Minangkabau people), *nagari* was the highest human settlement recognized by adat. The internal organization of the *nagari* is described by an adat aphorism, which may be translated as follows:

> The *nagari* has four *suku* (clans)
> The *suku* has lineages
> The settlement has a chief
> The house has an elder

The *suku*, an exogamous group, is a matrilineal clan. Each of the four *suku* has its own name, for example, Bodi, Caniago, Koto, Piliang. A *suku* is headed by a clan-lineage head called *pangulu andiko*. A *pangulu andiko* (fig. 3.5) is the chief of a matrilineal corporate group. The institution of *pangulu andiko* is embedded in the Minangkabau matrilineal system. That system is characterized by matrilineal descent; matrilineal clans; clan exogamy; clan authority theoretically in the hands of the mother (but

3.5 Young Minangkabau chieftain. Lima Puluah Koto. 1989.

rarely exercised by her); authority exercised by the mother's brother; matrilocal marriage, in which the husband visits his wife, who continues to live in her matrilineage house even after marriage; vendetta as the duty of the entire clan; and the succession of male leadership from mother's brother to sister's son (Manan 1984).

As chief of a corporate group, a *pangulu andiko* represents his group within the adat council of the *nagari*. This body is the highest authority within the village community. In this council all *pangulu andiko* of a village deliberate to achieve consensus. Decisions reached by consensus are the ultimate authority within all groups, including the village council.

According to the adat, the Minangkabau live in their *nagari* following two different systems of community life, said to originate with two brothers of the same mother but of different fathers, namely, Datuak Katumangguangan and Datuak Parpatiah Nan Sabatang (see chapter 2).[1] The Koto Piliang system recognizes a hierarchy of *nagari* chieftains; the Bodi Caniago system places all chieftains on an equal footing (figs. 3.6, 3.7). Both systems are generally found in most villages in the three original districts, or *luhak nan tigo* (Tanah Datar, Agam, and Limo Puluah Koto). The two systems are of equal importance in Minangkabau adat and form the core of the Minangkabau social system.

Originally a Minangkabau *nagari* was a semiautonomous territorial entity with a population of about two to ten thousand inhabitants. Although the population of any one *nagari* shared the same adat system and spoke the same dialect, the adat in another *nagari* might differ somewhat because of differing conditions. The *nagari* consisted of several smaller villages, which were called *jorong* or *kampuang*. A Minangkabau belongs to the *nagari* of his mother, rather than that of his father, and he regards his *nagari* as his beloved motherland. It is not important whether he was born in the village; the important thing is whether his mother or grandmother was originally an inhabitant of the *nagari*. Where the father comes from is regarded as unimportant.

The Minangkabau, as already noted, regard themselves as a separate people, as a special ethnic group among the many ethnic groups of Indonesia. According to adat, however, their ethnicity is not as important as their adat. It is their adat, or culture, that distinguishes them from other Indonesians. Clans are organized on the basis of blood relationships along female lines. People from outside, however, including non-Minangkabau, can be adopted as members of a clan. Participating in Minangkabau cultural traditions in an adat way can qualify someone to become a member of Minangkabau society, and his descendents will automatically become Minangkabau as well.

The Minangkabau have great love for their homeland, but many prefer to leave it and to live and work in the *rantau*. They tend to idealize the beauty of their country and the good qualities of their culture from a distance. Many people who have settled in the *rantau* apparently dislike living in the homeland, which they find rather suffocating. But they make an effort to visit their *nagari* from time to time and to bring their children with them to acquaint them with their roots. Many Minangkabau families living in Jakarta and other places in the *rantau* maintain houses in their *nagari*. Kahn (1974, 238) reports on one family living in the *rantau* who built a house in their home village of Sungai Puar, in the Minangkabau highlands, with no intention of occupying it.

In each town in the *rantau* there are normally many Minangkabau associations and one All Minangkabau Association. Each smaller association consists of members whose mothers belong to the same *nagari* of origin. Members of the association are concerned not only with their own welfare but also with the welfare of the *nagari*. The association collects contributions from its members and sends some of the funds back to the *nagari*. Today membership in the associations includes, in addition to the original inhabitants, husbands of women members. Many men are members both of their *nagari* association and of the association of their wife's *nagari*. The primary loyalty of the Minangkabau is to their *nagari* of origin; secondary loyalty is to the Minangkabau World.

Adat and Islam in Minangkabau Culture

The Minangkabau are known to be good Muslims. Many believe that they are better Muslims than those in other countries. Most Minangkabau do say their five-times-a-day prayers regularly and fast during the month of Ramadan. They observe the Five Pillars of Islam. It is characteristic of Minangkabau society, however, to be moderate in observing ideology and principles. According to adat, "religion prescribes, but adat implements." In other words, Islamic teachings have to be carried out in an adat way. Religion is said to be naked, while adat is properly dressed. When it comes to Islamic law concerning property and inheritance, the Minangkabau pay more attention to the precepts of adat than

3.6 A new adat house under construction in accordance with the Koto Piliang style, with the end sections (*anjuang*) raised above the level of the central section of the house, representing the hierarchical structure of the Koto Piliang clan. The size of the sweep of the roof can be gauged from the men working on the top of the building. This structure houses the Yayasan Dokumentasi dan Informasi Kebudayaan Minangkabau (Foundation for Documentation and Information concerning Minangkabau Culture). Padang Pajang. 1990.

3.7 An old adat house built in accordance with the Bodi Caniago style, with all parts on the same level, representing the egalitarian structure of the Bodi Caniago clan. Courtesy Yayasan Dokumentasi dan Informasi Kebudayaan Minangkabau.

THE MINANGKABAU AND THEIR CULTURE

3.8 A village council hall (*balai*) where chieftains meet to discuss village problems and resolve disputes. When the chieftains are meeting, the shutters are opened so that the proceedings are open to others from the village who wish to listen. Limo Puluah Koto, 1994.

to those of Islam. Regarding the individual observance of Islam, there is a common saying: "For living, you observe reason; for death, you observe faith." (This is comparable to the English saying "Live an atheist, die a Catholic.") In practice this maxim leads many to forget the teachings of Islam in their struggle to earn money.

The Minangkabau take a pragmatic rather than a philosophical or intellectual view of religion. They are strong in faith but weak in soul-searching and doubting, which are essential to intellectual growth. They are far from being fanatics. Of the many religious armed rebellions in Indonesia, none has happened in Minangkabau. Muslim leaders of Minangkabau descent are followers of a modern Islamic reform movement with a strong democratic orientation

Male Roles in Minangkabau Society

In the traditional Minangkabau social system an adult man has three roles:[2] uncle, husband, and father. Any male with the proper credentials (Manan 1984, 118ff.) may also serve as a chieftain. The duties of an uncle, especially a man who also functions as the chief of a matrilineal group, are very heavy. He is the protector of all of his sisters and of his sisters' children. He is the representative of the matrilineal group in the village adat council. As a member of that council, he shares a responsibility to increase the welfare of the village community. He also has a father's responsibility toward his own children. An adat saying prescribes that "his children are held, his sisters' children are guided, and fellow villagers are treated generously."

In order for a man to be able to carry out the functions of chieftain, he must be endowed with authority. But the authority he has is not the authority to command; it is the authority to serve the welfare of his clan or community. The notion of authority in Minangkabau society is stated in the following adat maxim:

> The sisters' children are subject to their uncle
> The uncle is subject to the chief of his lineage
> The chief of lineage is subject to consensus
> Consensus is subject to the power of reasoning
> The power of reasoning is subject to what is appropriate and possible
> What is appropriate and possible is subject to truth
> It is truth that is the highest authority[3]

The decision-making process in Minangkabau society is usually based on common deliberation to achieve consensus. Truth is sought through common deliberation, beginning at the lowest level, the ancestral house (*rumah gadang*), and carried to the highest level (the village council). Common deliberations take place at two locations: the ancestral house and the council hall (*balai*), of the village (fig. 3.8). Women take part in deliberations at the ances-

60 THE MINANGKABAU

tral house, and the wisdom of the eldest women is always sought. A chieftain earns a small fee for his participation in settling various disputes and conflicts. He also has the right to use a portion of communal land.

As husband, in-law, and father, a man is treated as a respected guest at his wife's house. In the past it was said that the in-married man, as a father, had no economic responsibility toward his wife and children. He still had an important role, however, providing the seed to continue the lineage of his wife. In ceremonial events at his wife's house, the in-married chieftain plays the role of orator for his wife's lineage. He is expected to be a good speaker who knows the art of oratory based on traditional language and traditional wisdom (see chapter 15). Male members of a lineage have the same functions as the chief of the lineage in terms of managing and expanding the lineage property. What they don't have is the function of speaker of the lineage at formal meetings outside the lineage.

The position of a male in traditional Minangkabau society may appear strange to outsiders. He owns no property, not even a house. All buildings and property belong to his mother, sisters, or his sisters' daughters. At his wife's house he is just a guest of honor. If he builds a house on his wife's land, it is a house for his daughter. If his wife dies or he is divorced, he must return to sleeping at the prayer house, as he did during his adolescent years. He can get food from his mother or sisters. The heavy duties and precarious position of males in Minangkabau society may partially explain the dynamism and entrepreneurial capacity of Minangkabau men.

Female Roles in Minangkabau Society

Most of the traditions of the Minangkabau matrilineal system seem to favor women. Matrilocal residence keeps women in their natal residence, surrounded by their kin. It is a cultural imperative for a man to pay primary attention to his sisters and their children. Matrilineal inheritance allocates most of the land to women. Although the land belongs to the matrilineage (figs. 3.9, 3.10), most use rights are in the hands of women. In other words, most of the means of production belong to women. Matrilineal descent makes women the backbone of the society, because without them the building block of the society disappears. Without women a lineage or a clan will become extinct.

According to Minangkabau tradition, the eldest woman is the pillar of the ancestral house, the lock on the chest in which the ancestral property is kept. She wields the highest authority within the ancestral house because she controls and has the dominant voice in the distribution of ancestral property, the land, and any surplus the land may yield. A Dutch colonial administrator at the beginning of the twentieth century stated that in the Minangkabau family circle the eldest common ancestress, if still alive, actually stood above an uncle (senior male) who was the formal chief of a lineage. In each case in which family affairs have to be decided within the lineage, she remains the highest authority.

Other married women, not just the eldest, are also holders of ancestral land. Decisions regarding the distribution of ancestral land are

3.9 Minangkabau man plowing a field with the aid of a water buffalo, preparatory to planting rice. Between Bukittinggi and Batu Sangkar. 1989.

3.10 Rice paddy on the mountainous slopes near Palembayan. 1995.

THE MINANGKABAU AND THEIR CULTURE 61

3.11 Ceremonial shoulder cloth (*salendang*) with bamboo shoot motif (the six large triangular gold motifs). The bamboo shoot motif represents the three leaders of Minangkabau society: chieftains, Muslim scholars, and intellectuals. Cotton, gold-wrapped thread. 214 x 57 cm (including braid). Collection of Don Cole.

made by all women of the lineage who have use rights to the land under the leadership of the eldest woman and the eldest male, as chief of the lineage. Because women are the recognized heirs to the lineage's land, they play an important role in the lineage's common deliberations. Strong family ties give them a guaranteed source of protection and support, which is never disturbed by events such as divorce or being away from home. A woman's rights over the land are recognized both by her lineage and by the village community. If a conflict arises between the interest of her family and that of her husband's family, she must always consider her family first. Family protection and support bring security and undoubtedly account for "the spirit of independence which conventional Indonesian wisdom ascribes to Minangkabau women in contrast to other archipelago women" (Graves 1971, 48).

As a wife, a woman respects her husband because he helps her to perpetuate her lineage. Since marriage is hypergamous, her husband has also helped to elevate her lineage's prestige. But her respect for her husband does not mean submission, because the economic basis for the

THE MINANGKABAU

family's life lies with her. She has brothers to help her in all situations that require male hands.

As daughter-in-law of her husband's mother and lineage, a woman has responsibilities to fulfill, as prescribed by tradition. They are not only her responsibilities but those of her lineage as well. Whatever happens at the ancestral house of her husband (ceremonies, mourning events, and so on) requires her presence or that of other females of her lineage.

In earlier times, if a woman did not like her husband, she could get rid of him quite easily. According to an adat saying, the position of the husband was like that of dust on a stone. If you wanted to get rid of the dust, you just blew it away. A traditional Minangkabau wife was not worried if her husband decided to divorce her. The bond of traditional marriage was not strong, and divorce was very common. Polygamy was the rule rather than the exception.

Today polygamy hardly exists, and divorce is very rare. Some women's dependence on their husbands has become absolute. Minangkabau women in general, however, do not want to depend for their maintenance entirely on their husbands. Educated women believe that their adat encourages them to assert their rights as equal members of society. Compared with women in many Asian countries, Minangkabau women tend to be more assertive and articulate. Although in traditional Minangkabau society men represent the clan, women have never been excluded from decision making. Members of a clan work hard and struggle mainly for the sake of their women's interests.

Leadership in Minangkabau Society

As members of an egalitarian society, the Minangkabau recognize the importance of the role of their leaders in conducting community affairs, but they do not look upon their leaders as great and lofty men. A leader is a little higher than the ordinary members of society, but only one twig higher; he is indeed asked to walk in front, but only one step ahead. A leader should urge his people to work hard, but not mainly by using words; he should set an example. During time of war the leader must lead his followers by demonstrating his bravery and not his boastfulness. The leader must be patient and should be prepared to endure the vagaries of his followers and to tolerate some of the antics that his unthinking fellow-men tend to demonstrate.

The chief of the clan, the *pangulu*, is said to be analogous to a big tree standing in a wide field. The leaves of the tree give shade during sunny days, a tired traveler can lean on the tree trunk, the fruit should taste good and be nourishing. In appearance the leader is worshiped by the people, but in reality it is he who worships his people. It is the chief who guards the interests of his followers, not the other way round.

The Minangkabau leadership system is democratic. It thrives on diversity of opinion, which may or may not end in unanimity. Men and women both tend to look at life in a realistic way. The male leadership is compared to three stones on which a pot is placed for cooking over an open fire on the earth. If there were only one or two stones, the pot would not be stable. The three stones symbolize three leaders: the chieftain (*niniak mamak*), the Muslim scholar (*ulama*), and the intellectual (*cadiak pandai*). Sometimes the Bundo Kanduang (the earth mother) is also mentioned as part of the leadership system. The textile motif of the bamboo shoot is interpreted as representing the concept of the three leaders. This triangular motif has three points, each of which stands for one of the leaders (fig. 3.11).

The Persistence of the Minangkabau Adat

Anthropologists have long predicted that the Minangkabau adat, like those of many other Indonesian ethnic groups, would fade into obscurity with the flowering of industrialization and tourism. Yet this system of traditional beliefs still maintains a strong hold in the Minangkabau heartland. One possible contribution to its persistence is the fact that people of the Sumatran highlands are repeatedly reminded of the precepts of their adat through carvings on the *rumah gadang* (see chapter 10); through motifs on ceremonial textiles (see chapter 7); through folds in ceremonial textiles worn as garments (see chapter 5); through dance, music, and traditional speech at ceremonies (see chapters 13–15); and through daily and widespread use of adat sayings (see chapter 15).

David and Vicki Salisbury

4

TRADITIONAL MINANGKABAU CEREMONIES

Ceremonies are major and frequent events in Minangkabau life. A succession of ceremonies marks an individual's passage from childhood through adulthood. It is in part for the purpose of providing proper adat attire for participants in these ceremonies that Minangkabau weavers have long produced the magnificent textiles described in detail in part 2 of this book. In addition to ceremonial attire, Minangkabau weavers also produce food covers, covers for betel leaves (*siriah*), and wall hangings for use in ceremonies.

The first ceremony is a washing or blessing ceremony (*turun mandi*) for a baby, marking the arrival of a new member of the family and the community. The next big event in a young man's life is the circumcision ceremony (*sunek rasua*), which takes place around his eleventh or twelfth birthday and marks his passage into manhood. The wedding ceremony (*pesta parkawinan*) signifies the transition of a young woman and man to wife and husband and eventually to parenthood. For the select few, the ceremony for installation as a clan leader (*batagak pangulu*) is the final and most important ceremony in the active life of a male and his family. In addition to other ceremonies for individuals and families, such as an adoption or a funeral, there are ceremonies celebrating various aspects of community life, such as a community work party (*turun ka sawah*), harvesting ceremonies (*manyambik*), the dedication of a major building, and the wild boar hunt.

Minangkabau adat ceremonies are characterized by processions, by elaborate sessions of oratory called *pidato adat*, or traditional speech, by feasting, and by music. The Minangkabau are typically highly accomplished speakers, and traditional ceremonies provide a forum for displaying verbal skills. The oratory at the heart of these ceremonies is not ordinary speech, but is a highly stylized form of discourse that includes the recitation of traditional proverbs and *pantun*, all in the service of fulfilling the purposes for which the ceremony is held (see chapter 15 for more on *pidato adat*).

For the Minangkabau, music adds pomp and circumstance to any ceremony as well as providing entertainment and contributing to the uplifting of spirits during the sequence of events that mark a ceremony. Traditional Minangkabau music is performed by a *talempong* ensemble, which consists of several gong-chime instruments (*talempong*; fig. 4.2) played in an interlocking fashion by three or more performers. The ensemble may include a double-headed drum (*gandang*; fig. 4.3), a frame drum (*rabano*; fig. 4.4), and a multiple-reed instrument made from coconut leaves (*pupuik batang padi*; fig. 4.5). The coastal region and each of the three original regions—Agam, Tanah Datar, and Limo Puluah Koto—have their own distinctive styles of traditional *talempong* performance and unique musical approach to ceremonial custom (see chapter 13).

4.1 Women carrying food to a ceremony. The food is covered with textiles (*tutuik*) decorated with couched gold-wrapped thread. Balingka. 1995.

4.2 A group of women, seated on the ground, playing *talempong*. 1994.

4.3 *Talempong* ensemble in the village of Air Tabit. Four women hold *talempong*, and one plays the *gandang* (a double-headed drum). 1994.

4.4 Young musician in the village of Kacangutara performing with a *talempong* group. He is playing the *rabano*, a frame drum similar to a tambourine but without the jingles. 1994.

4.5 Musician from the village of Ombilin playing the *pupuik batang padi* at a wedding. The horn is shaped from strips of coconut leaves, and the mouthpiece is cut from a rice stalk. 1994.

Turun Mandi
(Baby-Washing Ceremony)

The baby-washing ceremony (*turun mandi*) is held to thank Allah for a healthy child and to allow relatives and community members to formally acknowledge the addition of a new member. In the past the baby was taken to the river and ceremonially washed and given a name by a Muslim priest (Loeb 1972, 117). Currently the baby is washed at a well at the family's house.

The *turun mandi* ceremony usually takes place in the morning about six or seven days after the child is born. It begins with a procession from the baby's house to the father's family's house. The mother, father, and baby head the procession. They are followed by close rela-

tives and then by friends and any other community members who want to join. A *talempong* ensemble announces the event to the community. After the procession and ceremonial washing at the well, everyone retires inside for coffee, tea, and food. The parents give a prayer of thanks, and everyone contributes to the ensuing discussion. Afterward the group walks in procession back to the baby's mother's house.

In the evening there is a gathering at the mother's house. After the many guests arrive, the *talempong* ensemble performs from about 9 P.M. until 4 or 5 the next morning (fig. 4.6). Much of the discussion centers around childbirth, local politics, and current events. Finally everyone returns home, and the *turun mandi* ceremony is complete.

Sunek Rasua (Circumcision Ceremony)

The *sunek rasua* ceremony, which marks a young man's passage from childhood to adulthood, involves several steps that demonstrate the event's significance. Everything must be done in proper fashion to ensure that the ceremony proceeds according to tradition (adat). For example, because of his importance in the Minangkabau kinship system, the boy's uncle (his mother's brother) is responsible for initiating the sequence of events by holding a meeting to discuss the ceremony (*mamanggia*). At this meeting decisions are made about what day the event shall occur, which guests should be invited, and who should be designated as the person (*pagawai adat*) whose traditional responsibility it is to invite the guests.

The first duty of the *pagawai adat* is to formally invite the father's sisters. Accompanied by two women, he brings them a container (*kampia*) made of pandanus leaves in the shape of a pouch, which contains betel leaves, areca nut (sometimes called betel nut), slaked lime, and gambir (a flavoring). These four items are the ingredients of betel quid, which is chewed as part of ceremonial activities. Other guests are invited less formally.

The ceremony usually takes place on a Friday. A group from the father's matrilineal house, usually consisting of three women and one man, picks up the boy who is to be circumcised. The group returns to the father's matrilineal house with the father and two married men from the father's clan. Other guests are village chieftains (*niniak mamak*), male in-laws (*sumando*), and invited guests from the father's village. Guests arrange themselves in the room according to custom; the chieftains sit between the front gate and the upper window and face

4.6 Musicians from the village of Guguk playing *talempong* in a seated position (*talempong duduak*). 1994.

TRADITIONAL MINANGKABAU CEREMONIES

the male in-laws. Women sit on the other side of the door next to the kitchen. The ceremony opens with a speech by the senior male of the house explaining the purpose of the ceremony. Then everyone eats a midday meal and prays for the boy who is to be circumcised. After prayers the boy is dressed in a black shirt, baggy trousers, and a vest. He wears a hat (*saluak*) formed from a square batik textile, and at his waist is a ceremonial dagger (*karih*) in an ornate sheath tied by a black cloth.

The whole party walks in procession, the boy walking in front with a male member of the father's matrilineage (*bako*), followed by women carrying trays of food. The rest of the party and a *talempong* group follow. This procession may walk for several kilometers, taking the longest route to allow the party to pass through the entire community. An important function of the *talempong* ensemble is to announce to all within hearing distance that a ceremony is in progress.

After the party arrives back at the boy's house, the circumcision takes place. The surgery is usually performed by an *ulama* (religious leader and teacher) or a *dukun* (village spiritualist and healer). After the *sunek rasua* has been performed, the *bako* must pay the *ulama* or *dukun* for his services. The payment is preceded by much discussion, as is the case with most traditional Minangkabau ceremonies. The boy then lies down on a couch with a covering that has been shaped into a tent to avoid contact with the fresh wound. Guests come by to congratulate the parents and their son and to give them money. Throughout the night feasting and *talempong* performances keep the guests and the boy entertained and awake.

4.7 *Palaminan* being set up in a family house in Bukittinggi. "Tongues" are being hung for the canopy over the bridal seat. 1995.

PESTA PARKAWINAN
(WEDDING CEREMONY)

In Minangkabau culture marriage involves a complex series of events. One reason why much time and many resources are expended on marriage ceremonies is that the marriage produces a bond between two clans. The traditional ceremony described here occurred in the village of Padang Magek (Harimansyah 1993, 18–118). The procedures and ceremonial activities practiced in other villages or at other times may differ from those described here.

The search for a match may begin while a girl is still very young. The girl's family and friends do their best to find a suitable groom for her. Once a candidate has been identified and accepted by the girl's female relatives, a long process of negotiation begins. The first step in the process is the *maanta galamai*, or delivery of *galamai* (a food made from glutinous rice flour and sugar). *Galamai* and other gifts are brought by the bride's female relatives to the prospective groom's matrilineal house at night. Gifts are covered with specially made textiles (*tutuik*), which have been couched with gold-wrapped thread (fig. 4.1). The two families engage in conversation, eat, and chew betel. After eating, the visiting women disclose the real purpose of their visit, the proposed engagement. The groom's family cannot reply at this time because they must first discuss it with the uncle (*mamak*) and the father of the groom. The groom's family chooses a representative to reply the following night.

Delivery of *lamang* (glutinous rice cooked in a bamboo tube) by male relatives of the prospective groom is a sign that the engagement proposal has been received and acknowledged and that negotiations may continue. The men also bring betel quid, cigarettes, food, and a gilded-silver engagement ring wrapped in a decorated textile, called a *saputangan*. The men are welcomed by women representing the bride's family. After conversing, eating, and chewing betel, the male visitors present the ring. The couple are officially engaged.

Traditional wedding activities take place primarily at the bride's house. As host, the bride's family incurs great expense for food, gifts, rental of decorations, and hiring of musicians. Many activities are involved in wedding preparations, and the help of many persons is necessary. Several days before the ceremony, friends and relatives of the bride are invited to discuss and organize the distribution of work.

Decorations for the ceremony are particu-

larly interesting and eye-catching. Banners (*marawa*) of red, yellow, and black adorn both sides of the road leading to the wedding house (see fig. 6.73). To the Minangkabau, red represents courage, yellow represents prosperity, and black represents the adat. Outside the house a bamboo gate is erected at the entrance with the words "*Salamat Datang*" (welcome) written across it. A bridal alcove (*palaminan*) is set up inside the house. The *palaminan*, a symbol of fertility, was once adjacent to the marriage bed. Today it consists of an elaborately decorated seat surrounded by ornate and colorful embroidered hangings and placed under a wedding canopy hung with heavily embellished cravat-shaped textiles called *lidah* (tongues), which remind the Minangkabau couple to speak to each other with care (fig. 4.7)

In a prenuptial ceremony called the *malam bainai*, the bridal couple's fingernails are stained with henna. One or several nights before the wedding party, the bride is brought from her bedroom and is seated beside the groom in the *palaminan*. The ceremony is led by an old woman. Guests apply henna to the fingernails of the bridal couple as a sign that they will soon be married. The bride's nails are done by the groom's guests, and the groom's nails by the bride's guests. The groom's mother is the first person to apply henna to her future daughter-in-law's nails.

Traditionally the bridal alcove was adjacent to the bridal boudoir. Now several layers of satin curtains hanging behind the seat of the *palaminan* symbolically separate the couple from the bridal bed, indicating that they must be able to control their carnal desire for several days (Frey 1986, 131). The wedding bedroom is also decorated with a brightly colored satin bedspread and matching curtains. In some villages an elderly female relative is assigned the duty of sleeping under the bed to make certain that the marriage is not consummated before the appropriate time.

Two wedding ceremonies are required—one Islamic, one adat. The Islamic ceremony, or *nikah*, is usually conducted in the mosque on a Friday, and the Minangkabau wedding ceremony is held on the following Sunday. The *nikah* ceremony takes place in accordance with Islamic teachings, and the bride's family's consent is read. The groom wears a dress jacket, a felt hat (*kupiah*), a short tube skirt (*sisampiang*), and trousers (*sarawa*). The bride wears a long tunic (*baju kuruang*) and a tube skirt. Although in the eyes of Islam the couple is legally married, they must wait several more days before the marriage is consummated.

After the Islamic ceremony the groom is accompanied by some friends and an intermediary (*janang*) to the bride's house. They bring betel and cigarettes wrapped in a *saputangan*. The men are waited on by the bride's female relatives. On Saturday the bride's family invites guests to the adat wedding ceremony. Saturday night the clan chieftains (*niniak mamak*) come to the bride's house to eat and to make speeches (*pidato adat*). The evening is full of eating and speechmaking, which may continue until dawn. Soon after the chieftains' introductory speeches, nine of the groom's friends accompany him to the bride's house. This is the first of three bridegroom nights, during which the groom and his friends stay at the bride's house till morning.

On Sunday morning the adat wedding ceremony begins at the bride's house. All furniture has been removed from the public rooms, and mats have been laid on the floor. As a *talempong* ensemble plays, a musician may strike a large hanging gong with a *cubadak* (jackfruit; fig. 4.8), a practice usually reserved for weddings. From morning to night a succession of guests arrives bearing gifts. Guests eat, congratulate the bridal couple seated in the *palaminan*, and leave. Most guests wear simple Minangkabau costume and Islamic head covering—a felt hat (*kupiah*) for men and a veil-like headcloth for women. The bridal couple, by contrast, is dressed in elaborate traditional (adat) costumes under the bridal canopy (fig. 4.9). The groom wears a hat formed from a square of cloth (*saluak*), and the bride wears a *suntiang*—a heavy metallic gold-colored headdress of flowers, leaves, and birds—which sits like a large fan-shaped crown on her head (see chapter 6). A Minangkabau bridal couple is treated as king and queen for the day.

4.8 Musician performing at the bride's house for a wedding in the village of Guntung. She is striking a large hanging gong with a *cubadak* (jackfruit), a practice usually reserved for weddings. 1994.

TRADITIONAL MINANGKABAU CEREMONIES

4.9 A bride and groom sitting in a bridal alcove (*palaminan*) in the village of Bukittinggi. 1994.

4.10 Procession of women carrying platters of food to the bride's house for a wedding feast in the village of Kacangutara. 1994.

THE MINANGKABAU

In the afternoon the bride and groom pay a visit (*manampuh*) the bridegroom's house. The bridal couple walks at the front of a procession, followed by women carrying trays of food covered by portable cone-shaped forms made from plaited sugar palm leaves and then covered with a textile couched with gold thread (*dalamak*; fig. 4.10). At the rear of the procession are *talempong* players. When the procession arrives at its destination, the musicians position themselves outside the house and continue to perform. The procession is welcomed outside the house of the groom's family by female relatives of the groom. They offer trays of food to the bridegroom's relatives, who then exchange the trays for other items, such as rice, coconuts, cigarettes, and betel leaves arranged and decorated with colored paper. The bridal couple sit in state on the bridal seat under a second decorated alcove that has been erected inside the groom's house. Later the procession returns to the bride's home. The "bridegroom night" program is continued for two more nights.

Following afternoon prayers on Tuesday, the groom, an uncle, his brothers, and five to seven other men, all wearing street clothes, go to the bride's house to introduce the groom to the bride's family. After they eat and drink coffee, the groom goes to his mother's home. The next day the groom is presented to the relatives of the bride in her family house. The purpose is to further investigate the bride's family and to determine how the groom will be treated by her family.

The following day (Thursday) the newly married couple and some followers visit the bride's and groom's relatives' houses. The groom wears a jacket, a felt hat, a short tube skirt (*sisampiang*), and trousers (*sarawa*). The bride wears traditional ceremonial garments, but now she also wears a shoulder cloth (*salendang*), indicating that she is a married women. Relatives are visited in a specific sequence, beginning at the groom's mother's house. The bride and groom eat and exchange food at every house. The bride is also given gifts such as textiles and kitchen ware.

Friday is "entrusting night" (*pitaruah*), the last step of the traditional wedding. The groom's family entrusts him to the bride's house forever. At about 10 P.M. the groom is accompanied by an intermediary (*janang*) and two men carrying betel and cigarettes to the bride's family house. They are met by older women, who serve them. The *janang* expresses his hopes that the family of the bride will treat the groom as their own son and that, if he makes mistakes, they will advise him. The male relatives go home, but the groom remains. One of the older women invites the groom to sleep with his new wife, but he refuses several times, confessing that he is too shy. He finally enters the bride's bedroom, where she is waiting for him. This concludes the myriad rituals of the marriage ceremony, and the couple begin their life as husband and wife.

The traditional wedding party is one way to ensure that established customs continue, yet in contemporary Minangkabau society many changes are evident. Traditional *talempong* music is sometimes replaced by contemporary music. Residence patterns are changing; young couples are moving away from traditional matrilineage homes into separate residences. Women who leave home to pursue an education may delay marriage. Thus, the social sphere of many young people has widened, giving them a greater choice of marriage partners and enabling them in some instances to choose their own partners rather than relying on decisions made by their families. These changes have affected the social structure within the family unit.

Batagak Pangulu (Chieftain's Installation Ceremony)

The ceremony elevating a man to the role of chieftain (*pangulu*) is infrequently performed. It is common for a chieftain to hold that position for most of his adult life. If, for example, he is in his late twenties or thirties when appointed, he may maintain the position for the next thirty or forty years. Nevertheless, there are reasons other than death or retirement for assuming the elaborate, lengthy preparations and considerable financial burdens of installing a new chieftain. If, for example, a clan is divided because of a conflict among its members, a decision may be made to separate the clan into two factions and appoint a chieftain for each. Another reason for appointing an additional chieftain might be that an increase in the population has resulted in too great a burden for one man to carry.

The expense of an installation ceremony is enormous, and preparation and planning may take months or years and involve the entire clan. Events that precede the ceremony, such as meetings to choose the appointee and determine the title to be used by him, are critical points of negotiation. Decisions are thoroughly considered and must be agreed upon by the whole clan. Each of the events at which discussions take place requires extensive food preparation. Meals

are a significant aspect of every adat ceremony. During preceremony events people will be assigned various tasks, such as delivering invitations, repairing the traditional house, or putting up banners, flags, and decorations.

Red, yellow, and black banners (*marawa*) lining the road announce the installation ceremony. Houses along the side of the road may also signal the event with archways made of bamboo decorated with coconut leaves and bamboo letters spelling out the new chieftain's title. The central market area teems with ceremony participants dressed in their finest costumes, watching performances of Minangkabau arts. There may be *talempong* music to entertain members of the clan during preparations for the ceremony.

Before sunrise on the day of the ceremony, a buffalo is slaughtered by a man from the appointee's clan. "Slaughtering and eating a buffalo has deep symbolic meaning. According to adat, a *penghulu* [*pangulu*] must be installed by having a ceremony in which the 'horn is buried' (*tanduk ditanam*), 'the meat is eaten' (*daging dilapah*), and 'the sauce of the meat is properly mixed' (*kuah dikacau*)" (Manan 1984, 147). After the buffalo is cleaned and cut, it is separated into specific dishes for different purposes. One part of the meat is prepared as a curry. Just as the skillful mixing of various ingredients is important in producing a delicious curry, so a chieftain should "master the arts of management. His wisdom in guiding the various kinds of his sisters' children is the key to his success as the chief." Eating buffalo meat symbolizes "that [the chieftain] has many sisters' children with a diversity of characteristics, good and bad; the good characteristics should be put forward and the bad ones should be eliminated" (Manan 1984, 148). The head, organs, and some of the meat not used as curry are given to the new chieftain's wife (Erma 1991, 59). According to Manan (1984, 148), burial of the buffalo horn symbolizes "that all human characteristics that can hurt others are buried."

On the day of the ceremony, there is a procession from the appointee's father's clan's (*bako*'s) house. The candidate is dressed in a chieftain's costume consisting of a headcloth (*saluak*) made of batik or of silk with a supplementary weft of gold-wrapped thread, an oversize collarless black shirt (*baju gadang*), and loose-fitting black trousers (*sarawa gadang*). A short red tube skirt (*sisampiang*), worn between the waist and knees, is covered at the waist by a belt (*ikek pinggang*). The new chieftain wears a special kind of shoulder cloth (*salempang*). In his belt is a dagger (*karih*). He carries a staff (*tungkek*) and wears sandals. Each of these items of clothing carries adat significance (see chapter 5).

The appointee walks at the head of a procession with members of his clan to his traditional house (his mother's clan's house), shaded from the sun by a bright yellow umbrella. As the participants walk, accompanied by *talempong* music, a wave dance (*galombong*) greets them as they reach the candidate's traditional house. They are offered betel leaves from a ceremonial brass bowl (*carano*) and invited to sit down.

Speeches and a dedication of the new chieftain's title follow. The new chieftain is given advice, and the oral history of the clan is recited for him as a means of establishing continuity and the validity of his position and title (Errington 1984). The outgoing chieftain removes the headcloth from the new chieftain's head and exchanges it for the heirloom hat (*saluak*) that belongs to the clan. The new chieftain then recites his oath of office (Manan 1984).

Turun Ka Sawah (Work Ceremony)

Turun ka sawah (literally, "to go down to the wet rice field") is an annual event for a rural community. Much of the cycle of rice production is labor-intensive, including preparing the field, cultivating the rice seedlings, cleaning the irrigation canals, planting the rice seedlings, and harvesting the rice crop. Handra Kadir (1993, 43) reports that at one time almost 80 percent of the population of the village of Kubang Pipik, in Agam, was involved with farming, and work in the rice fields was done by the community, employing a system of mutual cooperation (*gotong royong*).

Turun ka sawah can apply to a range of activities in the rice field, or there can be specific events that fall under this general heading, such as cleaning out irrigation canals (*turun kabanda*). An entire rural community is called upon for this effort, which in turn benefits everyone in the community. The *talempong* serves two functions during a procession to the fields: to alert community members to the impending work party, thereby rallying supporting participants, and to make the walk to the fields, sometimes several kilometers long, more enjoyable and prestigious.

One of the most important activities of rice cultivation occurs during the harvest. In the past

the harvest was a time to celebrate and to give thanks. During a rice-cutting ceremony (*manyambik*), the community gives thanks to the Rice Mother (Induak Padi): "*Manyambik* was for a large wet rice field (*sawah*). First, seven stalks of rice are cut and taken home. It is important not to look at anyone during the walk home. At home the stalks are hung from the peak of the roof. The rest of the *sawah* is cut the next day starting at sunrise. After the rest of the rice is cut, a special thanksgiving ceremony is held at home, where prayers are made for *manyambik*" (Maklis, conversation with authors, 1994). To the Minangkabau, rice has a spirit, and the purpose of the ceremony is to replant the spirit into the rice field. The Rice Mother is asked in prayer not to let birds eat all of the rice so that there will be more rice the next season.

Other Ceremonies

Two other adat ceremonies, the adoption and boar-hunting ceremonies, are less frequently performed. When a non-Minangkabau marries a Minangkabau, a formal adat ceremony may be performed to adopt the newcomer into the family. On rare occasions this adat ceremony is performed to recognize outsiders (even foreigners) who have made a considerable effort to do something of benefit to the Minangkabau community.

The boar-hunting ceremony developed out of necessity. Wild boar were destroying the rice crop to the point that the community's food supply was threatened. An adat ceremony was held to ensure the success of a planned hunt to eliminate the threat.[1] Village males joined forces and, with their dogs, chased and killed large numbers of wild boar. Today the "pig hunt," as Frederick Errington (1984, 146ff.) refers to it, has turned into a sport for men and boys, as the threat to crops has disappeared.

One additional Minangkabau ceremony, of Muslim rather than adat origin, deserves mention. The Tabuik (tall mountain) festival, an annual Muslim celebration in the coastal village of Pariaman, is performed to commemorate the battlefield death of Muhammad's grandson Husayn. Colorful wooden monuments carried on the backs of wooden *borak* (named for al-Buraq, the mythical winged horse that carried Muhammad to heaven) are paraded through the streets (fig. 4.11) and are eventually thrown into the sea.

4.11 The Tabuik festival, an annual Muslim celebration in the village of Pariaman commemorating the death of Muhammad's grandson. Several colorful monuments are carried through the streets and eventually thrown into the sea. 1994.

This chapter has dealt mostly with major ceremonies at which elaborately decorated textiles bearing signs of adat are worn and used. A typical Minangkabau family also shares many small observances (*salamatan*), such as thanksgivings and other celebrations. Special foods may be prepared for these occasions, although dress is usually not formal and processions, music, and dance are not part of the event. It is the major ceremonies, often held in the adat house of the matrilineage, that are enlivened by the inclusion of major Minangkabau arts: handwoven ceremonial attire, carved adat motifs, dance, music, ceremonial speech, and cooking of special foods. Each of these ceremonial arts is in some way governed by adat, and their inclusion in major ceremonial events provides a means of reinforcing the participants' knowledge of adat. Ceremonies, in addition to fulfilling their stated purposes, serve as celebrations of the culture's complex code for living, reaffirming the high value the society places on being Minangkabau.

Part 2

CEREMONIAL TEXTILES

*The secret to the capacity
to make meaning lies in the artifact.*

—MILES RICHARDSON
ON GEORGE HERBERT MEAD

*If all societies and, significantly,
all the 'totalitarian institutions'... that
seek to produce a new man through a process
of 'deculturation' and 'reculturation' set such store on
the seemingly most insignificant details of dress, bearing,
physical and verbal manners, the reason is that,
treating the body as a memory, they entrust to it
in abbreviated and practical, i.e. mnemonic,
form the fundamental principles of the
arbitrary content of the culture."*

—PIERRE BOURDIEU

INTRODUCTION TO PART II

REGIONAL ORIGINS OF CEREMONIAL TEXTILES

Most of the textiles discussed in this book were made and worn in the landlocked West Sumatran highlands of the Barisan Mountains.[1] The three original highland areas settled by Minangkabau were in valleys collectively known as the *luhak nan tigo* (the three regions): Tanah Datar, Agam, and Limo Puluah Koto (see map, pp 22–23). Because these valleys are shut off from one another by surrounding rings of hills, they developed somewhat independently. As a consequence, ceremonial dress, especially women's, may vary significantly in appearance from region to region even though the highland area is relatively small.[2]

Ceremonial dress also varies in appearance within a given valley region. Headwear and shoulder cloths especially are often village specific. The adat that regulates ceremonial wear differs from village to village. In some villages, adat may call for different tunics and skirts, different shoulder cloths and headdresses to be worn for different ceremonies, while in other villages the same attire is suitable for all ceremonies. In one area one's choice of ceremonial wear may depend on which relatives will also attend the ceremony (Ng 1987, 1: 192). Because of these variations, it is helpful to consider briefly the differing characters of the three regions before looking in detail at examples of ceremonial dress.

Tanah Datar (literally, "flat land") is a broad valley extending south and east from the volcanic Mount Marapi. Marapi is venerated by all Minangkabau as the site of their legendary first settlement in Sumatra and as the place of origin of Minangkabau adat. Tanah

Datar, now a regency of the province of West Sumatra, claims to be the first valley settled after the ancestors' descent from Mount Marapi. Many centuries later, in the fourteenth century, Tanah Datar was a seat of the first monarch, Adityawarman, a Theravada Buddhist and a member of the Majapahit court of Java who was intent on building an empire in Sumatra. He established one court, Pagaruyung, near Batu Sangkar, which is now the capital of the regency of Tanah Datar, and another in what is now the neighboring province of Jambi.[3] Batu Sangkar (literally, "caged [*sangkar*] stone [*batu*]") became the cultural and artistic center of the Minangkabau highlands. The monarchy, mostly remote from the everyday life of established villages, existed mainly by controlling a lucrative trade in pepper and gambir and in gold from Tanah Datar mines. Clan chieftains (*pangulu*) administered the established villages, and the monarchy appointed rajas to administer outlying regions. The monarchy survived until 1844, seven years after the beginning of direct Dutch rule.

The Agam Valley extends north and west of Mount Marapi. Agam (the name of a type of local rush), now a regency of the province of West Sumatra, is partly contiguous with Tanah Datar and was probably settled by emigrés from Tanah Datar. Agam is dominated by Mount Marapi and by nearby Mount Singgalang, an extinct volcano. The attractive town of Bukittinggi (literally, high [*tinggi*] hill [*bukit*]), at an altitude of about nine hundred meters, lies in the shadow of these two volcanoes. It has the most comfortable climate of the three regency capitals and has become an economic center. From Bukittinggi immediately across beautiful Sianok Canyon, part of a tectonic rift valley that runs the length of Sumatra, lies Koto Gadang, a village known for producing fine jewelry and some of the most exquisite weaving in Indonesia. During the time of Dutch occupation of the highlands, Bukittinggi and Koto Gadang together became the intellectual capital of the Minangkabau region.

Limo Puluah Koto (fifty fortified villages), stretching to the east of Mount Marapi, is the lowest in altitude of the three valleys and has the hottest climate, being less than one degree from the equator. This region, now a regency of the province of West Sumatra, also contains a major mountain, Mount Sago, giving the *luhak nan tigo* three peaks that dominate its skyline. But Limo Puluah Koto, its villages alleged also to have been settled by emigrés from Tanah Datar, prides itself on a unique legacy from what is one of the oldest known cultures in Sumatra. Megaliths dating from the third to second millennium B.C.E. (Bahar 1993, 14) are found at several sites in this regency. In the village of Mahat lies a field of several dozen carved megaliths (see fig. 1.4) so shaped and installed that nearly all point toward Mount Sago. Motifs carved into these ancient stones are found on highland Minangkabau ceremonial textiles.

Most textiles from Limo Puluah Koto differ markedly from those of the other two regions, except in a narrow area where textiles from either side of the current border with Tanah Datar are indistinguishable (see, for example, fig. 6.54). In Limo Puluah Koto, in contrast to the other two regions, cotton was used more often as ground material for decorated ceremonial clothing; plaids, checks, and stripes are used more often for patterning; metallics are used more sparingly. Yet, as is apparent from the illustrations that follow, these weavings can be just as exquisite, refined, and sophisticated as their silken counterparts from Agam and Tanah Datar.

As highland populations expanded, descendents of the original settlers ventured into frontier areas, the *rantau*. Young men, who found themselves more or less at loose ends in a matrilineal society, were expected to spend time in the frontier areas, gain knowledge and wealth, and bring them back to their home villages. Some who went "on *rantau*" stayed and established families. The frontier was pushed further and further back as more and more visitors settled permanently in these areas. The first *rantau* were to the south and east of the *luhak nan tigo*. Later coastal regions became *rantau*, then other Indonesian islands. Today even Europe and the United States are sometimes treated as *rantau*. When Indonesia became an independent nation, what had once been *rantau* areas in the highlands became part of the province of West Sumatra as the regencies of Solok and Sawahlunto/Sijunjung.

John Summerfield

5

MEN'S CEREMONIAL DRESS

Visual statements of traditional beliefs and customs pervade Minangkabau culture. They appear as motifs woven into textiles; as motifs carved on walls of adat houses; and as folds, as drapes, and even as part of the actual construction of men's ceremonial dress. Textiles a Minangkabau male wears at a ceremony convey information about his role and responsibilities in the society. For example, a chieftain (*pangulu*) wears a black shirt (*baju itam*), sometimes made of velveteen, with gold braid at the neck, on the ends of the sleeves, and at the shoulder seam (fig. 5.2). The shirt's loose V-neck signifies that the chieftain is broad-minded, merciful, and insightful. The ends of the sleeves "can be used as fans against heat and dust, symbolizing that a *penghulu* [the Indonesian word for *pangulu*] has all means and ways to overcome the difficulties and trouble to be faced as a chief" (Manan 1984, 128). The *baju itam* itself "represents the *penghulu*'s function as a protector of his children, nephews and nieces, with an open mind, wise and prestigious, tolerant, and a leader of many followers" (Bahar 1993, 100).

Not all of the symbolic elements of men's ceremonial dress are visible. The shirt's braid-covered shoulder seams are emblematic of the *pangulu*'s role as arbitrator. When he has settled a dispute between family members, according to Minangkabau adat, all parties to the dispute must be satisfied, their relationship must be restored, and differences must no longer be apparent, just as the *pangulu*'s shoulder seams are not apparent.

Although Minangkabau society is matrilineal, men play important roles both in ceremonies and in daily decision-making in their villages. As discussed in chapter 3, a married man has three responsible roles in this culture: husband, father, and uncle. If he is appointed chief of a matrilineal group (*pangulu andiko*), he is expected to be an adat authority in the community (Manan 1984, 5). Young, unmarried men are encouraged to venture out into the world beyond the borders of the Minangkabau heartland (*marantau*) to seek wealth and knowledge and to bring both back to the village.

On ceremonial occasions processions of both men and women through a village are common, but at one stage of most ceremonies men become the principal participants, engaging in extended oratory (*pidato adat*) and eating ceremonial food, which the women have prepared and serve to the guests. Custom varies from village to village, and examples given in this chapter may be typical only of the village cited.

A Minangkabau male attired for a ceremony is adorned in several magnificent woven cloths: a head covering (*deta* or *saluak*), a big shirt (*baju gadang*), trousers (*sarawa gadang*), a short sarong (*sisampiang*), a belt (*ikek pinggang*), a

5.1 Chieftain wearing a head-dress (*deta*) from Solok, a town outside the original Minangkabau heartland. The textile is a plain black silk square folded into a triangle. In this area the *deta* is tied at the forehead, metallic rings having been threaded onto the ends of the cloth before the headdress is tied. The point is folded forward from the back of the head and tucked under the tied ends. Tanah Datar. 1989.

5.2 Group of chieftains at a wedding ceremony in Payakumbuh. Each wears a *baju itam* (chieftain's ceremonial shirt) of black velveteen with gold braid. The gold braid is sewn to the velveteen at the neck, at sleeve cuffs, and at the junction of the sleeves with the shoulder section of the shirt. Aspects of the shirt represent to the Minangkabau attributes and responsibilities of a chieftain. 1995.

5.3 A young chieftain (*pangulu*) dressed to attend a ceremony. He wears a *saluak* on his head, a large black shirt (*baju itam*), black trousers (*sarawa gadang*), a short tube skirt (*sisampiang*) held in place by a belt (*ikek pinggang*), one end of which is visible along his left leg, and a folded tubular textile (*salempang*) draped from right shoulder to left hip. He wears a silk scarf (*tanahliek*) around his neck, carries a staff (*tungkek*), and has a ceremonial dagger (*karih*) tucked into his belt. On his feet are gold-ornamented leather sandals (*tarompa*). Bukittinggi. 1989.

shoulder cloth (*salendang* or *salempang*), and perhaps a neck scarf (*kain kaciak*). In addition, he may have a short ceremonial dagger (*karih*) tucked in his belt and carry a silver- or gold-handled staff (*tungkek*) as a symbol of authority (fig. 5.3).

Donning ceremonial dress is more than an opportunity to display magnificent garments. It is an opportunity to participate in activities that are a very important part of Minangkabau life. The clothing, procedures, guests, food—in fact, all aspects of a ceremony—are determined by Minangkabau adat, the traditional belief system described in earlier chapters of this book. Different adat ceremonies may call for different combinations of the elements of men's ceremonial dress. The selection of garments for any ceremony depends in part on the role of the participant in the ceremony and may vary from village to village, as do many other aspects of Minangkabau adat.

Men's dress is at its most sumptuous for a groom at his wedding ceremony and for a clan chieftain (*pangulu*) at the ceremony celebrating his inauguration. A traditional Minangkabau wedding is a multiday affair at which the groom appears from day to day in different but equally splendid costumes. The elevation of a chieftain may be even more elaborate. When a former governor of West Sumatra was inaugurated as a chieftain, the ceremony lasted for six weeks, and portions of it took place at many different locations in West Sumatra and in the Minangkabau-settled province of Negeri Sembilan in Malaysia (Frey 1986, 83).

The shapes into which some male ceremonial textiles are structured, folded, or draped carry specific meanings relating to men's leadership roles and responsibilities in the community. Woven into the textiles themselves are motifs to which the Minangkabau have attributed meaning, often through references to metaphorical proverbs (*peribahasa*) that delineate proper forms of behavior. (For a detailed discussion of motifs and their significance to the Minangkabau, see chapter 7.)

HEADDRESSES

Men's headdresses, worn for ceremonies throughout the Minangkabau heartland, take a number of forms, which differ from village to village. An ancient form of male headdress, the *deta*, is still worn by musicians and dancers at ceremonies and by *dubalang* (bodyguards for a chieftain), among others. The *deta* is formed from a piece of cloth that is about one meter square. The cloth is sometimes plain red or black, sometimes ornamented (fig. 5.4). It is folded across opposite corners to form a triangle. The *deta* is usually tied at the back of the head, with the point extending upward over the forehead, held vertically by a stiffening reinforcement. A particular *deta*, different from the one shown in figure 5.1, is worn to ceremonies by chieftains from the village of Solok. It is formed before it is placed on the chieftain's head (figs. 5.5a–f).

The *deta* illustrated in figure 5.1 is tied on the head with the point positioned at the back but folded over toward the front. A bright and sometimes audible note is added to the headdress by threading hollow metallic rings 3 to 6 centimeters in diameter, some containing pellets of dried resin, onto the ends of the folded cloth before they are tied at the forehead (figs. 5.1, 5.6). As a man wearing this *deta* moves his head, the pellets inside the hollow rings rattle. These pellets may be fragments of the shaped resin over which the ring was originally formed.

The *saluak* (figs. 5.7, 5.8) is one of the most

5.4 Textile for a *deta* (chieftain's ceremonial headdress) from the village of Batipuah. Silk, gilded coins, gold-wrapped thread. The headdress is formed from a textile about one meter square, folded from corner to corner to form a triangle and tied at the back of the head. The point is held upright at the forehead by stiffening material. For a chieftain's bodyguards (*dubalang*), plain red cloth squares are used to tie *deta*. *Deta* are also worn by male dancers and by some musicians. 94 x 94 cm. FMCH X93.25.9; collection of H. Elly Azhar and H. A. Sutan Madjo Indo.

5.5a–f These images show how a particular *deta* from Solok is folded and worn, starting from a one-meter-square plain black textile. 1994.
a. The textile is folded from corner to corner into a triangle around a piece of heavy paper, which serves as a stiffener.
b. The stiffened triangular textile is straightened, the long edge folded, and the textile smoothed.
c. The stiffened triangular textile is rolled into a conical shape.
d. The loose exterior end of the textile is pinned to the conical structure to hold the cone in shape.
e. A chieftain (*pangulu*) tries on the *deta*.
f. The bedecked chieftain is now ready to participate in a ceremony.

MEN'S CEREMONIAL DRESS

5.6 Hollow gilded silver rings, similar to those tied into the headdress illustrated in figure 5.1. Diameter 4 cm. Private collection.

important forms of male headdress. It is folded from a rectangular cloth about one meter square, sometimes a batik, sometimes a silk or cotton textile richly embellished with gold-wrapped thread. The *saluak* is thought to have been introduced in Minangkabau ceremonies as an alternative to the *deta* during the reign of Adityawarman in the fourteenth century (Manan 1984, 125).

The folds of the *saluak* convey messages to the Minangkabau about responsibilities of male leadership. The hat is flat across the top, which is said to signify that the wearer must treat everyone equally. Though the hat is folded from a square cloth, its form is approximately circular; the absence of sharp corners signifies the chieftain's calming behavior toward his people. Across the front of the hat are an uneven number of sharp horizontal folds. According to the Minangkabau interpretation, these folds signify the steps leading to the adat house (*rumah gadang*), where many ceremonies take place; steps in the chieftain's learning process, in which he acquires the wisdom to guide and protect his extended family; and steps a chieftain takes to resolve family disputes.[1] Spiral curves on either side of the panel of pleats, formed by the particular folds used to construct the *saluak*, stand for the chieftain's reaching out to the community as well as his turning inward to care for his family.

The right side of the hat is taller than the left, signifying that a man's responsibility to his own children is greater than that to his sister's children. As an uncle in a matrilineal society, however, he has serious responsibility for the education and well-being of his sister's children, as outlined in a traditional Minangkabau saying (cited by Sweeney 1987, 121):

If shy, give encouragement
If thirsty, give water
If weak, give rice
If fallen in, dive after them
If lost, search for
If ill, give medicine
If dead, bury

When unfolded, the cloth of the *saluak* can be powerful: "It can be used to fence the settlement, to embrace all sisters' children, to protect the ancestral house, to provide protection from the heat of the sunshine, and to give shelter during the rain" (Manan 1984, 125). Thus, the cloth

5.7 *Saluak* (man's ceremonial headdress). Cotton starched for stiffening. Like the *deta*, the *saluak* is usually folded from a one-meter-square cloth, in this case a batik from the Sumatran province of Jambi, with which the Minangkabau have traded for centuries. Folds in the *saluak* symbolize responsibilities of male leadership in the society. Diameter 22 cm. FMCH x97.50.22; private gift.

5.8 *Saluak* (man's ceremonial headdress). Cotton, gold-wrapped thread. This *saluak*, which is similar in shape to the example illustrated in figure 5.7, is folded from a red cotton textile richly embellished with supplementary weft patterns of gold-wrapped thread. Diameter 24 cm. Private collection.

CEREMONIAL TEXTILES

itself is a sign of the chieftain's responsibilities toward his family and community.

In the regency (*kabupatan*) of Limo Puluah Koto,[2] the men's ceremonial headdress, called *deta bakaruik* (or *deta bakatak*), is made from a long black cloth with pleats or gathers sewn in. Some are sewn into a circle and worn in this fashion on the head (figs. 5.9, 5.10). Others are simply worn wrapped around the head (Ng 1987, 180).

In the village of Si Guntur, in one of the early *rantau* areas southeast of the heartland, a ceremonial hat of pillbox shape was ornamented with a repoussé gold band and several large repoussé gold emblems (fig. 5.11). This headpiece is worn on ceremonial occasions by the local raja. (Following the arrival of Adityawarman in the fourteenth century, villages in the *luhak nan tigo*, the heartland, were ruled by their local *pangulu*. Villages in the areas outside the heartland, however, continued to be ruled by raja appointed by the king, a carryover from the Hindu-Buddhist tradition of that early period.[3])

Perhaps the commonest form of Minangkabau head covering is the *kupiah* (fig. 5.12), a fezlike cap made of black velvet, widely worn by Muslims in Southeast Asia. The *kupiah*, not an adat headpiece, constitutes daily wear for many Minangkabau men but is also worn by some guests at ceremonies.

In earlier days wooden headdresses (*saluak deta batimbo kayu*) were intricately carved in imitation of folded textiles and then decorated with gold leaf (figs. 5.13, 5.14). Another form of wooden headdress, sometimes gold-leafed, is a carved toroidal ring that resembles a rolled textile tied into a knot, with the ends flared (figs. 5.15, 5.16).

5.9 *Deta bakaruik* (man's ceremonial headdress) from the regency of Limo Puluah Koto. Cotton. It is made from a long black cloth, folded and sewn with many pleats or gathers. Diameter 21 cm. FMCH X97.50.29; private gift.

5.10 Group of men attending a ceremony. The two at the left wear *deta bakaruik* from Limo Puluah Koto while the next three wear *saluak* more commonly worn in the regencies of Agam and Tanah Datar. 1995.

5.11 Raja's ceremonial headdress from the village of Si Guntur. Cotton, gold. The gold repoussé band and ornaments reflect the high level of workmanship commonly found in Minangkabau. After the reign of Adityawarman in the fourteenth century, the Minangkabau kings continued to appoint rajas to rule villages in the areas outside the three original heartland regencies of Agam, Limo Puluah Koto, and Tanah Datar. Descendents of those rajas have no official status today, but villagers look to them for leadership. Even today the rajas wear ceremonial dress as elaborate as that worn in the heartland. 1994.

MEN'S CEREMONIAL DRESS

5.12 A Minangkabau wearing a *kupiah*, a black velvet fez. Although he wears Western dress, his shoulder cloth indicates that he is a participant in a ceremony. The *kupiah* is worn by many Minangkabau daily, both outdoors and indoors. It is also worn to some ceremonies. Bukittinggi. 1995.

5.13 The *saluak deta batimbo kayu* (man's ceremonial hat) worn by this early twentieth-century Minangkabau is made of wood, carved to have the surface appearance of a textile and then gold leafed. A closer view of a similar carved hat can be seen in figure 5.14. Courtesy of the Yayasan Dokumentasi dan Informasi Kebudayaan Minangkabau.

5.14 Carved and gold-leafed hat (*saluak deta batimbo kayu*) similar to the one worn in figure 5.13. Carved wooden hats have not been worn ceremonially for many years and are now mostly found in private or museum collections. Private collection.

5.15 *Deta baikek kayu* (man's ceremonial hat) of wood carved to look like a rolled textile tied around the head. After carving, the hat was gold-leafed. 20 x 26 x 22.5 cm. The Glassell Collection.

5.16 An early twentieth-century photograph of a Minangkabau wearing a toroidal wooden hat (*deta baikek kayu*) similar to the one illustrated in figure 5.15. Courtesy of the Yayasan Dokumentasi dan Informasi Kebudayaan Minangkabau.

CEREMONIAL TEXTILES

5.17 *Baju* (man's ceremonial shirt). Silk and gold-wrapped thread. The two vertical creases running from the shoulders to the hem of this *baju* were caused by repeated folding of the textile, which is heavily embellished with metallic-wrapped thread. The metallic thread has acquired a permanent bend. The location of the creases strongly suggests that the cloth from which the *baju* was made was originally used for another purpose, probably as a shoulder cloth. It is not likely that a *baju* would be folded in a way to have caused these creases. Ceremonial textiles are held in very high regard, and when they become too worn for their primary use, portions that are still serviceable may be cut and sewn to form a cloth for a different ceremonial use. Length 71 cm. FMCH X97.50.30; private gift.

5.18 *Baju* (man's ceremonial shirt). Cotton and gold-wrapped thread. Contemporary version of a traditional *baju* with adat motifs included as supplementary weft. Length 88 cm. Private Collection.

Shirts (Baju)

Dressed for a ceremony, a Minangkabau male wears a long-sleeved, loose-fitting, collarless tunic (*baju*) open at the neck. One variety, commonly worn by a chieftain (*pangulu*), is the *baju itam* that was described at the beginning of this chapter. A second form of *baju* is made of *songket* (silk or cotton with supplementary-weft patterning of gold- or silver-wrapped thread; figs. 5.17, 5.18). (See chapter 8 for a discussion of supplementary weft.) Another type of men's ceremonial shirt is a plain-colored short tunic, open at the neck, with long sleeves. The end of each sleeve is patterned with a band of gold-wrapped thread (fig. 5.19). A fourth shirt is the *baju cino* (Chinese-design shirt). It is a white cotton or white silk shirt with round Mandarin neckline, long sleeves, and two front pockets. The *baju cino* is usually embroidered with white silk thread.

For some ceremonies of lesser importance, a man may wear a Western-style shirt, open at the collar, and a Western-style jacket (fig. 5.20).

5.19 *Baju* (man's ceremonial shirt). Silk, cotton, gold-wrapped thread. Purple silk lined with red cotton. The cuffs of the sleeves are ornamented with supplementary weft of gold-wrapped thread. Length 67 cm. FMCH X97.50.32; private gift.

5.20 A group of village chieftains (*niniak mamak*), dressed in Western style open-neck shirts and jackets and wearing *kupiah*, arriving for an adoption ceremony. Bukittinggi. 1995.

MEN'S CEREMONIAL DRESS

Trousers (Sarawa)

Trousers for ceremonial dress come in several varieties. To match the black velveteen *baju itam* described above, a *pangulu* wears black velveteen trousers with a low crotch and voluminous body (*sarawa gadang*; fig. 5.21), which "symbolize that he is able to walk freely to visit his sisters' children, to attend any lineage, clan, or village meeting that requires his presence and wisdom" (Manan 1984, 128). The wide waist "demonstrates the *penghulu*'s freedom of movement according to the proper way of adat, fairness in his treatment of his children, his nephews and nieces, and showing his greatheartedness" (Bahar 1993, 100). The bottoms of the trouser legs are decorated with gold braid to match the braid on the chieftain's *baju itam*. Sometimes the fabric contains an ikat stripe, and often pieces of *songket* cloth or ikat cloth are added at the crotch as additional trim (fig. 5.22).

The *sarawa gadang* are often referred to as Arabic-type trousers (fig. 5.23), and their design probably came to the Minangkabau from Aceh, at the northern tip of the island of Sumatra, where Islam made its first Indonesian inroads in the thirteenth century.[4] In Aceh *sarawa gadang* are worn by women.

Not all ceremonial trousers are as loose-fitting as the ones described above. Straight-legged trousers of several types are also worn. Some are of batik (fig. 5.24), and some are of plain silk or cotton, often embellished with rows of supplementary weft of gold- or silver-wrapped thread (fig. 5.25). The *dubalang* (guards for a *pangulu*) and some musicians wear red straight-legged trousers, sometimes ornamented with gold braid at the cuffs.

5.21 *Sarawa gadang* (chieftain's ceremonial trousers with low crotch). Cotton velveteen, gold braid. These trousers, of black velveteen with gold braid at the ankles, are worn with the *baju itam* illustrated in figure 5.2. Length 112 cm. FMCH X97.50.34b; private gift.

5.22 *Sarawa gadang* (man's ceremonial trousers with low crotch). Cotton, silk, *ramin*, gold-wrapped thread. The trouser legs have fine lines of bast fiber called *ramin* and wide bands of weft ikat. The crotch includes a piece of silk patterned with supplementary weft of gold-wrapped thread. Length 111 cm. FMCH X97.50.38; private gift.

5.23 *Sarawa gadang* (man's ceremonial trousers with low crotch). Silk, cotton, and gold-wrapped thread. The trousers were probably imported from the province of Aceh, in northern Sumatra, where Islam attained its first foothold in Indonesia, hence the Arabic style. A pink cotton band has been added at the waist to make the trousers long enough to reach just above the ankles. Length 112 cm. FMCH x97.50.39; private gift.

5.24 Man's cotton batik trousers, often worn to Muslim evening prayer and sometimes to adat ceremonies. Length 98 cm. Private collection.

5.25 *Calana* (man's ceremonial trousers). Silk and gold-wrapped thread. Worn with a *baju* of the type shown in figure 5.19. The cuffs of the trousers are patterned with supplementary weft of gold-wrapped thread. Length 110 cm. FMCH x97.50.41; private gift.

MEN'S CEREMONIAL DRESS

5.26 *Sisampiang* (man's ceremonial short tube skirt) from the village of Batu Sangkar. Silk and gold-wrapped thread. To the red and blue weft stripes of the ground cloth have been added bands of continuous supplementary weft of gold-wrapped thread and small emblems (called *bintang* or stars, even when they do not have a star shape) in discontinuous supplementary weft. The two narrow bands in the *kapalo* (literally, "the skirt's head"—the part with the principal pattern) have the "split peanut" motif discussed in chapter 7. Length 87 cm; circumference 189 cm. FMCH X93.25.100; collection of H. Elly Azhar and H. A. Sutan Madjo Indo.

5.27 *Sisampiang* (man's ceremonial short tube skirt) from the village of Batu Sangkar. Silk, *ramin*, and gold-wrapped thread. The checked pattern of the ground cloth is formed by using two different shades of red silk both in the warp and in the weft threads. The squares are further delineated by warp and weft stripes of bast fiber called *ramin*. The *kapalo* is patterned with supplementary weft of gold-wrapped thread. Length 86 cm; circumference 185 cm. FMCH X93.25.28; collection of H. Elly Azhar and H. A. Sutan Madjo Indo.

Short Tube Skirt (Sisampiang)

Male ceremonial dress includes a short tube skirt (*sisampiang*) covering the trousers from waist to knees and held in place by a belt (*ikek pinggang*). Preferably the *sisampiang* is red silk heavily embellished with gold supplementary weft (figs. 5.26–5.31), connoting the richness of the wearer's soul as he carries out his responsibilities. The "placement [of the *sisampiang* on the body] symbolizes that a *penghulu* puts the right thing in the right place, that he always follows adat and laws.... This sarong is red, symbolizing the bravery of a *penghulu*" (Manan 1984, 130). Because the circumference of the *sisampiang* is considerably greater than that of a man's waist, the cloth must be draped to fit snugly about the waist. After the wearer has put on the *sisampiang*, traditional draping calls for folding a pleat at the waist from each side to the center front. One pleat should hang longer than the other (fig. 5.32). The longer pleat signifies to the Minangkabau that the *pangulu* protects (covers) his family.

5.28 *Sisampiang* (man's ceremonial short tube skirt) from the village of Padang Magek. Silk, gold- and silver-wrapped thread. Red and blue weft stripes and continuous supplementary weft bands of gold- and silver-wrapped thread. The two narrow bands of silver-wrapped thread supplementary weft in the *kapalo* (head of the skirt) have stick figures representing "ducks going home in the afternoon," a motif discussed in chapter 7. Length 74 cm; circumference 194 cm. FMCH X93.25.33; collection of H. Elly Azhar and H. A. Sutan Madjo Indo.

5.29 *Sisampiang* (man's ceremonial short tube skirt) from the village of Batu Sangkar. Cotton and gold- and silver-wrapped thread. White cotton warp and weft stripes provide a checked pattern in the ground cloth. Thirteen bands of supplementary weft of gold-wrapped thread pattern the *kapalo* section, and rows of "stars" (*bintang*) of silver-wrapped thread fill out the pattern. Length 57 cm; circumference 166 cm. FMCH X93.25.24; collection of H. Elly Azhar and H. A. Sutan Madjo Indo.

MEN'S CEREMONIAL DRESS

5.30 *Sisampiang* (man's ceremonial short tube skirt) from the village of Batipuah. Silk, cotton, and gold-wrapped thread. Checks in the ground cloth are constructed by alternating stripes of red silk and blue cotton both in the warps and in the wefts, although warps in the selvage patterns and wefts in the *kapalo* are all red silk. The *kapalo* is patterned with supplementary weft of gold-wrapped thread. Length 56.7 cm; circumference 174.8 cm. FMCH X93.25.6; collection of H. Elly Azhar and H. A. Sutan Madjo Indo.

5.31 *Sisampiang* (man's ceremonial short tube skirt) from the village of Balai Cacang. Silk, cotton, and gold-wrapped thread. Warps and wefts are red silk with a few rows of blue cotton weft at each end. The *kapalo* (head of the skirt) is patterned with continuous supplementary weft of gold-wrapped thread, primarily with the "split peanut" motif. The remaining portion of the *sisampiang* is patterned with continuous and discontinuous supplementary weft, the latter mostly *bintang* (star) motif. Length 62 cm; circumference 226 cm. FMCH X97.50.4; private gift.

5.32 Group of Minangkabau attending a ceremony. The two men on the right wear *sisampiang* in the traditional manner, with one pleat or fold draped longer than the other, signifying that a man protects (shelters) his family. The man on the right wears a *kupiah* on his head, while his male companion wears a *saluak*. Limo Puluah Koto. 1989.

90 CEREMONIAL TEXTILES

5.33

5.34

5.35

5.33 *Ikek pinggang* (man's ceremonial waist tie) from the village of Pariangan. Silk, cotton, gold-wrapped thread. The warp ends (the only parts that show when the *ikek pinggang* is worn) are decorated with bands of different-colored wefts that are patterned with supplementary weft of gold-wrapped thread. The long tassels are braided and tufted. The center section (covered by other parts of the ceremonial costume), composed of a separate piece of white commercial cotton, was originally woven silk, which probably wore out from use. 428 cm (including fringe) x 33 cm. FMCH X93.25.41; collection of H. Elly Azhar and H. A. Sutan Madjo Indo.

5.34 *Ikek pinggang* (man's ceremonial waist tie) from the village of Pitalah. Silk, cotton, gold-wrapped thread. The warp ends (the only parts that show when the *ikek pinggang* is worn) are decorated with bands of different-colored wefts, which are patterned with supplementary weft of gold-wrapped thread. The long tassels are warps, braided along with white cotton thread and then tufted. 305 (including fringe) x 27 cm. FMCH X93.25.46; collection of H. Elly Azhar and H. A. Sutan Madjo Indo.

5.35 *Ikek pinggang* (man's ceremonial waist tie) from Limo Puluah Koto. Silk, cotton, silver-wrapped thread. The warp ends are patterned with bamboo shoot and tree-of-life motifs in supplementary weft of silver-wrapped thread. The long cotton tassels are braided and tufted. 296 (including fringe) x 41 cm. FMCH X97.50.25; private gift.

WAIST TIES OR BELTS (IKEK PINGGANG)

Some waist ties or belts in the Minangkabau heartland are 20 to 30 centimeters wide and 230 centimeters or more in length, often with long fringes on each end (figs. 5.33–5.35). Most are of cotton or silk patterned with supplementary weft of metallic-wrapped thread. Depending on length, this type of *ikek pinggang* is wrapped around the waist one or more times and tied at the left hip, the fringed ends flowing down the front and side of the left leg. The fringes, often in the form of braided tassels, depict bamboo shoots, said to represent the wearer's sisters' children. Wearing a waist tie signifies that the wearer has many ways to tie these nieces and nephews to the family and to educate them (Manan 1984, 130).

Ikek pinggang from the area just south and east of the Minangkabau heartland are markedly different in design and format. An example woven in the village of Silungkang is partially patterned in weft ikat (fig. 5.36). Another—from the village of Muaro Labuah, farther to the southeast—is patterned with supplementary weft both on the long panel on one end and on

MEN'S CEREMONIAL DRESS

5.36 *Ikek pinggang* (man's ceremonial waist tie) from the village of Silungkang. Silk, cotton lining, gold-wrapped thread. One end is patterned with blue and red weft-ikat diamonds. The other end is decorated with bands of supplementary weft. Plied ikat fringes have been added to each end. Weft-ikat cloths are rare in Minangkabau and, to the best of our knowledge, were and are made only in Silungkang. 233 (including fringe) x 26 cm. Collection of Robert J. Holmgren and Anita Spertus.

5.37 *Ikek pinggang* (man's ceremonial waist tie) from the village of Muaro Labuah, far to the south and west of the Minangkabau heartland. Silk, cotton, gold-wrapped thread. The warps are natural cotton. The ends are embellished with red silk supplementary weft, and the center section contains stripes of red silk weft and thin bands of black supplementary weft. 285 (including fringe) x 23 cm. FMCH X93.25.79; collection of H. Elly Azhar and H. A. Sutan Madjo Indo.

the short panel on the other. The motifs are reminiscent of those found on Dongson or Dongson-like drums, several of which have been excavated in the region (fig. 5.37).

Ikek pinggang in the village of Solok are much narrower (5 to 10 cm wide) but are at least as long as the belts in the *luhak nan tigo* and sometimes much longer. Some are woven in slit tapestry technique, with *songket* panels at the ends. Others are patterned with silver *songket* bands and motifs (figs. 5.38–5.41). Occasionally one also discovers a small band of red wool trade cloth incorporated into the end panels of such a belt (fig. 5.42). These belts are worn differently from those described above. The belt is wrapped around the waist but is tied so that an end falls down the front of each leg (fig. 5.43). This method of wearing the *ikek pinggang* can be traced to the early Hindu-Buddhist period in Sumatra, as evidenced by sculpture of that period (fig. 5.44).

Fastened to an unusual ikek pinggang from the village of Solok (fig. 5.45) is a 6-by-13-centimeter silver ornament that would be positioned at the center of the body of the wearer as the belt was worn to a ceremony. Onto the base of the ornament is affixed a pyramid crowned with a green stone. Both base and pyramid are of gilded silver, on the surface of which is added very fine elaborate silver filigree and granulation work. Motifs in the silver work include *aka cino* (a motif found on four-thousand-year-old megaliths in Limo Puluah Koto), *barantai* (a chain motif), and *tampuak manggih* (calyx of the mangosteen fruit). The ends of the belt are patterned in supplementary weft of silk and gold-wrapped thread. Fringes are added by sewing a short piece of red wool to each end of the belt and then attaching red silk fringe on one end and white silk fringe on the other. A ceremonial dagger (*karih*) with matching gilded and silver work (see fig. 5.60) is worn tucked into this belt.

A different type of ceremonial belt, possibly from the village of Batu Sangkar, is made of a heavy padded fabric into which are embedded

CEREMONIAL TEXTILES

5.38

5.39

5.40

5.38 *Ikek pinggang* (man's ceremonial waist tie) from the village of Solok. Silk, cotton, silver-wrapped thread. The belt is tapestry weave 10 centimeters wide. Only the central 5 centimeters of that portion of the belt contains wefts of silver-wrapped thread. The 2.5-centimeter section of each edge is folded back and sewn together at the selvages. At each end of the belt a section is patterned with supplementary weft, terminating in a small rectangle of silver-wrapped thread woven on a red silk background in an Indian pattern. The fringes are silver-wrapped thread. 319 (including fringe) x 10 cm (folded to 5 cm for wearing). FMCH X93.25.91; collection of H. Elly Azhar and H. A. Sutan Madjo Indo.

5.39 *Ikek pinggang* (man's ceremonial waist tie) from the village of Solok. Silk, cotton, silver-wrapped thread, silver. The ends are patterned with silver-wrapped thread and silk supplementary weft and silver chains holding small, thin silver leaves. The center contains a series of stripes and bands of supplementary weft of silver-wrapped thread on black ground thread. 327 x 18 cm (folded to 9 cm for wearing). FMCH X93.25.89; collection of H. Elly Azhar and H. A. Sutan Madjo Indo.

5.40 *Ikek pinggang* (man's ceremonial waist tie) from the village of Solok. Silk, cotton, silver-wrapped thread. The center portion of the belt is patterned with lines and small motifs in continuous and discontinuous supplementary weft of silver-wrapped thread on black weft ground thread. Ends are patterned with silk and silver-wrapped thread supplementary weft, bounded by a repoussé strip ornamented with red and blue glass beads. Silver chains holding small silver leaves constitute the fringe on each end. 319 (including fringe) x 18 cm (folded to 9 cm for wearing). FMCH X93.25.90; collection of H. Elly Azhar and H. A. Sutan Madjo Indo.

pieces of mica or of mirror and couched patterns of gold-wrapped thread. The belt is closed with a large buckle, sometimes of niello (fig. 5.46), sometimes of silver or gold.

Less frequently seen is a man's silver ceremonial belt (fig. 5.65, left). It is made up of a series of rectangular embossed silver pieces with a number of small silver chains connecting adjacent rectangular pieces.

MEN'S CEREMONIAL DRESS

5.41 *Ikek pinggang* (man's ceremonial waist tie) from the village of Solok. Cotton, silver-wrapped thread, silver. This mostly black and silver-wrapped thread belt is woven 16.6 centimeters wide but is patterned with metallic thread only on the 8.3-centimeter central section. The edges are doubled back and seamed together. Design elements in the center are done in slit tapestry weave. End panels are decorated in supplementary weft. Fringes of silver chains at each end of the belt terminate in folded thin silver sheet ornaments. 396 (including fringe) x 16.6 cm (folded to 8.3 cm for wearing). FMCH X97.50.35; private gift.

5.42 *Ikek pinggang* (man's ceremonial waist tie) from the village of Solok. Silk, cotton, wool, silver-wrapped thread. This *ikek pinggang* is woven 17.2 centimeters wide, folded in half, and stitched to join the two selvages. The end panels are patterned with supplementary weft of silver-wrapped thread. Strips of red wool are wrapped around and sewn to the ends of each of those folded panels. Fringes are red silk and silver-wrapped thread. 360 (including fringe) x 17.2 cm. (folded to 8.6 cm for weaving) FMCH X93.25.88; collection of H. Elly Azhar and H. A. Sutan Madjo Indo.

5.43 A man from the village of Solok en route to a ceremony. His belt (*ikek pinggang*) is tied around his waist with an end falling down the front of each thigh. Note the similarity between this method of wearing a belt and that shown in the adjacent illustration of a sculpture produced during the Hindu-Buddhist period in Sumatra (fig. 5.44). 1989.

5.44 Fourteenth-century Javanese sculpture of Bhairava or Mahakala. Volcanic stone (andesite). Note the way the belt ends fall down the front of each thigh and compare with the way the man from Solok shown in figure 5.43 wears his belt. This sculpture was made at the height of the Majapahit kingdom, whose influence was strongly felt through much of Java and Sumatra, including the Minangkabau region. Similar sculptures have been found in West Sumatra and Jambi. (For more on this sculpture, see Fontein 1990, 167, 168.) 198 cm. Museum of Fine Arts, Boston; Frederick I. Jack Fund, 1972.951.

5.41

5.42

5.43

5.44

94 CEREMONIAL TEXTILES

5.45 *Ikek pinggang* (man's ceremonial waist tie) from the village of Solok, worn with the ceremonial dagger illustrated in figure 5.60. Silk, cotton, wool, gold-wrapped thread, silver, gilded silver. The belt has paired white silk warps and wefts of white, red, and black cotton. End panels are patterned with supplementary weft of gold-wrapped thread and red silk. The fringe, red silk on one end and white silk on the other, is sewn to a short piece of red wool fastened to the end of the belt. The 6-by-13-centimeter gilded ornament with gilded pyramid is heavily patterned in silver filigree and granulation with motifs that appear on ancient megaliths and are commonly found woven into textiles and carved on houses. 346 (including fringe) x 12 cm (folded to 6 cm for wearing). Private collection.

5.46 *Ikek pinggang* (man's ceremonial waist tie), probably from the village of Batu Sangkar. Cotton, mica, gold-wrapped thread, silver, niello. The belt is padded and quilted black cotton, couched with patterns of gold-wrapped thread and embellished with mica rounds. The buckle is niello. Belt: 69 x 13 cm (maximum width). Buckle: 19 x 11.4 cm (maximum width). Private collection.

MEN'S CEREMONIAL DRESS

5.47 This photograph shows one way of wearing a *salendang* (shoulder cloth). The man, from the village of Tanjung Sungayang, is dressed for a ceremony in a short tube skirt (*sisampiang*) held in place by a belt (*ikek pinggang*), into which is tucked a ceremonial dagger (*karih*). 1986.

5.48 The man in white (with back to camera) and the chieftain (*pangulu*) on the right (with head bowed down) are wearing *salempang* (shoulder cloths), closed tubular textiles folded in half along the warps. They have put the *salempang* on over the right shoulder. The cloth drapes across the chest and the back; the end of the loop falls below the left hip. Balingka. 1989.

Shoulder Cloths
(Salendang and Salempang)

A *salendang* is a rectangular textile approximately 60 centimeters wide by 220 centimeters long. It is usually folded in half (sometimes in quarters) lengthwise and draped over a shoulder in various ways (fig. 5.47). A *salempang* is a tubular garment also folded in half along the warp, its long dimension. The wearer steps into it or puts it on over his right shoulder and allows it to drape diagonally across his body (fig. 5.48).

It is thought that originally each village had its own way of wearing a ceremonial shoulder cloth. These differences in the way shoulder cloths are worn make it possible at a ceremony to identify the region from which a man comes (for examples of village-specific dress, see table 1). Regional variation in the way shoulder cloths are worn reflects a long history of isolated, independent villages or village regions, which the Dutch, in their frustration at trying to govern the Minangkabau in a unified way, called "village republics." That ceremonial dress should be found to be village- or region-specific comes as no surprise when it is remembered that the adat that governs ceremonies varies in some aspects from village to village. Textiles themselves and women's headdresses that are folded from some of these textiles are also village-specific in design

5.49 A group of men at a Minangkabau ceremony in Limo Puluah Koto. The variety of their costumes suggests that they are not all from the same village. 1989.

96 CEREMONIAL TEXTILES

5.50 Except for the musicians in the background, most of the men at this ceremony appear to be from the same village, Solok, despite some differences in one or two aspects of their attire. Limo Puluah Koto. 1989.

TABLE 1: EXAMPLES OF HOW EACH TYPE OF SHOULDER CLOTH IS WORN[5]

VILLAGE REGION	SALENDANG	SALEMPANG	NECK SCARF
Batipuah	On left shoulder, ends fall front and back		
Sungayang	On right shoulder (fig. 5.53), ends fall front and back		*Patola* (fig. 5.54), once around neck, ends fall front and back from left shoulder
Limo Puluah Koto	Once around neck, ends fall down chest from each shoulder		
Padang Magek	Once around neck, ends fall front and back from left shoulder	Encircling body from right shoulder to left hip	
Lintau	Around back of neck, ends fall down chest from each shoulder		
Solok	Loosely draped around neck, one end falls down back from right shoulder, other end falls down front from right shoulder to left hip		
Agam		Encircling body from right shoulder to left hip	
Coastal		Encircling body from right shoulder to left hip	

MEN'S CEREMONIAL DRESS

and format. (For a full discussion of women's ceremonial dress, see chapter 6.) Today, however, usage has become less rigid (figs. 5.49, 5.50).

At weddings in the village of Koto Gadang, the uncles of the groom place upon his shoulder seven special shoulder cloths called *tarewai* (fig. 5.51). Some have a decorated panel along each warp end; some are wholly covered with gold and silver patterns of *songket*. The textiles are not given to the groom but are lent for the ceremony as a sign of respect. If a family cannot afford to own seven *tarewai*, the tradition is honored by sewing seven bands of lace trim to the ends of a single *tarewai* (fig. 5.52).

In the village of Batu Sangkar a special shoulder cloth is given to a *pangulu* at the time of his inauguration as a chieftain. He wears this *salendang* to ceremonies as a sign of rank. When he dies, it is used as a shroud to cover his casket. After his burial the shroud is stored by the family until the next *pangulu* is inaugurated, at which time the textile is bestowed upon the new chieftain and the cycle is repeated.

Some *salempang*, especially those from the village of Batipuah, were woven of cotton warps that had been starched to facilitate the weaving. After the *salempang* was woven, the starched cotton was rubbed with a shell, giving the fabric a shiny, polished surface resembling chintz (fig. 5.55).

The form of a shoulder cloth "suggests that it could be used to absorb sweat and to wrap things, symbolizing industriousness and the ability to settle disputes" (Manan 1984, 130). It is also said to show "that the *penghulu* is fully equipped to carry out the adat" (Bahar 1993, 100).

5.51 *Salendang tarewai* (man's shoulder cloth) from the village of Koto Gadang. Silk, gold-wrapped thread. Patterned by supplementary weft of gold-wrapped thread. The large figured herbal and bird patterns are unusual in Minangkabau ceremonial textiles and demonstrate European and Indian influence. 197 x 59 cm. FMCH x93.25.58; collection of H. Elly Azhar and H. A. Sutan Madjo Indo.

5.52 Detail of *salendang tarewai* (man's shoulder cloth) from the village of Koto Gadang. Cotton, gold-wrapped thread, lace. This shoulder cloth is a substitute for the seven *tarewai* traditionally placed on the shoulder of a groom by his uncles. Here seven different lace bands are sewn to the ends of the *tarewai* to simulate seven separate textiles. Private collection. 1985.

5.53 *Salendang* (man's shoulder cloth) from the village of Tanjung Sungayang. Silk, cotton, gold-wrapped thread, sequins. The *salendang* is patterned with continuous supplementary weft of large diamond motifs of gold-wrapped thread across a weft band at each end section. Stars and other small motifs are woven in discontinuous supplementary weft of gold-wrapped thread on other parts of each end section. Rows of sequins were added to the weft patterning. Warps are indigo-dyed cotton, except for the red silk selvage bands and the two smaller lines of red silk warps. The white warp and weft lines that make up small square patterns are cotton. 199.5 (including fringe) x 59.4 cm. FMCH X93.25.55; collection of H. Elly Azhar and H. A. Sutan Madjo Indo.

5.54 *Patola*. Silk ikat. The *patola* was introduced at first by Indian traders and later by the English and Dutch and became highly treasured by many different ethnic groups in Indonesia. It is now accepted by the Minangkabau as an adat garment and is sometimes worn as a neck scarf by men at ceremonies. 235 x 88 cm. FMCH X97.50.42; private gift.

5.55 *Salempang* (man's ceremonial shoulder cloth) from the village of Batipuah. Silk, cotton, gold-wrapped thread. A *salempang* is worn folded along its center seam by placing the tube over the head, resting the textile on the right shoulder, and letting the tube fall across the chest and back. The lower end will fall at or below the left hip. The *kapalo* is patterned with supplementary weft of gold-wrapped thread. The surface of the textile was rubbed with a shell to polish the starch that was added to the cotton thread to facilitate the weaving. As a result, the surface is shiny. 197 x 89 cm. FMCH 93.25.2; collection of H. Elly Azhar and H. A. Sutan Madjo Indo.

MEN'S CEREMONIAL DRESS

5.56 Man's ceremonial leather sandals (*tarompa*) with black velveteen straps decorated with gold beads and gold-wrapped thread. FMCH 97.50.6 a,b; private gift.

5.57 Man's ceremonial leather sandals (*tarompa*) with maroon velvet straps decorated with gold beads. FMCH 97.50.26a,b; private gift.

5.58 Chieftain (*pangulu*) with a short ceremonial dagger (*karih*) tucked into his belt. Traditionally it should lean to his left so that he will have to move it to the right in order to remove it, giving him time to consider whether using the *karih* is wise or necessary. 1995.

Ceremonial Dagger (Karih)

The ceremonial dagger—or kris, as it is called in much of the Malay world—is not so much a weapon as it is a symbol of the power and prestige of the *pangulu*, who wears it tucked into his belt leaning to the left (fig. 5.58). If he feels the need to use it, he must turn it to the right to grasp the handle, thus giving him time to think about whether it is really necessary to use it. It is said that a *pangulu* "should think at least twice before doing or deciding anything, because his decisions are a model for others" (Manan 1984, 135). The *karih* "symbolizes the *penghulu* as a leader skilled in strategy and tactics" (Bahar 1993, 100).

Some Minangkabau believe that a kris has magic powers, that spirits occupy the weapon, and that it must be treated with respect and be "fed." If two occupied krises are left alone together, they may fight. One Sumatran

Sandals (Tarompa)

For some ceremonial occasions, men wear leather sandals with leather thongs and one-inch heels (figs. 5.56, 5.57), "symbolizing that a *penghulu andiko* has the means to walk to visit all his sisters' children to check on their condition and situation" (Manan 1984, 137). It is also said that "its peculiar form and function, as a base on which he stands, symbolizes the clear base of his actions" (Bahar 1993, 100). *Tarompa* are sometimes made with textile uppers that match one of the ceremonial garments that the man is wearing.

CEREMONIAL TEXTILES

5.59

5.60

5.61 above, 5.63 below

5.62

museum curator reported that he developed a severe headache after removing from its sheath one of his museum's krises, which was said to be occupied by a spirit (Carda Amin, conversation with author, 1986).

Kris handles are often made of gold or silver or of elaborately carved bone, ivory, or wood embellished with gems (figs. 5.59, 5.60, 5.65). One handle shape frequently found in West Sumatra is the figure of a man, Cipaduik, a human figure portrayed with only one arm (figs. 5.61, 5.62). He is in a crouching position with his arm held diagonally across his chest. Many different impressions of the character of Cipaduik have been reported; most see him as a person who likes to play tricks on others.

Some *karih* handles are carved to look like a bird with a large beak (fig. 5.63), and Frey wondered "whether it is indeed an aspect of the Hindu bird-god Garuda, carrier of Vishnu" (1988, 50), another relic of Sumatra's Hindu-Buddhist past.

5.59 Elaborately formed gold handle or hilt of a ceremonial dagger (*karih*) in the collection of the raja of Si Guntur. 1994.

5.60 Man's ceremonial dagger (*karih*) from the village of Solok, worn tucked into the belt illustrated in figure 5.45. Silver, gilded silver, wood. The spherical portion of the hilt and the front of the fitting that separates the hilt from the blade were made of gilded silver, over which was fastened intricate silver work of filigree and granulation. The sheath is silver with repoussé and granulation work. As if to emphasize the fact that the *karih* is a ceremonial dagger rather than a fighting implement, this *karih* has a wooden blade. Private collection.

5.61 Man's ceremonial dagger (*karih*) with ivory handle (illustrated in fig. 5.62) and metal sheath. The top of the sheath is formed in repoussé silver, while the bottom is covered with silver twined with hair plucked from the tail of a horse. Three bands of gold granulation—one at the bottom of the handle, one joining the two halves of the sheath, and one separating the lower part of the sheath from an ivory tip—form the remainder of the decoration. Private collection.

5.62 Carved ivory handle or hilt of the ceremonial dagger (*karih*) illustrated in figure 5.61. The hilt is in the form of a one-armed man named Cipaduik, depicted in a crouching position. There are many legendary stories about Cipaduik's behavior; most Minangkabau think of him as a man who liked to play tricks on people. Because his face is pointed, his figure has been misinterpreted as that of a bird.

5.63 Ceremonial dagger (*karih*). The highly stylized bird on the ivory hilt is thought to represent Garuda, the Hindu bird god who carried Vishnu. The sheath is also ivory, the straight portion of which is covered with intricate repoussé and filigree gold sheeting. 35.24 x 12 x 9 cm. The Glassell Collection.

MEN'S CEREMONIAL DRESS

5.64 Man's ceremonial bag (*uncang siriah*) for carrying betel leaves (*siriah*) to a ceremony. Cotton, silk, gold-wrapped thread, silver. *Siriah* is offered as a greeting or welcoming to a ceremony. It also encloses the ingredients of a betel quid, often chewed at ceremonies. The bag is couched with gold-wrapped thread. Attached to it with a silver chain are a number of small ornaments, Muslim token tools for ensuring cleanliness. They are called *sapik jangguik* (literally, "bearded claws"). 71 x 28.2 cm (maximum width). FMCH 93.25.93; collection of H. Elly Azhar and H. A. Sutan Madjo Indo.

OTHER CEREMONIAL ACCOUTREMENTS

For some ceremonies, men may carry a bag (*uncang siriah*) made of cloth that has been elaborately decorated with couched gold thread (fig. 5.64). The bag is further decorated with a set of silver ornaments called *sapik jangguik* (literally, "bearded claws"). The bag is used to carry *siriah*, the leaf of the betel pepper vine, which is offered to guests at ceremonies, as an invitation to a ceremony, and as a welcoming greeting at important events. *Siriah* is also the leaf used to wrap the ingredients of a betel quid, a common accompaniment to Minangkabau ceremonies.

Men and women both carry tobacco boxes (fig. 5.65, lower right corner) for ceremonial use in conjunction with chewing *siriah* leaves or betel quid. These ornamental silver or gold pieces consist of two small, nearly spherical hinged boxes, the larger of which contains tobacco and the smaller of which contains slaked lime. Some believe that chewing tobacco will prevent staining of teeth that results from chewing betel. Lime is added to the betel quid to produce saliva.

A *pangulu* often carries a set of token Islamic tools for cleanliness. Sometimes these are fastened to the man's bag (*uncang siriah*), sometimes to the end of a *salendang*, and sometimes suspended from a silver chain that may be worn around the waist (fig. 5.65). A Muslim must cleanse himself before he prays. Carrying these token tools signifies to the Minangkabau that the *pangulu* "is fully equipped to carry out the adat" (Bahar 1993, 100).

A *pangulu* also carries a cane (*tungkek*) of black wood with handle of silver or gold. The *tungkek* is a symbol of authority, and the gold or silver stands for the wealth of his lineage (Manan 1984, 135). It may also be used for support or, if need be, as a weapon.

COMBINATIONS OF COSTUME ELEMENTS FOR PARTICULAR CEREMONIES

Selection of the specific variety of each costume element depends on the type of ceremony at which it will be worn and on the role the wearer plays in that ceremony. On the first day of his wedding ceremony, for example, a groom may wear a *saluak*, *baju*, *sarawa*, *sisampiang*, *ikek pinggang*, and *salendang*, all of cotton or silk embellished with supplementary weft of gold-wrapped thread. On a subsequent day of the ceremony, however, he may change to Western-

style shirt, tie, and jacket but retain the *saluak*. Other male participants may wear straight-legged trousers, Western-style open-neck shirt and jacket, and a cotton plaid *salempang*; a *kupiah* may replace the *saluak*.

Even as the adat often differs from village to village, so may the prescribed adat dress differ. Ng (1987, 178) notes that in the village of Koto nan Gadang, for example, men who have gone on the *haj*, the Muslim pilgrimage to Mecca, may participate in adat ceremonies but may not wear adat costume to the ceremonies.

Minangkabau men's ceremonial dress is extremely varied. Not only are there different styles for some of the garments—such as hats, trousers, shirts, and belts—but there are differences from village to village in the way some items of clothing are worn. The ways garments are folded or draped make specific visual statements about Minangkabau beliefs and cultures. The textiles of these garments are themselves very different from one another; some are predominantly black, while others shine with reflections from gold thread. And, as described in chapter 7, motifs woven into the textiles may be village-specific, resulting in a variety of design patterns in the weavings. A large ceremony that draws men from different villages provides a panorama of colors and styles, which, during ceremonial processions, offers a true walk in splendor.

5.65 Set of chieftain's ceremonial accoutrements, including (from left to right): (1) man's silver belt consisting of seven embossed silver pieces with several silver chains connecting adjacent solid pieces and a silver buckle; (2) set of token Islamic tools for cleanliness, referring to the practice of washing before prayer; (3–5) three ceremonial daggers (*karih*) of different sizes; (6, bottom right) large niello belt buckle similar to that shown in figure 5.46; and (7, above 6) a tobacco box and lime container. 1996. Collection of H. A. Sutan Madjo Indo.

MEN'S CEREMONIAL DRESS 103

Anne Summerfield

6

WOMEN'S CEREMONIAL DRESS AND RELATED CEREMONIAL TEXTILES

In cultures around the world dress is used to express identity, social position, and the wearer's wealth and to give insight into a culture's values and beliefs. Minangkabau ceremonial dress is especially rich among world cultures in its expression of values and beliefs, as was seen in the preceding chapter on men's ceremonial wear. Women's dress is considerably more varied than men's. Except in the case of headdresses, the garments' relation to adat appears to lie mainly in the motifs that embellish them, not in their structure or folds.

THE STRUCTURE OF MINANGKABAU WOMEN'S CEREMONIAL COSTUME

The most spectacular part of a Minangkabau woman's ceremonial dress is a soaring, gold-resplendent headdress. When the headdress is made of metallic gold, silver gilt, or even gilded brass, the wearer appears adorned as a queen (fig. 6.2). Equally regal is women's headwear made of ornately embellished textiles folded and draped into complex shapes (fig. 6.3). The visual impact of this headwear in a ceremonial procession is stunning (fig. 6.4). The size and splendor of women's ceremonial headwear proclaim the importance of the role of women in this matrilineal culture.

Three additional basic elements of women's ceremonial dress are also made of decorated cloth: the tunic, called a *baju kuruang*, or "enclosing" blouse, because it has no opening down the front and must be put on over the head (fig. 6.5); the skirt or *saruang*, which is sometimes village specific, sometimes imported (fig. 6.6); and the shoulder cloth (fig. 6.7), or *salendang*, which in the nineteenth century was usually village specific and which today often carries characteristics of the wearer's village, although the cloth itself is usually produced elsewhere.

Accessories include backless shoes of the type known as mules or slides, today often made of fabric to match a *saruang* (fig. 6.8); purses for carrying *siriah* (fig. 6.9), the leaf of a climbing pepper vine (*Piper betle*); and adat-prescribed jewelry, including earrings, necklaces, bracelets (see chapter 12 for a discussion of Minangkabau ceremonial jewelry); and sometimes belts. Often a silver or gold and silver tobacco box (*salapah*), ornamental enough to be considered a piece of jewelry, is carried to ceremonies (figs. 6.10, 6.11). The *salapah* may contain shredded "betel" nut (nut of the areca palm) and slaked lime as well as tobacco. It is alleged that wiping the teeth with tobacco prevents them from becoming stained from chewing the betel quid.

OPPOSITE:
6.1 *Kain tangkuluak*, a textile for tying the traditional Pariangan headdress. Silk, cotton, gold-wrapped thread. A typical cloth with supplementary weft pattern bands and no selvage border patterns. The patterned end panel in this textile is unusually long, measuring 72 centimeters. 272 x 70 cm. FMCH X93.25.45; collection of H. Elly Azhar and H. A. Sutan Madjo Indo.

6.2 A bride from the town of Payakumbuh, in the regency of Limo Puluah Koto, standing in the marriage alcove (*palaminan*) set up for her wedding in her matrilineage home. She wears the Chinese-influenced *suntiang*, a bridal headdress. It is traditional to treat brides and grooms as queens and kings during the days of their marriage ceremony. 1988.

6.3

6.5

6.3 Women from the village of Pariangan, in the regency of Tanah Datar, en route to a ceremony wearing the traditional Pariangan headdress folded from silk textiles embellished with supplementary silk and gold-wrapped thread. 1985.

6.4 Women from the town of Solok assembling for the start of a ceremonial procession during the dedication of a palace in Limo Puluah Koto in 1989. They carry on their heads huge cones of ceremonial yellow rice and footed brass bowls (*carano*). The bowls are filled with ingredients for betel quid and are covered with elaborate embroidered cloths.

6.5 Attendants and friend at a renewal-of-vows ceremony in Bukittinggi wearing traditional *baju kuruang* from Agam or Tanah Datar. The materials from which the *baju* are made are (from left): embroidered Chinese silk, velvet with attached gold-colored metallic pieces, and unembellished silk. 1985.

6.4

106 CEREMONIAL TEXTILES

6.6 *Saruang* (skirt), imported from Palembang into Minangkabau. Silk weft ikat and supplementary weft of gold-wrapped thread. During the height of its dominance of Sumatran trade several centuries ago, the Minangkabau monarchy received tribute from many other regions of the island of Sumatra. Fine woven textiles from southern parts of the island were imported into the heartland, creating a market for garments woven especially in and around the south Sumatran town of Palembang, alleged to have been the center of a great Buddhist kingdom, Srivijaya (c. 600–1400 C.E.). Today Palembang garments are valued pieces in Minangkabau family collections of heirloom textiles. 220 x 105 cm. Private collection.

6.7 *Salendang* (shoulder cloth) from the village of Koto Gadang. Silk, gold-wrapped thread. A *salendang* is one of the most visible parts of a Minangkabau woman's ceremonial costume. It is usually elaborately decorated and very finely woven. The way a shoulder cloth is worn in some other villages may convey the age and marital status of the wearer. When heavily decorated with gold-wrapped thread, a shoulder cloth may indicate that the wearer comes from a wealthy family. 129 x 55 cm. FMCH x93.25.59; collection of H. Elly Azhar and H. A. Sutan Madjo Indo.

6.8 *Sapatu* (women's shoes). Leather, cotton embellished with supplementary weft of gold-wrapped thread. Ceremonial shoes as well as shoes worn every day are often of the type pictured here: mules or slides. Because one must remove one's shoes before entering a Minangkabau house, this type of shoe is preferable to a pump. Today it is considered fashionable and correct for a woman's dress shoes to match or at least nearly match her ceremonial *saruang*. Private collection.

6.9 *Uncang siriah* (ceremonial purse) for carrying betel leaves (*siriah*) to ceremonies. Cotton, couched gold-wrapped thread, nineteenth-century Dutch copy of an Indian cotton print, wood, wool, silver. A woman inviting a friend or relative to be her guest at a ceremony would typically extend a leaf from such a purse to the invitee, who in turn would break off and take a small piece of the leaf to indicate that she accepted the invitation. The purse is elaborately accessorized. Its drawstring consists of a square, hand-forged silver chain, attached to which are two sets of Islamic token tools for maintaining cleanliness, including a nail file, earwax reamer, pincers for pulling whiskers, and toothpick. There is also an attached multilevel dangle made of wooden disks covered with fine imported red wool, a fabric just as prestigious as the print that bands the top of the purse. The red wool-covered disks are hung with silver chains that end in silver leaf-shaped ornaments. A purse almost identical to this is in the national collection of treasures on view by appointment at the rajah's palace at Si Guntur, now a museum in the Sawahlunto/Sijunjung regency. FMCH x97.50.66a,b; private gift.

WOMEN'S CEREMONIAL DRESS AND RELATED CEREMONIAL TEXTILES

6.10 A Minangkabau bride from the village of Sungai Puar, in the Agam regency, in a photograph originally published in 1920. The young woman carries a tobacco box in her left hand as part of her ceremonial wedding ensemble. Her enormous repoussé bracelets are village specific. Courtesy of the Yayasan Dokumentasi dan Informasi Kebudayaan Minangkabau.

6.11 *Salapah* (tobacco box). Gold, silver. The *salapah* may be carried by either men or women. It contains shredded areca nut, slaked lime, and tobacco; the first two items are part of the betel quid, which may be chewed during ceremonial rituals; wiping the teeth with tobacco is alleged to prevent stains that commonly result from chewing betel. The chain joining the two containers in this *salapah* is a late replacement. Private collection.

6.12 This mid-twentieth-century photograph, which shows Minangkabau matrons in Agam and Tanah Datar ceremonial dress, illustrates how the shoulder cloth and jewelry partially obscure the tunic, or *baju*. Courtesy of the Yayasan Dokumentasi dan Informasi Kebudayaan Minangkabau.

THE ENCLOSING TUNIC OR BLOUSE (BAJU KURUANG)

Baju from Agam and Tanah Datar

In Agam or Tanah Datar the *baju*, or tunic, may be the least conspicuous element of a woman's costume when a shoulder cloth is also worn. Partly covered by an elaborately decorated shoulder cloth and by jewelry, the often relatively undecorated *baju kuruang* provides two blocks of color and adds a sense of richness to the overall ensemble (fig. 6.12). When a shoulder cloth is not a part of ceremonial attire, decoration of the tunic often mimics that of the *saruang* (fig. 6.13). The currently fashionable matching "sets" of ceremonial *saruang* and *salendang* are not known to have been common in the past.

Some tunics appear to have been made from shoulder cloths (figs. 6.14, 6.15). Whether this was occasioned by excessive wear that left a particular shoulder cloth no longer suitable for its original ceremonial role is not known. Several Minangkabau men's ceremonial shirts also appear to have been made from *salendang* (see fig. 5.17), suggesting that at least during World War II, when thread was not available, badly worn heirloom textiles were restructured to add to the dwindling store of ceremonial costume elements. Not all women's tunics were handwoven in Minangkabau. *Baju* were also made from imported cloth such as Chinese silk damask (figs. 6.16, 6.17). Although highly popular in Agam and Tanah Datar, such garments were initially not accepted as adat but were later approved for ceremonial use.

ELEMENTS OF WOMEN'S CEREMONIAL DRESS

What follows are discussions and illustrations of women's ceremonial garments from five regencies in the West Sumatran highlands. These textiles range in date from around the late eighteenth century to the late twentieth century. Minangkabau weavings have been published only rarely in the West. A conscious effort has been made here to select for publication a representative group of Minangkabau women's ceremonial textiles from the collection at the UCLA Fowler Museum of Cultural History. A few pieces from other collections are included as well.

108 CEREMONIAL TEXTILES

6.14 A Minangkabau woman's ceremonial tunic, or *baju*, apparently made from a shoulder cloth similar to that shown in figure 6.15. Silk, cotton lining, gold-wrapped thread. Length: 98.3 cm. Private collection.

6.15 Detail of *kembang cino*, an older shoulder cloth from the village of Batu Sangkar. Silk, gold-wrapped thread. The small motifs in the body of the textile are called *bintang*, or stars. They may also represent the scattering of Minangkabau villages throughout the highlands. Compare this shoulder cloth to the cloth of the woman's ceremonial *baju* in figure 6.14. 163.3 x 44.5 cm. The Textile Museum, Washington, D.C., no. 1985.57.9, Collector: Mary Hastings Bradley, Donor: Alice Bradley Sheldon.

6.13 A young Minangkabau woman in ceremonial dress made in Saniang Baka for use in the village of Batipuah, in Tanah Datar. There is no shoulder cloth to obscure the tunic, which is embellished with couched silver-wrapped thread to match the skirt. 1993.

WOMEN'S CEREMONIAL DRESS AND RELATED CEREMONIAL TEXTILES

6.16 A tunic, or *baju*, from the village of Koto Gadang. Silk damask, braid of gold-wrapped thread. The upper sleeves of this woman's tunic are trimmed with appliquéd gold braid. This trim is characteristic of silk damask tunics from Koto Gadang. Length 90.2 cm. FMCH x97.50.86; private gift.

6.17 Woman's ceremonial tunic. Chinese silk damask. This tunic may be worn with many different ceremonial costumes because it has no unique motifs or other trim that would link it to a specific village. Length 97.6 cm. FMCH x97.50.9; private gift.

OPPOSITE:
6.18 The longer *baju kuruang*, or tunic, typical in Limo Puluah Koto is worn by the woman in the center of the photograph. The woman on the left is wearing the Javanese-originated *kabaya*, a long blouse that opens in the front and is traditionally pinned shut with three silver or gold jeweled pins fastened on a chain. The woman on the right is wearing a contemporary matched *baju* and skirt, which are not traditional ceremonial wear. The women, walking along a village road en route to a wedding, carry gifts of food on their heads. 1990.

Baju from Limo Puluah Koto

Tunics from Limo Puluah Koto are generally longer and form a more visible part of the costume (fig. 6.18) than those discussed above. Early reports indicate that in Limo Puluah Koto much of the clothing was made from imported commercial yardage (Dobbin 1983, 30). Today the Limo Puluah Koto tunic is usually made of one of four types of cloth: velvet or velveteen, sometimes embellished by a strip (*minisia*) woven with metallic thread and sewn at the hem (worn by girls aged twelve to fifteen, young women, or new brides); yardage trimmed overall with appliqué, usually light-colored; sateen, worn by older women, especially if it is black; and silk, either shantung or other Chinese silk. Gold-embellished handwoven *baju* still exist in some family heirloom textile collections.

THE SKIRT (SARUANG)

The Minangkabau ceremonial *saruang* is a skirt that is either tubular in form or consists of a rectangular piece of cloth that wraps around the hips. It extends from waist to ankles. Most such skirts are considerably larger than the circumference of the wearer's body and are made to fit by being pleated or folded so that walking is not inhibited by the garment's tightness.

Skirts from Agam

Two *saruang* made in Agam, at Koto Gadang, illustrate the fineness of weaving for which that village was known. One is completely covered with especially finely executed motifs in gold-wrapped thread on a silk ground (*balapak*; fig. 6.19). Most motifs in this textile are executed with pattern wefts that are single strands of gold-wrapped thread. What appears as a brighter area is the *kapalo*, or "head," of the skirt. It is woven with pattern wefts that are doubled strands of gold thread, thus making the *kapalo* motifs appear more densely gold than those in the body of the textile. The silk ground warps in this *saruang* are arranged as stripes of alternating colors, a subtle patterning that was once unique to Koto Gadang (fig. 6.20). Permanent creases, or fold lines, can be seen along the length (warp) of this textile, indicating that, although patterned as a *saruang*, it was folded and worn for a substantial amount of time as a shoulder cloth or, in some village other than Koto Gadang, as a headdress. (Koto Gadang women traditionally wear veils as headdresses.)

The second *saruang* from Koto Gadang is named after the small, separate figures of mangosteen blossoms (*bunga manggih*) woven into the body of the cloth (fig. 6.21). The format of this *saruang* is unique to Koto Gadang. Several variations of the skirt were made, differing mainly in the shapes of the small figures. Two of these skirts, for example, are called *sisiak ikan* (fish scales) and *sisiak tanggiliang* (anteater scales). The names are based on Minangkabau adat sayings such as "One looks in vain for scales on a catfish" (a fish known not to have scales), which might be more freely translated as "Don't go to a pauper for a handout," an admonition to direct one's behavior judiciously.

6.19 An especially fine *saruang* completely covered with motifs of gold-wrapped thread (*balapak*). Silk, gold-wrapped thread. An outstanding example of the great skills of Koto Gadang weavers, this gold-covered skirt is woven with only one or two threads per pattern stick (see chapter 8 for a discussion of weaving techniques), an extremely time-consuming process rarely used today. The work is so fine that in a full day at the loom a weaver could complete only three to five centimeters of cloth. Full-length creases in the metallic thread in this skirt indicate that, although formatted as a skirt, it may have been folded and worn as a shoulder cloth. 189.2 x 73.7 cm. FMCH X97.50.79; private gift.

6.20 Reverse side of *saruang* in figure 6.19. Warps in the ground fabric of this skirt are formatted as stripes of two alternating colors, which is characteristic of some weavings from the village of Koto Gadang.

6.21 Woman's ceremonial *saruang* (*bunga manggih*), from the village of Koto Gadang. Silk, gold-wrapped thread. The format of this textile is unique to Koto Gadang. It consists of a major panel with one selvage band of red silk and gold-wrapped thread and a field of small, closely set repeating motifs of gold on a purple silk ground. A separately attached bottom band is finely woven with motifs unique to Agam. To make the finished skirt long enough to reach the ankles, the handwoven textile is sewn to a width of other cloth at the waist. The *baju kuruang* conceals this added cloth when the complete costume is worn. Several different versions of this skirt were made. The differences occur mostly in the small motifs in the body of the textile. The small images here represent blossoms of the mangosteen tree (see chapter 7 for the significance of this motif). 142 x 82.3 cm. FMCH X97.50.78; private gift.

CEREMONIAL TEXTILES

6.22

6.24

6.22 Beautifully designed and woven *saruang* from the village of Pandai Sikek. Silk, gold-wrapped thread. The skirt, made before the start of World War II, was rolled up, placed in a large section of bamboo, and hidden during the war to protect it from theft. The *kapalo*, or "head," of the skirt displays a pattern of isosceles triangles, one of the oldest motifs, commonly referred to in Minangkabau adat teachings as bamboo shoot (*pucuak rabuang*). The motifs appear both in positive space and in negative space, a patterning technique characteristic also of many Middle Eastern textiles, which may have influenced Minangkabau weavers. 156.2 x 75.0 cm. FMCH x97.50.81; private gift.

6.24 Detail of reverse side of textile shown in figure 6.22. Weft stripes in this *saruang* from the village of Pandai Sikek are made of alternating colors, in contrast to the alternately colored warps of a *saruang* from the village of Koto Gadang (fig. 6.20). Sometimes differences such as this are sufficient to establish the provenance of a textile.

6.23 For protection from moisture and insects, textiles were often stored in bamboo cylinders together with aromatic spices such as cloves. Village of Mungo, Limo Puluah Koto. 1988.

Skirts from Tanah Datar

A *saruang* with a format similar to that found in many Javanese batiks comes from the village of Pandai Sikek, in Tanah Datar. The *kapalo*, or "head" section of the pattern, is decorated with motifs in the shape of elongated isosceles triangles. When placed base to base, the triangles form diamonds or lozenges that appear stretched horizontally (fig. 6.22). An important feature of the arrangement of motifs in this *kapalo* is the negative-positive play of the triangles—some placed point to point, others placed base to base.

Many Minangkabau ceremonial textiles are decorated so that both positive and negative spaces form motifs that relate to adat teachings.[1] During World War II this textile was stored in a bamboo cylinder (similar to the one in figure 6.23) and buried to keep it from being stolen. Ground wefts in this *saruang* form stripes of alternating colors (fig. 6.24), in contrast to Koto Gadang's two-color ground warps (see fig. 6.20). Such differences are often crucial in determining provenance.

A remarkable contemporary *saruang* woven

WOMEN'S CEREMONIAL DRESS AND RELATED CEREMONIAL TEXTILES

6.25 *Saruang.* Polyester, gold-wrapped thread. This extremely finely woven *saruang* from the village of Pandai Sikek was made about 1995, commissioned by a young Minangkabau, Zulkifli Abu Bakar. Three similar sets of *saruang* and matching *salendang* were made. This skirt is decorated with weft pattern bands of forty-four different traditional adat motifs rather than formatted with a major panel, or *kapalo*, dominated by isosceles triangles flanked by smaller motifs (compare fig. 6.22). 159 x 97.7 cm. FMCH X97.50.82; private gift.

in Pandai Sikek (fig. 6.25) showcases the extremely fine weaving that can still be produced in the Minangkabau highlands. The piece, which was made around 1995, was commissioned by Zulkifli, a young Minangkabau anthropologist-entrepreneur from Padang who is encouraging and supporting a resurgence of traditional skills. Three similar sets of *saruang* and *salendang* were made. One set is currently in a museum in Jakarta, another is in Zulkifli's collection, and the third is at the UCLA Fowler Museum.

Skirts from Limo Puluah Koto

Limo Puluah Koto is alleged to have the most rigidly prescribed system of ceremonial dress of any highland regency. There are twelve different ceremonial ensembles specified in detail for women in the region of Koto nan Gadang, a group of villages around the capital city of Payakumbuh. Here costume elements indicate a woman's reproductive status: whether she is married or unmarried, a young wife with one or two children, an older one with three or four children, or a grandmother. Costume elements also indicate a woman's social status: whether she has a son-in-law, for example, or whether, as a wedding participant, she is the mother of the groom or of the bride.

Skirts in Limo Puluah Koto are of two basic types: the *lambak*, or underskirt (which may sometimes be worn without an overskirt), and the *saruang*, which may be worn singly or as an overskirt. Two skirts from the region of Koto nan Gadang are illustrative: the *lambak ampek*, an unmarried girl's underskirt, and the *lambak babintang*, worn by a woman who is mother of the bride or who already has a son-in-law. The *lambak ampek* (fig. 6.26) is worn without overskirt. It is patterned with decorative strips of gold- or silver-wrapped thread woven on a card or tablet loom. Four (*ampek*) strips are sewn around the bottom portion of the skirt. They stand for the four attributes a young girl should have to be considered marriageable. When a knowledgeable Minangkabau, the late Saifud'din of Bukittinggi, was asked the meaning of these four rows, his response was a prime example of the baffling indirection in communication for which the Minangkabau are known: a marriageable girl should know how to go forward, she should know how to go backward, she should

know how to go uphill, and she should know how to go downhill. To a Minangkabau, this means that she should be thrifty, she should be skillful enough to manage matrilineage property wisely and profitably, she should be of serene temperament, and she should be motherly.

The *lambak babintang* (fig. 6.27) contains two overlapping panels. Each is woven plaid and is ornamented with colored silk thread and gold-wrapped thread. The two panels are sewn one underneath the other so that about 15 centimeters of the bottom panel hang below the top panel. The attached panels are in turn sewn onto a piece of commercial cloth long enough to make the plaid portion of the skirt reach to the wearer's ankles. The upper commercial cloth is completely covered by an overskirt.

Overskirts in several Limo Puluah Koto ceremonial clothing sets are made from floral batiks and from a type of checkered cloth known in the highlands as *kain bugih* because it resembles cloths woven by the Bugih people of Sulawesi. Today the only *saruang* decorated with supplementary weft of gold-wrapped thread is the one worn by the bride for her wedding ceremony. That type of *saruang* is currently woven in the village of Pandai Sikek for use in Limo Puluah Koto.

6.26 *Lambak ampek*, an underskirt for a young unmarried girl from Limo Puluah Koto. Cotton, silver-wrapped thread. The bottom of this skirt is overlaid with four rows of card-woven silver strips, reminders that there are four qualities that a young girl must possess to be eligible for marriage: she should be thrifty; she should be shrewd enough to successfully manage the matrilineage property; she should be serene; and she should be motherly. 168 x 45.5 cm. FMCH x97.50.77; private gift.

WOMEN'S CEREMONIAL DRESS AND RELATED CEREMONIAL TEXTILES

6.27 *Lambak babintang*, or underskirt with star motifs, Limo Puluah Koto, worn by the mother of the bride or by a woman with a son-in-law. Cotton, gold-wrapped thread, plied silk thread. The bottom two panels of this skirt, the only portion visible when it is worn, are joined, one under the other, so that the wearer appears to be dressed in two underskirts, one longer than the other. The two panels are attached to a piece of commercial cloth to make the skirt long enough to reach from the waist to the ankles. This commercial cloth is concealed by a tunic or an overskirt. 110 x 40.5 cm. FMCH X97.25.69; collection of H. Elly Azhar and H. A. Sutan Madjo Indo.

6.28 *Saruang* from the village of Saniang Baka, in the regency of Solok. Wool, commercial cotton, gold-wrapped thread. Fine imported wool from the Netherlands or England was considered a prestige fabric in the nineteenth and early twentieth centuries in the Minangkabau highlands (see also figs. 6.9, 6.94). This red wool ceremonial skirt, lined with printed cotton, is decorated with gold-wrapped thread couched in the *balah kacang*, or split-peanut, motif. Weaving was probably not done in Saniang Baka at the turn of the twentieth century, when this skirt was made. Because the yardage from which the skirt was made was unpatterned, the Minangkabau employed the embroidery technique known as couching to overlay their adat motifs on the wool (i.e., an appropriate design of gold thread was placed on the fabric surface and then anchored with decorative stitches). Gold-wrapped thread cannot be used satisfactorily for embroidery stitches that require thread to penetrate the cloth because the gold wrappings would be loosened or perhaps even stripped away from the core of the thread as it passed through the fabric. 128 x 94.5 cm. FMCH X97.50.80; private gift.

CEREMONIAL TEXTILES

Skirts from Regions beyond the *Luhak Nan Tigo*

Solok was an especially rich rice growing area in the nineteenth and early twentieth centuries, and many objects have survived to show that gold ornaments and textiles with supplementary weft of gold-wrapped thread were used freely in ceremonial wear as displays of wealth. A *saruang* from the village of Saniang Baka (fig. 6.28), now in the Solok regency, is typical of its period and location. There was probably little or no weaving in this village around the turn of the twentieth century, and many ceremonial skirts from that time were made from imported wool. Adat motifs were embroidered on the wool in a technique known as couching.[2] A photograph originally published in Amsterdam in 1914 (fig. 6.29) shows a group of women from this area in ceremonial dress, most of whom are wearing woolen skirts couched with gold-wrapped thread. Young boys in the photograph wear tops and trousers of gold-couched wool.

An early twentieth-century skirt from the town of Silungkang is covered with images of birds in gold-wrapped thread, interspersed with stylized floral motifs (fig. 6.30). The *kapalo* is decorated with slightly modified traditional triangular motifs. This garment and other early twentieth-century Silungkang textiles, such as wall hangings (*ieh dindiang*; fig. 6.31), contain little adat-related imagery. Examination of a contemporary *saruang* from Silungkang (fig. 6.32) shows that, except for the modified triangular motifs in the *kapalo*, motifs on this skirt also are not the same as those found in the *luhak nan tigo* (the original settlements). One selvage is elaborately patterned with warp bands and realistic trees. The other is left plain so that it can be folded, rolled, and secured around the wearer's waist without damaging the trim. The black and white weft-ikat pattern band has a somewhat indistinct image of a flower on a stem with three leaves, reminiscent of the more sharply defined woven floral patterns seen in the example discussed earlier (see fig. 6.30). Multicolor weft stripes found in this contemporary *saruang* are also found in old weavings from the Solok area, but not in textiles from the *luhak nan tigo*. Clearly there were cultural differences between the former *rantau* areas and the regions of the original settlements at the turn of the twentieth century.

6.29 A group of Minangkabau highlanders dressed for a ceremony. Many of the women are wearing wool skirts couched with gold-wrapped thread. A young boy on the right of the photograph is wearing wool trousers that have been couched with gold-wrapped thread. The photograph was originally published in 1914. Courtesy of the Yayasan Dokumentasi dan Informasi Kebudayaan Minangkabau.

6.30 *Saruang* from the village of Silungkang. Cotton, gold-wrapped thread. This skirt was woven in the early twentieth century, when Silungkang was developing into a major weaving center. Bird motifs appear in the body of the sarong. Birds, abundant in the forests surrounding Silungkang, are typical pattern elements in textiles from this area. Also in the body of the skirt are florals, possibly copied from European pattern books. Neither the birds nor the florals are known to be adat-related motifs. The *kapalo* contains modified shapes of the traditional isosceles triangle pattern. 198 x 100.3 cm. Private collection.

6.31 *Ieh dindiang*, or wall hanging, from Silungkang. Cotton, gold-wrapped thread, plied silk thread. This butterfly-strewn wall hanging is another example of an early twentieth-century Silungkang textile that bears no known adat-related motifs. 143.5 x 65.4 cm. Private collection.

6.32 Contemporary *saruang* from the village of Silungkang. Cotton, gold-wrapped thread. This red and gold ceremonial skirt with bands of black and white weft ikat does not incorporate adat motifs, except for the modified isosceles triangles in the kapalo. Compare the trees in the hem border of this saruang to the similar shapes in the hem border of the example in figure 6.30. Also compare the weft-ikat bands to the florals in the body of the earlier textile. These two skirts display many similarities, although they were made some seventy or eighty years apart. 112.4 x 102 cm. Private collection.

CEREMONIAL TEXTILES

6.33 Young Minangkabau women wearing the *salendang* crossed at the left hip, photographed in the 1920s at the Kweekschool in Fort de Kock (now Bukittinggi). Courtesy of the Yayasan Dokumentasi dan Informasi Kebudayaan Minangkabau.

6.34 Ceremonial procession in Limo Puluah Koto. Women wearing the *salendang gaba* tied over their right shoulders so that the embellished part of the textile drapes down the arm. This shoulder cloth is worn only by married women. 1986.

Shoulder Cloths (Salendang)

Before World War II the *salendang* was usually the richest, most heavily embellished element of a Minangkabau woman's ceremonial costume. Motifs in the selvages of shoulder cloths from Agam and Tanah Datar were often village or village-region specific, as were formats. The display of adat-related motifs was more varied and more conspicuous than in *baju* or *saruang*. Current fashions have modified this only a little. Older *salendang*, usually worn folded in half lengthwise, are considerably wider and heavier than their contemporary counterparts. The more recent pieces are cooler and more comfortable to wear over the long time periods consumed by ceremonial processions and receptions on this equatorial island. As was true for the *saruang*, the *salendang* from Tanah Datar and Agam are usually more heavily embellished with gold-wrapped thread than are those from Limo Puluah Koto.

A *salendang* is generally worn in one of three ways. It may be draped over the right or left shoulder, preferably the right, with the ends crossed at the opposite hip (fig. 6.33); it may circle the upper body from under the left arm to the top of the right shoulder, where it is knotted in such a way that decorated end panels cover the right arm (fig. 6.34); or it may drape over the right shoulder, around the back to the left underarm, and then fall either over the left arm (fig. 6.35) or over the left shoulder to the back. In a few instances the shoulder cloth is wrapped from the back of the waist; the ends, crossed to opposite sides at the top of the chest, fall over the shoulders and down the back.

6.35 Woman from the village of Tanjung Sungayang on her way to a minor ceremony carrying food on her head. She wears the *salendang* over her right shoulder, around the back, and draped over her left arm. 1987.

WOMEN'S CEREMONIAL DRESS AND RELATED CEREMONIAL TEXTILES

Village-Specific Attributes of Some *Salendang*

Designs woven into selvage borders of shoulder cloths are sometimes village-specific and may be used to help establish the provenance of a textile. Such designs are usually a set of patterns, a combination of a featured warp stripe and flanking narrower patterned stripes. Although individual elements of these design sets may appear in selvage borders from many different villages, a specific set of individual pattern stripes is often village- or village-region specific. Selvage borders found on many Pandai Sikek *salendang*, for example, contain warp stripes made up of a column of diamonds arranged point to point either as a feature stripe (fig. 6.36) or as two narrow stripes flanking a different feature stripe. The diamond motif, called *labu* (squash), refers to the pumpkin seed, which is said to represent the detailed but all-encompassing nature of Minangkabau adat. The corresponding saying is:

> If rolled up, it is as small as a bird's talon;
> if spread out, as vast as the universe.
> Although it may be no larger than the seed of
> a pumpkin,
> it contains the sky and the earth.

Sometimes the feature stripe of a Pandai Sikek selvage-pattern set contains the *saluak laka*, or interwoven rattan, motif (fig. 6.37). In adat sayings interweaving refers to the importance of close-knit community in the culture. The small basket-weave figure at the outer edge of this selvage is called *anyam*, or wickerwork, also a reference to close-knit community. The flanking chevron patterns that alternate direction are described as fishes on a fish hook. The motif's close resemblance to this subject is demonstrated by a photograph of a string of fish (fig. 6.38).

Village-specific selvage-pattern sets are found also in Pitalah and in Koto Gadang. Textiles from the village of Pariangan have no selvage patterns; weft pattern bands extend across the entire width of the textile (fig. 6.39). Minangkabau weavers say that this omission was deliberate, designed to emphasize the fact that Pariangan was the first major settlement of the Minangkabau in the highlands and that the community had to grow outward from there. Selvage border patterns on Pariangan textiles would represent a barrier to outmigration. Textiles from other villages occasionally may be woven without selvage border patterns, but no Pariangan textile has a selvage border pattern.

To illustrate the remarkably rich and varied art of Minangkabau women's ceremonial shoulder cloths, more than two dozen examples are included here with descriptive captions (figs. 6.40–6.65) and an additional cloth appears on the back cover of this volume. These examples are from Tanah Datar, Agam, Limo Puluah Koto, Solok, and Silungkang. Two very old shoulder cloths of less certain provenance are also illustrated and discussed.

6.38 A catch of fish strung for easy carrying. Note how the pattern made by the fish resembles the chevron patterns in the two narrow warp stripes shown in figures 6.36 and 6.37.

OPPOSITE:
6.39 *Tangkuluak*, or headdress textile. Silk, gold-wrapped thread. This elegant textile from the village of Pariangan is heavily patterned with bands of supplementary weft but has no selvage patterns. Local weavers interpret this to mean that selvage patterns would have represented a barrier to outmigration from the village, and according to legend all subsequent Minangkabau settlements were peopled by those who left Pariangan or by their descendents. 245 x 73 cm. FMCH X93.25.43; collection of H. Elly Azhar and H. A. Sutan Madjo Indo.

6.36 Detail of the selvage pattern of a shoulder cloth from Pandai Sikek featuring a main selvage stripe of diamonds stacked point to point. The diamonds, according to Pandai Sikek weavers, represent squash or pumpkin. The motif refers to the saying that the adat may be as small as a pumpkin seed but contains the whole universe. The two narrower stripes flanking the squash represent fish on a line (see fig. 6.38). FMCH X93.25.37; collection of H. Elly Azhar and H. A. Sutan Madjo Indo.

6.37 Detail of a selvage pattern found on textiles woven in the village of Pandai Sikek. Here the featured selvage-stripe motif is *saluak laka*, or interwoven rattan. This motif refers to the importance of close-knit community in Minangkabau society. The outer edge of the selvage is patterned with a small checkerboard design, *anyam*. It represents wickerwork, a form of interweaving, also referring to closely intertwined community members. FMCH X97.50.15; private gift.

CEREMONIAL TEXTILES

OPPOSITE:

6.40 *Tagak tujuah*, a shoulder cloth also used as a shroud, from the village of Batipuah, Tanah Datar. Silk, gold-wrapped thread. The textile name refers to the seven (*tujuah*) white stripes associated with the seven pattern bands. This refined, sophisticated old textile is a stunning example of a traditional Batipuah weaving. The piece is woven of very fine silk and consequently is fragile. A similar cloth woven with cotton wefts instead of silk wefts in the white center area is made to be strong enough to serve also as a ceremonial baby carrier. 264.7 x 83.5 cm. FMCH X93.25.10; collection of H. Elly Azhar and H. A. Sutan Madjo Indo.

6.41 *Salendang*, or shoulder cloth, probably from the village of Batu Sangkar. Silk, gold-wrapped thread. This exquisitely woven, sheer textile is unusual in several respects. It has no selvage border patterns, and it has a format that is not entirely typical of Batu Sangkar weavings. In addition to having traditional motifs formed with supplementary weft of gold-wrapped thread, the textile has one band in which gold-wrapped thread follows the same path as ground wefts. Use of gold thread to parallel ground threads is extremely rare in Minangkabau weavings but is common in south Indian saris. The textile exemplifies the freedom of design that Batu Sangkar weavers in particular cultivated. 223 x 76.2 cm. FMCH X97.50.71; private gift.

6.42 *Salendang*, or shoulder cloth, from the village of Batu Sangkar. Silk, gold-wrapped thread. The decorated end panel of this textile is patterned with a grid of crossing diagonal lines formed of repeated *X*s. Spaces enclosed by these lines are filled with diamond-shaped motifs, some enlivened with colored plied silk thread. This overall pattern is called the Bugih chain, or *barantai bugih*, presumably after a design first introduced by Bugih weavers from the island of Sulawesi. The Bugih suffered a diaspora in the seventeenth century after the arrival of the Dutch on the island of Sulawesi. Many of the displaced found homes on other islands, including Sumatra. Several Minangkabau weaving techniques, motifs, and textile types carry the Bugih name. 243 x 73 cm. FMCH x93.25.19; collection of H. Elly Azhar and H. A. Sutan Madjo Indo.

6.43 *Salendang*, or shoulder cloth, from the village of Batu Sangkar. Cotton, silk, gold-wrapped thread. This red, blue, and natural plaid textile is decorated with three bands of gold motifs and scattered small figures both in the end panels and in the body of the textile. This sparse arrangement of gold motifs is called *batabua* (as opposed to overall gold embellishment, called *balapak*). The diamond-shaped figures represent *galamai*, a cake that must be served at ceremonies. Plaids are commonly found in Indonesian textiles and, according to Hall (1996, 114), were woven in Indonesia at least as early as the eleventh century. 208 x 60 cm. FMCH x93.25.20; collection of H. Elly Azhar and H. A. Sutan Madjo Indo.

CEREMONIAL TEXTILES

6.44 *Salendang*, or shoulder cloth, from the village of Lintau. Cotton, silk, gold-wrapped thread. Dyes for this textile were especially well selected. The deep blue of the ground threads sharply intensifies the red and gold of the pattern bands. Lintau textiles often display marks of sophistication in design, such as the differing widths of the three pattern bands in this example. The diamond-shaped figure in the widest band is identical to one found in many Middle Eastern rugs (see chapter 7). 237 x 76 cm. FMCH X93.25.31; collection of H. Elly Azhar and H. A. Sutan Madjo Indo.

6.45 *Salendang*, or shoulder cloth, from the village of Lintau. Cotton, silk, gold-wrapped thread. Many shoulder cloths from Lintau are deceptively simple in appearance but sophisticated in design. The center of this textile is patterned with a red, blue, and natural plaid. The narrow area between the gold triangles and the end of the textile is, however, patterned in stripes, providing a subtle contrast to the plaid. 198.1 x 58.4 cm. FMCH X97.50.14; private gift.

6.46 *Salendang*, or shoulder cloth, from the village of Padang Magek. Silk, gold-wrapped thread. The major pattern band of this textile, the second band in from the end, contains a repeated asymmetrical motif. The identity and meaning of this motif apparently are no longer known. It has been likened variously to a bird, a lopsided tree, or a dragon. The same motif appears in textiles from the town of Solok but has not been found in weavings from the *luhak nan tigo*. 223 x 70 cm. FMCH X93.25.92; collection of H. Elly Azhar and H. A. Sutan Madjo Indo.

WOMEN'S CEREMONIAL DRESS AND RELATED CEREMONIAL TEXTILES

Detail of 6.47

Detail of 6.47

OPPOSITE:
6.47 *Salendang*, or shoulder cloth, from the village of Padang Magek. Silk, gold-wrapped thread, plied silk thread. This exquisite, very rare textile comes from a village where the traditional headdress is considered by Minangkabau highlanders to be a metaphor for the way the culture has successfully blended Islam and an adat-based matrilineal society, two belief systems that appear superficially to be irreconcilable. Elements of such blending are also evident in this textile. The shoulder cloth is an adat textile, but the embellishment at the corners of the gold eight-pointed stars is almost identical to the embellishment of individual letters in some forms of written Arabic, the language of the Quran. The exceptional intricacy and sophistication of the overall design are apparent also in the narrower pattern bands extending across the width of the cloth, which exhibit striking color and pattern changes every few centimeters. 224.8 x 84.5 cm. FMCH x97.50.69; private gift.

WOMEN'S CEREMONIAL DRESS AND RELATED CEREMONIAL TEXTILES

6.48 *Salendang*, or shoulder cloth, from the village of Pandai Sikek. Silk, gold-wrapped thread. Diamonds in the end panels of this textile are filled with what appear to be vertical gold stripes. Stripe-filled diamonds are characteristic of many weavings from this village; its shoulder cloths are often *balapak* (completely covered with gold motifs), as is this example. Pandai Sikek is now one of the most active weaving centers in the highlands, claiming one thousand working looms. The uniqueness of textiles made in Pandai Sikek is, however, being severely diluted. On client demand, village weavers readily copy textiles customarily made in other villages. Competition among weaving establishments is fierce, and customer demand for innovation has led to invention of new motifs and formats and to mixing of once village-specific formats. 161 x 62 cm. FMCH X93.25.36; collection of H. Elly Azhar and H. A. Sutan Madjo Indo.

Detail of 6.48
Vertical lines fill some of the diamonds in the patterning.

6.49 *Salendang*, or shoulder cloth, from the village of Pandai Sikek. Silk, gold-wrapped thread. The diamonds in this extremely rare and fine textile are patterned in a technique the Minangkabau call *bugih-ing*. Most textiles exhibiting this unusual weaving technique limit it to small sections of the cloth. Close examination shows that in *bugih-ing* the gold supplementary wefts do not appear to follow a straight path across the textile but seem to weave back and forth across adjacent ground wefts. 208 x 58 cm. The Metropolitan Museum of Art, Gift of Ernest Erickson Foundation, Inc., 1988. (1988.104.78). Photograph © 1999 The Metropolitan Museum of Art.

WOMEN'S CEREMONIAL DRESS AND RELATED CEREMONIAL TEXTILES

6.50 *Salendang tuo rarak*, or shoulder cloth, from the village of Pitalah. Cotton center, silk and gold-wrapped thread in end panels. This shoulder cloth is probably the only Minangkabau ceremonial textile woven as separate pieces, not as a continuous whole. After the two decorated end panels are woven, they are sewn onto a longer center section. That section may be either handwoven or made of commercial cloth. This piecemeal approach is dictated by practicality. The *tuo rarak* is used to carry rice to throw at weddings. The rice is colored with turmeric, which is used as a permanent yellow dye as well as a seasoning. Gold-wrapped thread cannot be laundered, and if a gold-embellished textile becomes soiled, it may be impossible to clean it satisfactorily. It is known from the outset that the *tuo rarak* will be subject to heavy soil, and the piece is structured so that it is easy to replace the center section when it becomes stained. The fine weaving apparent in the decorated end panels of this textile is typical of textiles woven in the village of Pitalah. 180.3 x 69.9 cm. FMCH X97.50.72; private gift.

6.51 *Salendang*, or shoulder cloth, from the village of Tanjung Sungayang. Cotton, *ramin*, silk, gold-wrapped thread. The light threads in the warp and weft of this textile are the bast fiber *ramin*, which probably has not been used in weaving in the Minangkabau highlands for at least a century (see chapter 8 for a discussion of bast fibers). The motif known as the Bugih chain, which covered most of the end panel of the textile in figure 6.42, appears here in two single bands. 168 x 58.5 cm. FMCH X93.25.54; collection of H. Elly Azhar and H. A. Sutan Madjo Indo.

6.52 *Salendang*, or shoulder cloth, from the region of Koto nan Gadang. Cotton, gold-wrapped thread, silk. This shoulder cloth is called *cukia kuniang*, or design in yellow, in recognition of the brilliant yellow-orange bands in the end panels. It is tied over the right shoulder as a *salendang gaba*. It is worn by married women who are more than forty years old. 256 x 79 cm. FMCH X93.25.72; collection of H. Elly Azhar and H. A. Sutan Madjo Indo.

CEREMONIAL TEXTILES

6.53 *Salendang gaba*, or shoulder cloth, from the regency of Limo Puluah Koto. Cotton, gold-wrapped thread, plied silk thread. This plaid shoulder cloth is worn only by married women. It wraps under the left arm and ties on top of the right shoulder so that the decorated end panels drape down the right arm. One meaning of the word *gaba* is festoon, and the draped and tied textile echoes that shape. The gold motifs have been enriched with colorful silk thread woven in geometric shapes. 252 x 68 cm. FMCH X93.25.71; collection of H. Elly Azhar and H. A. Sutan Madjo Indo.

6.54 *Salendang gaba*, a shoulder cloth from a border area between Limo Puluah Koto and Batu Sangkar, where textiles woven on opposite sides of the border are very similar, if not identical. Cotton, gold-wrapped thread, silk, *ramin*, plied silk thread. It is worn by married women with children. 244.5 x 88.5 cm. Private collection.

WOMEN'S CEREMONIAL DRESS AND RELATED CEREMONIAL TEXTILES

6.55 *Salendang gaba*, or shoulder cloth, probably from the town of Payakumbuh. Cotton, silk, gold-wrapped thread, *ramin*, plied silk thread. A shoulder cloth for older married women. 253 x 81 cm. FMCH x93.25.76; collection of H. Elly Azhar and H. A. Sutan Madjo Indo.

Detail of figure 6.55.

6.56 *Salendang gaba*, a shoulder cloth for younger married women. Silk, gold-wrapped thread. The village where this shoulder cloth was made—Balai Cacang, near the village of Payakumbuh—can be identified from the red, blue, and white plaid of the ground cloth. Weavers in Balai Cacang produce many different textiles patterned with this plaid (see fig. 6.116). 246 x 97 cm. FMCH x93.25.68; collection of H. Elly Azhar and H. A. Sutan Madjo Indo.

6.57 *Kain sandang cukia kuriak putiah*, a shoulder cloth with a white spotted or speckled design. Cotton, silk, gold-wrapped thread. In the region of Koto nan Gadang, where this textile was made, there are twelve different combinations of headdress, shoulder cloth, tunic, and skirt from which women select the appropriate attire for a ceremony. This shoulder cloth is also worn on other occasions that require ceremonial clothing; for example, it is worn by a daughter-in-law who is paying a formal visit to her in-laws and also by a mother-in-law when she is to meet with her son- or daughter-in-law. The cloth is a *salendang gaba*, which circles the body under the left arm and is tied on top of the right shoulder. The decorated ends drape over the right arm. 244 x 80 cm. FMCH x93.25.74; collection of H. Elly Azhar and H. A. Sutan Madjo Indo.

WOMEN'S CEREMONIAL DRESS AND RELATED CEREMONIAL TEXTILES

6.58 *Salendang*, or shoulder cloth, from the village of Tilatang, in Agam. Cotton, silk, gold-wrapped thread. This example is unusual among Minangkabau textiles because of the metallic supplementary-weft band across the center. Center bands are known to have been used in the villages of Tilatang, its near neighbor Ampek Angkek, and Koto Gadang. This striking shoulder cloth is a good example of the sparsely decorated type of weaving called *batabua* (see fig. 6.59). 206 x 64 cm. FMCH x93.25.67; collection of H. Elly Azhar and H. A. Sutan Madjo Indo.

6.59 *Salendang*, or shoulder cloth, from the village of Ampek Angkek. Silk, gold-wrapped thread. This textile also contains the Agam-specific center weft band of metallic thread. It is more heavily ornamented than its counterpart from the nearby village of Tilatang (fig. 6.58). The format is similar also to that of textiles woven in the village of Koto Gadang. 187.2 x 52.1 cm. FMCH x97.50.73; private gift.

6.60 *Salendang tarewai*, or ceremonial shoulder cloth, from the village of Koto Gadang. Silk, gold-wrapped thread. That this textile carries none of the traditional adat motifs is undoubtedly a result of contact with foreign cultures. Koto Gadang, along with Bukittinggi, was the intellectual center of Minangkabau from the late nineteenth century to the time of independence in the mid-twentieth century. Many Koto Gadang residents received at least part of their education in Holland. Exposure to international arts resulted in the adoption of European decorative techniques such as pillow lace and drawnwork embroidery. 197 x 55 cm. FMCH x93.25.62; collection of H. Elly Azhar and H. A. Sutan Madjo Indo.

6.61 *Salendang*, or shoulder cloth, from the town of Silungkang. Silk, gold-wrapped thread. This beautiful and finely woven early shoulder cloth is part of the heirloom textile collection of Mien Soedarpo of Jakarta. The traditional flowering bamboo shoot and cornflower or tree of life motif band appears at the top of the densely decorated end panel. The diamonds within diamonds within diamonds in the end panel are especially finely and artfully woven. The outer diamond is outlined in smaller diamonds with an interior vertical line, a design found in many adat-related motifs. The linear outlines of the inner diamonds are embellished with fern tendrils (spirals) and with solid small triangles, motifs commonly found in Minangkabau and other Southeast Asian ceremonial weavings as well as in Middle Eastern textiles and rugs. The innermost diamond here is filled with vertical lines strongly reminiscent of a Pandai Sikek patterning technique. Any meaning that might have been attached to this finely executed multidiamond motif in Silungkang is not known today. 179.5 x 50.4 cm; collection of Mien Soedarpo.

WOMEN'S CEREMONIAL DRESS AND RELATED CEREMONIAL TEXTILES

6.62 *Salendang*, or shoulder cloth, from the town of Solok. Silk, gold-wrapped thread. The complex design of this rich red textile includes many elements typically found in Solok weavings. The vertical isosceles triangles in the end panels are unusually large and contain scattered small pattern elements. There are multicolor weft stripes of red, white, yellow, and dark blue, which appear in many types of Solok textiles. Motifs in this textile are sometimes outlined in the red ground color, calling particular attention to certain areas of the design. 226 x 64 cm. FMCH x93.25.94; collection of H. Elly Azhar and H. A. Sutan Madjo Indo.

6.63 *Salendang*, or shoulder cloth, from the village of Muaro Labuah. Cotton, silk, gold-wrapped thread. This shoulder cloth with a white cotton center was sometimes also used as a shroud. Most textiles from this area have cotton warps, although silk is often used as a weft thread. Muaro Labuah is in the southwestern part of the province of West Sumatra and is fairly remote from the *luhak nan tigo*. Dongson drums have been excavated in this area, and many of the motifs on traditional Muaro Labuah weavings bear a strong resemblance to the motifs found on these bronze drums (see also fig. 5.37). A century ago Muaro Labuah was a big rubber-processing area, and many workers were brought from Java to tend the trees and perform other menial jobs. The demand for clothing for this influx of people diverted most local looms from weaving ceremonial garments to weaving cotton for work clothes (Zulkifli Abu Bakar, conversation with author, 1986). 221 x 85 cm. FMCH x93.25.78; collection of H. Elly Azhar and H. A. Sutan Madjo Indo.

CEREMONIAL TEXTILES

6.64 *Salendang*, or shoulder cloth, probably from the village of Silungkang. Silk, gold-wrapped thread, plied silk thread, sequins. This exquisite cloth is exceptionally finely woven and embellished. The pattern in the body of the textile is red squares outlined in blue. There is a question as to whether ikat dyeing techniques were required to produce the multicolored warps. All warps are red in the decorated end panels, but alternate sets of warps in the body of the textile are white for a few centimeters as they leave the end panel and then are dark blue in the body of the textile. Wefts also are multicolored; all are red in the selvage, but alternate sets go from red in the selvage to white and then to dark blue in the body of the weaving. The textile has been variously assigned to Silungkang, where weft ikat was and is made, and to Sijunjung, where there is as yet no evidence that weft ikat was used as a patterning technique. It is possible that individual weavers not based in Silungkang could have produced textiles such as this by careful, controlled dipping of the warp and weft threads into dye before the loom was warped. The irregularity of the dye patterns suggests either dipping or, if the threads were ikat dyed, rather poorly controlled wrapping (see also fig. 6.65). 219.7 x 78.7 cm. FMCH x97.50.76; private gift.

6.65 *Salendang*, or shoulder cloth, of uncertain provenance. Silk, gold-wrapped thread. The technique of dyeing the warps and wefts in this cloth appears to have been the same as in the cloth in figure 6.64, except that they are two colors, red and white, instead of red, white, and blue. This textile, however, contains motifs that are traditionally used only in the village of Batu Sangkar. Current residents claim that ikat was never done in Tanah Datar. The question is: did someone in Batu Sangkar dip-dye the threads and weave the textile, or did someone from Silungkang ikat-dye it especially for use in Batu Sangkar? Dyers in Tanah Datar are known to have often dyed silk threads so that warps in the end panels of their fine weavings were a different color from warps in the body (zone dyeing), but we have found no examples, other than this one, of a textile with Batu Sangkar motifs and two-color wefts. The textile is so old that no one, not even weavers in their eighties, knows where or when it was made. The textile also appears to be a Minangkabau adaptation of a somewhat similar two-panel cotton Indian ikat that was exported to Sumatra (see discussion and photographs in chapter 7). 255.5 x 72 cm. Private collection.

WOMEN'S CEREMONIAL DRESS AND RELATED CEREMONIAL TEXTILES

6.66 *Suntiang gadang* (big diadem), a crown assembled from seventy-nine different pieces. The components are a gilded base made of three layers of filigree blossoms, and peacock figures, durian flowers with rhinestones, blossom clusters mounted on springs for stalks, featherlike ornaments, and assorted dangles, all in gilt. Wearing this heavy headdress for long periods of time may be painful as well as tiring. Some forty-eight of the ornaments are added to the basic crown of blossoms by means of long, sharp, stakelike pins. Although these pins are supposed to anchor in a pillow worn on top of the head, they sometimes dislodge and pierce the scalp. Furthermore, the whole structure is somewhat unstable. The wearer cannot bend her head, shake hands vigorously, or walk rapidly without risking dislodging the headdress. This flatteringly ornate *suntiang* is, however, unquestionably the bride's headdress of choice for her wedding costume. Height 32.5 cm measured from center of forehead. Private collection.

6.67 *Suntiang*, or bridal diadem, that may be purchased in the market already assembled and boxed. Assorted blossom and feather shapes of gilded or red enameled brass, assorted dangles of gilded brass. This may be the poor bride's headdress, but it is much lighter and much less potentially painful to wear than the *suntiang gadang* shown in figure 6.66. Height 23.5 cm measured from center of forehead. FMCH X97.50.60; private gift.

Headdresses

Suntiang and Other Metallic and Gold-Leafed Headdresses

Many metallic ceremonial headdresses found in Minangkabau strongly resemble exotic headwear found in other Asian countries. The *suntiang* (figs. 6.66, 6.67), in particular, is reminiscent of women's headgear worn at Chinese rituals. Another type of metallic headdress, a silver-gilt crown from the village of Sawahlunto (fig. 6.68), is worn with a fabric collar ornamented either with gold-leafed carved wooden shapes (fig. 6.69) or with gold-colored metallic shapes. A newspaper clipping shows the crown and collar as they are worn in the highlands (fig. 6.70).

Women of the town of Solok have for centuries worn a spectacular two-piece ceremonial headdress consisting of a snoodlike velvet cap with a stiffened front panel decorated with small gold shapes (fig. 6.71) topped with a large metallic overlay. The overlay consists of a wide repoussé panel (worn at the back of the head) hinged to a bulk of golden leaves (fig. 6.72), which cascade across the top of the velvet cap to the forehead (fig. 6.73). A gold cape made in the form of a net with large square elements is often worn with this headdress today (fig. 6.74). A twenty-two-carat gold crown from the area of Muaro Kubu is an example of a regional gold headdress (fig. 6.75).

Some forms of Minangkabau ceremonial headwear and jewelry that were once probably made exclusively of gold or of silver gilt were

138 CEREMONIAL TEXTILES

6.68 Woman's crown for ceremonial wear from the village of Sawahlunto. Repoussé silver-gilt. This headdress is designed with separate floral depictions on five front panels. These five individual slightly curved repoussé structures are topped with small assemblies of stemmed, gilded leaves and blossoms representing individual flowers. Two attached side panels cover more of the head. The right side panel is topped with the tallest and largest assembly of leaves and blossoms. The crown is tied to the head with a piece of cloth that is knotted at the back. Height 25.5 cm measured from center of forehead. Private collection.

6.69 Collar worn with Sawahlunto crown shown in figure 6.68. Velvet, gilded wood. 56 cm long x 29 cm wide at widest point. Private collection.

6.70 Newspaper clipping showing a woman from the village of Sawahlunto wearing the traditional ceremonial crown and collar.

6.68

6.69

also made of intricately carved, gold-leafed wood (see fig. 6.76). Gold-leafed wooden headdresses (fig. 6.76) are not part of women's ceremonial dress today, but we know from published drawings (fig. 6.77) that they were worn in the second half of the nineteenth century. Such wooden ornaments are often seen in archival pictures of ceremonial garb and sometimes can be found today selling for very high prices in antique stores in Sumatra. They are part of many matrilineage heirloom collections and are unquestionably considered to be adat.

6.70

WOMEN'S CEREMONIAL DRESS AND RELATED CEREMONIAL TEXTILES 139

6.71 Cap worn as a ceremonial headdress in the town of Solok. Velvet, silver-gilt ornaments. This ceremonial cap is worn as a headdress by young girls. When worn by older girls and young women, the cap is topped with an extravagant overlay consisting of a repoussé back plate hinged to a fall of gilded-silver leaves that drape across the top of the cap to the forehead. 11 x 33 cm. FMCH x97.50.58a; private gift.

6.72 Back plate and leaf clusters used as an overlay for the Solok ceremonial cap shown in figure 6.71. Gilded silver wrapped over base metal. The addition of this gilded silver fall to the somewhat sedate Solok velvet cap creates a headdress that rivals the *suntiang* in splendor. Total length 46 cm x 29.5 cm wide. FMCH x97.50.58b; private gift.

6.72 front

6.72 back

140 CEREMONIAL TEXTILES

6.73 A young woman, center, from Solok wearing the ceremonial cap and fall as a participant in a ceremonial wedding procession in Limo Puluah Koto. 1995.

6.74 Mesh or net overlay often worn with the Solok ceremonial headdress. Gilded silver. FMCH X97.50.59; private gift.

WOMEN'S CEREMONIAL DRESS AND RELATED CEREMONIAL TEXTILES

6.76

6.77

Headdresses Formed from Embellished Textiles

Minangkabau women's intricately folded textile headdresses are usually village-region specific. When women congregate at ceremonies, a knowledgeable observer can readily identify the area from which each woman has come by the headdress she is wearing. A headdress from the region around the village of Tanjung Sungayang is traditionally formed from an heirloom cloth that also serves as a chieftain's *salendang* (fig. 6.78). This is one of the more difficult headdresses to fold (fig. 6.79a–q). As a result of repeated pinning, most textiles used to form this headdress have been severely damaged on one end. According to the Minangkabau, the flat, vertical decorated panel at the top of the headdress serves to admonish the wearer to treat all persons equally, just as the flat top of the chieftain's hat (*saluak*) is a sign that male leaders must treat all members of the community equally.

A headdress unique to the village of Padang Magek has significance for all Minangkabau (fig. 6.80). It is formed from two textiles: an adat *saruang*, often of the type called *sapik udang* (shrimp or crustacean claws; fig. 6.82), and an Islamic woman's prayer veil, or *mukena* (fig. 6.81). The two pieces are wrapped so that only the decorated edge of the white prayer veil shows, forming a contrasting trim to the darker *saruang*. This headdress is significant to the Minangkabau because they see it as a metaphor for their skillful blending of their matrilineal *adat* and traditionally patriarchal Islam.

The majority of Minangkabau women's headdresses are folded so that the cloth forms hornlike shapes, either pointed or blunt, at the sides of the top of the head. Sometimes, as in the village of Lintau, there are two sets of "horns" (fig. 6.83). Today these shapes are likened to the

6.78

OPPOSITE:

6.75 A young Minangkabau girl wearing a solid gold crown from the region of Muaro Kubu. 1984.

6.76 Minangkabau woman's carved wooden ceremonial headdress. This type of headdress was usually gold-leafed and was worn on the top of the head over an embellished cloth that draped like a veil over the shoulders and back of the wearer (fig. 6.77). The wood has been shaped to suggest the hornlike appearance of headdresses folded from decorated textiles. The carving on this example is especially attractive and well done. 11.6 x 32.5 cm. Private collection.

6.77 Detail from an illustration of "exotic" Southeast Asian costumes published in Berlin in 1880. The young girl on the right is wearing a carved and gold-leafed wooden headdress similar to the one in figure 6.76.

6.78 Textile used as a *salendang* by chieftains from the village region of Tanjung Sungayang, Tanah Datar, or worn as an elaborately wrapped ceremonial headdress by women (fig. 6.79). Silk, cotton, gold-wrapped thread (*ramin* was used in some versions of this textile). This headdress cloth is folded so that it forms a flat vertical panel on top of an inverted V shape. The flat panel indicates that the wearer must treat all persons equally. 182.9 x 54.6 cm. FMCH X97.50.1; private gift.

WOMEN'S CEREMONIAL DRESS AND RELATED CEREMONIAL TEXTILES

6.79a–p The wife of the *pangulu* of the village of Minangkabau (Minang Jaya), Tanah Datar, demonstrates the process of tying the traditional headdress. 1989.

a. The headdress textile is folded in three—enclosing either paper or cloth, which provides stiffening—and is draped over the back of the head so that the end that hangs down on the left is shorter than the end that hangs down on the right. The two ends are crossed at the front of the head, with the shorter end passing under the longer end.
b. The ends are lifted in preparation for moving them to the top and back of the head.
c. The ends are flipped up over the head to form an inverted V.
d. The headdress is adjusted.
e. Front view showing the uneven ends of the textile hanging down the wearer's back.
f. Back view showing clearly the difference in length of the two ends. Getting this difference exactly right is crucial to achieving the proper shape of the headdress.
g. Removing the headdress to another head so that it can be manipulated more easily.
h. Pinning the corners to stabilize the headdress.
i. Placing a piece of bent cardboard over the inverted V to provide a foundation for the flat, vertical panel.
j. Opening the longer end of the textile and folding it up over the cardboard so that the entire width is covered.
k–l. Adjusting and pinning the cloth to completely cover the cardboard.
m. The completed headdress.
n. Returned to the head of the chieftain's wife.
o. Back view of completed headdress.
p. Side view of completed headdress.

a.

b.

c.

g.

h.

i.

m.

n.

144 CEREMONIAL TEXTILES

d.

e.

f.

j.

k.

l.

o.

p.

WOMEN'S CEREMONIAL DRESS AND RELATED CEREMONIAL TEXTILES 145

6.80 *Tangkuluak*, or tied headdress, from the village of Padang Magek. This headdress is formed from a *mukena*, an Islamic woman's prayer veil and a *saruang*, an adat ceremonial skirt. The headdress is viewed by Minangkabau as a metaphor for the successful blending of Islam and adat in their matrilineal culture. 1992.

6.81 *Mukena*, or Islamic woman's prayer veil. Polyester. This veil serves as a garment that covers the head; surrounds the face, completely concealing the hair; and is long enough to cover the hands and torso. A *mukena* must be kept scrupulously clean. An advantage to wearing it as part of the Padang Magek ceremonial headdress is that it is almost completely protected by being covered by the *saruang*. When it is time to pray, the woman removes her headdress, unfolds it, dons the *mukena*, and performs her prayers. The headdress is then reassembled, and participation in the ceremony continues. Length 52.5 cm; circumference 144 cm (at bottom). FMCH x97.50.54b; private gift.

6.80

6.81

6.82

6.82 *Saruang*, or skirt, called *sapik udang* (shrimp or crustacean claws), from the village of Padang Magek. Cotton, silk, *ramin*, gold-wrapped thread. This unusually finely woven *saruang* is more than one hundred years old. It contains *ramin*, a bast fiber that has not been used by Minangkabau weavers for at least a century. The weaver of this skirt employed a clever combination of colors in her warps and wefts to make the plain-weave skirt look as if it had been woven in a basket-weave pattern. 190.5 x 135.9 cm. FMCH x97.50.54a; private gift.

CEREMONIAL TEXTILES

6.83 Headdress from the village of Lintau, in Tanah Datar. Cotton, silver-wrapped thread. This headdress is unique to Lintau. It is shaped from two textiles, each forming a separate set of horns, one set larger than the other. The smaller set rests on top of the larger set. Currently the two textiles are woven in Pandai Sikek for use in Lintau. 194.3 x 41.9 cm, 134 x 15.9 cm. FMCH X97.50.52a,b; private gift.

6.84 The upswept roofs of houses in the old village of Pariangan bear a strong resemblance to the upswept curves of the Minangkabau woman's ceremonial headdress, calling attention to the important role of women and of the matrilineage in Minangkabau culture. 1985.

horns of the water buffalo, the *kabau* in the name Minangkabau. The Minangkabau today also equate the upswept roofs of the matrilineage-owned adat houses with horns of the water buffalo (fig. 6.84). This type of woman's headdress serves as a reminder of the important cultural roles played by individual Minangkabau women and by their matrilineages.

Headwear in the village of Koto Gadang is completely different (fig. 6.98). It is a very attractive, veillike covering, usually of silver-gilt-embellished velvet or velveteen with no suggestion of a horn shape. This veil may be derived from Islamic costume.

Some headdresses are folded so that heavily embellished portions of the textile are in full display. In others, such as the Padang Magek *sapik udang* headdress discussed above, the beauty of the textile is largely concealed. In the accompanying illustrations (figs. 6.85–6.105)—which show examples from Tanah Datar, Agam, Limo Puluah Koto, and Solok—sometimes both the folded headdress and the textile or textiles from which it is folded are illustrated.

WOMEN'S CEREMONIAL DRESS AND RELATED CEREMONIAL TEXTILES

6.85 Textile for a tied headdress, *kain tangkuluak*, from the village of Pandai Sikek. Silk, cotton, gold-wrapped thread. This textile format has elements characteristic both of Pandai Sikek and of neighboring Koto Baru. A featured weft band near the bottom of the decorated end panel has the split-peanut motif. Toward the center there are two nearly identical featured weft pattern bands separated by smaller pattern bands. 236 x 50.5 cm. FMCH X93.25.39; collection of H. Elly Azhar and H. A. Sutan Madjo Indo.

6.87 Traditional ceremonial headdress from the village of Pariangan. Silk, gold-wrapped thread. This headdress is draped so that the lavishly decorated end panels fall to the sides of the head and thus are highly visible. 237.9 x 72.2 cm. FMCH X93.25.42; collection of H. Elly Azhar and H. A. Sutan Madjo Indo.

OPPOSITE:
6.88 *Kain tangkuluak*, a textile for tying the traditional Pariangan ceremonial headdress. Silk, gold-wrapped thread. This rare and particularly fine headdress textile was made at least 150 years ago. The warps are entirely the bast fiber *ramin*, a very time-consuming material to prepare for weaving. The fibers, stripped from the bark or pulled from the debarked stem of *Boehmeria* plants, are seldom longer than two meters. Every warp length in this textile would have been knotted from at least two lengths of the fiber. More than fifteen hundred knots would have been tied to provide fibers long enough to warp the loom. 281.9 x 70.5 cm. FMCH X97.50.57; private gift.

6.86 Textile for ceremonial headdress, *kain tangkuluak*, from the village of Koto Baru. Silk, cotton, gold-wrapped thread. The format of this textile closely resembles that of the example woven in the nearby village of Pandai Sikek (fig. 6.85) with one featured band of the split peanut motif and two other featured pattern bands separated by narrower pattern bands. The color of the weft threads in the unusually long decorated end panel of this textile changes from band to band. It may be purple, red, or a faded black, which is sometimes mistaken for green. The proximity of this faded thread to the red warps makes it appear to be green to the unaided eye. It does not appear to be green when viewed under magnification. Using different-colored ground wefts in different pattern bands, a common practice in Tanah Datar, makes it easier to quickly distinguish the different motifs in a complexly patterned textile. 266.7 x 51.4 cm. FMCH X97.50.79; private gift.

CEREMONIAL TEXTILES

6.90 *Kain tangkuluak*, a textile for tying the traditional ceremonial headdress from the village of Pariangan. Silk, cotton, plied silk thread, gold-wrapped thread. Although the format of this textile and the one in figure 6.89 are the same, the two textiles look quite different. Here the elements in the main pattern band are simpler geometrics, and the red dye is a much brighter shade. The dominant impression is more one of order than one of subtle richness. A comparison of these two textiles of identical format indicates how two weavers could achieve quite different results while adhering strictly to a traditional form. 278 x 74 cm. FMCH X93.25.11; collection of H. Elly Azhar and H. A. Sutan Madjo Indo.

OPPOSITE:
6.89 *Kain tangkuluak*, a textile for tying the traditional Pariangan ceremonial headdress. Silk, plied silk thread, gold-wrapped thread. This textile is woven with an elaborate weft pattern band that contains both silk supplementary weft and gold-wrapped thread supplementary weft. A similar motif band is found in some textiles from the village of Padang Magek (see fig. 6.47). Which of these two villages is the source of the textile can be determined from a subtle technical difference in the way certain motifs in this pattern band are executed. The dye colors in this textile are particularly rich. The piece is especially refined and sophisticated. 255 x 69 cm. FMCH X93.25.44; collection of H. Elly Azhar and H. A. Sutan Madjo Indo.

6.91 *Kain tangkuluak*, a textile for tying the traditional Pariangan headdress. Silk, cotton, gold-wrapped thread. A typical cloth with supplementary weft pattern bands and no selvage border patterns. The patterned end panel in this textile is unusually long, measuring 72 centimeters. 272 x 70 cm. FMCH X93.25.45; collection of H. Elly Azhar and H. A. Sutan Madjo Indo.

6.92 *Kain tangkuluak*, a traditional ceremonial headdress textile from the village of Pitalah. Silk, gold-wrapped thread. Pitalah headdress textiles are distinguished by an inmost selvage pattern of either small triangles (bamboo shoots) or small lacy triangular shapes that resemble fern tips, pointing toward the center of the weaving. The Pitalah *tangkuluak* is tied so that the patterned end panel of the textile sweeps horizontally across the head at forehead level. Horn shapes are not visible from the front. 234 x 72 cm. FMCH X93.25.47; collection of H. Elly Azhar and H. A. Sutan Madjo Indo.

OPPOSITE:

6.93 *Kain tangkuluak*, a textile for tying the traditional ceremonial headdress from the village of Pitalah. Silk, gold-wrapped thread. The format of this textile bears some resemblance to formats of Pandai Sikek textiles. It has a featured band of the split-peanut motif and two featured bands of a chainlike motif enclosing stepped shapes similar to the silver-gilt beads in the ceremonial necklace of figure 6.85. This textile differs from most Pandai Sikek headdress textiles, however, in two readily apparent ways: it is 50 percent wider, consisting of two panels sewn together along the selvage, instead of a single panel, and the inmost selvage pattern is the small triangular motif. This selvage motif occurs commonly in Pitalah textiles but also, infrequently, in headdress textiles from nearby Pandai Sikek. 296.9 x 75 cm. FMCH X93.25.51; collection of H. Elly Azhar and H. A. Sutan Madjo Indo.

6.94 Wool *kain tangkuluak* for tying the Batipuah ceremonial headdress shown in figure 6.95. Wool, silver-wrapped thread, Dutch cotton print lining. This headcloth is couched with silver-wrapped thread and framed with appliquéd supplementary-weft bands of silver-wrapped thread. It was probably made in Saniang Baka for use in Batipuah. The couched motifs are Indian: blossoms and the *boteh*, or paisley, design. 166.3 x 68.5 cm. FMCH X93.25.8; collection of H. Elly Azhar and H. A. Sutan Madjo Indo.

6.95 A Minangkabau woman from the village of Batipuah in her home. She wears a wool ceremonial headdress couched with silver-wrapped thread and framed with appliquéd bands patterned in silver-wrapped thread supplementary weft. She wears a silk batik from Java as a *salendang*.

WOMEN'S CEREMONIAL DRESS AND RELATED CEREMONIAL TEXTILES

OPPOSITE:
6.96 Exquisite, old, and extremely rare *kain tangkuluak*, or headdress textile, from the village of Batipuah. Silk, *ramin*, gold-wrapped thread. This headcloth, used for tying a headdress similar to the ones worn in nearby Pariangan, is a masterpiece of hand weaving. It may be more than two hundred years old. The densely packed white silk wefts in the center of the textile and the exquisitely woven supplementary weft motifs in the end panels could have been executed only by a hand weaver with exceptional skills. All the warps of this textile are *ramin*, very narrow strips of the inner bark of a form of *Boehmeria* that grows along streams and near wet rice paddies in Southeast Asia. This bast thread dries over time, becomes brittle, and breaks when flexed. Very few textiles with such fragile warp material have survived in as good condition as the one pictured here. Narrow white silk bands interspersed between the red pattern bands suggest that the textile is related to the Batipuah *salendang*, the *tagak tujuah* (see fig. 6.40). 264 x 76.5 cm. FMCH x93.25.40; collection of H. Elly Azhar and H. A. Sutan Madjo Indo.

Details of 6.96
Three successive and slightly overlapping photographs of the patterning in one end panel of the textile shown in figure 6.96. The topmost photograph is nearest the center of the textile. The three read in order from the center to the warp end of the cloth.

Detail of 6.96

Above and below, details of 6.96

6.97 Very rare *kain tangku-luak* for tying a ceremonial headdress from the village of Gunuang, in the region of Padang Panjang, Tanah Datar. Silk, gold-wrapped thread. The textile is unusual in its extensive use of the red ground color in the motif bands, and in its width, which is almost half again as wide as other single-panel textiles woven in the region. The textile has been zone dyed: warps in the end panels are red, and warps in the center are purple. Each end panel of this remarkable weaving has fifty-one bands of supplementary weft plus selvage motifs. 288 x 73 cm. FMCH x93.25.30; collection of H. Elly Azhar and H. A. Sutan Madjo Indo.

6.98 *Talakuang*, or ceremonial veil, from the village of Koto Gadang. Velvet, gold-wrapped thread, silver-gilt. This graceful veil is constructed from a rectangular piece of velvet that, when folded in half lengthwise, makes an almost perfect square. It is seamed to make a hoodlike head covering. The seam, which is at the back of the hood, is not entirely closed. A length of about 15 centimeters is left open at the top so that the velvet can fall gracefully into folds at the back of the head. 127 x 59.7 cm. FMCH X97.50.50; private gift.

6.99 An elaborately decorated textile from the South Sumatran city of Palembang serves as a ceremonial headdress textile in the town of Bukittinggi. Silk, gold-wrapped thread, plied silk thread. Imported ceremonial textiles from Palembang have been cherished items in Minangkabau women's wardrobes for more than a century. The Bukittinggi woman's headdress is large and impressive. The lavish gold decorations woven into this textile underscore the headdress's statement about the importance of women in the Minangkabau culture. 213.4 x 83.8 cm. FMCH X97.50.51; private gift.

6.100 Bukittinggi woman's ceremonial headdress tied from an imported textile from Palembang (see fig. 6.99).

WOMEN'S CEREMONIAL DRESS AND RELATED CEREMONIAL TEXTILES

6.101 A wedding party from the village of Tilatang, Agam. The bride's headdress is the same as that worn in the village of Bukittinggi. The photograph was originally published in Haarlem, the Netherlands, in 1911. Courtesy of the Yayasan Dokumentasi dan Informasi Kebudayaan Minangkabau.

6.102 Several women from the village of Tilatang wearing contemporary ceremonial headdresses, which differ markedly from the version shown in the archival photograph (fig. 6.101). 1988.

6.103 Three textiles that make up the *tanduak* (horn) or *cawek* (waist tie) headdress from Limo Puluah Koto (fig. 104). Velveteen, silver-gilt, polyester, gold-wrapped thread, cotton. The black veil, or *talakuang itam*, is placed on the head first. The two-color velvet top veil (*talakuang songkok mato*), appliquéd with pieces of silver-gilt, hangs down the back, centered over the black veil. The red *cawek* (the same textile as the Limo Puluah Koto chieftain's waist tie) is formed into two blunt horns, *tanduak*, at the top of the head. 87 x 130 cm, 69 x 31 cm, 242 x 35 cm. FMCH X97.50.48 a,b,c; private gift.

6.103a

6.103b

6.103c

158 CEREMONIAL TEXTILES

6.104 front

6.104 back

6.104 The three pieces shown in figure 6.103 as they appear when formed into the ceremonial headdress.

WOMEN'S CEREMONIAL DRESS AND RELATED CEREMONIAL TEXTILES 159

Other Ceremonial Textiles
Funeral Shrouds and Veils
(*Kain Palambo Panutuik* and *Talakuang*)

At Minangkabau funerals, which are Islamic ceremonies, coffins are shrouded in adat textiles, and adat textiles are displayed on walls of the room holding the coffin. Shoulder cloths often serve as coffin shrouds. A chieftain's shoulder cloth from Batu Sangkar (fig. 6.106) becomes his shroud when he dies and is then carefully stored until a successor is chosen by the family. The successor wears the cloth to his investiture and to all subsequent ceremonies until he dies, and the cycle is repeated. These cloths are woven of cotton with red silk and metallic trim and are very sturdy. They are also very well cared for; one-hundred-year-old examples may look new.

A very old shroud from Batu Sangkar (fig. 6.107) is made with red silk selvages and patterned with red silk supplementary weft. This rare two-panel cloth, possibly from the eighteenth century, is woven with warps and wefts that are alternating groups of twelve cotton threads and twelve fine *ramin* threads, yielding a pattern of small squares of different textures.

A shroud from the village of Batipuah, a *tagak ampek* (fig. 6.108), is a textile also used ceremonially as a baby carrier. Although the format of this textile is typical of Batipuah weavings, such shrouds were not necessarily made only in that village. A weaver who lives in Pandai Sikek but whose family came originally from Batipuah has woven a shroud for herself in

6.105 This towering white headdress, *basipek putiah*, from Limo Puluah Koto is worn by older married women. The material is rice-water-starched cotton embroidered on the ends with a few rows of cross stitch. The billowing top layer of the headdress has been stiffened with concealed paper. The *basipek* headdress may also be folded out of batik. 186.2 x 152.4 cm. Private collection.

6.106 *Salendang/panutuik*, chieftain's shoulder cloth and shroud, from the village of Batu Sangkar. Cotton, silk, plied silk thread. A Batu Sangkar chieftain first wears this textile when he is elevated to office and thereafter when he attends ceremonial functions; it serves as his shroud when he dies and then becomes a *salendang* and *panutuik* for his successor. The extensive use of red silk and of multicolor silk supplementary weft make a striking foil for the deep indigo blue of the body of this distinctive shoulder cloth-shroud. 257 x 83 cm. FMCH x93.25.16; collection of H. Elly Azhar and H. A. Sutan Madjo Indo.

OPPOSITE:
6.107 *Panutuik*, or shroud, from the village of Batu Sangkar. Cotton, *ramin*, silk, plied silk thread. This large, extremely rare, two-panel textile is an example of the seldom-found use of *ramin* or bast as a major fiber in a Minangkabau weaving. Roughly half the warps and half the wefts are of *ramin*. As a bast fiber, *ramin* dries out in a relatively short time after it is removed from the parent plant. When it is dry, the fiber breaks easily, and the wear and tear that result from handling can seriously damage and weaken a textile woven with large amounts of this bast. Empty squares can be seen where *ramin* warps and wefts have both been lost. Even in the humid tropical climate of West Sumatra, which should help to preserve the bast, most of the relatively few surviving weavings with large amounts of *ramin* are found in shreds. The precise age of these textiles is not known, but they are generally thought to be at least two hundred years old. 262 x 96.5 cm. FMCH x97.50.90; private gift.

160 CEREMONIAL TEXTILES

6.108 *Panutuik* (shroud) or baby carrier from the village of Batipuah. Cotton, silk, gold-wrapped thread. This two-panel textile is called a *tagak ampek* because of the four (*ampek*) major white bands in the decorated end panels. The format is typical of a type of weaving from the village of Batipuah (compare fig. 6.39). The extensive use of cotton in this textile makes it sturdy enough to withstand the handling it also receives as a ceremonial baby carrier. 254.8 x 98 cm. FMCH X93.25.5; collection of H. Elly Azhar and H. A. Sutan Madjo Indo.

6.109 *Tangkuluak*, or veil, from the village of Batu Sangkar. Cotton, silk, gold-wrapped thread, silver. This woman's mourning veil with supplementary silk and supplementary gold-wrapped thread would have been worn by a widow to her husband's funeral and to subsequent rites dictated by the Islamic faith up to one hundred days after the burial. The supplementary end border contains the *kuruang* (enclosed or caged) motif, which appears also on prehistoric Minangkabau megaliths. When this motif is incorporated into a textile, it identifies the wearer as being from Batu Sangkar. 230 x 76.2 cm. FMCH X97.50.89; private gift.

OPPOSITE:
6.110 *Dalamak* (cover), a large *carano* cover. Cotton, silk thread for satin-stitch embroidery. This cotton square, probably woven in the town of Silungkang, is lavishly embroidered with 289 individual multicolored satin-stitch images of flowers, birds, butterflies, insects, fish, gamboling horses, elephants, dogs, men, Chinese characters, and Chinese symbols. The embroidery was most likely done by Chinese-Minangkabau. 68.6 x 68.6 cm. FMCH X97.50.64; private gift.

the Batipuah format, exemplifying the many problems confounding efforts to determine provenance.

Shoulder cloths also double as funeral veils. A blue-black shoulder cloth from Batu Sangkar (fig. 6.109), for example, also serves as a widow's mourning veil. It is decorated in red silk and gold-wrapped thread with the *kuruang* motif found on the four- to five-thousand-year-old megaliths and is trimmed with a fringe of silver leaves hung at the ends of short silver chains.

Food and *Siriah* Covers (*Dalamak, Tutuik*)

Dalamak, textiles used to cover and decorate trays of food carried by women on their heads during ceremonial processions, are highly embellished, often with couching or with satin stitch embroidery. The smaller satin-stitched textiles used to cover *carano* (the ornamented and footed brass bowls that carry elements of the betel quid, including *siriah* leaves) were embroidered by women from the local Chinese-Minangkabau population in the city of Padang, descendants (*paranakan*) of settlers who emigrated from China to Sumatra, some as early as the sixteenth century. Satin stitch has long been a staple of Chinese embroidery techniques (Shih 1977, 308–11).[3] An early twentieth-century *dalamak* (fig. 6.110) is made of a cotton square embroidered in silk satin stitch with 289 separate multicolored Chinese images.

A quite different contemporary food cover shows Indian influence. It is made of cotton velveteen couched with gold-wrapped thread and trimmed with several mirrors fastened to the cloth with embroidery stitches (fig. 6.111). At some ceremonies groups of women carry on their heads trays of food that are covered with these ornate *dalamak* (fig. 6.112).

Smaller than food covers are *tutuik*, or covers for *carano*. Three exquisitely decorated examples are illustrated here (figs. 6.113–6.115). Two are made of silk; one is cotton. All are embroidered in the technique known as drawnwork and have at least some satin stitch embroidery. The drawnwork embroidery is extremely fine. Before this type of embroidery can begin,

CEREMONIAL TEXTILES

6.111 *Dalamak* (cover). Velveteen, sequins, mirror, gold-wrapped thread, polyester lining and cords. This type of contemporary food cover can be seen in ceremonial processions where women carry large covered trays of food on their heads. The Indian-like use of mirrors on these covers is an example of the Minangkabau's willing adoption of decorative techniques from other cultures. 63 x 63 cm. Private collection.

6.112 Part of a procession at the dedication of a palace in Limo Puluah Koto in 1989. Several women are carrying on their heads trays of ceremonial food that are covered with elaborately decorated *dalamak* (food covers) made expressly for that purpose.

6.113 *Tutuik* or *saputangan siriah* (*carano* cover). Cotton, plied silk thread. This cotton square was woven in the town of Silungkang and is embroidered in a technique known as drawnwork. On all four edges of the textile, a band of threads that are parallel to the edge has been removed, leaving on each edge a width of unwoven threads perpendicular to the edge. These unwoven threads serve as warps for embroidery, which is needled in as color blocks to form images of birds, deer, roosters, and men. 55 x 60 cm. Private collection.

6.112

6.111

6.113

CEREMONIAL TEXTILES

one set of the interwoven threads must be drawn out of the area to be decorated in order to provide a framework of remaining threads into which the patterns can be needled. Special care is required to draw out (a single thread at a time, without damaging remaining threads) half of the fine silk threads in the patterned areas. A prodigious amount of patience and skill was required to produce these covers.

6.114 *Tutuik* (*carano* cover). Silk, plied silk thread, gold-wrapped thread. This striking square of silk decorated with satin-stitch embroidery is patterned in the center section with flowers and with a phoenix in each corner. The center is framed with drawnwork depicting four-legged animals. Two outer rows of embroidery contain satin-stitched florals and the triangles that represent the bamboo shoot to the Minangkabau. 44 x 44 cm. FMCH x93.25.97; collection of H. Elly Azhar and H. A. Sutan Madjo Indo.

6.115 *Tutuik* (carano cover). Silk, plied silk thread. This stunning small silk cover is decorated with 144 different multicolored images of birds, insects, crabs, blossoms, butterflies, and Chinese symbols. None of the motifs is repeated. The four different framing bands of embroidery contain triangles, swastikas, blossoms, animals (mostly flying creatures), and Chinese symbols. 54 x 51 cm. FMCH X93.25.98; collection of H. Elly Azhar and H. A. Sutan Madjo Indo.

6.116 *Titian* (bridge), a floor cover from Limo Puluah Koto. Cotton, gold-wrapped thread. According to tradition, this two-panel wedding textile was woven half by the bride's family and half by the groom's family. It is called a bridge because the bride and groom walked on it to approach each other during one part of the marriage ceremony. The act represented the bridging or joining of their two clans. Some *titian* were reportedly as long as four meters. 231 x 103 cm. Private collection.

Titian

The *titian* (bridge) was in earlier times a Limo Puluah Koto wedding textile (fig. 6.116). It is made of two cotton panels, one woven by the bride's family and the other woven by the groom's family. The two panels are joined at the selvage to make a wide, rectangular floor cloth. Some examples may be as long as three or four meters. During one part of the wedding ceremony the bride and groom approached each other, walking on this cloth, to symbolize the joining of their two clans (Anis and Anneka Salim, conversation with the author, 1986).

WEAVING THE COSTUME ELEMENTS

Centuries ago all weaving for an extended family was done by women of the matrilineage. Ceremonial garments and jewelry were heirloom treasures considered to be the property of the matrilineage. Not every family member had (or has) a complete set of ceremonial textiles,

and borrowing within the extended family was (and is) common. One finds extraneous pieces of cloth sewn to the back of a textile or to the inside of a shaped garment to identify its owner. Sometimes the owner's name has been written on the textile in ink.

In the last half of the nineteenth century the Dutch tried to discourage weaving so that imported cotton and wool yardage could more readily be sold to the Minangkabau. It is a testament to Dutch salesmanship that there are many ceremonial garments made of imported wool in this equatorial region. This sales effort helped to accelerate a trend to localize weaving in only a few villages where ceremonial garments as well as everyday wear were made either to order or to be sold off the merchant's shelf.

The most robust and lasting programs of village workshops or weaving factories grew in three villages: Silungkang, Pandai Sikek, and Kubang. Silungkang supports one family of hand weavers and a factory of fly-shuttle looms and exports its woven products not only to Sumatran villages but also to other Indonesian islands. Pandai Sikek today claims one thousand active looms, including those of a government-sponsored weaving cooperative. Kubang has a large fly-shuttle weaving factory making attractive and relatively inexpensive garments, sometimes available in hotel gift shops. Weaving has just begun as a subsidized government enterprise in a fourth village, Sijunjung (fig. 6.117).

Several individual hand weavers are currently active in the area around the town of Payakumbuh, in the regency of Limo Puluah Koto. Also, Rohanyi (fig. 6.118)—a weaver known for her excellent skills, though in her eighties—was still producing in the Tanah Datar village of Tanjung Sungayang in 1997. Her daughters are not weavers and will not carry on the family tradition. The headdresses and shoulder cloths that are her specialties (fig. 6.119) are being copied in Pandai Sikek.

In the 1950s the government of the newly formed nation of Indonesia, in an attempt to weld hundreds of disparate ethnic groups into a unified nation, introduced a campaign to wipe out the use of ethnic clothing and to substitute Western-style garments. The campaign was ended not long after its inception. Now the national government, through the establishment of weaving cooperatives around the country and through national contests, is working to revive weaving as a national art.

6.117 Fabric produced at the weaving cooperative in Sijunjung, which was established in the 1980s. The looms are warped in the town of Silungkang and delivered to Sijunjung. Warps, wound on a large roller, are installed at the foot of the loom. They are long enough to allow several pieces to be woven before the loom must be rewarped. The cloth is sold as yardage and is used in locally designed fashions made especially to promote Sijunjung weaving and thus provide employment for local young women. 1995.

6.118 The weaver Rohanyi at her home in the village of Tanjung Sungayang. She is known throughout the Minangkabau heartland for the excellence of her weaving. In 1997, at the age of eighty, she made her second pilgrimage to Mecca. 1988.

6.119 Contemporary headdress cloth or *basahan itam* (dipped in black). Cotton, supplementary weft of gold-wrapped thread. The headdress is worn by women from Tanah Datar, in the region of the village of Tanjung Sungayang, as an intricately folded ceremonial headdress (see fig. 6.79). This example, woven by Rohanyi, is made from cotton warps that were dyed black and green in the town of Silungkang. The great majority of older versions of such cloths are black with gold trim, although some extant examples are gray or brown. 194 x 60.8 cm. FMCH X97.50.49; private gift.

WOMEN'S CEREMONIAL DRESS AND RELATED CEREMONIAL TEXTILES

The Status of Minangkabau Weaving Today

New textile formats are emerging, which differ from the formats of traditional ceremonial textiles but still carry the time-honored adat motifs (see fig. 6.25). (See chapter 7 for a detailed discussion of Minangkabau adat motifs.) Today Minangkabau weavers are having difficulty finding affordable premium materials for their looms. The only gold-colored metallic thread that is available commercially in West Sumatra breaks easily and disrupts the already slow process of hand weaving. Weavers must stop and knot the broken thread, then continue weaving while maneuvering the knot to the back of the textile. Because the thread may break many times during production of a textile, such a defect adds measurably to the time a weaver must spend at the loom to complete a single piece. As a result, some women have quit weaving and have turned to decorating commercial cloth with couched metallic thread.

Add to the deficiencies of currently available gold-wrapped thread the fact that many women do not like its appearance, and a rationale for the practice of stripping gold thread from old, worn textiles becomes apparent. The thread salvaged from old textiles is not, however, entirely satisfactory either. Although the metallic or gold-on-paper wrappings of this thread may be of high quality, wear and handling often cause them to come loose from the core around which they were once tightly wound. This looseness gives an undesirable rough look to the new textiles into which stripped threads are woven.

Judging from textiles being handwoven today in the highlands, many Minangkabau weavers still possess the consummate skill and artistry of their forebears. If good quality gold thread were available to them, they could alter their looms to weave silk ceremonial garments to match those made centuries ago. Many clients would be willing to pay for such quality. But, for the time being, commercially spun cotton and synthetic threads generally supplant the extremely fine cotton, bast, and silk found in earlier weavings. Mediocre gold thread is found throughout. In spite of these difficulties, Minangkabau weavers are producing beautiful, sophisticated textiles-testaments to their remarkable art and skill (fig. 6.120). Heirloom garments made in earlier centuries can still be seen as part of some women's dress in ceremonial processions, but many of the beautiful contemporary textiles seen in these processions are just as refined and sophisticated.

It is obvious from the quality and artistry of the textiles illustrated here that providing Minangkabau women with ceremonial garments is costly in terms of both time and money. Ceremonial textiles, once purchased, are treated as the works of art they truly are. High levels of artistry in textiles are especially valued, and exceptional weavers are widely known and honored. Although great care is given to maintenance and storage, fragile garments eventually, sometimes over generations, succumb to the vicissitudes of age and wear and must be replaced.

Why was and why is a society willing to commit so much of its resources to the production of clothing, albeit ceremonial clothing? To the Minangkabau the great and indestructible value of their ceremonial garments is intrinsic. Ceremonial dress is rich in meaning. It speaks of village, family, and self; it speaks of adat, of centuries of tradition, and of responsible behavior; and it speaks of family cohesiveness and wealth. One of the old tutorial stories, the *kaba* known as *Malin Kanduang*, states that ceremonial textiles are the "skin of adat," the covering that makes the all-encompassing Minangkabau adat visible. In a society that boasts that its members are "people of the adat," such ceremonial textiles are worn with pride in what it means to be Minangkabau.

6.120 Contemporary *salendang*, or shoulder cloth, woven in Pandai Sikek. Polyester, gold-wrapped thread. This stunning textile contains some of the elements of older traditional formats of Pandai Sikek headdress weavings (fig. 6.85) and has incorporated elements traditionally used by weavers in other Tanah Datar villages. It exemplifies both the high quality of weaving skill and artistry in the Minangkabau highlands today and the erosion of conformity to village-specific formats and textile traditions. Collection of Mien Soedarpo.

WOMEN'S CEREMONIAL DRESS AND RELATED CEREMONIAL TEXTILES

Anne Summerfield and H. A. Sutan Madjo Indo

7

MOTIFS AND THEIR MEANING

The Minangkabau embellish their ceremonial textiles, sometimes lavishly, with motifs woven of colorful supplementary-weft silk threads and gold- and silver-wrapped threads—a technique known as *songket* (fig. 7.1; see chapter 8 for a discussion of the technique of *songket*, or supplementary-weft patterning). Garments are fashioned from these textiles in accordance with adat specifications and are worn during ceremonies as emblems of adat. The richness of embellishment both honors the adat and displays family wealth to the assembled community.

Minangkabau ceremonial textiles are elegant, refined, and sophisticated (fig. 7.2). Close examination of the weavings reveals additional interesting attributes. Intricate motifs are sometimes repeated, almost identically, from textile to textile, suggesting a relationship between the women who did the weaving, such as common village membership. Some textile formats (overall arrangements of patterns on textiles) seem to persist regardless of the dates of the textiles, as if they were recurring versions of an established textile type.

Some formats and motifs are village specific. This is to be expected, partly because the adat that governs ceremonial matters may also be village specific. A common saying expresses this:

In different grasses, different grasshoppers
In different ponds, different fish
In different villages, different adat

The adat that deals with ceremonies governs, among other things, what is acceptable as ceremonial wear. When the council of village chieftains finds it appropriate, it is empowered to add new rules to that adat. These new rules can affect what is acceptable as ceremonial dress in a given village. An additional, non-adat factor that may also have contributed to some ceremonial textiles being village specific is that, as late as the nineteenth century, village regions were largely self-sufficient and were socially separate from one another.

Names from Nature, Meanings from Adat

The format of a ceremonial weaving may identify its region of origin, but, according to our current understanding, it is the motifs within the format that convey the major import of the textile.[1] Names are regularly associated with motifs, and through those names meanings are also regularly associated with motifs. The names refer sometimes to ceremonial objects or practices; more often to botanic or animal entities such as the fern tendril, bamboo shoot, mangosteen calyx, wild snakes, dragonflies, or ducks.

References to flora and fauna not only are associated with motifs found in weaving and in house carving but are commonly found throughout the culture. They appear abundantly in Minangkabau poetry, proverbs, and other adat sayings. For example, a clan chieftain (*pangulu*), who has a responsibility to guide and protect his family, is poetically described as a tree in the middle of a field:

> With strong roots
> The top points toward heaven
> The roots are a place to sit
> The trunk is for leaning
> The branch is for hanging onto
> A place to dwell if it is raining
> A place to rest if it is hot[2]

Instead of speaking directly of the strengths and responsibilities of the *pangulu*, the Minangkabau speak indirectly or metaphorically, a practice dictated by adat. Almost all Minangkabau understand the meaning of the metaphor, and many are able to quote the poem.

7.1 *Kain tangkuluak*, headdress textile from the Pariangan/Batipuah region. Two panels, silk, cotton, plied silk thread. Both metallic threads and plied silk threads are used as supplementary wefts in the decorative band patterned with rectangles and hexagons. The two panels were woven so skillfully that the pattern bands in the two halves match almost exactly where the panels are joined. Although warps in the end panels are all red, warps in the center of this textile form alternate stripes of red and deep indigo blue, requiring a complicated process of partially overdyeing, or zone dyeing, some of the red warps with indigo and warping the loom so that red and blue warp stripes alternate. 255.3 x 71.1 cm. Private collection.

Not all metaphorical references to natural objects are as dignified as that of the sheltering tree. Some *pangulu* have human failings that suggest different natural models—for example, the *pangulu ayam gadang*, or "big chicken."

—he clucks about here and there,
crows to the left and the right
boasting of his fine qualities.
If anything good is done
it's always thanks to him;
if anyone else has planned it,
this is hidden by clever words
—that's what the *ayam gadang* is like.
There's a lot of clucking, but no egg
a fine parcel but no contents,
a beautiful package, but not enough string.
(Johns 1958, 100)

The *kaba* (an instructional story), from which this description is taken, describes six different types of "bad" *pangulu* in equally unflattering terms.

Metaphorical reference to a particular plant, insect, or animal is usually intended to remind the Minangkabau about some social responsibility or wise course of conduct. There is a proverbial warning against excessive pride: the squirrel can run fast, can jump far, and can fall (see fig. 10.19). A warning that one must protect one's treasure is phrased as "Got sugar? Got ants!" Literally thousands of such sayings have over centuries been used widely both in the current vernacular and in ceremonial speech (*pidato adat*) as brief expressions of the teachings of the Minangkabau's all-encompassing adat.

The name of a natural object assigned to a motif on ceremonial weavings usually serves as a reminder of a saying or sayings centered on that natural object. For example, the motif called the mangosteen calyx (*tampuak manggih*; fig. 7.3) refers to the mangosteen fruit (fig. 7.4), a luscious white sectional fruit encased in a thick, woody, mottled red rind. The sense of the adat teaching is that just as one would be sorely mistaken to judge the mangosteen fruit by its outer rind, so one should not adversely judge another human being because of skin color or unattractive appearance.

When and why did this Minangkabau practice of assigning names and, indirectly, meanings to textile motifs come about? There exists no record of when or why the names, let alone the meanings, were first assigned. One can, however, construct a probable explanation of why motifs were given names and sometimes meanings, and why the structure and folds of chieftains' ceremonial costumes are interpreted as signs pointing to responsibilities of male leadership (see chapter 5). An argument is given in some detail in the introductory chapter of this book to justify the conclusion that the Minangkabau assigned these names and meanings for mnemonic reasons.

How widespread in the Minangkabau heartland and how uniform is the practice of naming motifs? It is common in all of the heartland area if for no more profound reason than to make it possible for motifs to be discussed unambiguously by weavers or carvers. And using those names as signs to point to adat teachings also still obtains in most of the heartland region.[3]

Names and interpretations of certain motifs—such as the fern tendril (*kaluak paku*), Chinese root (*aka cino*), and bamboo shoot (*pucuak rabuang*)—appear to be the same from village to village. Names and meanings of many other motifs may vary (Kartiwa 1984, table I, following 54). The name of a motif may sometimes change over time, even within a given village (H. Elly Azhar, conversation with authors, 1988). Motifs that are universally recognized in the same way are generally thought to be the oldest (Anas Nafis, correspondence with author, 1989). Many appear on prehistoric megaliths found in the highlands.

OPPOSITE:
7.2 *Kain tangkuluak*, headdress textile from the region of Pandai Sikek/Koto Baru. Silk, cotton, gold-wrapped thread. This textile typifies the beauty and sophistication of design found in Minangkabau ceremonial textiles. 254 x 51 cm. FMCH X70.101; museum purchase.

7.3 Motif representing the calyx of mangosteen fruit, reproduced from a headdress textile woven in the village of Pandai Sikek. Textile detail, FMCH X97.50.15; private gift.

7.4 The calyx and unappealing red outer shell of the mangosteen fruit.

MOTIFS AND THEIR MEANING 173

7.5 A peanut, split, illustrating that the two halves of the split nut are of equal size.

7.6 A portion of the center field of a shoulder cloth showing concave-sided diamonds enclosed within overlapping octagons. This motif—called *balah kacang*, or split peanut—is a reminder that good Minangkabau must be honest in their dealings. Textile detail, private collection.

In the material that follows, six motifs are illustrated and discussed in detail to demonstrate how the Minangkabau use motifs as signs pointing to proper conduct as prescribed by adat. Additional drawings of thirty-five motifs are displayed with short comments. Finally, possible influences on motif design are discussed, including indigenous sources such as carvings on prehistoric megaliths. Influences from India, China, and the Middle East, in particular, are also considered. Later European influences, especially pictures in Dutch and English pattern books and examples of Indian *boteh* ("paisley" cloths) or herbals, gave rise to motifs that are not known to be associated with adat.

Some Common Woven Minangkabau Motifs and Their Meanings

Balah Kacang (Split Peanut)

When a single peanut is split in two, one observes that the two halves are equal (fig. 7.5). The teaching inherent in this motif is that if one is asked to divide something, one should go to all necessary lengths to ensure that the divisions are equal. And, by extension, a good Minangkabau is honest in his or her dealings.

The split-peanut motif (*balah kacang*) is constructed from circles, ovals, or octagons overlapping in such a way that a diamond with concave sides is formed in the center of the construction. Because it is difficult to weave curvilinear shapes, the form most commonly found in the body of textiles is that of overlapping hexagons (figs. 7.6, 7.8). The motif appears in textiles in two different forms. It may be woven as an overall repeated design that fills the body of a textile (fig. 7.6), or it may appear in a somewhat fragmented form in a single band (fig. 7.7), which is usually found in the elaborate warp-end panels of shoulder cloths or headdresses from the regency of Tanah Datar.

7.6

7.7 The *balah kacang* motif is not always an overall pattern. A weft band in the end panel of a headdress textile from the village of Pitalah is patterned with a single line of enclosed concave-sided triangles. Textile detail, FMCH X97.50.19; private gift.

7.8 A third way of representing the "split peanut" shows the motif as a small cluster of four overlapping octagons contained within a larger diamond-shaped outline. This motif is woven into an elaborately decorated old *salendang* from the village of Koto Gadang. Private collection.

174 CEREMONIAL TEXTILES

7.9

7.10

Barantai (Chain)

This motif appears most often in a form called the Bugih chain (*barantai bugih*),[4] a repeated pattern of intersecting diagonal lines of *X*s. The crossing lines form diamond shapes that in turn enclose other diamonds (fig. 7.9). Other chain motifs, such as the red chain (*barantai merah*; fig. 7.10) or white chain (*barantai putiah*; illustrated at the top of p. 182), are less common and appear to be more recent additions to the pattern vocabulary.

Among the Minangkabau the chain is used as a metaphor for community involvement, an essential and valued character of the culture. The meaning assigned to the chain motif is that just as a single link of chain is not a useful tool, so a single person, unconnected to the community at large, does not contribute to the strength and growth of the group nor to his own personal strength and usefulness.

A similar reference to strength of community is found for interwoven bamboo laths (*gedek*) used to form exterior rear or side walls of traditional houses (fig. 7.11). A single length of bamboo lath is flimsy; it bends and breaks easily. A single length is neither strong nor useful. But several such lengths, woven together, become strong and make useful house walls, providing privacy but letting cooling breezes blow into the sheltered rooms.

The importance of community to the Minangkabau is expressed in the following poem:

Sharing slights, sharing shames,
Sharing burial sites, sharing grave yards,
If going up a hill, climbing together,
If going down a gully, descending together,
Jingling clearly like iron,
Chirping in unison like chickens,
If there is good news, relayed from house to house,
If there is bad news, immediately coming to help.
(Kato 1982, 56)

7.9 The Bugih chain, or *barantai bugih*, motif is an overall pattern of intersecting diagonal lines made up of *X*s. The intersecting lines form diamond-shaped outlines, which in turn contain smaller diamonds. Textile detail, private collection.

7.10 Red chain, or *barantai merah*, motif formed with lines of *X*s outlining diamond shapes that enclose another diamond. The motif takes its name from the red color of the ground threads underlying the lines of *X*s. This motif appears as a single weft band rather than as an overall pattern. Textile detail, FMCH X97.50.15; private gift.

7.11 A Minangkabau house in the village of Sungayang with walls of woven bamboo (*gedek*). Both *gedek* and chains are strong, useful structures made up of weaker and not-so-useful individual elements. Thin strips of bamboo or single links of a chain by themselves are neither strong nor useful. These two motifs are used as metaphors for the Minangkabau ideal of a strong and well-functioning society made up of participants who as individuals are not as strong or as effective as the united community. 1991.

MOTIFS AND THEIR MEANING

Kaluak Paku (Fern Tendril)

The coiled form of the growing fern tendril (fig. 7.12) is a naturally occurring spiral, a shape found carved on Minangkabau megaliths dating from about the second or third millennium B.C.E. (fig. 7.13). Today the spiral-shaped folds in a chieftain's ceremonial hat (*saluak*) are used to describe the chieftain's responsibilities to his children, to his sister's children, and to his community (see chapter 5).

Because of the orthogonal nature of loom-based weaving, curved shapes are difficult to reproduce in woven textiles. The fern tendril is represented in some Minangkabau woven motifs as a series of short, straight lines approximating the curved shape of the spiral. The motif occurs most frequently as peripheral embellishments of diamond shapes (fig. 7.14). Such complex images are found in Middle Eastern rugs and textiles known to have been imported into the Minangkabau region.

Itiak Pulang Patang (Ducks Go Home in the Afternoon)

This motif appears on megaliths in the Minangkabau heartland and is thought to be one of the earliest indigenous motifs. It now appears in wood and stone carvings as well as in textiles, and its related saying is universally known in West Sumatra.

Wet-rice farmers lead their ducks to the flooded rice fields in early morning. There the birds swim in the water, eat insects, and fertilize the growing rice. At the end of the workday the farmer guides his ducks back to his dwelling compound. The ducks waddle down the road in a more or less straight line, and they seldom stray from that line (fig. 7.15). The teaching associated with the motif is: just as the ducks seldom stray from their line, so a good Minangkabau seldom strays from adat teachings.

Two forms of the motif are found in heartland textiles: one is a stick-figure representation of birds walking in a straight line (fig. 7.16), and the other is a woven form similar in outline to the wood- or stone-carved version of the motif (figs. 7.17–7.19).

A question sometimes raised by non-Minangkabau is whether these motifs are recognized by the general populace and whether they have current significance. An answer is given by a lighted transparency currently displayed above the ticketing counter at Padang's airport. At the top of this five-foot display is an image of several small yellow ducklings in a line (fig. 7.20). The headline advises travelers, "We must learn from them." The text urges readers to accomplish their good works without getting out of line (out of adat) and causing a commotion.

7.12 The spiral form of the young, growing fern accounts for the name *kaluak paku*, or fern tendril, assigned to spiral-shaped motifs.

7.13 A megalith in the field of four- to five-thousand-year-old megaliths in the village of Mahat, Limo Puluah Koto. The spiral shape was carved into the stone.

7.14 Some motifs from this Koto Gadang weaving consist of diamonds outlined by small spiral shapes. Although the spiral seldom appears alone as a motif in Minangkabau textiles, it is a shape folded into the *saluak*, a chieftain's hat. The shape suggests the leader's outer-directed responsibilities to the community and inner-directed responsibilities to his extended family. Textile detail, FMCH X97.50.79; private gift.

7.15 Ducks waddling more or less in a line as they return from the rice paddies to their home compound in the late afternoon. The Minangkabau say that just as ducks seldom stray from this line, so a good Minangkabau seldom strays from the teachings of adat. A Minangkabau village road, 1986.

CEREMONIAL TEXTILES

7.16 Stick-figure ducks march across a fragment of a weaving from the village of Pariangan, Tanah Datar, displaying the *itiak pulang patang*, or ducks-going-home-in-the-afternoon motif. The line of stick figures depicted here is one of two ways in which homebound ducks are represented in Minangkabau weavings (see also fig. 7.17). Textile detail, FMCH X97.50.18; private gift.

7.17 A second woven motif representing ducks going home in the afternoon. This shape more nearly resembles the shape that is carved into stone or wood to represent the *itiak pulang patang*. Textile detail, FMCH X97.50.15; private gift.

7.18 The repeated figure that follows the outline of this megalith is the carved motif for ducks going home in the afternoon. It is paired here with the triangle topped with a bloom, the flowering bamboo shoot. These are two of the oldest indigenous Minangkabau motifs.

7.19 Ducks going home in the afternoon and the bamboo shoot as carved into the wooden ceiling of a princess's bedroom in a palace built in Tanah Datar after World War II to replace the burned palace of Pagaruyung, a seat of the monarchy established by the fourteenth-century ruler Adityawarman.

7.20 This lighted display over the ticket counter in Padang's airport is an example of the way adat-based motifs still pervade the Minangkabau culture. The headline reads: "We must learn from them," admonishing readers to follow adat in their daily life. The body text reads: "Come, let us / build, do good works / and achieve / by working smoothly / and tranquilly, / all of us." In other words, follow the adat in your everyday activities, and don't engage in destructive behavior. 1997.

MOTIFS AND THEIR MEANING

7.21 Three variants on the way the bamboo shoot motif is depicted in Minangkabau weavings. The bamboo shoot is used in many different contexts to point to adat sayings about how young men should mature to become good Minangkabau.

7.22 The row of triangles representing bamboo shoots aligned across the end of this textile is called the *paga nagari*, or fence of the community. The three points of the triangle represent the three male roles responsible for maintaining the community: the *pangulu*, or keeper of the adat; the *ulama*, or keeper of Islamic traditions; and the *cadiak pandai*, or the intellectual who plans for the future of the village. Textile detail, collection of Don Cole.

7.23 A young bamboo shoot, showing the triangular shape depicted in woven and carved motifs.

Pucuak Rabuang (Bamboo Shoot)

The bamboo shoot motif, as depicted in Minangkabau ceremonial textiles, may vary from a simple isosceles triangle to a more elaborate and sometimes even flowered rendition of a roughly triangular shape (fig. 7.21). The three points of the triangle are said to represent the three men important to the survival of the culture: the chieftain (*pangulu*), responsible for maintenance of the adat; the religious leader (*ulama*), responsible for maintenance of Islamic religious practices; and the intellectual (*cadiak pandai*), who plans for the future of the village.

A row of triangles across the width of a ceremonial textile is called the *paga nagari*, or (protecting) fence of the community (fig. 7.22). The importance of the three leaders to the health of the village is expressed metaphorically in a saying: "When one cooks over an open fire, three stones [supports] are required to ensure that the cooking pot is stable."

A different teaching, also using bamboo as a reference, compares the way bamboo grows to the way young men should mature. Young bamboo, after it emerges from the ground as a shoot (fig. 7.23), grows very rapidly and very straight (fig. 7.24), until finally it leafs out and the topmost tuft bends over (fig. 7.25). In this instance the bamboo shoot motif says to the Minangkabau that a young man similarly should work fast and straight to his goals. When he has achieved his goals, he should look back to see from whence he came and, just as the top of the mature bamboo bends over, so should he bow his head and become humble.

The bamboo shoot motif also carries the meaning that a man should be like bamboo: when it is young, it is useful (it serves as food); when it is mature, it is helpful (it is too hard and coarse to serve as food but it may be used for scaffolding, walls, tools, flutes, and more). When a man is young, he is strong and can work long hours in the rice fields, can lift and carry heavy loads. He is useful. At this time he has only a single name, as is customary throughout Indonesia. When he becomes older and is probably not so strong, he has usually acquired a title (bestowed by the *niniak mamak*, an organization of *pangulu*), a place of respect in the community, and some clout. He is in a position to be helpful. This metaphorical reference to bamboo appears in a proverb:

> When the bamboo is young, it is called *rebuang*[5] [a shoot]
> When it is mature, it is called *batuang* [a trunk]
> When a person is still young he has a name
> When he is grown he has a title and position
> When a person is still young he is useful
> When he is old he is helpful.
> (Sanday and Kartiwa 1984, 19)

7.22

7.23

178 CEREMONIAL TEXTILES

Batang Pinang **(Trunk of the Areca Palm)**
This motif is normally found in selvage patterns. It consists of a narrow warp stripe of silver- or gold-wrapped thread. There are four such stripes in figure 7.26. The *pinang*, or areca palm, produces the mildly narcotic areca nut, which is an integral part of most ceremonial rites, but it is not in that capacity that the tree is recognized in textile motifs. The horizontally banded trunk of the areca palm grows very straight and very tall. When areca seeds are ripe, they fall straight down from the crown of the palm to the ground below, germinate in the fertile central Sumatran soil, and begin their growth close to the parent tree. Hence this palm trunk was selected as a metaphor for the good Minangkabau mother: she stands straight and tall in her integrity, her children stay close to her, and the family grows in concert.

Motifs Named after Ceremonial Objects
Some motifs refer to ceremonial foods such as the *galamai* or *kalamai*, a cakelike confection made of glutinous rice, palm sugar, and coconut milk. This cake is also called *ajik* or *wajik*, from the Arabic *wajib*, meaning "obligatory," because it must be served at certain ceremonies.[6] The cake is represented by diamond-shaped motifs both in weavings and in carving (fig. 7.27).

The ceremonial tobacco box, or *salapah* (fig. 7.28), is also represented by a textile motif. Two different-sized metallic containers that make up the *salapah* carry tobacco and shredded areca nut in the larger container and slaked lime for the betel quid in the smaller container. A multi-strand chain connects the two. Tobacco is frequently used to wipe the teeth when a betel quid is chewed. Its use is said to prevent the teeth from becoming stained by juices from the quid. The motif representing the *salapah* is often intricate (fig. 7.29).

7.24 The thin stem to the left of the picture is a straight, bare stalk of young bamboo during its period of rapid growth to mature height before it begins to leaf out, a metaphor for the rapid, straight path a young man should pursue to reach his goals.

7.25 Mature, leafed-out bamboo with its top tufts of leaves nodding toward the ground, a metaphor for the humility a man should feel when he has at last reached his goals.

7.26 *Batang pinang*, a narrow warp stripe that serves as a motif representing the trunk of the areca, or *pinang*, palm tree. Because of the tree's great height and the straightness of its trunk, and because its fallen seeds root close to the parent tree, the areca palm motif refers to the ideal Minangkabau mother. Textile detail, FMCH X97.50.15; private gift.

MOTIFS AND THEIR MEANING

7.27 Diamond shapes woven into a textile to represent the ceremonial cake *galamai* or *kalamai*, an example of a ceremonial object represented by a woven motif. Textile detail, FMCH X97.50.18; private gift.

7.27

7.28 Top and bottom of a *salapah*, a gold and silver tobacco box carried as part of the ceremonial costume. Contents of the larger container are shredded tobacco and a plug of shredded areca nut. The small container holds slaked lime. Private collection.

7.28a

7.28b

7.29 Complex motif representing the tobacco box from a headdress textile woven in Pandai Sikek. Many of the different variations of decorative diamond shapes used for this motif are village or village-region specific. Textile detail, FMCH X97.50.15; private gift.

7.29

7.30 The diamond-shaped motif for *katupek* in a textile from the village of Koto Gadang, Agam. The *katupek* is small packet woven of split palm fronds, which is used as a container for boiling rice. Private collection.

7.31 Clusters of the small rice containers called *katupek* purchased in the market in the town of Bukittinggi. To make a *katupek*, one wraps a length of split palm frond about two centimeters in width around each hand and proceeds to interlace the two fronds. Practiced plaiters can produce these little baskets at a rate of one every twenty seconds. 1996.

Katupek, a small container woven of split coconut fronds, is represented by a motif (fig. 7.30) from the regency of Agam. This small basketlike packet (fig. 7.31) is used as a container to cook rice in boiling water. Normally, as rice cooks, it expands into separate soft grains, but rice cooked in the *katupek* is so severely confined that it cannot expand as individual grains. The swelling grains push against one another and eventually merge into a rice cake the shape of the *katupek*.

The *katupek* motif is found mostly in textiles from Agam but sometimes appears in weavings from Limo Puluah Koto. There is an as yet unexplained relation between weavings from the Agam village of Koto Gadang and certain weavings in Limo Puluah Koto. A skirt called the *saruang Koto Gadang* is currently made in the region of Koto nan Gadang, in the regency of Limo Puluah Koto. And the *katupek* motif has been found on a shoulder cloth from the Limo Puluah Koto village of Taram.

7.30

7.31

CEREMONIAL TEXTILES

EXAMPLES OF TYPICAL MINANGKABAU
MOTIFS FROM CEREMONIAL TEXTILES

Names are known for most of the hundreds of motifs found in Minangkabau weavings, but many of the motifs have no known meaning. Thirty-five named motifs are represented below by drawings. Where meanings are known, they are included.

Ati ati basandiang: Side-by-side hearts. May refer to newlyweds sitting on a nuptial couch.

Atua maniak or *maniak barantai*: String of beads or bead chain, a ceremonial necklace.

Bada mudiak: Fish swimming upstream to spawn. Denotes courage and determination.

Bajanjang naiak batanggo turun: Whether one goes up or down, one must take the staircase, meaning that a good Minangkabau should act in accordance with tradition (adat).

Balah kacang gadang: Large split peanut in a single band of motifs rather than in the body of the textile (see earlier discussion of split peanut).

Balah kacang ketek: Small split peanut (see earlier discussion of split peanut).

Baliang baliang or *sajamba makan*: Weathercock or, quite different, several persons eating from the same ceremonial plate (see *sajamba* motif, discussed later).

MOTIFS AND THEIR MEANING 181

Barantai putiah: White chain (see earlier discussion relating chain motifs to community).

Batang padi: Stalks of ripened rice. Mature rice stalks in the field bend over at the top because of the weight of ripened grain. This motif has the same connotation as that of the mature bamboo's top that bends over: the mature Minangkabau who has reached his goals should look down to see from whence he came, bow his head, and become humble.

Batu bajanjang: Stone foundation for a staircase (the solid base of adat?). (See earlier discussion under *bajanjang*.)

Bijo bayam tatabua: Scattered spinach seeds.

Biku biku: Zigzag. Motif used as a dividing band between more complex motifs.

Bintang: Star. Any of a number of types of small motifs usually scattered throughout the body of a textile. They may sometimes represent the many villages scattered throughout the highlands.

Buiah dipantai: Foam or surf at the beach. If you know how to navigate the surf, you will arrive safe and sane at the opposite shore, meaning that if you learn how to handle the difficult jobs, you will be able to handle the easy ones.

Cukia Koto Gadang: A Limo Puluah Koto motif copied from a Koto Gadang weaving.

182 CEREMONIAL TEXTILES

Itiak pulang patang: Ducks going home in the afternoon (see earlier discussion).

Kunang kunang: Fireflies. Just as small fireflies can light up the night, so Minangkabau can by appropriate behavior spread hope and encouragement in the community.

Ladang batumpak: Small parcels of nonirrigated fields.

Lundi badadak: The beetle larva has a sound. From the proverb "Wherever one places the mortar, it makes the same sound," meaning that the condition of the poor man is always miserable, even if he changes his job.

Paku gerai: Waves or ripples of fern. A motif found in selvage patterns of textiles woven in the region of Pitalah in Tanah Datar.

Pucuak rabuang bungo sikaku (1): Bamboo shoot with cornflower or tree of life.

Pucuak rabuang bungo sikaku (2): A motif usually woven to be much larger than (1) but with the same meaning.

MOTIFS AND THEIR MEANING

Saik ajik: Ceremonial cake. The term *ajik* or, sometimes, *wajik* comes from the Arabic *wajib*, meaning "obligatory," because this cake must be served at ceremonies. It is often represented by a row of single diamonds rather than the band of diamonds created by intersecting diagonals, shown here. The latter motif is commonly found on bronze Dongson drums, which were known to be in Sumatra at least as early as 1000 C.E.

Sajamba makan or ***bajamba***: Four persons eating together from a single ceremonial plate. Refers to the importance of sharing in the Minangkabau culture.

Saluak barantai: Interlocking chains. Refers to the strength and usefulness that results when persons act together as members of the community (are linked to make a community).

Saluak laka: Interwoven rattan. A reference to the importance of individual Minangkabau becoming involved in common activities that help to build and strengthen the community.

Salapah: Reference to a ceremonial object, the tobacco box, which carries some of the ingredients used in assembling the betel quid (see also figs. 7.28, 7.29).

Salapah bada mudiak: The tobacco box motif with borders of the *bada mudiak* motif. Note here the depiction of the chain connecting the slaked lime container to the tobacco container.

Sipatuang mandi: Dragonfly's bath. We have been unable to obtain a direct explanation of the meaning of this motif, but there are two proverbial references to the dragonfly and water: (1) The time of a dragonfly's bath is very short and (2) When the dragonfly dives on the water, the harvest spiders (daddy longlegs) follow.

Tapuak manggih barantai: Mangosteen calyx in the form of a chain (see earlier discussion for a detailed description of the mangosteen calyx and chain motifs).

Tirai (from an Arabic ceramic): Motif taken from a piece of imported pottery. Sometimes called Muhammad's curtain (Muhammad was the name of the trader who imported the pottery).

Ula basisiak: Snake with scales. There are many proverbs that refer to snakes. For example, "to have a snake as a venomous friend" means that one should not let one's anger get the best of one. Another proverb—The serpent that coils around the tropical creeper does not die—means that one should not be afraid of confronting difficulties because of the possible outcome. A person who lives beyond his or her means is compared to a leech that wants to become a python.

Ula gerang: Wild snake. "The serpent in the bamboo is small but makes much noise" is an admonition not to let yourself be influenced by menacing comments from others.

Ulek sipasan: Centipede. "To rise up like the centipede" means do not try to raise yourself above others.

Ulek tantadu: Caterpillars on parade. Has a meaning similar to that of the ducks going home in the afternoon. Just as caterpillars who are moving together in a line are not off eating the flora, so a good Minangkabau does not stray from tradition and behave destructively.

MOTIFS AND THEIR MEANING

7.32 The weaver Rohanyi at her loom in the village of Tanjung Sungayang. The village road that passes her house is clearly visible from the loom, allowing her to keep abreast of village happenings while she is weaving. 1988.

7.33 Looms in the village of Balai Cacang are often placed under the house. The space is cool, and pierced slats that enclose the area let in any breezes. Although the weaver is more comfortable than she would be in the hot, humid atmosphere of the upper house, the location keeps her isolated from outside activity. 1986.

Possible Sources of Influence on Motif Design in Minangkabau Ceremonial Textiles

Contact with foreign cultures had significant influence on the forms of motifs woven into ceremonial textiles in the landlocked heartland of the Minangkabau. Christine Dobbin (1983, 1) argues that it was the nature of the Minangkabau to be open to such influences:

> The sober, regular tenor of farming life in the Sumatran highlands is in marked contrast to the bustling, competitive world of the coastal trader. But in the central highlands, which because of certain topographical peculiarities have ample access to the coast, agricultural change and innovation developed side by side with the ability to seize coastal trading opportunities, producing a people of peculiar dynamism and adaptability and necessitating constant readjustment within their society. The inhabitants of the Central Sumatran highlands, the Minangkabau, have become famous throughout the Indonesian world for their agricultural skills, for their commercial adaptability, and for their general willingness to seize new opportunities and adapt to new mental horizons, whether introduced from India, from the Middle East, or from Europe. Hand in hand has gone the capacity to preserve their own peculiar identity.

Contact with foreign cultures has been widespread. Young men who went to the *rantau* areas of the coasts of Sumatra and to other islands met with traders from many different lands. Direct contact with large numbers of outsiders was also made by Minangkabau traders who traveled the rivers from the highlands to Sumatra's east coast and the Straits of Malacca. There they exchanged gold, gambir, and pepper for textiles and other goods from the Middle East and from other parts of Asia. These men brought cloth, kilims, pile rugs, gold thread, and other treasures back to their families and to their villages. Foreign traders also came to the heartland, but in far fewer numbers than plied the straits.

Weavers in Tanah Datar worked on looms that were kept in the front of the house, where they could see foot traffic in the village (fig. 7.32). Many foreign traders passed through Tanah Datar's main villages. When strangers wearing unfamiliar clothing came within a weaver's view, she could observe and respond to any new and different motifs on the stranger's garments. If a particular motif was appealing, a weaver might later incorporate it into her patterns, although always within the strictures of adat. Tanah Datar textile specialists claim that the exposed location of looms explains in part why Tanah Datar textiles display a considerably richer and more varied vocabulary of motifs than do textiles from Limo Puluah Koto,[7] where looms either were closeted in the cooler enclosed areas under the house (fig. 7.33) or were kept inside the house, next to the kitchen. In either location, weavers could not watch the passing scene.

186 CEREMONIAL TEXTILES

The claim that contacts with external cultures or with their artifacts influenced Minangkabau textile design is not entirely speculative, but certainly not all Minangkabau motifs similar to motifs found in other cultures are the result of such external influence. Some undoubtedly came into being independently, either as developments of weavers' experimentation or as outgrowths of the orthogonal techniques and limitations of loom-based weaving. Some Minangkabau motifs that are also common to other cultures, however, are so complex, the duplication is so precise, and so many examples are found that it is reasonable to assume that some connection between cultures is responsible for the similarities. Weavers may have had common access to motifs through ancient heritages, such as the motifs found on megalithic remnants of a prehistoric Minangkabau culture. Or there may have been an exchange between cultures of decorated objects such as textiles and other objects that were known to have been imported into the Minangkabau heartland from around the world.

Examples and brief discussions below suggest ways in which lost or external cultures either did influence or might have influenced Minangkabau textile arts. Comparable examples are given of motifs common both to extant Minangkabau weavings and to arts from other cultures. These examples do not constitute an exhaustive list of motifs shared by the Minangkabau with other cultures. Reasons for displaying the commonalities are to expose the extent of possible external influence on Minangkabau weavers and to promote an interest in further examination of this relatively unstudied material.

Megaliths

Many motifs found in Minangkabau textiles were carved on megaliths located mainly in the regency of Limo Puluah Koto. Major examples are: the spiral, now called the fern tendril (see fig. 7.12); the isosceles triangle, now called the bamboo shoot (see fig. 7.23); the meander, now called Chinese root (*aka cino*; fig. 7.34); and an *X*-like figure (fig. 7.35) that has been found as a motif only in old textiles from the village of Batu Sangkar. The *X*-like textile motif (fig. 7.36) is a slightly geometricized copy of that carved into the stone; today it is named *kuruang*, or "enclosed." An interesting aside is that the village name, Batu Sangkar, translates as "caged stone."

7.34 In addition to "ducks going home in the afternoon" and the bamboo shoot, a third traditional motif found in Minangkabau weavings is *aka cino*, or Chinese root, a meander carved into the ancient megaliths at Mahat. It is seen here at the foot of the megalith. 1997.

7.35 The red *X*-like figure woven into this widow's mourning veil is called *kuruang*, meaning "caged" or "enclosed." The motif appears to be unique to weavings from the village of Batu Sangkar and environs. It appears on megaliths found at Balubuih, in Limo Puluah Koto. Detail of end panel decoration, FMCH x97.50.89; private gift.

7.36 Megalith from the region of Balubuih, Limo Puluah Koto, carved with the motif now known as *kuruang*. This stone was moved from Balubuih to the garden of the Adityawarman Museum in Padang, West Sumatra. 1997.

MOTIFS AND THEIR MEANING

China

Chinese influence is seen in the extensive use of gold-wrapped thread (much of it of Chinese manufacture) for patterning. Minangkabau weavers claim that the Chinese taught them to weave with gold thread (the gold-wrapped thread that was preferred by Minangkabau weavers before World War II is called *makau*, after the Macao Peninsula southwest of Hong Kong), but Javanese and Indian influences may also have contributed to that use. Court textiles imported from Java into Minangkabau during the fourteenth century, at the time of Adityawarman, were embellished with gold and with patterns probably influenced by Indian imports to the Javanese Hindu court of Majapahit.[8] Minangkabau weavers—at least those in Tanah Datar, where Adityawarman established his court—probably had the opportunity to see and to copy those textiles.

Chinese silks and models of elaborate Chinese headdresses imported into Sumatra became part of Minangkabau ceremonial costumes. Designs in ceremonial textiles made with satin-stitch embroidery were clearly influenced by Chinese art and were often produced by local Chinese. Certain nineteenth-century silk bowl covers used in heartland ceremonies (see figs. 6.114, 6.115) were probably embroidered either by Chinese who had immigrated to Sumatra or by their descendants, particularly those living in Padang. Satin-stitch motifs on these exquisite covers are uniquely Chinese, but the covers have been accepted as adat for use during ceremonies and are highly prized by their heartland owners.

In the early twentieth century larger embroidered covers were made on cotton cloth produced in the village of Silungkang. (see fig. 6.110). These covers were used to protect either ceremonial food or the *carano*, a footed brass ceremonial bowl used to store elements of the betel quid. There are also smaller cotton squares woven in Silungkang that have been embroidered in satin-stitch floral motifs by non-Chinese Minangkabau.

A Chinese silk damask tunic decorated with satin-stitch floral motifs, probably executed by highland Minangkabau embroiderers, has been approved as adat to be worn as part of a woman's ceremonial costume. Unembroidered Chinese silk damask tunics are now acceptable as adat ceremonial wear.

India

Much of the cloth imported into the Minangkabau highlands from India through the early second millennium C.E. was simple cotton cloth that the Minangkabau dyed with indigo and made into everyday wear (Dobbin 1983, 99). Enough cloth was imported into the highlands for Indian companies to establish a trade mono-

7.37 Detail from a headdress embroidered in the village of Batipuah with couched figures of blossoms and *boteh*, the Indian "paisley" design. Textile detail, FMCH X97.50.53; private gift.

7.38 The *boteh*, or "paisley," design and Indian herbals are woven into a shoulder cloth from the village of Koto Gadang. 207 x 52 cm. Collection of J. Daniel and Gerdy Ungerer.

tor in the area of Tanah Datar in the twelfth century (Dobbin 1983, 61). Whether gold-embellished Indian textiles were introduced at that time is not known.

Later Indian influences can be seen from the inclusion of Indian designs in Minangkabau ceremonial textiles. The Indian *boteh*, or paisley, design appears both in couched designs (fig. 7.37) and in woven designs (fig. 7.38). Indian herbals appear on shoulder cloths from the village of Koto Gadang. Many Minangkabau textiles were woven in the patola format (fig. 7.39).

Indian silk ikat patola textiles were brought to Sumatra and to other Indonesian islands by Indian traders and later by the Dutch. Both groups gave these exquisite silk ikat cloths to local rulers in exchange for favorable trade agreements. The cloths soon became symbols of prestige. Persons who could not own a patola were eager to find acceptable substitutes. To satisfy this demand, Indian traders first imported into Sumatra, and later local factories produced (Bühler and Fischer 1979, 158–59), printed cotton cloths called *sarassa* (fig. 7.40), which mimicked the patola.

One old, highly valued Minangkabau shoulder cloth woven in the patola format is still kept in family heirloom collections and worn by both sexes in Minangkabau (fig. 7.41). This type of shoulder cloth is so highly revered that in at least one known instance it was kept in a family collection by being made into a man's ceremonial shirt when it became too frayed for use as a shoulder cloth.[9] This shoulder cloth probably has an Indian ancestor. In its format and patterning, the Minangkabau cloth strongly resembles an Indian ikat cloth found in the nearby Lampung region of Sumatra (fig. 7.42).

7.39 End portion of an Indian silk ikat patola showing details of the patola format: selvage border patterns, weft pattern bands (often with repeated triangular *tumpals*) at the warp ends of the textile, repeated motifs in the body of the textile, and, often, fringe. Private collection.

7.40 *Sarassa*, an example of the printed cotton textiles designed in the patola format as inexpensive substitutes for the silk double-ikat weavings that carried great prestige in all of Southeast Asia, including the Minangkabau community. Private collection.

7.41 A silk, possibly double-ikat shoulder cloth woven in the patola format. Motifs on this ikat textile are typical of weavings from the village region of Batu Sangkar, but the dyeing technique is not. Minangkabau weavers claim that two-color wefts were never ikat-dyed in Batu Sangkar. How this textile was dyed and where it was woven are not known today. It was probably inspired by an Indian textile imported into the Minangkabau region (see fig. 7.42). Private collection.

7.42 End portion of one panel of a two-panel cotton Indian ikat textile found in the Lampung area of Sumatra showing a close resemblance to the Minangkabau shoulder cloth in figure 7.41. Plaids were common decorative elements of Minangkabau ceremonial textiles, but small checks were not. Because South Indians resided in Tanah Datar from the twelfth century, it is highly likely that Minangkabau weavers could have seen or even owned textiles such as the one illustrated here and adapted their format to make a textile that met adat requirements. Note how similar in appearance the irregularly dyed wefts in the two textiles are. Were they dyed by the same technique? Textile detail, private collection.

MOTIFS AND THEIR MEANING

7.43

7.44

The Middle East
Yemeni Ikat
Yemen was a stop on major trade routes from the Red Sea, which led to the Indian Ocean and thence to India; to Aceh, at the northern tip of Sumatra; and, through the Straits of Malacca or the Sunda Strait, to China. Yemeni traders were active on this route, making fortunes selling frankincense (Osman Mawardi, conversation with authors, 1998). Some Yemeni travelers spent time on the island of Sumatra. Starting in the tenth century, Yemeni wove textiles patterned with a particular warp-ikat design of diamonds. In the Middle East that pattern is unique to Yemen. In Southeast Asia the pattern appears in Minangkabau textiles, executed not in warp ikat, but in weft ikat. Pictured are two early Yemeni ikat textile fragments (figs. 7.43, 7.44), a Minangkabau shoulder cloth (fig. 7.45), and a portion of a man's belt (fig. 7.46), the last two with the "Yemeni" pattern in silk weft ikat.

Turkish Pottery Decoration
A design painted on the rim of a sixteenth-century Iznik dish (fig. 7.47) is the same as a pattern woven in the selvage of a very old Minangkabau shoulder cloth (fig. 7.48). The same pattern has been found also in cloths known as *tampan* from the coastal region of Lampung, at the southern tip of the island of Sumatra.

Metalwork
Comparable Y-shaped motifs appear on a tinned-copper Persian bowl of the late sixteenth century (fig. 7.50) and on a Minangkabau textile probably from the Pariangan area (fig. 7.49).[10] The Minangk-abau have named this motif *kunang kunang*, or "fireflies." It refers to the adat teaching that just as groups of fireflies create light in the dark, so individual Minangkabau together can spread hope.

7.43 Fragment of a tenth-century Yemeni silk weaving showing the diamond warp-ikat pattern, which in the Middle East is unique to Yemen. Yemeni seamen and Yemeni textiles are known to have found their way to Sumatra through the lively trade route between Arabia and China. A pattern very much like the Yemeni diamond pattern appears in Minangkabau textiles, but executed in weft, not warp, ikat (see figs. 7.45, 7.46). The Metropolitan Museum of Art, Gift of George D. Pratt, 1929 (29.179.9). Photograph © 1992 The Metropolitan Museum of Art.

7.44 A further example of the unique Yemeni diamond ikat pattern is clearly visible in this fragment of a Yemeni weaving dating to the tenth century. Collection of Osman K. Mawardi.

The formats of the two cloths are roughly the same, except that the Indian cloth is wider, being made of two joined panels. Red and white checks in the bodies of the cloths are about the same size and color. Areas of unevenly dyed threads at the interface between the red color of wefts in the all-red selvage and in the all-white areas in the checkered center of the cloth look the same on both cloths (compare figs. 7.41, 7.42). The end panels bear some resemblance to each other, although the Minangkabau piece is patterned with supplementary-weft motifs that are typically Minangkabau and the Indian piece is patterned with mordant painted motifs that are typically Indian. Both carry a prominent weft band of isosceles triangles, called *tumpals* in Indian cloths. The beautiful and complex Minangkabau textile illustrates how a skillful local weaver might adapt a foreign design to her motifs and to her adat's requirements.

7.45 A Minangkabau chieftain's cotton, silk, and *ramin* shoulder cloth with a silk weft ikat pattern that closely resembles the Yemeni warp ikat diamond designs. Private collection.

7.46 A Minangkabau chieftain's ceremonial silk belt patterned with weft ikat that closely resembles the Yemeni diamond warp ikat pattern. FMCH, X97.50.63; private gift.

7.47 Figures on the rim of this sixteenth-century Iznik pottery bowl are the same as those found in selvage border patterns (fig. 7.48) and in supplementary-weft bands of Minangkabau shoulder cloths. The same figure also can be found in other Sumatran textiles. Courtesy of Sotheby's, London.

7.48 Very old Minangkabau shoulder cloth with selvage pattern matching figures on the rim of a sixteenth-century Iznik bowl (fig. 7.47). Textile detail, private collection.

MOTIFS AND THEIR MEANING

7.49 Textile from the Pariangan/Batipuah region with two supplementary-weft bands patterned with inverted-*Y* motifs found on a sixteenth-century Persian bowl (fig. 7.50). The Minangkabau have labeled the motif *kunang kunang*, or fireflies. The related adat saying expresses the idea that just as individual fireflies are points of light in the night, so individual Minangkabau should be points of hope in the community. Textile detail, FMCH X97.50.17; private gift.

7.50 The inverted-*Y*-shaped motifs in sections of this late sixteenth-century tinned copper Persian bowl are the same as figures found in supplementary-weft bands of a Minangkabau shoulder cloth. Courtesy of Sotheby's, London.

7.51 Early fifteenth-century Ottoman silver bowl with an intertwined motif that can be found in selvage patterns of Minangkabau ceremonial textiles. This motif is found on many types of Ottoman art objects. Courtesy of Sotheby's, London.

7.52 The motif in the selvage pattern of this Minangkabau textile from the village of Pandai Sikek strongly resembles a motif found in Ottoman art objects. The Minangkabau call the motif *saluak laka*, or interwoven rattan. It serves as a reminder of the importance to the Minangkabau of a close-knit community in which all members participate. Textile detail, private collection.

7.49

7.50

7.51

7.52

A motif called *saluak laka*, or "interwoven rattan," by the Minangkabau, appears on an early fifteenth-century Ottoman silver bowl (fig. 7.51) and in selvage motifs on a Minangkabau textile (fig. 7.52). This motif also appears carved in marble on a casket in Pamplona, Spain, and is the patterning in the warp border of some fifteenth-century Spanish rugs.

Persian Tiles
Tiles in a prayer niche from a mid-fourteenth-century Persian mosque at Kashan (fig. 7.53), now at the Metropolitan Museum of Art in New York, bear the same interlocked overall pattern that appears in gold supplementary weft in the body of a Minangkabau textile (see fig. 7.6). This pattern, the *balah kacang* (split peanut), is composed of intersecting oval or octagonal forms that overlap to form diamond shapes with concave sides.

Kilims and Pile Rugs from the Middle East
A large number of Minangkabau motifs have exact or nearly exact counterparts in Middle Eastern rugs. Several examples of Minangkabau motifs and their counterparts are illustrated here (figs. 7.54–7.73). These are only a few of the many available examples.

7.53 Tiles in the bottom of the cylindrical portion of a prayer niche of a fourteenth-century Persian mosque are patterned with a motif constructed from overlapping octagonal figures in the same manner as the Minangkabau *balah kacang* motif (see fig. 7.6). A very early example of this motif is incised as an overall pattern on a pottery vase from the Indus Valley, circa 2500 B.C.E. The Metropolitan Museum of Art, Harris Brisbane Dick Fund, 1939 (39.20). Photograph © 1982 The Metropolitan Museum of Art.

MOTIFS AND THEIR MEANING

7.54 Diamond motif in a textile from the village of Pariangan. The periphery of the diamond is outlined with small, solid-colored triangles. This motif appears in textiles found throughout Southeast Asia, particularly those from Laos. Textile detail, private collection.

7.55 Detail of Middle Eastern pillow cover displaying the same diamond motif found in the textile shown in figure 7.54. Collection of Valerie Justin.

7.56 *Kotsanak* pattern, a diamond enclosing a smaller diamond surrounded by four floral representations, in Middle Eastern rug. Collection of Valerie Justin.

7.54

7.55

7.56

7.57

7.58

7.57 Pattern bands from the end panel of a Minangkabau textile from the village of Lintau. The top band contains a floral-filled diamond-shaped motif that duplicates the *kotsanak* figure. Textile detail, FMCH X93.25.31; collection of H. Elly Azhar and H. A. Sutan Madjo Indo.

7.58 Minangkabau weaving from the village of Pandai Sikek containing a weft band of diamond-shaped motifs of floral elements. These motifs differ from the traditional Middle Eastern *kotsanak* in that there is no linear outline of the diamond. Textile detail, FMCH X97.50.81; private gift.

194 CEREMONIAL TEXTILES

7.59

7.60

7.59 Diamond with extended points from Central Anatolian kilim. Private collection.

7.60 A slit-tapestry belt from the town of Solok. Tapestry figures executed in silver-wrapped thread include diamonds with extended top and bottom points (compare fig. 7.59). Textile detail, FMCH X57.50.35; private gift.

7.61

7.61 Detail of shoulder cloth from the village of Koto Gadang with a weft band of diamonds with extended top and bottom points. Textile detail, The Textile Museum, Washington, D.C., no. 1985.57.6. Collector: Mary Hastings Bradley, Donor: Alice Bradley Sheldon.

7.62

7.63

7.62 Half of an Anatolian *yastik* patterned with diamonds outlined with double hooks that form *S* shapes. Collection of Dennis Dodd. Photograph reproduced from Brian Morehouse, *Yastics, Cushion Covers, and Storage Bags of Anatolia*; courtesy of Brian Morehouse and the International Conference on Oriental Carpets VIII.

7.63 Diamond motif from a Koto Gadang *saruang* showing a diamond outlined in *S*s formed from double hooks (compare fig. 7.62). Textile detail, FMCH X97.50.79; private gift.

MOTIFS AND THEIR MEANING

7.64 A *yastik* patterned with diamond-shaped figures enclosing a vertical line of three small diamonds flanked by opposing "figure threes." In Persian this motif is called *joshigan*, or tree of life. Collection of Dennis Dodd. Photograph reproduced from Brian Morehouse, *Yastics, Cushion Covers, and Storage Bags of Anatolia*; courtesy of Brian Morehouse and the International Conference on Oriental Carpets VIII.

7.65 Turkish pile rug containing an overall pattern of the diamond-shaped motif called *joshigan* in Persian. Collection of Brian Morehouse.

7.66 Motif from a Mamluk shawl. Egypt, thirteenth or fourteenth century, or possibly Fatimid, tenth or eleventh century. Linen tapestry. The figure displayed here in the interior of the stepped octagon is a further example of the *joshigan* motif. Detail from a textile fragment. 155 x 56 cm. Private collection.

7.67 A Minangkabau variant on the motif illustrated in figures 7.64 and 7.65 from a textile woven in Limo Puluah Koto. Private collection.

CEREMONIAL TEXTILES

7.68 The motif of a hexagonal shape with enclosed figures is often found in reed screens from the Caucasus as well as in pile rugs and kilims from the Middle East. The hexagonal figure pictured here is from a pile rug. Collection of Brian Morehouse.

7.69 The major pattern band in the end panels of a Minangkabau textile from the Pariangan/Batipuah region contains diamond shapes enclosed in hexagons. A similar motif appears in textiles woven in the village of Padang Magek. Private collection.

MOTIFS AND THEIR MEANING

7.70 Detail showing cursive forms used to embellish *X*-shaped figures in a shoulder cloth from the village of Padang Magek. It is likely that these cursive shapes were borrowed from Arabic writing, which Minangkabau were expected to learn to read in order to be able to study the Koran. Textile detail, FMCH X97.50.69; private gift.

7.71 Fifteenth-century Hispano-Moresque textile. Embellishment of Arabic letters in the calligraphy woven into this textile closely resembles the embellishment of the *X*-shaped motif illustrated in figure 7.70. Photograph from Los Angeles County Museum of Art, *2000 Years of Silk Weaving* (New York: E. Weyhe, 1944), fig. 137, pl. 38. Courtesy of Los Angeles County Museum of Art.

An example of Arabic influence that is not a direct match of motifs appears in the embellishment of *X* motifs in an exquisite shoulder cloth from the village of Padang Magek (fig. 7.70). That this motif closely resembles embellishment of letters in Arabic writing was first pointed out to us by Islamic scholar Rina Indictor. Compare, for example, the writing in a Hispano-Moresque silk textile (fig. 7.71). Embellishment in the Minangkabau piece is correctly interpreted as an Islamic element deliberately added to an adat textile. The textile was woven in the village of Padang Magek, where the adat headdress is folded from a *saruang*, an adat textile, and a *mukena*, an Islamic woman's prayer veil. This headdress is considered by heartland Minangka-

bau to be a metaphor for their skillful blending of Islam and adat.

* * *

The examples discussed above illustrate similarities between Minangkabau textile formats and motifs found in Chinese, Indian, Arabic, and Middle Eastern textiles. These similarities do not necessarily imply a direct relationship, but they present interesting possibilities deserving of further study.

A question that remains to be answered is whether the aggregate of adat-based motifs woven into a given ceremonial textile carries an additional message. Is the whole greater than the sum of its parts? Can survival over centuries of the format of a particular village textile be adequately explained by its containing a supra-message, a meaning above and beyond the several messages of individual motifs?

Examples of motifs and their meanings were presented here partly to provide insight into the great extent to which adat permeates the everyday life of the Minangkabau. In a sense they are immersed in symbols of adat: on elements of ceremonial dress; in traditional house carving; in poetry, *kaba*, and other dramatic performances; in proverbs and sayings; in ordinary conversation, and in traditional ceremonial oratory. In social functioning, the Minangkabau participate according to rules laid down by adat. Perhaps the ubiquity of Minangkabau adat accounts at least in part for its remarkable persistence in the face of colonialism, industrialization, Islamization, and rampant tourism.

7.72 The motif of a diamond with a short perpendicular leg or peg at the center of each side appears here in a Minangkabau textile from the village of Pandai Sikek. Similar motifs are found in Bedouin rugs. Textile detail, FMCH X97.50.15; private gift.

7.73 A pegged-diamond motif similar to that shown in figure 7.72 from a man's belt woven in the region of the village of Muaro Labuah. See also figure 7.69. Private collection.

MOTIFS AND THEIR MEANING

John Summerfield

8

FIBERS AND PATTERNING TECHNIQUES

In previous chapters we have seen how richly patterned textiles are worn by the Minangkabau as ceremonial dress. This chapter steps back to the production stage to discuss the raw materials that make up the fabrics and the techniques employed by the Minangkabau to produce the textiles and the intricate patterns they display. Although a few Minangkabau ceremonial textiles are imported from other provinces in Indonesia and from India, and although some batiks are made from imported cloth, for centuries most Minangkabau ceremonial textiles have been woven by women in the villages of what is now the province of West Sumatra.

Fibers

Prior to World War II the principal fibers used to weave Minangkabau textiles were cotton and silk with an occasional use of the inner-bark fiber (bast) called *ramin* (fig. 8.2), one of four forms of *Boehmeria* that grow in the highlands of West Sumatra. Gold- and silver-wrapped thread, silk, and occasionally wool were employed as supplementary patterning materials. Since World War II synthetics and cotton have been the dominant fabric fibers, and colored plastic thread has competed with gold- and silver-wrapped thread.

Cotton

At least as long ago as the mid-sixteenth century, cotton was grown along the coast of West Sumatra to supply weavers in the Minangkabau highlands. The Dutch East India Company (Vereenigde Oost-Indische Compagnie), in an effort to increase trade in Indian and European cloth, tried to prevent cultivation of cotton by declaring it contraband and encouraging the growth of pepper in its place. Accordingly, "coastal planters of pepper and cotton never ceased to experience Dutch interference" (Dobbin 1983, 78). But cotton was too important a commodity to be suppressed. Some cotton is still grown on Sumatra, as on many other islands of Indonesia, and is hand-spun to produce a somewhat coarse but strong thread for weaving. Today, however, most of the cotton woven into Minangkabau ceremonial textiles is imported commercially spun cotton thread. Textiles in the regency of Limo Puluah Koto were often woven entirely of cotton. Today's ceremonial textiles are often woven with synthetic threads.

Silk

Silkworms and the mulberry trees on which they feed are found in several parts of Indonesia. In the sixteenth century the village of Pasai, in Aceh, on the northern tip of Sumatra, "was the acknowledged source of the best regional silk. The local ruler was said to have magical power to convert thread into gold, an allusion to Pasai's yellow-colored silk" (Hall 1996, 117). Shortly thereafter, however, Chinese silk of superior quality became readily available, and the Sumatran silk industry declined. Though more expensive than cotton, silk has long been the preferred fiber for ceremonial cloth for those able to afford it. Cotton textiles of the Minangkabau, however, are fully as elegant and beautiful as those made of silk (figs. 8.1, 8.3).

8.1 *Salendang gaba* (woman's shoulder cloth) from the village of Payakumbuh. Cotton, silk, silver-wrapped thread. The blue cotton center section is ornamented with thin warp and weft lines of white cotton and rows of chevronlike motifs. Selvage bands are of red silk. The warp-end panels of the textile are patterned with supplementary weft of silver-wrapped thread and colored silk. 250.4 (including fringe) x 71.3 cm. FMCH X93.25.73; collection of H. Elly Azhar and H. A. Sutan Madjo Indo.

8.2 Photomicrograph of textile detail showing red silk, dark blue cotton, and the natural bark fiber called *ramin*.

Most of the fine ceremonial textiles produced in the regencies of Agam and Tanah Datar were silk, but when a textile was to be tied into a headdress, cotton was used for the weft in the part of the textile that was to be tied, to add strength and durability.

Wool

Strange as it may seem for an area that lies almost on the equator, some old Minangkabau ceremonial textiles were made from imported wool yardage—a testimony to the persuasiveness of Dutch and British traders in the eighteenth, nineteenth, and early twentieth centuries. A woman's tube skirt (*saruang*) from the village of Saniang Baka, for example, is a red wool cloth with patterning of couched gold-wrapped thread (see fig. 6.28). And a headdress worn by women from the village of Batipuah is a black wool cloth with patterning of couched silver-wrapped thread and a band of gold supplementary weft sewed to its edges (see fig. 6.94). Also, some weavers from Limo Puluah Koto used colored wool thread for supplementary-weft patterning.

Gold- and Silver-Wrapped Thread

Most Minangkabau ceremonial cloths are patterned with metallic-wrapped threads, either woven as supplementary wefts or couched on the surface of woven cloth. Viewed under magnification, metallic thread can be seen to consist of metallic material wrapped around a core. These threads, either gold-wrapped or silver-wrapped, are of two types: (1) a very thin strip of a metallic gold or silver alloy (0.20–0.35 millimeters wide) wrapped around a cotton or silk core, resulting in a thread that is 0.15 to 0.30 millimeters in diameter (fig. 8.4), or (2) a thin strip of gold or silver leaf attached to paper (0.65–1.00 mm wide) wrapped around a cotton or silk core, resulting in a thread 0.35 to 0.60 millimeters in diameter (fig. 8.5).

For the last two millennia, Sumatra has been known as Suvarnadvipa, the island of gold. Gold exports from the area were key to the booming trade the Minangkabau conducted with the Middle East, India, China, and Europe. Yet there is no evidence that gold thread was ever produced in Indonesia. Rather, it was imported from Europe, the Middle East, India, and China.

The metallic strip on most type 1 gold thread—principally from Europe, the Middle East, and India—contains less than 10 percent gold despite its golden hue. It retains its brilliant luster very well over many years of wear, but the metal strip tends to cut the threads of the cloth that is repeatedly folded or tied into a headdress.

The metallic strip on type 2 gold thread, principally from China, contains 65 to 80 percent gold. Most of the remainder is silver. Because the gold leaf is very thin and soft, it rubs off with repeated handling, leaving only the paper strips to which it was attached during the manufacture of the thread. Textiles woven with type 2 thread therefore tend to lose their brilliant luster after years of wear.

Some metallic thread is still imported from Thailand and Singapore, but much of it has been displaced by gold- and silver-colored plastic. (For more information about gold- and silver-wrapped threads, see chapter 9.)

Bast Fibers

Hall reports that "Southeast Asians commonly wore high quality indigenous textiles made of inner tree and shrub fibers (bast) well into the sixteenth century" (Hall 1996, 100). As late as the nineteenth century the Minangkabau wove some textiles that incorporated the bast fiber they called *ramin* (fig. 8.6). *Ramin* was used as a fine-line feature in the warps and wefts of many textiles and, rarely, as the entire set of warps on a textile.

Ramin comes from a shrub of the genus *Boehmeria*. Four different types of *Boehmeria* grow in West Sumatra, and *Boehmeria nivea*,

OPPOSITE:

8.3 *Salendang* (woman's shoulder cloth) from the village of Silungkang. Cotton, silk, *ramin*, gold-wrapped thread. The dark blue ground cloth is cotton. The white checks are natural *ramin*. A wide band of silk weft ikat is bordered by bands of supplementary-weft patterning. The selvage bands are red silk. 244.9 (including fringe) x 79.7 cm. FMCH x93.25.84; collection of H. Elly Azhar and H. A. Sutan Madjo Indo.

8.4 Photomicrograph of gold-wrapped thread from a skirt (*saruang*) from the village of Lintau. The metallic wrapping is an alloy containing about 80 percent copper, nearly 20 percent silver, and a small amount of gold. It is gold in appearance. The strip is 0.31 millimeters wide and is wrapped around a silk core. The wrapped thread is 0.18 millimeters in diameter.

8.5 Photomicrograph of gold-wrapped thread from a shoulder cloth (*salendang*) from the village of Tanjung Sungayang. The wrapping is a leaf of a gold-silver alloy on a paper substrate. The gold leaf is approximately 80 percent gold, 16 percent silver, and 4 percent copper. It is gold in appearance. The strip is 0.98 millimeters wide and is wrapped around a silk core. The wrapped thread is 0.38 millimeters in diameter.

FIBERS AND PATTERNING TECHNIQUES

8.6 The thin, light-colored thread in this photomicrograph is the bast fiber called *ramin*. It is used as a fine decorative line on the man's ceremonial trousers with ikat band illustrated in figure 5.22. Textile detail, private collection.

8.7

8.7 The fine bast fiber *ramin* is not spun, and hence it cannot readily be made into a continuous thread for weaving. Since individual pieces are only two to three meters long, the weaver ties or twists the ends together as she weaves, making certain that the junctions fall on the back of the cloth, as shown in this photomicrograph. Textile detail, private collection.

8.8 The *Boehmeria* shrub, which grows along wet rice fields and streams, yields a very fine bast fiber, *ramin*, which is stripped from the inner bark or the debarked stem of the shrub.

8.9 Photomicrograph of a shroud from the village of Tanjung Sungayang. It is constructed of alternating groups of cotton threads and threads of the bast fiber *ramin* in both warps and wefts. The *ramin* becomes brittle with age and is broken by repeated handling of the textile as it is used over the years in ceremonies. Many breaks in the *ramin* are visible here. Textile detail, private collection.

or ramie, is one of the fibers used by weavers. Botanists at Andalas University in West Sumatra are trying to determine which of the other three were also used. Commercial ramie thread is spun; *ramin* thread is not spun and, as used in weaving, is finer than silk thread.

The *ramin* bush grows wild along the banks of small streams and at the edges of wet rice paddies (fig. 8.8). Stalks and branches of the shrub are cut and soaked overnight so that the bark may be readily peeled the following morn-

8.8

ing. Very fine white or light beige bast fibers are stripped from the inside of the bark or from the debarked stalk. These fibers are then dried in the family kitchen for four days. If left in the sun, the bast would dry too rapidly and become too brittle to be woven.

Boehmeria shrubs grow to a height of no more than three meters, and the stripped fibers

are therefore relatively short. Individual strands of *ramin* are not twisted or spun together to make a long, continuous thread. The weaver must join the strands by tying fine knots or by twisting the ends of the strands together and then concealing such junctions by assuring that they fall on the back side of the weaving (fig. 8.7). As a textile ages, *ramin* dries and becomes brittle, and the textile may be weakened by breaks in some of its threads, leaving holes and gaps (fig. 8.9). This poses a serious problem, especially for those textiles that incorporate a large amount of *ramin* and that are folded when worn.

A very small number of very early ceremonial textiles[1] were woven using *ramin* for the entire warp (fig. 8.10). More than a thousand strands would have to be joined to provide enough continuous fiber to warp the loom for one such textile. Handling of these old textiles can cause several adjacent warps to break, resulting in slits that threaten the integrity of the cloth.

It is believed that *ramin* has not been used

8.9

for textiles for at least one hundred years. Until recently, however, it was plied and used to make fishnets and even to produce hawsers capable of mooring ocean-going ships. Monofilament nylon has replaced *ramin* in some of these applications.

Another type of bast fiber comes from a native mountainside plant called *si cantung*. Men

204 CEREMONIAL TEXTILES

8.10 Photomicrograph of the bast fiber *ramin*, dyed indigo, used in this textile for nearly all of the warps. The light-colored warp is undyed *ramin*. Textile detail, private collection.

8.11 Branches of the *si cantung* bush gathered from fields around the village of Talang Dasun, in the regency of Tanah Datar.

8.12 Inner bark stripped from branches of the bush *si cantung* at the village of Talang Dasun.

8.13 Simple twisting tool used by Talang Dasun villagers to spin *si cantung* fibers.

8.14 Macramé bag made from plied *si cantung* by Talang Dasun village women. Each side of the bag was constructed from forty-eight three-meter-long pieces of plied yarn.

from the village of Talang Dasun gather branches about one meter in length from the shrub (fig. 8.11), strip the leaves, and soak the branches for a week. Then the branches are debarked, and the inner bark is separated from the outer bark (fig. 8.12). Using a simple twisting tool (fig. 8.13), strips of the inner bark are then Z-twisted by women from the village to form a continuous fiber, with more strips added as the twisting proceeds. A yarn is then produced by S-plying a pair of the fiber strips. The women then use the plied yarn to make macramé bags (fig. 8.14).

FIBERS AND PATTERNING TECHNIQUES

8.15 Ibu Arimi wearing bark-cloth jacket made from the *ipuah* (*Erythrina japonica*) tree by her husband near the village of Lompek, Limo Puluah Koto. 1990.

Bark Cloth

During World War II cloth and thread for making everyday clothes were very scarce or, at times, unavailable. Accordingly, some Minangkabau families turned to an old and nearly forgotten technique of beating the inner bark of *ipuah* and *tarok* trees into a clothlike material from which they could fashion garments. Production of bark-cloth garments has been well documented on several Indonesian islands (Aragon 1990, Kooijman 1959), but, to the best of our knowledge, Minangkabau use of this technique has not previously been documented. Several families in Limo Puluah Koto are still making bark-cloth garments on a small scale, primarily for their own use (fig. 8.15).

The *ipuah* (*Erythrina japonica*) and *tarok* (*Erythrina variagata*) are large trees native to West Sumatra. At a demonstration of the making of beaten-bark cloth, witnessed by the author in Limo Puluah Koto, a branch or trunk of a young tree about 10 centimeters in diameter was cut into pieces about one meter long and soaked overnight (fig. 8.16). Each log was then pounded with a wooden beater (fig. 8.17) from end to end and all around the circumference to loosen the bark from the log, a process taking many minutes (fig. 8.18). Once the worker felt that the bark was completely loosened from the log, he took a sharp knife and sliced completely through the bark along the length of the log (fig. 8.19). He then stripped the bark from the log, being careful to remove it in a single piece (figs. 8.20, 8.21). The bark was not loose at some locations along the log, so the worker again pounded the log at such points until the bark was finally freed. He now had a single piece of bark that, if flattened, would measure about one meter by 30 centimeters.

The next step in the process was to separate the inner bark from the outer bark. To accomplish this, the worker first used a sharp knife to cut through the inner bark along a line about 3 centimeters from one end (fig. 8.22), being careful not to cut the outer bark. This provided a handle about 3 centimeters wide by 30 centimeters long to hold while he gradually pulled the inner bark from the outer bark (figs. 8.23–8.25). He then had a piece of inner bark approximately 30 centimeters by one meter (minus the 3 centimeters he lost in making a handle). The outer bark was then discarded, and the worker moved to a large, smooth flat rock and began to pound the inner bark, using the same wooden beater he had used to loosen the bark from the log (fig. 8.26).

As the pounding proceeded, the bark began to soften and to spread laterally, gradually increasing in width. After many minutes of pounding, the worker folded the bark in half (fig. 8.27), giving him a doubled piece approximately 45 centimeters square. He continued beating (fig. 8.28) and then folded the piece in half again and continued pounding (fig. 8.29). The folding and pounding continued (fig. 8.30) for more than an hour. The longer the pounding, the finer the texture of the cloth. Six hours is considered the minimum amount of time it takes to produce beaten bark of a texture suitable for making into clothing.[2]

8.16 A log of the *tarok* tree (*Erythrina variagata*) 10 centimeters in diameter being cut to a length of about one meter, a first step in demonstrating the making of beaten-bark cloth. Limo Puluah Koto. 1996.

8.17 Wooden beater used to loosen the bark from the log and later to beat and soften the inner bark.

8.18

8.19

8.20

8.18 Pounding the log with a wooden beater to loosen the bark.

8.19 Cutting a slit the full one-meter length of the log, preparatory to removing the bark.

8.20 Beginning to peel the bark from the log after pounding has loosened it.

FIBERS AND PATTERNING TECHNIQUES

8.21

8.22

8.23

8.24

8.25

8.21 Completing stripping the bark from the log.

8.22 Cutting through the inner bark across the width of the bark about 3 centimeters from the end to provide a handle for separating the inner bark from the outer bark.

8.23 Starting to separate the inner bark from the outer bark. The inner and outer bark are quite firmly attached, and it requires great strength and care to separate the two while maintaining the integrity of the inner bark.

8.24 Continued stripping of the inner bark from the outer bark.

8.25 Nearing the end of the stripping of inner bark from the outer bark.

8.26

8.26 Laying the inner bark on a large, flat rock, the worker begins to beat the bark to soften and expand it. He uses the same beater he used to loosen the inner bark from the outer bark.

8.27 The softened inner bark is folded in half for further pounding.

8.28 Pounding of the doubled inner bark.

8.29 The inner bark is folded in half again. It is now four layers thick.

8.30 The inner bark after a fourth fold. It is now sixteen layers thick and ready for final pounding.

8.27

8.28

8.29 above, 8.30 below

8.31 The beaten bark cloth is unfolded and soaked thoroughly in a nearby stream.

8.32 The bark cloth is wrung out. The washing and wringing are repeated twice.

8.33 The piece of bark cloth is straightened out and left to dry, later to be sewn, together with other pieces, into a garment.

After the pounding was finished, the worker unfolded the cloth, which was now about 60 by 90 centimeters, soaked it thoroughly in a nearby stream (fig. 8.31), and wrung it out (fig. 8.32). He repeated the soaking and wringing twice, then declared the cloth ready to be dried (fig. 8.33) and sewn together with other, similar pieces into a garment (fig. 8.34). Thread for sewing pieces of bark cloth together is made from thin "strings" of the inner bark, which a worker spins by rolling them together on his bare thigh.

Garments made from beaten bark may be washed. They become softer and lighter in color with use and washing. They are comfortable to wear and are soft, lightweight, and warm.

Several aspects of this West Sumatran technique for making bark cloth differ from those reported in Sulawesi (Aragon 1990). In West Sumatra the work of preparing and pounding the bark is done by men, while in Sulawesi it is done by women. In West Sumatra pounding begins after an overnight soaking and continues for several hours. If pounding is interrupted, the bark is allowed to dry but is moistened again before pounding resumes. In Sulawesi strips of inner bark are boiled in water. When cool, they are wrapped in palm leaves and allowed to ferment for several days. Only then does the pounding begin, and it goes on for several more days. In West Sumatra the cloth is beaten from a single piece of inner bark, while in Sulawesi several strips of inner bark are beaten together to make a larger piece.

PATTERNING TECHNIQUES
Patterns on Minangkabau ceremonial textiles are produced by weaving, dyeing, embroidering, and lace making.

Weaving Techniques
In the Minangkabau heartland, woven patterns are the most prevalent. Looms in common use throughout the province for weaving ceremonial

8.34 A finished bark-cloth jacket made from the beaten inner bark of the *ipuah* tree. 138.4 x 71.8 x 66 cm. FMCH X97.50.67; private gift.

textiles are relatively simple frame looms (fig. 8.35). There is no evidence that body-tension or back-strap looms were ever used by the Minangkabau. In that respect they are unusual among Indonesian weavers, virtually all of whom use or used body-tension looms. Traditionally weaving of ceremonial textiles was done only by women, but today some young men have taken up the craft and are also producing textiles of high quality. In areas that produce commercial cloth, such as Silungkang, fly-shuttle looms are operated by men.

Stripes, Checks, and Plaids

The simplest way to weave a pattern into a cloth is to vary the color of the warps or wefts, producing stripes, checks, or plaids. The village of Silungkang is in the business of providing warped looms on order for most of the Minangkabau heartland weavers. Silungkang is well equipped to provide any combination of warp stripes for its many clients (figs. 8.36, 8.37). According to Hall (1996, 114), plaids were woven into Indonesian cloth as early as the eleventh century.

8.35 An old Minangkabau frame loom. From P. J. Veth, *Midden-Sumatra*, vol. 3.1 (Leiden: E. J. Brill, 1881), pl. CXV.

FIBERS AND PATTERNING TECHNIQUES

8.36 Bobbins of colored thread for feeding the warping machine in the village of Silungkang. 1995.

8.37 Colored thread feeding a machine that is warping a loom in the village of Silungkang to meet the specifications of a customer, a weaver from another Minangkabau village, Pandai Sikek. Silungkang developed a specialty in warping looms in large measure because the paucity of arable land in the immediately surrounding area necessitated finding alternative means to support the community. 1995.

8.38 Detail of a shroud from the village of Tanjung Sungayang. The shroud is texturally patterned in light-colored checks by means of alternating groups of heavier cotton threads and lighter *ramin* threads in both the warps and the wefts. FMCH X97.50.90; private gift.

In a few textiles the effect of checks is created by changing the texture, but not the color, of the warps and wefts. For those textiles, the loom was warped by alternating, for example, ten successive relatively coarse hand-spun cotton threads with an equal number of the very fine bast (*ramin*) threads. The wefts were woven in a similar sequence so that the finished textile was patterned with alternating densely packed squares and delicate, almost transparent squares (fig. 8.38).

Supplementary-Weft Patterning (Songket)
By far the prevalent patterning technique for Minangkabau ceremonial textiles is supplementary-weft patterning (*songket*). As the word *supplementary* implies, a pattern is incorporated into the cloth as the weaving progresses by weaving an additional nonstructural weft thread of the color or material of the desired pattern into the ground cloth. Silver- and gold-wrapped threads are the most frequently used supplementary threads, but a few villages also used colored silk thread for this purpose, and textiles from some villages in Limo Puluah Koto contain motifs made with colorful wool threads. Some contemporary weavers have substituted colored silk for the gold-wrapped thread that was the traditional supplementary weft on ceremonial textiles. This substitution has several advantages: the cloth can be laundered (metallic threads cannot be washed successfully), and silk supplementary thread will not cut the ground cloth or take on permanent creases that detract from the glowing appearance of the textile.

Minangkabau weavers work with the back side of the textile up and hence see the reverse of the pattern. With warp threads in place on the loom, the weaver, in order to pick out the path through those warps for the supplementary-weft pattern threads, takes a long, thin piece of bamboo (*lidi*) in one hand. Starting at one side of the loom, she passes the *lidi* under warp threads at each location where she wants the pattern to show and passes it over the threads where she does not want the gold thread to show on the surface of the textile. The *lidi*, viewed from the underside, then shows exactly how the pattern thread will look in the finished textile. The pattern thread will be visible when the textile is woven only where the *lidi* rest on the underside of the warps. This process of tracing different paths for pattern threads with *lidi* is repeated for the next supplementary line in the pattern and so on until all or a large block of the pattern has been laid out with *lidi* (fig. 8.39). Some weavings require hundreds of *lidi* and consequently many, many hours to set up the loom (fig. 8.40).

As the weaver begins to weave a patterned portion of the textile, she brings forward a *lidi*, inserts a thin, 10-centimeter-wide highly polished stick called a sword along the path of the *lidi* (fig. 8.41), removes the *lidi*, and turns the sword on edge to make an opening, called a shed, for passing the supplementary-weft pattern thread. After she has put the pattern thread through the shed, she lays the sword flat or

8.39 Portion of a loom in the village of Tanjung Sungayang showing *lidi* (pattern sticks) that have been placed across the warps. *Lidi* are placed over and under specifically selected warp threads to lay out the paths that supplementary-weft pattern threads will follow in the weaving. 1985.

8.40 A loom in the village of Silungkang with 570 *lidi* (pattern sticks) in place. 1985.

8.41 A weaver in the village of Pandai Sikek inserting a sword along the path of one pattern stick (*lidi*). When the sword is inserted across all of the warp threads, the weaver removes the *lidi* and turns the sword 90 degrees. This raises warp threads that were on top of the *lidi* and makes an opening, or shed, through which she can pass a supplementary pattern thread. 1985.

FIBERS AND PATTERNING TECHNIQUES

8.42 *Salendang tarewai* (shoulder cloth) from the village of Koto Gadang. Silk, gold-wrapped thread. The small stars (*bintang*) are woven with discontinuous supplementary weft. 215 (including gold lace fringe) x 53.4 cm. FMCH x93.25.60; collection of H. Elly Azhar and H. A. Sutan Madjo Indo.

8.43 Detail of the back of a *saruang* (skirt) from the village of Silungkang. Cotton, gold-wrapped thread. This *saruang* has small, widely spaced supplementary-weft patterns on the front but was woven by continuous supplementary weft. Large quantities of gold thread, not seen when the *saruang* is worn, float on the back of the textile. This practice is an extravagant use of expensive gold-wrapped thread. Furthermore, the loose, floating threads can readily be snagged if the back of the textile comes in contact with a sharp projection. Private collection.

8.44 Detail of *salendang tarewai* (shoulder cloth) from the village of Koto Gadang. Silk, gold-wrapped thread. Only a single pair of gold-wrapped threads is woven into the textile before changing to the next *lidi* (pattern stick). This process is very labor-intensive because hundreds of supplementary gold threads in hundreds of separate paths are required to complete the textile. The result is, however, an extremely delicate pattern. 193 x 53 cm. Private collection.

8.45 Detail of contemporary *salendang* (shoulder cloth) woven at the National Weaving Cooperative, near the village of Pandai Sikek. Cotton, gold-wrapped thread. This textile was woven quite rapidly because it repeats the same pattern path of the supplementary-weft thread ten times before moving to the next *lidi*. 157 x 17 cm. Private collection.

removes it and weaves one ground-weft thread in plain weave, which anchors the pattern thread. If she wants more than one supplementary thread with an identical path at that location in the pattern, she again puts the sword on edge, repeating the process. When ready to change to the next different path in the pattern, she removes the sword, pulls down the next *lidi*, and proceeds line by line to complete the pattern in this fashion.

When a supplementary-weft thread is passed across the entire width of the textile, as in the example above, the technique is called continuous supplementary weft. Some textile designs call for small, widely spaced motifs (fig. 8.42). The continuous technique would hide most of the supplementary-weft thread on the back of the textile, an expensive use of thread that will not be seen (fig. 8.43). To save thread, it is common to pass the supplementary-weft thread back and forth over only that part of the textile on which the pattern is to appear. This method of patterning, usually accomplished by having bobbins of patterning thread at the site of each small pattern across the weft, is called discontinuous supplementary weft.

Changing the *lidi* (and therefore the pattern) after each pass of the pattern weft thread creates a very delicate image, and only the very finest Minangkabau ceremonial textiles were and are woven with a single thread or a pair of threads per *lidi* (fig. 8.44). Because weaving with supplementary weft is a very slow process, a weaver might be able to complete only 3 to 5 centimeters of a fine Minangkabau textile in a full day at the loom. Some contemporary weavers attempt to speed up production by using as many as ten supplementary wefts per pattern stick (i.e., ten identical successive paths of the pattern thread), producing a much coarser pattern (fig. 8.45). Sometimes two women work at the loom, one to throw the shuttle to pass the wefts and one to manipulate the *lidi* and the sword (fig. 8.46).

Tapestry Weave
Many of the silver, red, and black narrow belts (*ikek pinggang*) from the village of Solok were woven in a technique known as slit tapestry (fig. 8.47), found in Middle Eastern kilims. Slit tapestry is used to construct patterns in which one block of color is separated from an adjacent

CEREMONIAL TEXTILES

8.46 Two women from Koto Gadang working together at a loom to speed the weaving. One manipulates the *lidi* and the sword, freeing the other to throw the shuttle to pass wefts across the warps. Photo courtesy of Yayasan Dokumentasi dan Informasi Kebudayaan Minangkabau; originally published in *Sumatra's Westkust in beeld* (1920).

8.47 Detail of *ikek pinggang* (man's ceremonial waist tie) from the village of Solok. Silk, cotton, wool, gold-wrapped thread, mica. This red, black, and gold belt is woven 23 centimeters wide but is patterned only on the 11.5-centimeter center portion, the edges being folded back and sewn together. Patterning is by slit tapestry. At the end is a strip of red wool trade cloth. 320 (including fringe) x 23 cm (folded to 11.5 cm for wearing). FMCH X97.50.36; private gift.

block of another color. Weft threads in one block of color are woven back and forth across only that block, turning back around the warp threads on each edge of the block, rather than passing from selvage to selvage. Wefts of a different color in the adjacent block are turned back around a warp adjacent to the turnaround warp on the other color block, leaving a slit between the two blocks of color.

Bugih-ing

In one rarely found variant of supplementary-weft weaving, which the Minangkabau call *bugih-ing*, the gold-wrapped supplementary-weft thread does not pass straight across the width of the textile but shifts its path over successive warps of the ground cloth (fig. 8.48).

Tablet (or Card) Weaving

Gold bands sewn onto the bottom selvages of women's tube skirts in the region of Koto nan Gadang are woven on tablet looms (Ng 1987, 1:147n 2), as are the four bands on the bottom of an unmarried woman's tube skirt in the village of Payakumbuh. A tablet (or card) loom consists of a series of thin, flat pieces of wood, cardboard, bone, plastic, or the like, each pierced with a number of holes, through which warp threads are passed. The set of cards can be rotated in different combinations to form a shed through which wefts can be passed to produce the desired pattern as the weaving progresses along the warp threads.

FIBERS AND PATTERNING TECHNIQUES

8.48 Photomicrograph of detail of a man's waist tie from the village of Pitalah. In this unusual form of supplementary-weft weaving, which the Minangkabau call *bugih-ing*, the supplementary-weft thread is not passed straight across the width of the textile, but instead changes its path. Private collection.

8.49 Threads in the village of Silungkang that have been tied with blue plastic in preparation for dyeing. The dye will not penetrate the portions of the threads that have been firmly tied. 1995.

8.50 Detail of a *salendang* (shoulder cloth) from the village of Silungkang. Cotton, gold-wrapped thread. Portions of the weft threads in the black-and-white band are dyed by the ikat process and then woven as part of the ground fabric of the textile. 183.4 (including fringe) × 29.3 cm. Private collection.

Dyeing Techniques
Ikat

A few old Minangkabau ceremonial textiles were patterned by the weft-ikat process, that is, the pattern of the finished cloth was tied and then dyed into the weft threads before the textile was woven.[3] In preparation for weaving a weft-ikat textile, a worker stretches white or natural-colored weft threads on a tying frame that is the width of the proposed textile. Then, with a pattern in mind, she tightly ties bundles of threads with palm leaf (or, today, with plastic twine) where she does *not* want the dye to take. The entire bundle of weft threads is then removed from the tying frame and dyed. When the threads are dry, the ties are removed, and the threads are then used as wefts for the textile. If the work has been done skillfully, the pattern the worker has envisaged will have been woven into the textile and the image will be clear. Weft-ikat textiles are typically weft-faced so that the weft threads, not the warp threads, are dominant. More than one color can be incorporated into an ikat textile by retying the threads after the first dyeing in such a way as to expose to the new dye only those parts of the thread that are to be patterned in another color.

Weft-ikat textile production has recently become a thriving industry in the village of Silungkang (figs. 8.49, 8.50). The production process is decentralized within the village; one group ties the threads, a second group in another part of the village dyes the tied-thread bundles, and a third group warps looms for producing ikat cloth. A number of individual weavers in Silungkang weave cloth with bands of ikat patterning, often combined with bands of supplementary weft of gold-wrapped thread.

The large Arab-style trousers (*sarawa gadang*) worn by men to some ceremonies are sometimes patterned with bands of weft ikat (see fig. 5.22). Other Minangkabau ceremonial weft-ikat textiles are shoulder cloths (*salendang*), skirts (*saruang*), and belts (*ikek pinggang*). Some patterns that have survived in known collections are virtually identical to warp ikats from Yemen, which is not surprising since Yemen was for centuries on the ocean trade routes between the Middle East and India, Indonesia, and China. Moreover, Arab scholars from Yemen are known to have been in Sumatra as early as the 1580s (Reid 1993, 144). (For a more complete discussion of foreign influences on Minangkabau weaving, see chapter 7.)

Zone Dyeing

Careful examination of a few nineteenth-century (or earlier) textiles from the regency of Tanah Datar reveals that all warp threads are red in the patterned end portions of the textile but are dark blue, purple, or natural in the center portion. Since warps are continuous, this variation in color could have resulted from ikat dyeing, but it is more likely that a section of the warp threads was simply dipped into dye and allowed to dry, with the remaining portion held away from the dye. In the context of Lao Tai textiles, this process has been described as zone dyeing (Gittinger 1992, 35).

A few red-and-white-checked textiles, thought to have been woven in the village of Batu Sangkar (fig. 8.51), appear to have zone-dyed warps in the end sections and zone-dyed wefts in the selvage margins of the center section. All warps along the patterned end sections of the textile are red, but in the body of the weaving, they alternate in groups of red and white. Similarly, all wefts along the 10-centimeter-wide selvage margins of the textile are red, but in the center section of the weaving, they are alternately red and white.[4] This produces a pattern of red and white checks in the finished cloth, closely resembling a double-ikat textile. Unevenly dyed areas appear between red and white areas where both colors are visible, as is typical of ikat cloth. Yet the Minangkabau claim that there was no ikat dyeing in the original three settlements, the *luhak nan tigo*, and therefore no ikat dyeing in Batu Sangkar, the alleged source of the textile.

Batik

Until recently, batik was not used by the Minangkabau to pattern cloth. They have, however, long accepted as adat batik scarves produced in Java called *tanahliek* (literally, "looking like earth"), usually a silk batik with a brown pattern on a natural background. The *tanahliek* is worn as a ceremonial shoulder cloth in the village of Payakumbuh and as a ceremonial headcloth in the village of Lintau (Moussay 1995, 1136). Also, squares of batik (fig. 8.52) from the province of Jambi (on the east coast of Sumatra) have been used for *saluak* (a man's headdress; see chapter 5). Imported batik tube skirts are worn by both men and women. Since World War II the Minangkabau have produced a limited number of batiks, using the same wax-resist methods employed in Jambi and Java. A common form of work pants is made from batik, and men's trousers worn for prayer are often batik.

Embroidery Techniques

Four types of embroidery are used for patterning on Minangkabau ceremonial textiles: satin stitch, drawnwork, couching, and fine French or Pekin knot.

Satin-stitch embroidery is achieved by stitching fine patterns onto a woven cloth, often employing many colors of silk thread (fig. 8.53). In the hands of an expert, the embroidered stitches are precisely parallel and touch each other, producing a solid pattern or motif that is the same both on the front and on the back of the textile. In China satin-stitch embroidery dates at least as far back as the second century C.E. (Shih 1977, 308ff.). Minangkabau of Chinese ancestry living along the coastal areas and in the highlands of West Sumatra continue to carry on this centuries-old Chinese technique.

Drawnwork involves removing a band of successive weft or warp threads from one or more parts of a woven cloth. The worker then uses the remaining warps or wefts as warps. Using a needle and colored threads, she needles-in patterns or motifs that replace the threads that were removed from the original cloth (figs. 8.54, 8.55). Women in the highland village of Koto Gadang are famous for their skill at drawnwork. In the early twentieth century girls with this skill were excused from other work to protect their sensitive fingertips. Women in Padang have patterned *siriah* covers with drawnwork.

Couching is accomplished by arranging threads on the surface of a woven cloth to form a decorative pattern and then, with small stitches, attaching these threads to the cloth in the desired form (fig. 8.56). In the Minangkabau region couching with gold-wrapped thread is commonly found on food and bowl covers (fig. 8.57), purses, and wall hangings, both in the highlands and on the west coast. Woolen garments were also decorated with couching. In the village of Saniang Baka, for example, floral and paisley patterns were couched onto a black woolen ceremonial headcloth (see fig. 6.94), and a red woolen tube skirt was couched with the split-peanut motif (see fig. 6.28).

Fine French or Pekin knot embroidery involves adding "an accessory stitch...to form a 'knob' on the surface of the fabric...[to] produce certain visual or tactile effects" (Emery 1980, 244). Thread is wound around a needle several times to form a hollow cylinder of thread, which is then anchored to the cloth with a simple stitch. Weavers in the village of Koto Gadang have produced women's scarves and headcloths using this embroidery technique (fig. 8.58).

8.51 *Salendang* (shoulder cloth) probably from in the village of Batu Sangkar. Silk, gold-wrapped thread. On this red-and-white-checked shoulder cloth (*salendang*), all warps are red along the patterned end sections of the textile, but groups of those warps are alternately red and white in the body of the weaving. Similarly, all wefts are red along the four-inch-wide selvage margins of the textile, but groups of those wefts are alternately red and white in the center section of the body of the weaving. This result could have been accomplished by the ikat technique, but it appears that both the warp end section and the weft selvage sections were zone-dyed, either by selectively dipping threads or parts of the textile in the dye or by daubing the dye while the textile was on the loom. 257 (including fringe) x 74 cm. FMCH X97.50.43; private gift.

8.52 Cloth for folding into a *saluak* (chieftain's ceremonial hat). Cotton batik. For information about the *saluak*, see chapter 5. 36 x 35 cm. FMCH X93.10.1; museum purchase.

8.53 Detail of a *dalamak* (cover for a *siriah* set). Cotton, silk embroidery floss. The *dalamak* is embroidered in satin stitch with 289 individual images in silk of birds, flowers, fish, elephants, horses, Chinese characters, and other motifs. The cloth was woven in the village of Silungkang and was probably embroidered by Chinese Minangkabau in the West Sumatran capital, Padang. 68.6 x 68.6 cm. FMCH X97.50.64; private gift.

8.54 The major pattern bands of this *tutuik* (*siriah* cover) are embroidered with drawnwork. Silk, cotton. The textile was originally woven in the village of Silungkang. Weavers in the village of Koto Gadang removed bands of warp or weft threads along the borders and used the remaining threads as warps to handweave (with needle and thread) images of lions and birds. 53 x 53 cm. FMCH X93.25.65; collection of H. Elly Azhar and H. A. Sutan Madjo Indo.

8.54

FIBERS AND PATTERNING TECHNIQUES

8.55 This *tutuik* (*siriah* cover) is an example of drawnwork. Silk. The center of the textile is a silk batik with many images of flowers and animals. Weavers in Padang removed bands of warp or weft threads along the borders and used the remaining threads as warps to hand-weave (with needle and thread) images of camels, horses, and birds. 53 x 52 cm. FMCH X93.25.96; collection of H. Elly Azhar and H. A. Sutan Madjo Indo.

8.56 Detail of a 3-by-4-meter wall covering used as part of a wedding alcove installation. Black velvet couched with gold-wrapped thread. Private collection.

OPPOSITE:

8.57 Ceremonial procession including women carrying platters of food on their heads. The food is covered with textiles (*tutuik*) that are couched with gold-wrapped thread and ornamented with pieces of mirrored glass. Limo Puluah Koto, 1989.

220 CEREMONIAL TEXTILES

8.58 This women's ceremonial scarf from the village of Koto Gadang is red silk with floral patterns outlined in silver-wrapped thread. Centers of the flowers are decorated by the French or Pekin knot technique. The end braid is gold-wrapped thread. 55.5 x 200.3 cm. FMCH X95.42.1; gift of Redjeki Arifin.

8.59

8.60

8.58

8.59 Detail of the crocheted fringe on a man's ceremonial shoulder cloth (*salendang tarewai*) from the village of Koto Gadang. Gold-wrapped thread. Private collection.

8.60 Contemporary pillow lace table cloth made in the village of Koto Gadang.

222 CEREMONIAL TEXTILES

Lace-Making Techniques

Lace-making techniques used by the Minangkabau include crocheting and bobbin lace.

The warp ends of many Minangkabau ceremonial textiles are adorned with bands of crocheted gold- or silver-wrapped thread (fig. 8.59), sometimes crocheted directly onto the ends of the textiles but most often crocheted separately and then sewn in place. These bands were produced locally in the highlands.

The village of Koto Gadang is noted for its production of fine lace, used as place settings and doilies at ceremonial events and for trim on some textiles (fig. 8.60). This lace is produced by manipulating many separate threads, each wrapped on a separate bobbin. To maintain tension on each of the threads while producing the lace, the end of each thread is fastened at the center of a well-stuffed pillow. The bobbins rely on gravity to hold the structure in place (figs. 8.61, 8.62). Bobbin lace is, accordingly, sometimes called pillow lace.

Over the centuries Minangkabau weavers have employed a variety of materials—cotton, silk, wool, *ramin*, and metallic-wrapped threads—to produce stunningly beautiful ceremonial textiles of widely different designs. The technical skill of these weavers has been and remains unsurpassed in Indonesia. Although weaving has died out in many Minangkabau villages, it has been revived and is expanding in others. The metallic threads now available are of inferior quality, but the ability to produce spectacular ceremonial garments remains. Young weavers are introducing new designs and colors, but most changes remain within the tradition that has kept this culture true to its all-encompassing adat.

8.61 Making pillow (or bobbin) lace in the village of Koto Gadang. 1995.

8.62 Pillow for producing lace in the nineteenth century in the village of Koto Gadang. From P. J. Veth, *Midden-Sumatra*, vol. 3.1 (Leiden: E. J. Brill, 1881), pl. CXVIII.

FIBERS AND PATTERNING TECHNIQUES

Norman Indictor

METALLIC THREADS IN MINANGKABAU TEXTILES

Indonesian textiles are renowned for their beauty and variety. A special measure of beauty is apparent, however, in fabrics woven on the islands of the Indonesian archipelago west from Sumbawa to Sumatra. The "special measure" that accounts for the sumptuous quality of many western Indonesian textiles is the supplementary weft or couched addition of gold- and silver-wrapped threads (figs. 9.2, 9.3). Although the literature of Indonesian textiles abounds with illustrations and descriptions of these textiles, few examples have been subjected to examination by microscopic techniques. Comparison of the composition and structure of the threads from West Sumatran textiles with the composition and structure of threads from textiles woven in other parts of the world may shed light on trading patterns and provide clues to provenance and age of the weavings themselves.

To date there has been little objective analysis of the age of Minangkabau textiles. Most accounts in the literature imply that Indonesian textiles in current collections date no earlier than the late eighteenth century. It is frequently argued that, because of the humidity and insects, it is unlikely that any cloth could survive in the Southeast Asian climate for more than two hundred years. No systematic study of Indonesian textiles by carbon 14 analysis has been undertaken to date. Given the assumptions about the age of these textiles, such an analysis has not been considered worthwhile, since it is impossible to obtain dates with reasonable certainty on cloth made after 1650–1700.

It is certain that textiles embellished with gold thread existed in the Malay Archipelago long before the late eighteenth century. For example, the seventeenth-century Malay chronicle *Hikayat Banja* reports on "a purple *kain* [cloth wrap] which was embroidered with gold" and "fringed umbrellas embroidered with gold thread" (Hall 1996, 97). The carbon-dating of an Indian textile purchased in Indonesia, previously thought by experts to be of late eighteenth- or early nineteenth-century origin, showed that the textile dated to 1400 plus or minus forty years (Barnes 1996, 2). Since that textile was subject to the same environmental hazards as textiles elsewhere in Indonesia, it is reasonable to suppose that some textiles we think of as late eighteenth century might be much older. Carbon 14 analysis of old Minangkabau textiles has yet to be undertaken but is clearly in order.

This chapter reports on the analysis of two groups of metallic threads from a total of thirty-four Minangkabau ceremonial textiles estimated to date from the nineteenth to the early twentieth century (figs. 9.4, 9.5). These textiles, richly

9.1 Detail of figure 6.50. Motifs from thread of thin metallic strip wrapped around cotton core.

9.2 Woman's ceremonial shoulder cloth (*salendang*) from the village of Batu Sangkar. Silk, cotton, gold-wrapped thread. The warp end panels are decorated with supplementary-weft patterning using colored silk and gold-wrapped thread (type IVa). 251 (including fringe) x 72 cm. FMCH X93.25.29; collection of H. Elly Azhar and H. A. Sutan Madjo Indo.

9.2

9.3 Ceremonial food cover (*tutuik*). Cotton velvet, gold-wrapped thread. Gold-wrapped thread is couched onto the surface of the cloth. 64 x 62 cm. FMCH X97.50.65; private gift.

embellished with supplementary weft of metallic-wrapped thread, were worn or displayed during ceremonies. The sampled textiles are believed to have been woven in fourteen different weaving centers in the West Sumatran highlands. Preliminary optical microscopy indicated substantial differences in the construction of the metallic-wrapped threads despite the fact that the weaving centers lie within an area sixty miles in diameter.

For centuries the Minangkabau have been active traders, exporting spices and gold in exchange for cotton fabrics and other commodities. Some of the metallic-wrapped thread used so extensively in Minangkabau ceremonial textiles could have been produced locally, but much, if not all, was imported. Elderly weavers call the high-quality metallic-wrapped thread of earlier years Makau (referring to Macao, on the southern coast of China). Unlike Chinese thread, which usually had a gold surface on a cellulose substrate wrapped around a fiber core (silk or cotton), the thread known as Makau consists of a metal strip wound around a fiber

9.4 Photomicrograph of a portion of a woman's ceremonial shoulder cloth (*salendang*) from the village of Batu Sangkar. Silk, cotton, *ramin*, gold-wrapped thread (type III). Private collection.

9.5 Photomicrograph of a portion of a man's ceremonial shoulder cloth (*salendang*) from the village of Tanjung Sungayang. Silk, cotton, *ramin*, gold-wrapped thread (type IVa).

9.4

9.5

226 CEREMONIAL TEXTILES

9.6 Photomicrograph of type III gold-wrapped thread—metallic strip wrapped around a fiber core. The strip shown here is 0.31 mm wide, and the wrapped thread is 0.18 mm in diameter.

9.7 Photomicrograph of type IVa gold-wrapped thread—metallic surface applied with adhesive to paper wrapping wound around a fiber core. The strip shown here is 0.94 mm wide, and the wrapped thread is 0.54 mm in diameter.

core, suggesting an origin in India, Persia, or Europe, possibly transshipped through Macao. Some thread may even have been produced in Macao, which had a reputation for gold smuggling, importing ingots, and converting them into products for export.

Anthony Reid (1988, 100), citing A. de Vlaminghís's, report of 1644, states that "Aceh imported gold thread on occasion from Gresik in eastern Java." From that fact, Reid inferred that "Javanese craftsmen were able to make a profit simply by processing imported gold into thread and re-exporting it." Yet to date there is no strong evidence of the manufacture of metallic threads anywhere in Indonesia despite widespread presence of metallic ores and of sophisticated and delicate metalwork, including bronzes and silver and gold jewelry. It is more likely that Gresik, a major port in the seventeenth century, served as a transshipment point for gold thread from outside the Indonesian archipelago.

Analysis of Metallic-Wrapped Threads from Minangkabau Textiles

Metallic-wrapped threads have been classified according to the following five categories in recent efforts to describe the general occurrence of metals in textiles (Indictor et al. 1985, 1986, 1988, 1989, 1990):

I. Metal applied (with adhesive) to already woven fabrics
II. Metal wire or flattened strips
III. Metal wire or strips wound around fiber core
IV. Metallic surface applied (with adhesive) to organic wrapping wound around fiber core
 a. Organic–cellulosic
 b. Organic–proteinaceous
V. Metallic surface applied (with adhesive) to organic strips
 a. Organic–cellulosic
 b. Organic–proteinaceous

Threads belonging to all five of the above categories have been observed in Indonesian textiles. No examples of proteinaceous substrates (types IVb and Vb) have been found, however, possibly owing to an absence of examples of Indonesian textiles made prior to the eighteenth century, by which time paper had replaced animal hide and other protein-based wrapping substrates for types IV and V. Only types III and IVa are represented in this study (figs. 9.6 and 9.7, respectively, illustrate threads of these types).

Table 1 lists textiles sampled in the first of two different groups studied and shows categories to which the chosen specimens belong. Textiles in this group are believed to have been woven in the mid- to late nineteenth century; the metallic threads were supplementary wefts (fig. 9.8).

Light microscopy was used to observe the structure of the thread samples and to estimate their dimensions. A scanning electron microscope was used to take spectrographic pictures of emitted X-rays in order to determine the elemental composition of the metal and of paper substrates. For a description of the analytic method employed, see the note on methodology at the end of this chapter.

Table 2 summarizes the results of light microscopic examination of group 1 samples, including dimensions of the threads and wrapping materials. Ceremonial use of the textiles and later handling of the samples tend to increase the uncertainty of these measurements since use and handling may cause threads to unravel (fig. 9.9). In brief, all paper-wrapped samples (type IVa) had Z-twist wrapping; all metallic-wrapped samples (type III) had S-twist wrapping (fig. 9.10). As expected, the wrapping widths and thread diameters of type IVa examples were greater than those of type III examples. Both cotton and silk cores were found among type III and type IVa examples.

Table 3 shows elemental analyses obtained by energy-dispersive X-ray spectrometry. Analyses were obtained on both sides of each

9.8 One end of a man's *salendang* from the village of Tanjung Sungayang. Silk, cotton, *ramin*, gold-wrapped thread. The warps are blue and natural *ramin*, except for the selvage bands, which are red silk. The patterning is by supplementary weft of gold-wrapped thread (type IVa). 234 (including fringe) x 60 cm. Private collection.

CEREMONIAL TEXTILES

TABLE 1. TEXTILES SAMPLED (GROUP 1)

ACC. NO.	TEXTILE NAME	PROBABLE VILLAGE OF ORIGIN	TYPE
Su 473	*Saruang*	Lintau	III
Su 475	*Salendang tuo rarak*	Pitalah	III
Su 468	*Sisampiang*	Payakumbuh	III
Su 494	*Salendang*	Taram	III
Su 495	*Salendang*	Limo Puluah Koto	III
Makau	*Salendang*	Tanjung Pandai Sikek	III
Su 479	*Salendang*	Batipuah	III
Su 485	*Tangkuluak*	Pariangan	III
Su 488	*Tangkuluak*	Padang Magek	III
Su 477	*Saruang*	Koto Gadang	III
Su 450	*Salendang kain sambuaran*	Minangkabau Village (?)	IVa
Su 478	*Ieh dindiang*	Silungkang	IVa
Su 484	*Salendang*	Padang Magek	IVa
Su 486	*Salendang*	Batu Sangkar	IVa
Su 493	*Salendang*	Tanjung Sungayang	IVa

wrapping element and for each core thread. Analysis of most (nine of ten) of the type III examples showed less than 8 percent gold on the outer surface; most (nine of ten) contained a higher assay of gold on the outer (showing) surface than on the inner (hidden) surface. The first six of the ten examples of type III thread listed in table 3 were predominantly (60 to 80 percent) copper, with less than 30 percent silver and gold plus other trace metals. Of those six, four contained nearly 10 percent nickel. The last four of the ten examples of type III thread listed in table 3 were predominantly (70 to 90 percent) silver with measurable amounts of gold and copper. All five type IVa examples had large amounts of gold (60 to 80 percent) and silver (20 to 30 percent) present on the surface, usually with trace amounts of copper. Interior surfaces of type IVa threads are paper of various compositions, and hence no gold, silver, or copper is found there.

Among the type III and IVa samples, trace elements found in the cores are consistent with those found in other reported Indonesian threads. The presence of significant quantities of copper in the type III samples (present in every example) was noteworthy. Six of the ten samples were mainly copper (more than 60 percent); two had more than 10 percent copper; two had traces (less than 5 percent). As to the possible sources of these threads, copper seems to have become prevalent in metallic-wrapped threads in Indian textiles in the nineteenth century but is usually absent (or present in trace amounts only) in more sumptuous examples. Earlier examples observed were either nearly pure silver or silver with small amounts of gold (approximately 10 percent). Of course, the textiles that tend to be preserved are the more valuable ones, and the chances are greatest that these would have been made of more precious materials.

Gold in Type III Threads (Group 1)

Differences in the gold content on the inside and outside of the metal wrappings were found in nine of the ten type III examples, suggesting that the method of producing the lamellae involved

S-WRAP Z-WRAP

9.9 Photomicrograph of type III gold-wrapped thread—metal strip wrapped around a fiber core—illustrating how easily gold-wrapped thread becomes unwrapped when handled roughly.

9.10 Metallic strips, when wrapped clockwise, are called S-wrap; when wrapped counterclockwise, they are called Z-wrap.

METALLIC THREADS IN MINANGKABAU TEXTILES

TABLE 2. APPEARANCE AND DIMENSIONS OF METAL THREADS (GROUP 1)

ACC. NO.	CORE FIBER/ COLOR TWIST	THREAD DIAMETER (MM)[a]	OUTER SURFACE APPEARANCE	WIDTH OF WRAPPING (MM)	SUBSTRATE ADHESIVE COLOR	WRAPPING TWIST
TYPE III						
Su 473	Silk/undyed no twist	.18	Gold/silver reddish	.31	—	S
Su 475	Cotton/lt. yellow S 2-ply	.21	Gold/silver	.27	—	S
Su 468	Cotton/yellow S 2-ply	.20	Gold/silver	.18	—	S
Su 494	Cotton/yellow S 2-ply	.19	Gold/silver reddish	.20	—	S
Su 495	Cotton/yellow S 2-ply	.14	Gold/silver reddish	.20	—	S
Makau	Cotton/yellow S 2-ply	.20	Dull gold	.18	—	S
Su 479	Cotton/undyed S 2-ply	.32	Silver/gold	.21	—	S
Su 485	Silk/yellow Z	.32	Silver	.22	—	S
Su 488	Cotton/yellow S 2-ply	.21	Silver/gold	.20	—	S
Su 477	Silk/yellow Z	.18	Gold, some red pitting	.23	—	S
TYPE IVa						
Su 450	Silk/orange Z	.61	Smooth gold	.65	Paper/red	Z
Su 478	Cotton/red Z 3x2-ply	.42	Gold foil-like	.78	Paper/red	Z
Su 484	Silk/undyed Z 2-ply	.38	Coppery gold	.92	Paper/red	Z
Su 486	Cotton/red Z 3x2-ply	.54	Gold foil-like	.94	Paper/red	Z
Su 493	Silk/undyed Z	.38	Gold	.98	Paper/red	Z

[a] Measurement uncertain because of textile use and/or specimen handling.

the application of gold in a late step of its manufacture. Examples of this type of thread, mostly of European origin, have been reported recently. Accounts of thread manufacture in India and analyses of samples from historic textiles indicate uniform inclusion of gold, even on worn or old samples. The traditional Indian procedure for making gold thread involves combining silver with a small amount of gold prior to the drawing process. With the possible exception of one example (Su 479), the type III samples examined in this study were not made in this manner and therefore probably did not originate in India. Both Persian (often) and late Chinese (rarely) textiles have been noted with type III threads. Most studies describing elemental analyses of metal threads have not distinguished between the inside and outside of the samples. The measurable presence of nickel (about 7 to 10 percent) in several of the type III samples suggests a similar geographic source for those examples. Nickel has been shown to be present in Indian as well as in European examples. A European origin is suggested for most of the type III threads, although the possibility of a local or non-European origin cannot be totally excluded. Examination of scanning electron micrographs of several of the examples clearly showed draw lines in the metal surfaces. Uniform widths and bent edges observed on some of the micrographs suggest that width guides were used while flattening the drawn wires.

Gold in Type IVa Threads (Group 1)

The four type IVa samples were of common gold leaf composition. The surface composition was fairly consistent: high gold content (60 to 80 percent), with silver (20 to 40 percent) and traces of copper. The metallic threads of type IVa—paper support for metallic surface—are usually thought to come from China or Japan. The examples in this sample set have a red bole

adhesive for the metal leaf, characteristic of Chinese, rather than Japanese, metallic thread. A few particles taken from the bole of one of the threads and examined by polarized light microscopy were consistent with hematite (red ferric oxide). A small number of comparison samples taken from nineteenth-century costumes at the Metropolitan Museum of Art all showed red bole for Chinese examples (MMA nos. 46.6.13, 66.56, 79.418.1, 43.84.7, 1977.65) and a transparent adhesive (not identified) for Japanese examples (MMA nos. 46.9.73B, 53.22.10). The substrate papers were examined microscopically. Samples were moistened with deionized water, metallic surface and adhesives or boles were separated from the paper substrate, and the paper fibers were separated. All paper samples in group 1 showed greater similarities to the Chinese control samples than to the Japanese control samples. The five Minangkabau samples all showed the presence of bamboo fibers with a bast fiber similar to paper mulberry (*kozo*). The paper seems to have been made either from a mixture of fibers or from a source that is not quite identical to our comparative micrographs. Sixteen micrographs of samples taken from Chinese textiles are similar to our sample set. Japanese samples contained bast fibers closely identifiable as *Wikstroemia gampi* (thin rice paper) with none of the cellular materials characteristic of the Chinese samples. All evidence points to Chinese origin for the type IVa threads.

ANALYSIS OF A SECOND GROUP OF METALLIC-WRAPPED THREADS

A second group of metallic thread samples was examined by light microscopy and microprobe analysis in order to obtain observations recorded

TABLE 3. ELEMENTAL ANALYSES BY ENERGY-DISPERSIVE X-RAY SPECTROMETRY[a] (GROUP 1)

ACC. NO.	WRAPPING EXTERIOR SURFACE (RATIOS)[b]	WRAPPING INTERIOR SURFACE (RATIOS)[b]	CORE
TYPE III			
Su 473	Au:Ag:Cu 4:19:77	Au:Ag:Cu 0:15:85	Trace Cu,Cl,Si,K,S
Su 475	Au:Ag:Cu 6:13:81	Au:Ag:Cu 0:17:83	Trace Si,S,Cl,K,Ca,Cu
Su 468	Au:Ag:Cu:Ni 4:18:68:10	Au:Ag:Cu:Ni 0:25:66:9	Trace Si,S,Cl,K,Ca,Cu
Su 494	Au:Ag:Cu:Ni 3:18:70:9	Au:Ag:Cu:Ni 0:27:65:8	Trace Si,K,Ca,Cu
Su 495	Au:Ag:Cu:Ni 4:24:64:8	Au:Ag:Cu:Ni 0:23:69:8	Trace Al,Si,Cl,K,Ca,Cu
Makau	Au:Ag:Cu:Ni 3:27:63:7	Au:Ag:Cu:Ni 0:20:71:9	Trace Si,S,K,Ca,Cu
Su 479	Au:Ag:Cu 6:92:2	Au:Ag:Cu 6:92:2	Trace Al,Si,S,Cl,K,Ca,Ag
Su 485	Au:Ag:Cu 7:92:1	Au:Ag:Cu 0:98:2	Trace Al,Si,S,Cl,K,Ca,Ag
Su 488	Au:Ag:Cu 4:80:16	Au:Ag:Cu 0:88:12	Trace Al,Si,S,Cl,K,Ca,Fe,Cu,Ag
Su 477	Au:Ag:Cu 11:75:14	Au:Ag:Cu 0:70:30	Trace Si,S,Cl,K,Ca,Cu,Ag
TYPE IVa			
Su 450	Au:Ag:Cu 72:27:1	Trace Si,Fe,Al,Cl,K,Ca,Na,Mg,S	Trace Na,Mg,Al,Si,S,Cl,K,Ca,Fe
Su 478	Au:Ag 66:33	Trace Si,Cl,Al,Ca,K,S,Fe	Trace Ca,Cl,Si,K,S
Su 484	Au:Ag:Cu 64:32:4	Pb (more than 40%), trace Si,Al,K, Ca,Fe,P	Pb (more than 50%), trace P,Ca,Cl, Si,Al,Fe
Su 486	Au:Ag 80:20	Trace Ca,Fe,K,Cl,S,Si,Ti,Al,Mg	Trace Ca,Si,Cl,K,Al,Fe,S,P
Su 493	Au:Ag:Cu 81:16:4	Pb (more than 75%), trace Mg,Al, Si,K,Ca,Fe	Pb (more than 80%), trace Mg,Al, Si,K,Ca,Fe

[a] Elements of atomic number greater than 11.
[b] Normalized values.

in tables 4–6 similar to those recorded in tables 1–3 above. Ten samples were taken from textiles of different ages, all woven in the village of Koto Gadang, in the regency of Agam (fig. 9.11). The others are samples from early nineteenth-century textiles woven in a cluster of adjacent villages in the regency of Tanah Datar (fig. 9.12). The thread identified as Makau was included in both group 1 and group 2 to provide a cross-check. Four samples are on paper (type IVa). The remainder are metallic (type III). The samples are listed in table 4.

The microprobe analysis obtained for group 2 afforded only qualitative analysis, enabling the detection of the various metals with only approximate quantitative confidence. For a description of the analytic method employed, see the note on methodology at the end of this chapter.

Discussion of Type III Metallic-Wrapped Threads (Group 2)

As with group 1 samples, all type III threads in group 2 have S-twisted metallic strip wrapped on cotton or silk cores. Of the sixteen samples, fourteen have cotton cores, and two have silk. Most samples were very tightly wrapped (i.e., with almost no core showing [fig. 9.13]); in the four examples that were less tightly wrapped (listed as "even wrap" in table 5), the wrapping seemed to be very carefully applied so that the core was uniformly exposed (fig. 9.14). In these four threads, approximately equal spaces of core and metallic strip are visible under microscopic examination. Metallic threads in some Chinese textiles appear to have been deliberately wrapped loosely to expose cores of different colors, thus giving the thread an appearance of having different shades of gold, depending on the color of the core that is exposed. The illusion works because, with a thread so small in diameter, the core is not visible to the naked eye.

Examples of type III threads are of three types, which occur in roughly the same proportions in both groups: (a) predominantly copper (20 to 25 percent of samples); (b) predominantly copper with measurable amounts of nickel (25 to 40 percent of samples), and (c) predominantly silver (40 to 50 percent of samples). Many of the samples had different outer and inner surfaces because of abrasion, friction, use, or a technology that enriches one surface preferentially. Results as tabulated in tables 3 and 6 are consistent within the limitations of the methods, as described in the note on methodology below. Some trace elements found in the group 1 analysis of the Makau thread were not found in the group 2 analysis and vice versa.

TABLE 4. TEXTILES SAMPLED (GROUP 2)

ACC. NO.	TEXTILE NAME	PROBABLE VILLAGE OF ORIGIN	TYPE
Su 491	*Salendang tarewai*	Koto Gadang	III
Su 282	Trouser cuff fragment	Koto Gadang	III
KMI 63	*Salendang tarewai*	Koto Gadang	III
Su 196	*Salendang*	Koto Gadang	III
Su 425	*Saruang*	Koto Gadang	III
Su 427	*Salendang tarewai*	Koto Gadang	III
Su 447	*Salendang tarewai*	Koto Gadang	III
Su 164	*Salendang*	Koto Gadang	III
Su 428	*Salendang*	Koto Gadang	III
Su 346	*Salendang*	Koto Gadang	IVa
Su 527	*Salendang*	Pariangan	III
Su 417	*Salendang*	Batu Sangkar	III
KMI 34	*Salendang*	Tanjung Sungayang	III
Makau	*Salendang*	Tanjung Pandai Sikek	III
KMI 01	*Tangkuluak*	Pariangan/Batipuah	III
Su 455	*Salendang*	Pitalah	III
KMI 43	*Tangkuluak*	Pariangan/Batipuah	III
KMI 82	*Salendang tagak tujuah*	Batipuah	IVa
KMI 08	*Salendang*	Batu Sangkar	IVa
KMI 42	*Salendang*	Tanjung Sungayang	IVa

9.11 One end of a *salendang tarewai* from the village of Koto Gadang. Silk, cotton, gold-wrapped thread (type III). The warps are red silk, and the wefts are blue cotton, producing what appears to be a purple ground cloth. The patterning is supplementary weft of gold-wrapped thread. 203 x 52 cm. Private collection.

METALLIC THREADS IN MINANGKABAU TEXTILES

9.12 One end of a *salendang* from the village of Batu Sangkar. Cotton, gold-wrapped thread (type III). The end bands are patterned with continuous supplementary weft of gold-wrapped thread, while the center stars (*bintang*) are patterned with discontinuous supplementary weft of gold-wrapped thread. 214 cm (including braid) x 57 cm. Collection of Don Cole.

Discussion of Type IVa Threads (Group 2)

All type IVa threads in group 2 have Z-twisted lamellae on silk cores. All samples seemed to be made of mixtures of silver and gold leaf on a cellulosic substrate. Three of the four samples appeared to contain the red bole commonly attributed to Chinese source metal threads; the substrate of the sample lacking red bole appeared similar to the other three substrates. The substrate/adhesive elements seemed similar to other IVa threads attributed to Chinese workshops. All showed the presence of iron. The core on KMI 08 shows the effect of bleeding of red and blue dyes from a textile, giving the impression of a purple core.

The Significance of the Results

Several different varieties of metallic-wrapped thread were used in this small, remote highland area. Textiles for the first sample set (group 1)

TABLE 5. APPEARANCE AND DIMENSIONS OF METAL THREADS (GROUP 2)

ACC. NO.	CORE FIBER/ COLOR TWIST	THREAD DIAMETER (MM)[a]	OUTER SURFACE APPEARANCE	WIDTH OF WRAPPING (MM)	SUBSTRATE ADHESIVE COLOR	WRAPPING TWIST
TYPE III						
Su 491	Silk/yellow slight Z	.18	Bright silver even space 50/50	.20	—	S
Su 282	Cotton/white no twist	.23	Bright silver tight wrap	.28	—	S
KMI 63	Cotton/yellow slight S	.21	Bright silver even space 50/50	.23	—	S
Su 196	Cotton/yellow S twist	.22	Bright silver tight wrap	.25	—	S
Su 425	Cotton slight S	.18	Bright silver tight wrap	.22	—	S
Su 427	Cotton/white no twist	.25	Bright gold even wrap	.21	—	S
Su 447	Silk/yellow slight Z	.20	Bright silver even space 50/50	.20	—	S
Su 164	Cotton/white S twist	.25	Bright silver even wrap	.24	—	S
Su 428	Cotton/white slight Z	.20	Bright silver tight wrap	.27	—	S
Su 527	Cotton/white slight S	.28	Silvery even wrap	.27	—	S
Su 417	Cotton/white no twist	.20	Gold even wrap	.19	—	S
KMI 34	Cotton/white slight S	.19	Bright silver tight wrap	.22	—	S
Makau	Cotton/yellow S twist	.20	Tarnished silvery tight wrap	.18	—	S
KMI 01	Cotton/white slight S	.22	Silvery gold tight wrap	.29	—	S
Su 455	Cotton/white no twist	.19	Bright silver tight wrap	.21	—	S
KMI 43	Cotton/white slight S	.18	Silvery gold tight wrap	.27	—	S
TYPE IVa						
Su 346	Silk/yellow slight Z	.31	Gold, silver tight wrap	.63	Brownish red bole	Z
KMI 82	Silk/red slight Z	.30	Bright gold tight wrap	.58	Brownish red bole	Z
KMI 08	Silk/red slight Z	.23	Gold, silver tight wrap	.56	Brownish	Z
KMI 42	Silk/white slight Z	.36	Gold, silver tight wrap	.62	Brownish red bole	Z

[a] Measurement uncertain because of textile use and/or specimen handling.

9.13 Photomicrograph of type III gold-wrapped thread—metal strip wrapped around a fiber core—illustrating an example of tightly wrapped gold thread.

9.14 Photomicrograph of type III gold-wrapped thread—metal strip wrapped around a fiber core—illustrating an example of loosely but carefully wrapped thread with the core uniformly exposed. The color of the core, though not visible to the naked eye, affects the impression the viewer has of the color of the gold.

were selected to be representative of mid-nineteenth-century West Sumatran highland weaving centers (the exception, "old Makau" thread, was obtained from a textile that is probably more than two hundred years old). The second sample set (group 2) was selected to cover a range of ages (from early nineteenth to early twentieth century) of textiles from the village of Koto Gadang plus samples from the regency of Tanah Datar that were older than the samples selected for group 1.

Thread wrappings described in this study may be roughly classified as three types of type III thread and a single type of type IVa thread. The type III threads are (a) predominantly copper, (b) predominantly copper with measurable amounts of nickel, and (c) predominantly silver. The type IVa threads are predominantly gold on a paper substrate. Use of type IVa thread, as opposed to type III thread, may have been either an accident of availability or a conscious choice on the weaver's part. Different types of thread have different advantages and disadvantages. Villages represented by textiles bearing metallic-wrapped type III thread of high silver content (type c) were all noted for the beauty and richness of their heavily embellished weavings. Comparing these textiles with weavings from nearby villages, one observes that the high-silver-content thread resulted in a more flexible, drapable fabric than did the use of high-copper-content thread. Textiles with type IVa thread also have a soft, drapable quality. With repeated use, however, the gold leaf wears off the surface of type IVa thread (fig. 9.15), leaving the textile with a less lustrous appearance. The wrapped metallic strip of type III thread leaves permanent creases in textiles that

TABLE 6. ELEMENTAL ANALYSES BY ENERGY-DISPERSIVE X-RAY SPECTROSCOPY[a] (GROUP 2)

ACC. NO.	WRAPPING EXTERIOR SURFACE (RATIOS)	WRAPPING INTERIOR SURFACE (RATIOS)	CORE
TYPE III			
Su 491	Cu,Ag [3:1]	Ag,Au [trace]	Trace Ag,Ca,Cl,Si,K,Al,S
Su 282	Cu	Cu,Ag [7:1]	Trace Cu,Cl,Ag,Si
KMI 63	Cu,Ag,Ni [2:1:tr]	Cu,Ag,Ni [2:1:tr]	Trace Cu,Ag,Ni,Si,S
Su 196	Cu,Ag,Ni [5:4:1.5]	Cu,Ni,Ag [3:1:tr]	Trace Cu,Cl,K,Ca,S,Si,Ni
Su 425	Ag,Cu,Au [8:1:1]	Ag,Cu [9:1]	Trace Ag,Cu,Cl
Su 427	Ag,Cu [tr],Au [tr]	Ag,Cu [tr]	Trace Ag,Si,Ca,Cu
Su 447	Ag	Ag,Au [tr]	Trace Cl,Ag,Si,Ca,Al
Su 164	Ag,Cu [2:1]	Ag,Cu [2:1]	Trace Cu,Si
Su 428	Ag,Cu [8:1]	Ag,Cu [1.5–2:1]	Trace Ag,Cl,Cu
Su 527	Cu,Ag [3:1]	Cu,Ag [3:1]	Trace Cu,Cl,Ca,K,Ag,Si
Su 417	Cu,Ag,Au [3:1:tr]	Cu,Ag [3:1]	Trace Cu,Ag,Ca,Sn
KMI 34	Cu,Ag,Ni,Au [6:2:1:tr]	Cu,Ni,Ag [6:1:tr]	Trace Cu,Ni,Ca,Ag
Makau	Cu,Ag,Ni [3:1:0.3]	Cu,Ag,Ni [3:1:0.5]	Trace Cu,K,Ca,Ni,Ag
KMI 01	Ag,Cu [10:1]	Ag,Cu [10:1]	Trace K,Ag,Si,Al
Su 455	Ag,Cu [tr],Au [tr]	Ag,Cu [tr]	Trace Ag,Cl,Si,K,Ca
KMI 43	Ag,Cu,Au [3:2:1]	Cu,Au [3:2]	Trace Cl,Cu,Ag,Si,Ca,A
TYPE IVa			
Su 346	Ag,Au? [1:1?]	Trace Pb,Si,Al,Ag,Fe?	Trace Pb?
KMI 82	Au,Ag [8:1]	Trace Si,Ca,Al,S,K,Fe,Cl,Au	Trace S,Ca,K,Al,Si
KMI 08	Ag,Au [2:1]	Trace S,Si,Ag,Ca,Al,Cl,Fe	Trace S,Al,K,Si,Cl
KMI 42	Au,Ag [1:1]	Trace Pb,Si,Al,Ca,K,Fe,Mg	Trace Pb,Si,Ca,K

[a] Elements of atomic number greater than 11 in order of decreasing percentage of total weight.

remained folded for even relatively short periods. Although undesirable in appearance, these folds give definite clues about how the textiles were used or worn (see, for example, fig. 5.17). A distinct disadvantage of type III thread is that constant flexing during use causes metallic strips to abrade and eventually shred the silk threads of the ground fabric, and the textile disintegrates. Contact with water generally produces undesirable effects in either type of metallic-wrapped thread.

Local lore has it that the Chinese taught West Sumatran highlanders to weave with gold thread. That is consistent with the findings that type IVa threads in this study are of Chinese origin. Except in the case of the sample identified as Su 478, the villages represented in this type IVa subsample are neighboring and probably would have been visited frequently by Chinese based on the west coast of Sumatra, who were either traders or visitors in retreat from the oppressively hot, humid equatorial climate of the coastal plains. The village of Silungkang, although remote from other villages using type IVa thread, was a relatively easy journey from Solok, a rich trading center known to have been frequented by coastal merchants.

The hypothesis that only neighboring villages used a given type of thread is not supported by this study. Not only was paper-based type IVa metal thread found in weavings from widely separated areas, but so were all three types of type III thread. The variety of metal threads used appears to be the result of accidental availability of materials. No clear evidence emerges from the data of a geographic or ritualistic imperative for any of the specific types of metallic thread identified in this study. The sample base must be considerably expanded, and further research is required, using consistent methodology, for causal relationships to reveal themselves in accounting for the distribution of thread types observed. It appears, however, that the type of metallic-wrapped thread found in Minangkabau textiles will probably not help in determining village provenance.

Note on Methodology

All samples subjected to elemental analysis were carbon coated and placed in the stage of a scanning electron microscope equipped with energy-dispersive X-ray spectrometry, which yields data that allow for an estimate of relative amounts of elements of atomic number greater than 11. Each instrument is programmed to compensate for background scatter (nonzero baselines) and to select dispersion patterns from elements that correspond to those of atomic number greater than 11. The dispersion pattern that emerges is calibrated against samples of known similar composition, and the data is normalized (i.e., automatically calculated as a percentage of the total spectrum) to estimate the reproducibility of the data. When this is done, the uncertainty for normalized results generally falls in the neighborhood of 5 to 10 percent for elements present at levels above 50 percent and in the neighborhood of 50 to 100 percent for elements present at levels of 1 to 5 percent. Data for group 1, obtained at the Objects Conservation Department, Metropolitan Museum of Art, New York, were of this type.

For type IVa samples in group 1, paper comparisons were performed with a light microscope using magnifications up to 400x. The metal leaf was separated from its paper support with deionized water, and permanent slides of the paper fibers were prepared. These samples were compared with both Chinese and Japanese specimens of known origin. Paper substrates from Indonesian sources other than Sumatra were also examined.

Data for group 2, produced at the Conservation Analytical Laboratory, Smithsonian Institution, Washington, D.C., were obtained as raw printouts with spectral peaks identifying elements by program. The intensity of the selected peaks was measured and visually adjusted for nonzero baselines. Simple ratios were reported. The uncertainty (reproducibility) of this latter procedure was not ascertained, but the method is obviously inferior to the more automated normalized method. The uncertainty of this procedure may be at least an order of magnitude greater than that of the normalized data. The one sample (identified as Makau) subjected to both conditions gave sensibly similar results, though both methods failed to identify some trace elements.

9.15 Photomicrograph of type IVa silver-wrapped thread—metallic surface applied with adhesive to paper wrapping wound around a fiber core. On one portion of the thread the silver leaf is completely worn off, exposing the paper substrate. When this happens to a large section of a textile, the glittering metallic luster is lost.

Part 3
RELATED CEREMONIAL ARTS

*Seek not to follow
the footsteps of the men of old;
seek what they sought.*

—MATSUO BASHO

INTRODUCTION TO PART III

OTHER CEREMONIAL ARTS RELATED TO TEXTILES THROUGH ADAT
In a masterstroke of foresight, the two *datuak* who codified the Minangkabau adat made provisions for change in some aspects of adat if recommended by consensus of the village adat council. They realized that an adat that did not allow for modifications to accommodate new and changing circumstances would soon become irrelevant. Change may not be made lightly, however, or without due consideration. In a very real sense this flexibility allows contemporary society to seek the way of life that the men of old sought, as the Japanese poet Basho counsels. New rules of behavior must always be consistent with the intent of adat.

The seven chapters in this section serve as an introduction to the ways in which adat directs different ceremonial arts. Taken as a whole, these chapters outline a broad context within which one may judge the cultural significance of the exquisite ceremonial textiles of the Minangkabau.

The traditional arts introduced here are carving on adat houses; foods served at ceremonies; jewelry worn as part of women's ceremonial costumes; music played for ceremonies or other performances; dance, a part of ceremonial celebrations; orations delivered by *pangulu* during ceremonies; and the myths and legends from the *tambo* and parables from the *kaba*, which record and teach precepts of the adat.

Many motifs carved on the exterior walls of adat houses and on appropriate surfaces in the interiors are the same as motifs woven into ceremonial textiles. Assigned names and meanings are also the same in the two arts. These two visual arts perform the same mnemonic function, calling to mind the teachings and rules of behavior spelled out by the adat. Many, but not all, motifs are common to both arts.

Ceremonial food and ceremonial jewelry are related to textiles by the requirement that they must be approved as being in accord with adat before they can be used at ceremonies. Probably the greatest intervillage adat differences occur in these two areas. Village-specific meaning is given to some foodstuffs. In the village of Balingka, for example, a very large, smooth, delicious puffball of fried dough is a symbol of consensus, the important requirement that decisions of the village adat council be unanimous. A tasty coconut confection, made in the shape of a skimmer that will travel for long distances if thrown correctly, is a symbol of the Minangkabau's freedom to act in unlimited fashion within the confines of adat.

Music and dance also relate to the teachings of adat. Music is an integral part of ceremonies and an integral part of performances of the *kaba*, parables that spell out in great detail how "good" Minangkabau are expected to act. Whereas ceremonial textiles are embellished with motifs that recall adat sayings, the *kaba* repeat those sayings in the course of a teaching narrative. Traditional dance is choreographed and executed according to the same eight rules that adat specifies for social interactions.

The chapter on traditional oration, or *pidato adat*, presents three such speeches to show how they are filled with the sayings referred to in weaving, carving, food, and jewelry. Finally, there is a brief discussion of the *tambo* and *kaba*, which recount myths, legends, the codification of adat, and the parables that teach adat rules through dramatic narratives. Many Minangkabau *pangulu* fought actively in the struggle that freed Indonesia to become an independent nation in the 1940s. Principles laid down in their *tambo* were applied by these men in the founding of the new nation, and many were incorporated in various ways into its charter.

Ceremonial textiles, then, are only a part, albeit an important part, of a complex tradition of ceremonial arts. They are constituents of a material culture that, while glorifying the individual, exists mainly to honor and to serve the adat.

Ibenzani Usman

10

THE TRADITIONAL ADAT HOUSE AND ITS CARVING

In many Indonesian societies, and especially in the Minangkabau culture, there is a type of house that mirrors the culture and its basic values. For the Minangkabau that house is the *rumah gadang* (fig. 10.2), and the set of basic values is the adat, a traditional belief system handed down and refined through the centuries. The *rumah gadang* is, in a sense, a physical manifestation of the adat. The architecture and construction, the carvings on the walls and pillars, and the functions the house serves all reflect adat precepts.

The Rumah Gadang, or Great House: Its Function and Meaning

As an adat house, the *rumah gadang* is the major form of a spectacular building tradition. There are many accepted forms of adat house, but the *rumah gadang* is without doubt the most monumental residential structure that the Minangkabau have inherited from their ancestors. Although the word *gadang* means "great," the greatness here refers not to the building's physical size, but rather to the large variety of functions it serves and to its remarkable aesthetic value (Navis 1980, 176). The Minangkabau take justifiable pride in the majestic appearance and beauty of the *rumah gadang* and especially in its utility and symbolism.

In accordance with the adat rules of the Minangkabau matrilineal kinship system,[1] the *rumah gadang* is owned by the matrilineage, the women who stay and live there. In addition to being a residence, it serves as a hall for family meetings or extended family councils and for ceremonial activities, which are an important part of the traditional Minangkabau way of life.

A second function of the *rumah gadang*, its symbolic function, is embodied in the overall exterior form of the structure, the striking shape by which the building is generally identified. This form is made up of many elements (fig. 10.3), each of which has an independent symbolic meaning: the *gonjong* (hornlike roof structure), *singkok* (triangular wall under the ends of the *gonjong*), *pereng* (shelf under the *singkok*), *anjuang* (raised floor at the ends of one version of the house), *dindiang ari* (the two walls on the side elevations), *dindiang tapi* (the two walls on the front and back elevations), *papan banyak* (front facade), *papan sakapiang* (a shelf or middle band on the periphery of the house), and *salangko* (wall enclosing space under a house that has been built on stilts).

10.1 Rice barn (*rangkiang*) standing in front of a traditional house. Note the architectural similarities of the two structures. Rice is traditionally stored outside the main house, and rice for different uses is often stored separately in several different *rangkiang*. It is said that if the house burns down, at least the family can still eat.

10.2 Traditional adat house (*rumah gadang*) of the weaver Sanuar in the village of Pandai Sikek. The front and side walls of the house and the triangular walls under the roofs of the rice barns in front of the house are completely carved with adat motifs, some of which are illustrated in this chapter.

243

dindiang tapi (front elevation)

dindiang ari (side elevation)

10.3 The elements of the *rumah gadang* include the *gonjong* (horn-shaped roof structure), *singkok* (a triangular wall under the *gonjong*), *pereng* (shelf or upper band below the *singkok*), *papan banyak* (a series of vertical boards that make up a wall), *papan sakapiang* (middle band), *salangko* (wall enclosing space under a house built on stilts), and *anjuang* (raised floor at the ends of one version of the house).

Each of these elements has its own symbolic meaning, which is frequently referred to in adat speech and in adat aphorisms. For example, the meaning of the *gonjong* is explained in the following translated example of adat speech:

Gonjong is like a bamboo shoot,
Pumpkin[2] is also related to the word.
Earrings may be caught by eagles
supposing they are bait to eat.
But the truth is that it means growth.
That this "bamboo shoot" looks upward to
THE ONE is the point exactly.

The import of this speech is that the *gonjong* reaching toward "the one" symbolizes the Minangkabau belief in only one god.

Another example of the symbolism of house elements is found in the wall that covers the back elevation of the structure (*dindiang tapi*). This wall is made of plaited strips of bamboo (*gedek*), which provide privacy but also let the breeze flow into the bedrooms (fig. 10.4) The symbolic meaning of this plaited wall is that, even though these individual strips of bamboo are not strong or useful when standing alone, when they are plaited together, they form a structure that is both strong and useful. So the individual Minangkabau should become a part of a larger structure, the community, and, in so doing, make it strong and useful. (For further discussion of motifs that express the importance of community, see chapter 7.)

These structural elements stand in good proportion to one another and are aesthetically harmonious (note in fig. 10.2, for example, the relationship of roof to body of the house). The interplay of curved lines and straight lines, which are dissimilar or opposing line elements, express counterpoint, rhythm, emphasis. An adat aphorism says "crossing logs in the fire-

10.4 *Dindiang tapi:* back wall of a traditional house. The wall is built of woven strips of split bamboo, which provide privacy while allowing the breeze to pass through the house, a welcome effect in this equatorial climate. To the Minangkabau, interlocking bamboo strips are signs of the importance of community: individual strips are not particularly useful but, when joined, become useful and strong. So individuals should join together to make a useful and strong community.

RELATED CEREMONIAL ARTS

10.5 The two basic models of the *rumah gadang*: the Koto Piliang model, with *anjuang*, or raised floor, at both ends (top), and the Bodi Caniago model (without *anjuang*).

place makes for a roaring fire." In other words, one can find harmony in conflict. To the Minangkabau, counterpoint, rhythm, and emphasis are understood as design principles and sources of aesthetic value in the interpretation of this aphorism.

The *rumah gadang* is built in one of two basic models: Koto Piliang or Bodi Caniago (fig. 10.5). These two different forms result from differing adat conceptions of proper social structure. The two concepts were proclaimed by two half brothers, Datuak Katumangguangan and Datuak Parpatiah Nan Sabatang, who vied for leadership of the Minangkabau World centuries ago. Datuak Katumangguangan's belief in the superiority of his aristocratic and hierarchical organization of society (i.e., rule by kingship) influenced the Koto Piliang form of *rumah gadang*. The name comes from the two *sukus* or clans, the Koto and the Piliang, who followed the adat laid down by Datuak Katumangguangan. This model has raised floors, called *anjuang*, at each end of the house, permitting hierarchical seating of *pangulu* during ceremonial events. Datuak Parpatiah Nan Sabatang, however, opposed kingship and chose to glorify a democratic concept of social structure. His adat concept gave rise to the Bodi Caniago house model, which omits the *anjuang*. The floor of a Bodi Caniago *rumah gadang* must be flat and all on one level. The *anjuang* is the only structural element that differentiates the two models. (See chapters 2 and 16 for a fuller description of the roles of these two *datuak*.)

Over time each of these models acquired somewhat minor and parallel variations. These developments resulted in three main types of *rumah gadang*: the *gajah maharam* (literally, "elephant kneeling"), the *rajo babandiang* (design of grandeur), and the *bapaserek* or *surambi papek* (without veranda). The difference between the *gajah maharam* and the *rajo babandiang* lies in the number of pillars in each building. For example, in its main structure the *gajah maharam* may have forty pillars, and the *rajo babandiang* may have fifty. A Koto Piliang house will have an additional six pillars on each end for the *anjuang*. The difference in the number of pillars between a *gajah maharam* and a *rajo babandiang* house results in two proportionally different forms (fig. 10.6). The *gajah maharam* is characterized by stoutness and shortness. For the Minangkabau it calls to mind the bulk of a kneeling elephant. The other form, *rajo babandiang*, appears more slender, like a person who is dynamic and energetic. The *bapaserek* or *surambi papek* is defined by an entrance door that has been installed without a veranda at the top of the entry steps. This door is not necessarily located at the center front of the house but may be at one end of the front facade or at the side.

Bodi Caniago Model **Koto Piliang Model**

Gaja maharam Raja babandiang Gajah maharam Rajo babandiang

10.6 Elevations and floor plans showing variations on the two basic models of *rumah gadang*.

Inside the ideal *rumah gadang* are five rows of pillars running parallel to the front facade of the house, dividing the interior into four long spaces called *lanjar* (fig. 10.7). The *lanjar* that runs along the back of the house is shielded on the outside by the plaited bamboo wall and is usually divided into separate bedrooms. The other three *lanjar* are designed as living areas or as spaces for adat ceremonial events. This area is called the *labuah gajah* (elephant road; fig. 10.8). The configuration of pillars in a fifty-pillar *rumah gadang* may also be interpreted as ten columns of five pillars, each running perpendicular to the length of the house, making a total of nine spaces called *ruang* between adjacent columns of these pillars. In practice, the number of *ruang* built into a *rumah gadang* depends on the needs of the matrilineage. A *rumah gadang* must possess at least five *ruang*. An ideal *rumah gadang* has nine. A Minangkabau adat aphorism says:

> The Great House has nine rooms [that extend]
> as far from the beam pole as could be jumped
> by a horse
> [as far as] a screaming child could be heard.

To the Minangkabau this means that the ideal traditional house is very large and is filled with many images.

An ideal *rumah gadang* is usually accompanied by several rice barns (*rangkiang*), which have names that refer to their different functions (fig. 10.1). The *rangkiang sitinjau lauik*, for example, contains rice to be prepared for use by the family or extended family, especially during adat ceremonies. It is situated in the center of the cluster of granaries. The *rangkiang sitangka lapa* contains rice to be prepared for poor villagers to help stave off famine in the village. The cross section of this granary is in the form of a square. It is situated at the extremity of the cluster of granaries. The *rangkiang sibayau-bayau* contains rice to be used just for the daily needs of the immediate family. It is located nearest to the house. The wooden walls of rice barns are carved with a varied selection of ornamental motifs.

Another building with the same general appearance as the *rumah gadang*, the traditional council hall (*balai*), plays an equally important role in the culture. The *balai* serves as a special meeting place in which a group of clan leaders consider local problems over which they have jurisdiction and negotiate until solutions are reached by consensus (fig. 10.9). Only the raised wings of the Koto Piliang model of the *balai* are enclosed by walls; the remaining areas are left open.

10.7 The floor plan of a Koto Piliang *rumah gadang*. The *lanjar* is the space between two rows of pillars along the length of the house. *Lanjar* 4, at the rear of the house, contains bedrooms. *Lanjar* 1, 2, and 3 constitute the *labuah gajah*, or elephant road. The *ruang* is the space between two columns of pillars across the depth of the house.

RELATED CEREMONIAL ARTS

10.8 Interior of a traditional house (*rumah gadang*). Shown are the three front sections (*lanjar*), where members of the matrilineage gather for meals, ceremonies, and daily activities. This section is called the elephant road (*labuah gajah*). The rear *lanjar* is divided into separate rooms for the women of the matrilineage and, if married, their husbands and young children.

Traditional Carving on the Walls of the Rumah Gadang

For centuries the Minangkabau have ornamented the wooden walls, pillars, and ceilings of the *rumah gadang* with carvings that reflect the adat. One such house in the village of Palembayan, in Agam, which was torn down about twenty years ago, was built in 1790 and carved by artists brought in for the purpose from the province of Aceh. An old *rumah gadang* with extensive interior carving, which is still standing in the village of Balimbiang, is documented to be more than three hundred years old. In an account of his travels to West Sumatra in 1861 and 1862, Alfred Russel Wallace (1869, 96) wrote that "the gable ends [of the *rumah gadang*] and all the chief posts and beams are sometimes carved with exceedingly tasteful carved work."

Minangkabau traditional carving is one of the elements that increases the grandeur of the *rumah gadang*. Most of the wall surfaces of the house are covered with different ornamental motifs carved according to the dictates of tradition. These motifs are always rendered as floral designs based on a simple underlying geometric structure. In old traditional adat houses, no motif in the form of an animal or of a human

10.9 Village council hall (*balai*), used as a meeting place for clan chieftains (*pangulu*). Deliberations of the *pangulu* are public. Hence the front and rear walls are open so that any interested villager may listen to the proceedings. The roof structure is the same as that on the *rumah gadang*.

THE TRADITIONAL ADAT HOUSE AND ITS CARVING

10.10 Design elements of an ornamental motif: *gagang* (a scroll leaf stalk), *buah* (fruit), *duan* (leaf), *bungo* (flower), and *sapiah* (flower stem).

10.11 The *aka duo gagang* (root with two spirals) motif. The drawings show the basic geometric form of circles with (a) the embellished form and (b) the full design.

10.12 The *siku siku kalalawa bagayuik* (turning of a tiny hanging bat) motif. The drawings show the basic geometric form of scrolls on squares with (a) the final layout and (b) the full design.

10.13 The *pucuak rabuang jo salimpat* (bamboo shoot with interwoven rattan) motif. The drawings show the basic geometric form of scrolls on squares with (a) a variation on where the scrolls are placed and (b) the full design.

being has been found depicted in its natural, realistic form, although some motifs may be named after animals, human beings, or their activities or behavior. Most uninitiated persons view these motifs as floral designs only. For example, Robert Heine-Geldern (in Loeb 1972, 328), an archaeologist who had observed the wood carving on a *rumah gadang*, wrote: "The walls are lavishly decorated with scroll motifs and other ornaments, mostly of Indian or Mohammedan origin, though in a few cases still betraying the old Dong-son rudiments." This description, even if accurate, minimizes the importance of the carving because it does not take into account the rich hidden vocabulary of these adat motifs based on Minangkabau concepts of the ideal.

Recent research has shown that traditional carvings on the *rumah gadang* are based on a Minangkabau concept of aesthetics (Usman 1985). This concept is part of the Minangkabau view of their world (Alam Minangkabau), in which expression is always based on the world of nature. A well-known adat aphorism says, "Nature is our teacher." This point of view is based on principles laid down by adat for Minangkabau intellectual activity: *alua jo patuik* (appropriateness with propriety), *raso jo pareso* (perception with proportion), and *ukua jo jangko* (proper size and durability). Within these concepts of appropriate expression, Minangkabau traditional carvers have created the many traditional ornamental motifs that cover the walls of the *rumah gadang*, reinforcing the symbolic function of its every element.

Ninety-four different ornamental motifs have been observed on *rumah gadang*. Thirty-seven of them have names referring to flora, such as *kaluak paku* (fern tendrils), *saluak laka* (interwoven rattan), and *lumuik hanyuik* (washed-away moss). Twenty-eight motifs have titles describing fauna: *tupai tatagun* (startled squirrel), *itiak pulang patang* (ducks going home in the afternoon), and *kumbang janti*

RELATED CEREMONIAL ARTS

(golden bumblebee). The remaining twenty-nine motifs have titles describing human beings and sometimes their activities or behavior: *rajo tigo selo* (three kings of the realm), *kambang manih* (literally, "sweet flower," used to describe an amiable girl), *jalo takambang* (casting a net), and so forth. All ninety-four motifs are formed from a limited number of basic geometric patterns. Basic forms such as the circle, scroll, rectangle, and triangle are arranged into exact patterns on which the carver overlays images of leaves, blossoming flower stems, and other parts of plants (fig. 10.10).

Six different geometric patterns traditionally underlie most completed works. These six patterns are constructed from combinations of four basic shapes—circle, triangle, scroll or spiral, and rectangle—taken two at a time (figs. 10.11–10.17). Such geometric structures are general and simple enough to allow traditional carvers to create motifs that can be adapted to changing tastes. Innovative motifs found on some *rumah gadang* include a swastika motif reflecting the influence of the Hindu and the later Hindu-Buddhist period in Sumatra (seventh to fourteenth centuries), a crown motif reflecting the influence of Dutch culture (sixteenth to twentieth centuries), and the *garuda pancasila*, the formal symbol of the Republic of Indonesia. Use of the latter motif on a traditional Minangkabau house connotes that the Minangkabau culture is an integral part of Indonesian national culture.

10.14 The *kaluak paku kacang balimbiang* (fern tendril and blimbing nut) motif. The drawings show the basic geometric form of scrolls with (a) a superimposed sine curve and (b) the full design.

10.15 The *kuciang tiduah* (sleeping cat) motif (a), a single scroll, and the *aka cino* (Chinese root) motif, combined scrolls (b).

10.16 The *salimpat II* (variant of woven rattan) motif. The drawings show the basic geometric form of combined figures of the scroll-like sleeping-cat motif with (a) superimposed curved triangular form and (b) the full design.

10.17 *Kuciang tiduah jo saik galamai* (sleeping cat with ceremonial cake). The drawings show the basic geometric form of the scroll-like sleeping-cat motif with (a) interspersed diamond shapes and (b) the full design.

THE TRADITIONAL ADAT HOUSE AND ITS CARVING

Today traditional carving, with its rich aesthetic symbolism, is being challenged. Many carvers at craft centers in West Sumatra carve freely designed nontraditional motifs. They no longer feel obliged to follow a Minangkabau aesthetic that once had to be obeyed. Realistic forms of humans and animals appear in their works. They carve a door or a decorative piece of wood with motifs of their choosing and add it to the interior of a modern house only as a visually pleasing element. It is important to note that these contemporary carvers create designs just for the sake of visual pleasure, whereas formerly all carvers understood and agreed to abide by accepted criteria for traditional, meaningful symbolic design.

By tradition, if a carver wants to design the motif known as *tupai* (squirrel), he has to depict the movement of the squirrel. This movement must be represented only by flora (fig. 10.18). He is similarly restricted to depictions of flora when he wants to draw motifs relating to any living creature, including humans. There are two possible explanations for this restriction. First, in Islamic teaching there exist Hadith (records of actions and sayings of the prophet Muhammad and his followers) that forbid all Muslims to depict living creatures realistically in their paintings, sculptures, or other works of art. This restriction is widely honored even though no one verse of the Quran spells out such a proscription. Second, the Minangkabau have a long-standing special attitude toward the conduct of daily dialogue and other forms of communication, an attitude that emphasizes indirection. One must try to avoid saying anything "to the point," but instead must phrase it in a figurative sense. So if a traditional carver wants to depict a squirrel, he is bound by tradition only to hint at it or to depict it through images of flora. This preference for indirect expression is the most likely explanation why Minangkabau traditional carving does not depict living creatures in a realistic manner. (For other examples of the Minangkabau predilection for indirection, see chapters 1 and 15.)

Every ornamental motif carved on a *rumah gadang* has a name and, through adat teachings associated with this name, a unique meaning. Therefore, the placing of motifs on any element of the structure must be in accordance with the symbolic meaning of that element. For example, the *kaluak paku* (fern tendrils) or the *saluak laka* (interwoven rattan; fig. 10.19) motif must appear on the *pereng*. Both motifs are symbolic representations of kinship, which is basic to the life of the Minangkabau. The *kambang manih* (sweet flower) motif, a symbol of the amiable attitude of a Minangkabau family receiving guests (fig. 10.20), must be carved on the *papan banyak*. On the *salangko* must be carved the *lumuik hanyuik* or *jalo takambang* motif, symbolizing the responsibilities of *datuaks* (clan chiefs; fig. 10.21).

The adat teachings to which the carved motifs and structural elements of the *rumah gadang* refer are frequently expressed in a form of adat speech called *papatah-patitih*. One such aphorism—"the son is carried in the right hand, the nephew is led by the left hand"—is usually interpreted as stating the responsibility of a man to love and care for his son but also to guide and assist his nephew. The latter responsibility is a role common to matrilineal societies. Other motifs are related to other *papatah-patitih* or to other adat aphorisms. (See also chapter 15 for a discussion of *papatah-patitih* and other forms of traditional Minangkabau sayings.)

10.18 The ornamental motif called *tupai tatagun* (startled squirrel). The drawings show the progression from the form of a squirrel to geometric structure and, finally, floral forms.

10.19 The ornamental motif called *saluak laka* (interwoven rattan). This motif must be carved on the *pereng*, an element of the *rumah gadang*. It symbolizes eternal kinship.

10.20 The ornamental motif called *kambang manih* (amiable girl or sweet flower) must be carved on the *papan banyak* (front wall) of the house. It symbolizes welcome.

10.21 The ornamental motif called *jalo takambang* (scattered net) must be carved on the *salangko* (wall enclosing space under a house built on stilts). It symbolizes the responsibilities of the *datuak* (clan chieftain).

THE TRADITIONAL ADAT HOUSE AND ITS CARVING

A NOTE ON ORNAMENTAL MOTIFS
Traditional carving is not the only Minangkabau art form that employs motifs based on adat. Some ornamental motifs found in carving on the *rumah gadang* are also found on articles in daily use, such as the *carano* (metal bowl containing the elements of the betel quid, used during the initiation of Minangkabau adat ceremonies; fig. 10.22), the *salapah* (silver or silver and gold tobacco box; fig. 10.23), the *palaminan* (elaborately adorned alcove seat for a bridal couple; fig. 4.9, and *songket* (traditional ceremonial weavings; fig. 10.24). These adat-based motifs are also referred to in traditional speech. Ornamental motifs on the *rumah gadang* have the same meaning as the same ornamental motifs found in the other arts. There are, however, differences in the shapes of some motifs depending on the technology of the art form. A scrolled or spiral motif woven into a *songket* cloth, for example, cannot be as smoothly curved as a scrolled line carved in wood. The ability to produce curved lines in weavings is sharply limited by the orthogonal nature of the weaving process. (For a detailed discussion of motifs on ceremonial textiles, see chapter 7.)

10.22 Large brass bowl (*carano*) holding several smaller brass bowls. These bowls hold the ingredients for betel quid, which is chewed at some ceremonies. Ingredients include chopped areca nut, slaked lime, and a flavoring, usually gambir in Minangkabau, all wrapped in a leaf of the *Piper betle* vine (*siriah*).

10.23 Tobacco box (*salapah*). The large container holds tobacco, which, if chewed while chewing betel, is said to prevent tooth discoloration. The smaller box, attached to the *salapah* by a small silver chain, contains lime.

10.24 Man's waist tie (*ikek pinggang*) from the village of Batipuah. Silk, cotton, gold-wrapped thread. The end panels are patterned with several motifs done in supplementary-weft technique. The long fringes are braided and tufted. 328.8 (including fringe) x 24.2 cm. FMCH x93.25.12; collection of H. Elly Azhar and H. A. Sutan Madjo Indo.

10.25 Types of frame motifs: (a) *tantadu manyasok bungo* (caterpillar sucking a flower), (b) *kudo manyipak* (kicking horse), (c) *itiak pulang patang* (ducks going home in the afternoon), (d) *bada mudiak* (small fish going upstream, a chevron pattern), (e) *balah katupek* (split rice basket, a parallelogram pattern), (f) *jo sitampuak manggih* (calyx of mangosteen fruit and a zigzag pattern), (g) *aka duo gagang* (two-stem root), and (h) *buah palo bapatah* (broken nutmeg).

When arranging individual motifs into a larger overall composition, Minangkabau traditional designers, whether carving the motifs into a *rumah gadang* or weaving them at a loom, may choose from two types of motifs, framing or main. The framing motif is the smaller of the two, and its function is to frame a main motif or to divide two main motifs appearing in a larger composition. There are many framing motifs: *tantadu manyasok bungo* (caterpillar sucking a flower), *itiak pulang patang* (ducks going home in the afternoon), *bada mudiak* (small fish going upstream), *balah katupek* (a parallelogram representing a container woven of coconut fronds for cooking a special kind of rice), *saik galamai* (diamond pattern, representing a ceremonial cake), *siku siku* or *biku biku* (zigzag pattern), *jo sitampuak manggih* (calyx of a mangosteen fruit), and *buah palo bapatah* (broken nutmeg; fig. 10.25).

The structure of main motifs is usually not as simple as that of the repeated small elements in the framing motif. Whatever main motifs may be selected for a composition, the framing motif independently has a very important position within the composition as a whole and con-tributes to its meaning. Main motifs include *saik galamai* (diamond pattern; fig. 10.26), *jambuah cawek rang pitala* (belt plume of the Pitalan; figs. 10.27, 10.28), *kaluak paku* (fern scroll; fig. 10.29), *saluak laka jo pucuak rabuang* (interwoven rattan with bamboo shoot; fig. 10.30), *kambang manih* (sweet flower; fig. 10.20) and *ula gerang* (glad or bold snake or dragon). Main motifs appear in compositions found in *songket* and on walls of the *rumah gadang*.

In addition to the two types of ornamental motif described above, there exists a third type, the *bintang*, or star. This type of motif is usually

10.26 Two variants of the type of main motif known as *saik galamai* (diamond pattern, representing a ceremonial cake).

10.27 The type of main motif known as *jambuah cawek rang Pitalan* (belt plume of the Pitalan). The plume is located at the side of the circle (a).

10.28 Fringe on one end of a belt (*ikek pinggang*) from the village of Pitalah. Silk, cotton, gold-wrapped thread. This is the fringe referred to in the motif known as *jambuah cawek rang Pitalan* (belt plume of the Pitalan); see also figure 10.27. 352 (including fringe) x 22 cm. FMCH X93.25.49; collection of H. Elly Azhar and H. A. Sutan Madjo Indo.

10.29 Main motif known as *kaluak paku* (fern scroll). The main motif is in turn framed by a motif entitled *tantadu manyasok bungo* (caterpillar sucking a flower).

10.30 Main motif known as *saluak laka jo pucuak rabuang* (interwoven rattan with bamboo shoot). The main motif is framed by a motif entitled *saik galamai* (diamond pattern, representing a ceremonial cake).

a collection of small elements such as blossoms or stars, scattered over a large area. This "star" motif does not follow adat rules. It may be put anywhere freely, although it does sometimes refer to a *papatah-patitih* (adat speech). Star motifs only seldom appear on the *rumah gadang* but are more common in *songket* cloth (fig. 10.31).

There are two accepted ways of arranging framing and main motifs in compositions: *tata paduan longgar* (spacious manner) and *tata paduan padat* (compact manner; fig. 10.32). The aim of these two manners is to provide variety in achieving balance and harmony of composition.

Because the traditional Minangkabau house has long been an important part of the rich ceremonial life of the people, one would expect its architectural traditions to be very old. A sketch drawn during Alfred Russel Wallace's visit to the Minangkabau heartland (see p. 11) is evidence that the design style of the *rumah gadang* existed prior to 1861. An illustration of part of a house built and carved in 1790 (fig. 10.33) demonstrates that carving on Minangkabau houses goes back at least to the eighteenth century and probably much farther.

This description of the Minangkabau traditional house and its carving and of the use of the same ornamental motifs in traditional Minangkabau weaving has been necessarily brief. It was written in the hope of kindling an interest in knowledge yet to be found about the *rumah gadang* and its carving. There are still many points of interest in Minangkabau traditional culture which have not yet been touched by the hand of researchers.

RELATED CEREMONIAL ARTS

10.31 Shoulder cloth (*salendang*) from the village of Batu Sangkar. Silk, gold-wrapped thread. The small, separate motifs scattered through the center of the textile are called *bintang* (stars). 223.8 (including braid) x 73.8 cm. FMCH X93.25.13; collection of H. Elly Azhar and H. A. Sutan Madjo Indo.

10.32 Two ways of arranging motifs in one carving composition: (a) spacious manner (*tatapaduan longgar*) and (b) closely compacted manner (*tatapaduan padat*).

10.33 Ornamental motifs in a different style, found on the bedroom doorframe of a *rumah gadang* built in the village of Palembayan in 1790. The carver of this *rumah gadang* came from Aceh, on the northern tip of Sumatra. Most of the ornamental motifs he carved were influenced by Egyptian-style elements. The capitals on the pillars were decorated with papyrus motifs, but at the lintel (a) he added a traditional Minangkabau motif called *ula gerang* (glad or bold snake or dragon).

THE TRADITIONAL ADAT HOUSE AND ITS CARVING

Lisa Klopfer

CEREMONIAL FOODS FOR THE CELEBRATION OF MARRIAGE

Minangkabau cuisine is known throughout Southeast Asia and even in parts of Europe and America because of the enormously popular restaurants run by Minangkabau men in those regions. Padang restaurants, as these establishments are often called, specialize not only in a particular cuisine but also in a particular way of serving the food.[1] In order to experience Minangkabau ceremonial food in its social context, however, you must go to a village. This chapter is based on research done in one Minangkabau village, Sungai Patai. It cannot be emphasized enough that Minangkabau cuisine varies considerably from one village to the next; special foods are cooked in different ways, given different names, and even said to mean different things. Because of this variation, it is impossible to make general statements about all Minangkabau people and all ceremonial foods. The specific foods and practices described in this chapter may not be found in other Minangkabau villages, but the basic values expressed by the food symbolism are widely shared by the Minangkabau people.[2]

Minangkabau cuisine relies on two crucial elements of Minangkabau social life. One is the tradition of *marantau*, and the other is that of marriage alliances. The term *marantau* refers to the Minangkabau tradition of temporary migration by men in search of experience in the larger world.[3] It is common in Minangkabau villages for young men to seek their fortune abroad for a number of years before marriage. In some cases this means nothing more than taking a bus to a nearby city for further education or a job with an uncle; in others it might mean traveling to Jakarta or even abroad. In his initial efforts, a young man is usually given financial backing by his family, who in turn expect that he will send any earnings back to them and, most importantly, that he will return home mature, financially secure, and thus ready for a good marriage. Nowadays, with the expansion of work opportunities in Indonesian cities, many Minangkabau men don't return to their villages until they reach old age. A man may come home to get married, but then, instead of moving into his wife's house, he will set up a new household with his wife in a city where they both have jobs. Minangkabau people nonetheless maintain a special love for their home village. Even when they spend most of their adult life in a distant city, they send money home to support relatives; return to the village for religious holidays, weddings, and other ceremonial events; and usually plan to retire to the village in old age.

This special attachment that Minangkabau people have to their villages is expressed in their eating habits as well. Food ideally comes from one's home village, from the soil one has worked and cared for, and is cooked by people one knows and loves. Aside from believing that food cooked at home simply fits a person's constitution better than food from anywhere else, many Minangkabau fear that food from elsewhere may be adulterated with substances that do not agree with them. In extreme cases, strange food is feared to have been deliberately poisoned or contaminated with filth by witches or demons who only appear to be human beings. For this reason, people go out of their way to avoid eating and drinking in places where they are unsure of their welcome.

It is likely that many Minangkabau would prefer to take their whole kitchen with them when traveling, but barring that, they pack classic travel food, a dry spicy meat dish known as *randang*. When traveling abroad or going on the hajj,[4] Minangkabau people go to great lengths to conceal packets of *randang* in suitcase linings or other hiding places in order to smuggle it past suspicious customs agents charged with curbing the import of fresh foods. Because *randang* is taken abroad by Minangkabau people, and

11.1 Weddings, like other Minangkabau ceremonies, involve processions of whole extended families and guests from bride's house to groom's house and back, often detouring through the entire village. At the head of this procession is the bride, wearing on her head an elaborate golden headdress of Chinese origin, called a *suntiang* (see also figs. 6.2, 6.66).

11.2 Women cutting up red meat (usually water buffalo) for *randang*, a highly spiced stew that is a staple of Minangkabau daily diet as well as a ceremonial food. An interested small hunting dog keeps a close eye out for scraps.

11.3 Women rinsing cut-up meat in water. The meat will be cooked at length in a mixture of coconut milk and spices to make *randang*, a favorite food of the Minangkabau.

because it is served in Minangkabau restaurants abroad, it has taken on significance as a, or perhaps even *the*, quintessential Minangkabau food, one that is not eaten by any other Indonesian people and that signifies home for Minangkabau who are away.

Randang is produced by simmering red meat in coconut milk and the usual spices used for curry over a low heat for many hours (figs. 11.2–11.7) until the sauce is completely reduced and the meat has crumbled into small bits and flakes. People who cannot afford red meat will substitute jackfruit, potatoes, dried fish, or other curry ingredients that won't easily disintegrate (fig. 11.8), but the ideal *randang* food is red meat. As a result of long, slow cooking, the once golden curry becomes dark brown to black and shiny from the coconut oil, and it is said to keep for weeks without refrigeration. Eaten with rice, *randang* is not as peppery hot as many Minangkabau dishes. It has an extremely rich, slightly sweet, smoky taste. For most Minangkabau people abroad, eating *randang* takes them as close to home physically and mentally as they can get without actually returning.

At home, food symbolism expands for Minangkabau people to take on a much wider range of ceremonial and daily cooking. Weddings are the most regular ceremonial event in which food, in the form of both shared meals and gifts, is of central significance (other events would include those associated with bestowing adat titles, funerals, circumcisions, and various religious holidays). From the first moment that a possible marriage alliance is discussed until the eventual end of the marriage through separation or death, Minangkabau people share and exchange food to celebrate and maintain the relationship.

Marriages among traditional Minangkabau are said to be arranged, but in practice they range from situations in which a boy and girl, having met and begun a romance, go to their parents for approval to marry to situations in which they may in fact barely know each other. Arrangements always begin with informal, quiet talk among the older women from the families involved. Hints and counterhints are offered in such a way that either side can back out without insulting the other. Only after it is clear that no one will object is the question of marriage brought up in a formal manner.

The first public step is for the prospective bride's family to arrange a discussion of her future. On the day of that meeting, the women of the bride's house (in a traditional extended

11.4 Initial browning of meat for *randang*. In the village of Sungai Patai much of the cooking is done outside, over an open fire.

11.5 A woman takes her turn at stirring *randang* as it cooks down, a hot, smoky task. The trick to making good *randang* is said to be a low fire and constant stirring.

11.6 Pouring coconut milk into *randang*.

11.7 Adding other ingredients to *randang* while it cooks. Men are said to be the ones who make *randang* and curry for celebrations, but in fact all the basic food preparation, including squeezing the coconut milk, is done by women. Men may be called upon for heavy lifting, pouring, and stirring.

CEREMONIAL FOODS FOR THE CELEBRATION OF MARRIAGE

11.8 Ingredients for a meatless (and therefore much less expensive) *randang* prepared for cooking in a large wok.

11.9 Female relatives of a prospective bride who have come to help make *sagun*, a mixture of pounded rice, grated coconut meat, and palm sugar (*gulo jawa*).

there is little to do except sit and talk (fig. 11.13). Although it is not required, the host family may serve their helpers a meal, if they can afford it, or at least tea and sweet snacks after the main work is done. This gathering is an ideal place for exchange of information and for an informal airing of any concerns about the prospective groom or his family. Toward the end of the day the women arrange for packets of *sagun* to be carried by various persons among them as invitations for the evening meal. The guests to be invited include women of the same lineage, women related to the bride's father, wives of the bride's brothers and mother's brothers, and others felt to be close to the family, such as neighbors, religious leaders, or close allies of the bride's parents. Although the women carry the invitations to other women, it is expected that guests will bring their husbands along.

family this means her grandmother, mother, maternal aunts, and sisters) invite their female relatives to come and make *sagun* (fig. 11.9).[5] *Sagun* is a dry mixture of pounded rice, grated coconut meat, and *gulo jawa* (Indonesian palm sugar), in a ratio of roughly four liters of hulled rice and one kilogram of *gulo jawa* to the meat of two large coconuts. The hulled rice is soaked, pounded flat (fig. 11.10), and then toasted in a large iron dish along with the grated coconut meat (fig. 11.11). The sugar is dissolved in water, boiled, and then added to the rice mixture (fig. 11.12), which is cooled and spooned into folded banana palm leaf packets.

This work is done in a festive spirit, and if many women arrive to help, they might find that

11.10 Pounding hulled rice for *sagun*. The sound of young women pounding rice is associated with courting. According to some of the villagers, in the old days a girl might be asked to pound rice for her prospective in-laws so that they could take a good look at her skill and strength.

RELATED CEREMONIAL ARTS

11.11 Female relatives from the bride's family helping to make *sagun*: toasting the pounded rice and grated coconut.

11.12 Female relatives from the bride's family helping to make *sagun*: stirring palm sugar syrup into the pounded rice mixture. Women of the house are dressed casually in T-shirts and *saruang*. Visiting relatives wear nice blouses and colorful headscarves. Older women instruct the younger ones, and the children look on.

11.13 Female relatives from the bride's family helping to make *sagun*. Often there are more helpers than needed, so many just watch and talk.

CEREMONIAL FOODS FOR THE CELEBRATION OF MARRIAGE

11.14 A ceremonial brass bowl (*carano*) holds the ingredients for betel quid: leaf of the *Piper betle* (*siriah*), areca nut, slaked lime, and gambir. Chewing the betel quid, or sometimes just the leaf that encloses it, is part of nearly every Minangkabau ceremony.

At the appointed time guests gather at the prospective bride's house. The women sit near the kitchen or on the bedroom side in a traditional house (*rumah gadang*), and the men arrange themselves in the main hall. There follows an evening of oratory on the part of the men in which three candidates for groom are named. This is just for form's sake, as only one man is really under consideration, but he must be selected from the three. After the men have formally agreed on the groom, they select a young man, usually a *sumando* (a man who is married to one of the women of the house), who is instructed to carry the message to the prospective groom's family. After everything is settled, *sagun* is served in small dishes, and each person must take at least a pinch to celebrate the sweetness of the planned union.

The next evening the bride's messenger goes to the intended groom's house with a ceremonial brass vessel (*carano*) containing ingredients for betel quids (fig. 11.14) and formally states the offer of marriage. This formal offer of marriage is called *maminang*, to bring the *pinang* nut (areca nut) to be chewed with the betel leaf; figs. 11.15–11.17. The groom's relatives, having been forewarned, are there to receive the messenger. They take the betel quids and tell him they must consider the matter for a few days. In two days the bride's family sends its messenger back again, and this time he is told to wait one more day. The third day the groom's family meets to make and eat *sagun*, just as the bride's family did earlier, except that now the topic is whether to accept the offer. For a third time the bride's messenger visits, and this time, if all has gone well (it usually has), he is sent home with a positive answer, and the couple is considered formally engaged.

The length of the engagement varies greatly. In the case of long engagements, other interim ceremonies such as ring exchanges may be held. Legally all that remains is for the couple to have a *nikah* (Muslim marriage) ceremony performed by the appropriate Islamic official and then to have themselves registered as married, but most Minangkabau who can afford it prefer also to celebrate the marriage with a traditional (adat) wedding known as *baralek kawin*.

If *sagun* represents the sweetness of a promise, then *galamai* represents the sweetness of the adat wedding itself. When the bride's family is ready to host a wedding, they send a senior woman to the groom's house to announce that they are ready to make *galamai*. The groom's house sends back a representative, ideally a *sumando*, who offers a date. The three-day formula is followed in the reverse direction, so that the groom's representative must make three trips before the date is finalized. Sometimes the date has been agreed on in an informal way by women behind the scenes, but in other cases, especially if the families have consulted sages or religious experts in order to confirm an auspicious date, there is real debate within or between families. Once the bride's family agrees formally

11.15 Women sorting batches of *siriah*, the leaf of the *Piper betle*.

OPPOSITE:
11.16 Women stringing together *siriah* with strips of grass fiber for decorations for a wedding.

262 RELATED CEREMONIAL ARTS

11.17 The finished bundles of *siriah* and grass strips are placed in an embroidered velveteen bag. In the nineteenth century and earlier, the bag was made of black cotton and couched with gold thread. The top of the bag was banded with imported printed cotton (see fig. 6.9).

to the date, however, it is final and the *galamai* can be made.

To make *galamai*, the same categories of women from the bride's house who came to make *sagun* gather again. An iron cauldron is set over a fire in the house yard to cook the *galamai*, a hot, smoky process. *Galamai* is made from glutinous rice that has been soaked in water until soft, then dried and pounded into flour. The flour is gradually stirred into boiling coconut milk and cooked until it forms a gray, grainy batter (fig. 11.18). At that point *gulo jawa* is added, after which the mixture must be cooked for hours over a slow fire while being constantly stirred so that it does not burn or lump (fig. 11.19). By the end of the day the *galamai* has become reddish black in color, thick and opaque like fudge, and it takes considerable strength to stir. Finally, it is packed into coconut shell halves or metal trays to cool into a dense, dark, delicious cake.

Making *galamai* is women's work, but the men of the house help keep the fire going (fig. 11.20) or stand around the periphery to watch and talk. Over the course of the day many women come and go to take turns stirring the mixture, streaming sweat and tears from the smoky fire. They are fed a meal, and at the end of the day each is given a piece of *galamai* to take home to her family (fig. 11.21). The rest is saved to be served at the various wedding meals and teas.

Traditional Minangkabau weddings are complicated affairs that involve frequent processions back and forth between groom's and bride's houses (fig. 11.1) as the two parties host each other in turn, invite the groom to the bride's, escort him there, escort him home, return to get him again, and eventually celebrate the consummation of the marriage. Each of these episodes involves a complex etiquette that varies from village to village. To the outsider these comings and goings may appear to be excessive, but this is how the two families begin to lace together affinal ties that will last, they hope, well beyond the lives of the newlywed pair. The binding media are mainly of three kinds: oratory, cloth, and food. Here we shall concern ourselves only with the food that is shared and given between the families.

Roughly a week after the *galamai* has been made, adat wedding celebrations begin. Both the

11.18

11.19

11.18 Women cooking *galamai*: pounded glutinous rice is stirred into boiling coconut milk and cooked into a gray, grainy batter. At that point *gulo jawa* (palm sugar) is added, and cooking proceeds over a slow fire outside the house.

11.19 Women cooking *galamai*: constant stirring is required to keep the *galamai* from burning or lumping.

bride's and groom's houses slaughter at least one goat or, if they can afford it, many goats for a proper wedding curry. This curry is said to be different from other curries typically cooked in Minangkabau households because it uses a different set of spices, which must be purchased in the market rather than ground at home. These spices are said to be based on black pepper, not the more usual red chili peppers, and they are also said to be of foreign or Indian origin. Men do the slaughtering and look after the curry, which cooks in a large cauldron outdoors, and the women keep busy preparing other ingredients for the curry (coconut milk, vegetables), rice, sweets, and meals for the many persons who have come to help cook.

At the bride's house, after the curry is prepared, the men of the house are served some of the curry, and they then engage in formal oratory to discuss who will go to escort the groom. The party traditionally consists of one *sumando*, one woman related to the bride's father's lineage, and one woman from the bride's lineage. The selected people dress in their finest clothing and walk in procession through the village. The women carry large baskets on their heads (fig. 11.22) containing *galamai*, cooked rice, ingredients for betel quids, and a roasted or curried chicken. Sometimes other foods are added to this as embellishment, but the point is to bring a sample of the foods the bride and her family will provide for her new husband.

Meanwhile, at the groom's house, his mother's and father's matrilineal kin, plus the

11.20

11.21

11.20 Although cooking *galamai* is women's work, men of the house tend the fire as women come in turn to stir the mixture.

11.21 The cooked and cooled *galamai* is cut into small pieces and wrapped in banana leaves for the women to take home after their day's work helping to make it.

CEREMONIAL FOODS FOR THE CELEBRATION OF MARRIAGE 265

11.22 In the processions through the village during a ceremony, women carry food on their heads. The food is covered, either with elaborately patterned cloths, baskets, or plain cloths. One of the elaborately patterned textiles (*tutuik*) is visible in the middle of the procession shown in figure 11.1. That cloth is embellished with couched gold-wrapped thread.

men who have married into the family, gather to share their own celebratory meal of curry. When the bride's party arrives (often this is in the evening after prayers), they are seated, and a formal exchange of oratory between the men ensues. Eventually the visitors are served curry, and then the betel they have brought is chewed by the hosts. After a suitable amount of time has passed, during which the guests nibble just enough food to show they feel welcome but not so much as to seem greedy, they move to leave again. This is countered by the groom's relatives, who urge their guests to eat more and stay longer, but eventually the women of the groom's house take him aside for last-minute instructions, inspection, and a dousing of perfume before relinquishing him to the escort party. As the escort party leaves the groom's house, the baskets in which they brought the rice and other foods are returned filled with raw foods, hulled glutinous rice, corn, bananas or other fresh fruit, and sometimes even a freshly slaughtered chicken.

Readers familiar with the work of Claude Lévi-Strauss or the Dutch structural anthropologists will have noticed immediately the contrast between cooked and raw foods brought by the bride's and groom's parties. As Cecelia Ng (1987) and others have also observed, this symbolic difference marks the structural opposition and mutual dependence of female to male, bride to groom, and bride's lineage to groom's lineage. The masculine element brought to a marriage—

and, in more extended symbolism, to the growing of crops as well—is raw, young, dry, productive, and sometimes associated with iron. The feminine is cooked, mature, wet, reproductive, and associated with cloth.

The groom's escort is joined by a woman from his father's matrilineage, a *sumando*, three or four of his friends, and sometimes one or two men from his father's or mother's matrilineage as well. The men carry a brass vessel (*carano*) of betel quid elements, which they will offer to the men of the bride's side, and a bundle of the groom's clothes for his use the next morning. The groom himself is dressed in a jacket, cap or headcloth, and trousers or *saruang* (tube skirt). Dark glasses are sometimes added for a glamorous effect.

Back at the bride's house a specially decorated alcove (*palaminan*) or dais (depending on the layout of the house) has been prepared for the groom. After arriving and being ushered inside, the groom's men engage in an exchange of oratory with their hosts from the bride's side, one purpose of which is to agree that the groom and his friends should go and sit in the special place provided for them. In front of this seat the bride's family has set up antique brass trays with special foods for the groom, including *randang*, curry, a large sautéed fish, a goblet of rich buffalo milk yogurt (*dadiah*), a pitcher of sugar syrup for the yogurt, and a goblet of drinking water. The groom, despite some urging and teasing, knows better than to touch the fish. There

are many different interpretations given to the meaning of this fish, some of which actually contradict one another. As Frederick K. Errington has pointed out, many of the ad hoc explanations Minangkabau offer regarding the meaning of this or that custom seem eclectic to Westerners and not part of any general symbolic logic (1984, 158–66).[6] As for the fish, it seems to be related to immortality, to the immortal ties that now bind the two families, to the bride's virginal purity, or to all of these things.

After settling themselves, the members of the groom's party are served curry, followed by tea and sweets. Meanwhile in the kitchen women of the bride's family are working to prepare the curries, sweets, and cakes for the following day. As the night gets later, the men of both houses begin to take their leave and slip away, until only the groom and his friends are left, sitting silently on the dais surrounded by plates of uneaten sweets.

Meanwhile, the bride, secluded in a room for the whole day, has felt too shy to see anyone. She is said to be too embarrassed to see even her own mother. A distant kinswoman helps her get powdered and dressed in a fine new *saruang* and *baju* (blouse) and an antique *salendang* (long scarf to cover her head), and offers advice about the night to come. As the night gets later (in some cases this can happen well after midnight) and people drop off to sleep, the bride is finally led into the house, past the groom, and into the bedroom prepared and decorated for them. The groom continues to sit, showing shyness, until the bride's family tells the last of his friends to leave and instructs him to join the bride. Eventually, when the women who are still awake are pretending not to notice, he does so. As soon as the groom has gone into the bedroom, however, the women in the kitchen turn up the lights and begin working energetically, grating coconuts, chopping vegetables, and generally making noise. "Padusi-jantan" (literally, "female-male"), they announce to one another, with smiles.

Very early the next morning, before dawn prayers, the groom is called out of the bedroom, handed his shoes, and unceremoniously sent home. He leaves behind his formal jacket along with some other clothes, however, as a sign that he has not gone for good. The bride bathes, and a married woman from her family inspects the bed and places a spray of flowers or other decoration on it. In actuality, it is common for the new couple not to have sexual intercourse for the first weeks of the marriage, but it is generally agreed that the groom should know whether the bride is a virgin on the first night. If she is not, he has the right to take all his clothes and refuse to return to the house.

The day that now begins, the main day for celebrating the wedding, is exhausting for the bride and her family. After prayers and a morning cup of tea, they send a senior woman to the groom's house with the clothing he left. This is to show that they are ready to receive him again. If they delay returning the clothes, it suggests that they are not pleased with his behavior. Meanwhile food is laid out to serve to the groom's party when they return. This is often the most elaborate meal of the whole wedding, involving goat curry, variously colored curries of vegetables and chicken,[7] potato fritters, fried fish, fried chicken, fried egg, *randang*, and the large fish, which is not to be eaten.[8] Sweets for the meal include European egg-based cakes, butter cookies, *galamai*, *lapek*, *ajik*, and *godok* (fig. 11.23). *Lapek* are dumplings of sticky rice steamed in banana leaves, sometimes filled with sweetened coconut meat, *gulo jawa*, or bananas. *Ajik* (or *wajik*) is made of sticky rice kernels cooked with *gulo jawa* and cut into rhomboid-shaped bars. *Godok* (also called *kubang* and *puti baranang*) are deep-fried dumplings made out of ground sticky rice and filled with sweetened coconut meat, *gulo jawa*, and bananas. The version of *godok* made for weddings should be glistening white, slightly crisp on the outside, and burst with sweetness when bitten. All these sweets are sometimes consumed at other events, so they are not purely wedding foods, but their abundance and sweetness should signify the pleasure of the bride's family and the good treatment the groom can expect from them.

While the bride's family is hurrying to set out all the food in the most inviting and impressive manner (fig. 11.24), the groom's family receives the emissary carrying the jacket, serves her tea, and confirms that all is well. She is sent home with a large basket of hulled rice for the bride to cook (in fact, by then the rice for the meal is already cooked, but the significance lies in the groom's family providing raw goods to the bride's). Soon after that the groom parades through the village back to the bride's house with a few of his companions. They are served the meal and then leave once again.

Now it is the bride's turn. She is dressed in heavy, gold-embellished clothes, a gold headdress (*suntiang*),[9] and heavy makeup and is paraded through the village to the groom's house. She is expected to look shy and uncomfortable, and her sisters and friends fan her and

11.23 Making *godok*, deep-fried dumplings consisting of sticky rice filled with sweetened coconut meat, palm sugar, and sometimes bananas. For a wedding, *godok* should be glistening white, slightly crisp on the outside, and sweet on the inside.

11.24 Female hosts getting help from female relatives (dressed up) as they scoop rice and curry into dishes. Young men (sons and sons-in-law) carry the dishes out and serve the men in the front room.

walk solicitously nearby in case she should stumble or faint. At the groom's house she is seated in a decorated alcove or dais on a throne next to her new husband. The pair must now sit and be admired for most of the day while various guests of the groom's side come to be served an elaborate meal. Each guest brings a measure of hulled rice as a gift and is sent home with *lapek*, *kubang*, or other sweets. In rural areas it is considered polite for guests to show reluctance to eat and for the host to force food on them, but in cities, villagers note with shock, guests greedily consume whatever is put in front of them with no sign of shame.

Toward evening the bride, sometimes accompanied by her new husband, parades back to her house for the last ceremonial feast, consisting of the same foods served to the groom in the morning. If the bride parades alone, her family must again send a contingent to the groom's house to escort him back. The pair sit together on the dais to be admired while guests invited by the bride's side are served. The guests have also brought hulled rice as a sign of their blessing. It is at this meal that, in some cases, the large fish is finally eaten. At very elaborate weddings the night ritual and morning leaving are repeated, and the groom must be invited back for one last special meal, but in most cases this meal ends the official celebrations.

The end of the celebration does not end the gift exchanges, however. Fifteen days after the wedding the groom's mother and some other female family members escort purchases in large baskets to the bride's house. These include at least a kilo of red meat, nine coconuts, salt, garlic, red peppers, salt-dried sardines, and potatoes—in other words, all the raw materials needed to prepare a meal. The groom's party is received and served tea and sweets by the bride and her family (fig. 11.25). Roughly five months later the bride carries *galamai* to her new in-laws, and in the evening of that day they send back another gift of raw foods. Five days after that the bride brings them *randang* and *galamai*. The groom's family will take some of her offering as a sign of receiving it but return some to the bride's family too, showing that they care about her welfare.

At Ramadan (the Muslim month of fasting), the new wife carries *galamai* or other sweets used to break fast in the evening to her father's matrilineal kin and all her husband's relatives, beginning with his mother, married sisters, mother's sisters, and his father's other or former wives (in rural areas bigamy and serial remarriage are common enough that many people count a number of women as father's wife). These gifts can be carried to as many as thirty-five different families, but usually there are around a dozen. After the first year of marriage most women limit their gifts to closer relatives. These gifts are often reciprocated later in the month, or as the couple has children, they may be invited to break fast with their father's kin.

Other exchanges of food during the first year of marriage occur during harvest time. When the new wife's in-laws are harvesting, she

brings them a pyramid of yellow rice and some *ajik* to eat in the fields. When the harvest is brought in, they send her a sack of rice grains. She may do the same for her mother's brother's wife as well and also receive rice from her.

After the first year of marriage, food exchanges and shared meals between the two families are related to the birth of children, the child's first washing, circumcision, first complete reading of the Quran, and eventually marriage. If there is a divorce, the exchanges may or may not stop, depending on the warmth developed between the families and whether there are any children, but gifts are never returned. At the death of one of the spouses, however, final gifts, known as *putuih adat* (to rupture adat), are given, formally ending obligations. If the man dies first, his wife's family brings gifts called *padi anak* (rice from the children) to his surviving matrilineal kin. This gift consists of rice seed, hulled rice, a fresh chicken, a bamboo tube of *ragiah*, and two coconuts (note that these are raw foods, ending the pattern by reversing it). In return, the deceased husband's family distributes coins for each child and the wife as a sign of *tarimo kasiah* (meaning "thanks," but the literal meaning is to "receive love or concern"). If the wife dies first, the same gifts are given in the other direction and called *padi bako* (rice from the father's matrilineage). At funerals adat is further ruptured by the giving of antique cloths as symbolic shrouds by the deceased's in-laws.[10]

In conclusion, two points must be emphasized. The first is that this chapter has touched on only a few of the possible ways of understanding food usage in only one Minangkabau village and during only one period of time. While some practices do continue from generation to generation, the meanings attached to them sometimes change over time and vary from place to place (and sometimes the reverse occurs, with the meanings remaining stable but practices evolving). The variation and change over time of symbolic systems within West Sumatra, with regard to food and many other expressive forms, cry out for further research. Second, food is a particularly potent symbol in West Sumatra, as in many other parts of the world. It is what connects child to mother, husband to wife, and the people to the land that sustains them. The adat of food is sometimes reduced to a set of rules as to what may or may not be done at a wedding or to a list of foods with a corresponding list of meanings. Minangkabau culture is deeper and more subtle than such simplistic accounts would suggest, however, and the symbolism of food goes beyond etiquette or formal structural patterns. It is powerful enough to bring tears of homesickness at the taste of *randang* and is as intimately tied to Minangkabau social life as the grains of rice that are touched to the lips of an infant at its first washing. It is hoped that this chapter has conveyed something of the complexity and emotional significance of food symbolism in Minangkabau culture, as well as some of its formal aspects, and that it will inspire further and more comparative work in the future.

11.25 Members of a matrilineage waiting to receive guests.

CEREMONIAL FOODS FOR THE CELEBRATION OF MARRIAGE

Redjeki Arifin

12

MINANGKABAU CEREMONIAL JEWELRY

Traditional ornaments and jewels of the Minangkabau can be seen at their best at ceremonies such as weddings, the installation of a new chieftain, and other formal occasions. The jewelry of West Sumatra is not merely a means of displaying wealth and splendor but is an established part of elaborate ceremonial ensembles. Jewelry is an essential part of Minangkabau adat dress.

Sumatra has long attracted foreign traders interested in its pepper, benzoin, camphor, and especially its high-quality gold. Historical sources show that there were contacts between Sumatra and kingdoms outside Indonesia as early as the first century C.E. (see chapter 1 for details). The island, positioned at the crossroads of two strong maritime powers, India and China, benefited from intensive commercial contacts with the outside world. The long eastern coastline—which included prosperous ports at the mouths of such large rivers as the Rokan, Siak, Kampar, Inderagiri, and Batang Hari—opened channels of overseas trade with China, South Asia, and Europe. From the classical period to the colonial period, Sumatra delivered tons of gold and silver.

Traders were not the only visitors who came to Sumatra during that time. Religious pilgrims and craftsmen settled and mingled with the local people and brought with them their customs and culture. This migration brought characteristics of Buddhist, Hindu, Chinese, and Islamic decorative jewelry designs to the arts of Sumatra, reflecting the historical development of that period. These influences spread from Aceh, in the north, through northern Sumatra south to the Minangkabau region and eventually through much of the rest of Indonesia.

Relations with India and the Arab world were very intensive. The influence of these cultures in Sumatra is evident in Sumatran metalwork, especially the designs of spherical beads with granulated and geometric decorations (see the glossary of jewelry terms at the end of this chapter). In 1498 Vasco da Gama reported that Indian Muslims and Arabs governed the jewelry trade and were referred to by some as Turks and by others as Keeling, or Indian traders (Amran 1981, 124ff.).

Evidence has been found of gold working on the northeast coast of Sumatra in the eleventh to thirteenth centuries. During that period the area was largely populated by foreign traders, mostly Indians and Chinese (Amran 1981, 78). At that site, called Kota Cina, Buddhist and Hindu sanctuaries have been found along with fragments of gold foil and objects made of gold wire (Miksic 1990, 46). The gold jewelry that has survived from that period is decorated with filigree and granulation. A belt or girdle of Turkish work from the same period was also found. Such belts are an important part of Turkish costume. Among the Minangkabau such belts (*pandiang*) were formerly worn only by men, but today women's ceremonial attire may include a *pandiang*, both for embellishment and as a sign of wealth.

In 1558, when the Ottoman Empire was at its height, the Islamic sultanate of Aceh opened relations with the empire by sending a mission to Sultan Rum in Constantinople requesting help in strengthening the Muslim religion (Reid 1969, 396). Aceh also wanted assistance in repelling the Portuguese and other Western traders who dominated trade in the Straits of Malacca. Sultan Rum responded by sending craftsmen and other experts who knew how to make guns. At that time Aceh used ports on the west coast of Sumatra, including those in the Minangkabau region, over which it then had control. Many of the Turkish ships and their crews remained in Sumatra, and hundreds of Turks lived, worked, and fought in Aceh (Amran 1981, 138). Turkish jewelers, along with other metalworkers, may also have brought

OPPOSITE:

12.1 Woman's ceremonial pectoral consisting of a double tiger-tooth-like amulet, from which are suspended gold pieces interconnected by small chains. 22.5 x 26.7 x .8 cm. The Glassell Collection.

their arts to Sumatra at this time, or possibly at an even earlier date. To this day, the Minangkabau call one type of round bead a "Turk" bead (fig. 12.2).

In the mid-1840s there were hundreds of goldsmiths and silversmiths in central Sumatra. Artisans migrated to areas where there was strong demand and where materials were readily available. Hence one can observe similarities in forms, motifs, decorations, and methods of working throughout Sumatra and in the coastal areas of Malaysia, especially Malacca and Negeri Sembilan, a province that is predominantly Minangkabau (see chapter 2). The mingling of the Acehnese with other Sumatrans has resulted in common functions, values, and meanings in the region's jewelry. Renowned Minangkabau centers for gold and silver artistry include Koto Gadang and Bukittinggi.

The Arts of Traditional Minangkabau Jewelry

Before being fashioned into some types of jewelry, silver and gold must be hammered into thin sheets of uniform thickness. The sheets are then cut into the desired shapes for bending, decorating, and soldering. For practical reasons, many large pieces are made of silver or thin sheets of copper or brass and then dipped in gold dissolved in mercury or otherwise gilded. Overlaying gold on baser materials results in ornaments that are less expensive to produce than pure gold examples but have the same dazzling effect when worn. From the early eighteenth century on, the Dutch traded copper, among other commodities, for Minangkabau gold. Copper was "highly prized for use in jewelry" (Dobbin 1983, 71).

Spherical or other hollow objects are made from sheets of beaten metal folded over a mold made of wood or a resinous substance. The resin used in West Sumatra, called *ambalau*, is dark brown, almost black. It is hard when cold but soft and pliant when heated. When designs are applied by the technique known as chasing, the metal is placed on a bed of *ambalau*, and the pattern is beaten out with punches of various shapes. Because *ambalau* is yielding by nature, it allows the metal to follow the contours impressed by the tools. *Ambalau* also serves to keep the metal in place while it is being worked. After the work is finished, the resin can be removed by heating, but more often it is kept as filling or backing. Because the sheet of gold or silver is usually very thin, the backing will help prevent tearing or other damage. Over the years the resin may break away from the metal, and in hollow pieces one can hear the bits of resin rattle when the piece is shaken.

Most round objects and large, hollow bracelets are made by embossing, repoussé, chasing, or engraving. For some especially large pieces it is necessary to make at least two different parts, which are then soldered together to form the desired ornament. Because of its value, gold jewelry is often melted, remodeled to the taste of the owner, or merely sold.

12.2 Beads from three necklaces. The center bead is part of a necklace purchased in Istanbul, Turkey; the two outer beads are from necklaces made by Minangkabau jewelers. Turkish silversmiths arrived in Sumatra in the late fifteenth or sixteenth century, and their designs and skills spread throughout the Indonesian Archipelago. Private collection.

a

b

12.3a–e Set of gold merchant's tools. Minangkabau gold merchants controlled the gold trade and were equipped with the tools of the trade. Collection of H. A. Sutan Madjo Indo.

Nineteenth-Century Gold Traders and Their Equipment

In pointing out the important role of gold in the domestic trade of the Minangkabau, Christine Dobbin (1983, 52) reports: "Gold was not only a major item of export, but was also used as currency and actually sold on the market. In using gold dust as a means of exchange, the value of an article was expressed in terms of a gold weight. Gold traders therefore played a very important role in the domestic market; not only did they bring gold for sale, but they kept the scales and weights which were necessary to the operation of this means of exchange. Such weights were kept in attractive, carved boxes."

As soil suspected of containing gold dust was collected, it was placed in carved wooden boxes (fig. 12.3a) until enough was collected to begin to separate the gold dust from the dirt. For this purpose a nearly flat wooden dish was carved with a sloping ridge down its center (fig. 12.3b) and with adat-related motifs along both ends. The soil was placed on the upper side of the ridge of the slightly tilted dish. When the dish was gently tapped, the heavy gold dust remained in the upper half, while the lighter useless dust moved across the ridge to the lower half and could be discarded. The gold dust was then scooped up with a carved wooden scoop (fig. 12.3a) and placed in a small carved container (fig. 12.3c, right side).

Gold traders carried measured weights and small scales that were compactly stored in a wooden box that was carved to exactly fit the folded scales (figs. 12.3c, 12.3d). To keep track of day-to-day trading activities, these gold traders carried a document container carved from a short length of small bamboo (fig. 12.3b). Because of the risk of robbery, the traders also carried weapons and gunpowder, the latter being stored in carved wooden or gourd containers (fig. 12.3e).

c

d above, e below

CEREMONIAL JEWELRY

For the Minangkabau, jewelry serves as a sign of wealth and expresses a love of beauty and self-adornment. Of much greater importance, however, is the fact that jewelry is an essential part of the long tradition known as the Minangkabau adat. As previous chapters have pointed out, adat is more than tradition. It is the set of rules governing all behavior in Minangkabau culture. Hence it determines, among many other things, the types of jewelry women wear to ceremonies.

As with many things Minangkabau, ceremonial jewelry has a local flavor; that is, it varies from place to place but always conforms to the dictates of adat. In West Sumatra, where matriliny is a principal tenet of adat, jewelry and other valuables are often owned by the clan from the mother's lineage. These valuables are called *pusako*, or family heirlooms. Family members of a given lineage, *saparuik* (literally, "from the same womb"), are allowed to wear the jewels owned by the matrilineage or to borrow them when needed, but they must always be returned after the ceremony is over.

Traditional jewelry for Minangkabau women's ceremonial wear consists of head ornaments, ear ornaments, body ornaments, hand and arm ornaments, pins, and purses. (For a discussion of men's ceremonial ornamentation, see chapter 5.)

Head and Ear Ornaments

The most elaborate head ornament is the *suntiang* worn by a bride for her wedding ceremony (fig. 12.4). If a woman does not have a large head of hair, a bun (*tatah kundai*) made of hair or finely cut pandanus leaves is attached to her hair to provide a base to which the massive golden crownlike ornament can be attached. In its most elaborate form, the *suntiang* consists of a golden semicircle to which many small golden ornaments are attached. This semicircular piece is placed on the top of a bride's head, and then as many as eighty individual ornaments, each attached to a long pin, are inserted either into the bride's hair or into the bun that has been added as an anchor for the head ornament. These separate ornaments—in the shape of flowers, birds, leaves, and stars (fig. 12.5)—are usually gold, or at least gilded, and are sometimes ornamented with beads or jewels. Sprays of small flowers, real or made of cloth, are added to the final assemblage.

Arranging this many-pieced head ornament takes well over an hour and is a special art. The entire *suntiang* assemblage weighs as much as twelve pounds, and the bride must wear it for many hours during the wedding ceremony and reception. It is said that a Minangkabau bride never smiles, and the weight of the *suntiang* may be one of the reasons.

OPPOSITE:

12.4 Bride and groom during their wedding ceremony. On the bride's head is an elaborate headdress, called a *suntiang*, an assemblage of many separate gold and enameled pieces laboriously arranged just before the ceremony. Her somber visage partly reflects the fact that the *suntiang* is very heavy, is somewhat unstable, and must be worn for many hours. The bride also wears long gold pendant earrings, two very elaborate gold necklaces, a pair of large gold bracelets, and two gold rings on her right hand.

12.5 Hair ornaments (*bungo sanggua* or *tatah kundai*). A bride from Payakumbuh has an artificial bun, pinned high on the back of her head, into which are inserted an array of gold or gilded floral pins. These are single pins studded with translucent colored stones and red-stained flowers. The disklike ornaments at the bottom of the illustration are ear pendants. Because of their size and weight, they are not inserted through her pierced ears but are hooked in the hair facing front so that they dangle down near the ears. Private collection.

MINANGKABAU CEREMONIAL JEWELRY

12.6 A simple, lightweight *suntiang*. This preassembled version of the headdress is sold in the market. Unlike the example illustrated in figure 12.4, it is relatively inexpensive and does not require the assistance of professional dressers to prepare the bride for her wedding ceremony. FMCH X97.50.60; private gift.

12.7 Bride's ceremonial headdress and hair ornament. Between the flowers and tendrils of the headdress are two birds facing each other. Trimmings on both sides, called *gabai gabai*, sway gently with each movement of the head. Private collection.

12.8

12.9

12.10

Many families now turn to professionals to dress the bridal couple. These professionals are knowledgeable about rituals and customs, and they own all the necessary traditional ornaments and finery. Everything can be rented from them for use during the ceremony. Their job is to dress the bride and groom to perfection.

Today a preassembled *suntiang* (fig. 12.6), simpler and much lighter than the traditional version, is available for purchase in local markets. It can be secured on the head in a matter of minutes. A similar but somewhat more ornate ceremonial headdress (fig. 12.7) is accompanied by an ornamented piece that covers the forehead.

A number of other types of head ornaments appear in Minangkabau ceremonies. An elaborately ornamented but simpler tiara (figs. 12.8, 12.9) may replace the *suntiang*. Other headdresses are more crownlike (fig. 12.10). One, from the village of Sahwalunto, consists of seven gilded silver repoussé pieces sewn to a cloth backing (see fig. 6.68). It is worn wrapped around the head and tied in the back and is complemented by an ornamented fabric collar (see fig. 6.69). Several elaborate gold frontal crowns are also found in ceremonial wear (see fig. 6.75).

A black velvet headdress from the village of Solok, decorated with gold repoussé ornaments, is sometimes worn with a gold overlay of floral design and a repoussé backplate (figs. 12.11–12.13). It may also be worn as the sole headdress (fig. 12.14). The velvet cap does not appear in an earlier version of the Solok headdress (c. 1910), in which the top and the back of the head are covered, respectively, with a collection of stemmed metallic floral elements and an embossed plate hung with a fringe of chains (fig. 12.15). In the contemporary version of this metallic headpiece the top of the head is usually covered with an overlay of golden leaves.

Several types of ear ornaments are worn in Minangkabau ceremonies. They include silver dangles for pierced or unpierced ears (*antiang*; figs. 12.16, 12.17), Western-type pearl earrings (*gewang*), long ear pendants (*subang*), and gold disks (*sumbek talingo*), some as large as 11 centimeters in diameter, worn in the ear canal, not on the earlobe (figs. 12.18, 12.72).

12.8 Gold-plated woman's ceremonial headdress from the village of Sungai Puar. The repoussé metalwork is further ornamented with flowers made of bird feathers. Private collection.

12.9 Gold head ornament. The crescent-shaped repoussé piece has been given a reddish hue by dipping it in a solution of distilled water, salt, and alum, then washing it in an acidic bath. Appliquéd to that piece is a round repoussé piece. The whole ornament has been further decorated by applying silver blossoms. Museum Adityawarman, Padang.

12.10 Gilt crown-like ceremonial headdress from the regency of Limo Puluah Koto. The repoussé gold bands and dangles are augmented with gold eight-pointed stars and gold coins. Museum Adityawarman, Padang.

12.11 Velvet ceremonial headdress from the village of Solok embellished with appliquéd metallic blossoms and with gold braid along the border. The repoussé gold floral or leaf bouquet in the center is a separate metallic object worn so that the leaves cover the top of the velvet cap. A hinged backplate covers the back of the head. Private collection.

12.13 A pair of dancers. The woman is wearing a headdress similar to the one illustrated in figure 12.11.

12.12 Repoussé gold plate that covers the back of the bride's head. This piece is part of the headdress illustrated in figure 12.11, although it is not visible in the photograph. The six tassels on long chains fall down the back of the bride's neck. Private collection.

12.14 Girl wearing a velvet cap similar to the one illustrated in figure 12.11. She also wears a long collar of black velvet with gold ornaments appliquéd onto the velvet and gold braid to match that on her tunic (*baju*).

12.15 Early twentieth-century photograph of a ceremonial headdress, similar to the metallic overlay shown in figures 12.12 and 12.13 but worn higher on the head and with longer-stemmed metallic floral ornamentation. Photograph courtesy Yayasan Dokumentasi dan Informasi Kebudayaan Minangkabau; originally published in *Durch Zentral Sumatra* (Berlin, 1910).

12.16 Contemporary silver filigree earrings produced by silversmiths in the village of Koto Gadang, the heart of the silver and gold jewelry industry in Minangkabau. Private collection.

12.17 Gold spiral earrings with granulation, produced in the village of Solok. Private collection.

12.18 Large gold ear plates, approximately 10 centimeters in diameter, with intricate designs in repoussé and granulation. These large ear ornaments are not fastened to the earlobe. A projection on the back fits into the ear canal to hold the ornament in place. Private collection.

MINANGKABAU CEREMONIAL JEWELRY

12.19 Woman's ceremonial necklace. Gold mythical animals called *keelin* or *chiling* are connected with chains and hollow golden beads. Although the Islamic religion restricted the use of animal symbols, West Sumatra and the neighboring regions have kept traditions of the pre-Islamic period. Collection of H. Elly Azhar.

12.20 Woman's ceremonial necklace from the village of Solok. The gilded silver repoussé beads are said to be in the shape of kemiri nut shells. The kemiri nut, also called candlewood nut because of its waxy texture, is used in cooking many Indonesian dishes. The beads and dangles hanging from the repoussé pendant are carnelian. Private collection.

12.21 Woman's ceremonial necklace with eleven repoussé gold leaf-shaped pendants and coral beads. Collection of H. Elly Azhar.

12.22 Woman's ceremonial necklace with nine gold pendants executed in repoussé and granulation work in a style adapted from Hindu jewelry. Collection of Lies Alwi.

12.23 Woman's ceremonial necklace with nine gold pendants connected by triple chains of pierced openwork. The pendants are ornamented with small gold appliqué pieces. The center pendant, set with rubies, has a crescent moon with little corn cockles as tassels. The design is of Middle Eastern origin. Private collection.

12.24 Woman's ceremonial necklace with five large pendants of gold repoussé connected by six gold filigree chains. The design, bearing a strong resemblance to Turkoman necklaces, came to Sumatra through India and Malacca. The kingdom of Minangkabau had strong ties with both India and Malacca, and the influence of these cultures is apparent in many different Minangkabau arts. Collection of H. Elly Azhar.

12.25 Woman's rare ceremonial necklace with unusually pure red Atlantic coral and gold beads. The two large gold beads are of exceptionally fine serrated gold-ribbon filigree work. Four round red beads, probably coral, have been partially encased with fine filigree work and small glass beads. Collection of Anna Chatab.

Body and Hand and Arm Ornaments

Body ornaments include necklaces, pendants, body nets, belts, and buckles. The sumptuousness of women's ceremonial dress, as described in chapter 6, is greatly augmented by the necklaces Minangkabau women wear. Sometimes necklaces are worn singly (figs. 12.19–12.29) or as lockets on a chain (fig. 12.30); sometimes they are worn in pairs (figs. 12.31, 12.33, 12.34), sometimes in sets of three (figs. 12.32, 12.35), and quite often in sets of four (figs. 12.36–12.39). Occasionally a bride wears even more necklaces (fig. 12.41). Most of these necklaces are constructed of intricately worked gold and silver, often enhanced with exquisite beadwork of gold and silver (figs. 12.42–12.44) and also with carnelian, coral, and glass. A gold pectoral (fig. 12.1) may also be worn as part of ceremonial dress.

MINANGKABAU CEREMONIAL JEWELRY

12.26 Woman's ceremonial necklace from the village of Solok. The four oval pendants are repoussé metal backing covered with a thin sheet of gold foil. The main pendant, in the shape of a seahorse, is filled with a resin (*ambalau*) to add weight to the necklace. Sets of gilded leaves are suspended from the seahorse pendant. The necklace is strung with coral beads separated by thin gilded cylinders. Private collection.

12.27 Woman's ceremonial necklace similar to the one illustrated in figure 12.26. The oval pendants in this necklace, however, are made of carved wood covered with gold foil. One pendant is turned over in the illustration to show the printed trade cloth that covers the back side of the wood pendants. The main pendant has a more abstract form than that illustrated in figure 12.26. Private collection.

12.28 Woman's ceremonial necklace similar to the one illustrated in figure 12.26 but with six oval pendants. The seahorse on this necklace is more realistic than those found on most Minangkabau jewelry. Collection of Linda Pastorino.

12.29 Detail of a woman's ceremonial necklace (*maniak baranggo*) with alternating coral and gold beads. The gold beads are executed in a combination of pierced and appliqué work. Private collection.

12.30 Gilded woman's locket in appliqué work. The locket is decorated with tendrils of gold wire and tiny flowers with translucent colored stones. The foliated rim is of openwork. The locket is used as an amulet; the back has a hinged cover, revealing a space to hold a talisman (*jimat*) believed to have protective powers against harm. Private collection.

12.31 Two women's ceremonial necklaces. The necklace on the left has alternating silver filigree beads and faceted carnelian beads. The one on the right has alternating gold filigree beads and Tibetan coral beads. Two beads near the bottom of the necklace on the right are in excellent condition. They are new; the others are much older. Metallic beads in both necklaces are of Islamic design. Private collection.

12.32 Set of three ceremonial necklaces. The center necklace features amber beads with filigree filler beads of silver. The two outer necklaces are heirloom Tibetan coral strands. Private collection.

RELATED CEREMONIAL ARTS

12.33 Bride's ceremonial necklaces with large Tibetan coral beads and uniquely shaped hollow gold-washed beads—an exceptional design from the village of Payakumbuh. They are usually worn with a third necklace, such as the one shown as a detail in figure 12.29 (see also fig. 12.35). Necklaces of this design are the oldest type found in the Minangkabau region. Collection of Yasinar Effendi.

12.34 Pair of ceremonial necklaces and earrings of gold repoussé and filigree. A bug and a butterfly adorn the upper and lower necklaces, respectively. A set of matching gold earrings is also shown. Private collection.

12.35 Set of three ceremonial necklaces traditionally worn by a bride in the regency of Limo Puluah Koto. The shaped beads of silver gilt on the outer two necklaces are uniquely Minangkabau, and their design dates at least to the nineteenth century and probably much earlier. The red beads on all three necklaces are Tibetan coral. The smooth, round silver-gilt beads on the inner necklace owe their design to the arrival in Sumatra of Turkish silversmiths in the fifteenth or early sixteenth century. Private collection.

MINANGKABAU CEREMONIAL JEWELRY 283

12.36 Set of four bridal necklaces, two of which have double strands. At her wedding the bride's chest is covered with this assortment of gold necklaces. The Minangkabau names for these strands are (from top to bottom): *mansura, daraham, ampiang, ampiang, maniak gadang,* and *maniak baranggo*. The chains of the *maniak gadang* are made in pierced metal and metal appliqué work interspersed at intervals with small bouquets of flowers set with diamonds and rubies. Added under the main pendant is a crescent moon with charms attached. The *maniak baranggo* is similar to the one shown in figure 12.29. Collection of Yoebhaar Dt. Perpatih.

12.36

12.38

12.37

12.37 Set of four gold bridal necklaces. The repoussé and filigree work on all four necklaces is enhanced by the addition of pearls in different groupings. The bottom necklace depicts mythical animals, suggesting that the design dates to the period before the Minangkabau embraced Islam. Collection of H. Elly Azhar.

12.38 Set of four gold-gilt bridal necklaces, including one double-strand necklace, all four entirely executed in fine filigree work. The Minangkabau names for these necklaces are (from top to bottom): *ampiang, mansura, rago rago,* and *pamjaram*. Collection of Lies Alwi.

284 RELATED CEREMONIAL ARTS

12.39

12.40

12.39 Set of four contemporary silver bridal necklaces, including one double-strand necklace. The very fine filigree and granulation depicting peacocks on the bottom necklace attest to the great skills of today's silversmiths in the village of Koto Gadang, where these necklaces were made. Private collection.

12.40 Detail of a gold necklace similar to the silver one in the set illustrated in figure 12.39 (bottom). Private collection.

12.41 A bride and groom in the village of Koto Gadang. Many strands of gold chains with beautifully decorated pendants are worn by the bride so that the front of her tunic (*baju kuruang*) is almost entirely covered. The bride's headdress is a *talakuang*, or veil, made of red velvet trimmed with ribbons woven with gold-wrapped thread and appliquéd gilt blossoms and butterflies. Her shoulder cloth (*salendang*) is a *kain sambuaran* patterned in supplementary weft of gold-wrapped thread in the split-peanut and bamboo shoot motifs. She wears bracelets on both wrists. Photo courtesy of Lies Alwi.

MINANGKABAU CEREMONIAL JEWELRY

12.42 Detail of a necklace and a collection of silver and gold filigree beads from the famous silversmith village of Koto Gadang. Private collection.

12.43 Collection of large hollow beads covered with gold foil. All of the beads, except the largest one, have been stained red. Collection of Anna Chatab.

12.44 Large gold foil wooden bead with intricate design and a golden cord around its rim. The gold has a red hue. Collection of Sonja Tan.

12.45, 12.46 Front and back view of a woman wearing an overshirt of embossed six-pointed stars strung together by gold chains to form a net. Gold pendants hang from the bottom of the net. This flamboyant gold body net, from the village of Solok, is worn layered over a festive dress on ceremonial occasions. The woman is carrying a shoulder cloth (*salendang*) patterned in supplementary weft of silver-wrapped thread. Sheets of gold with gold diamond-shaped dangles are attached to each end of the *salendang*. Museum Aditya-warman, Padang.

12.42

12.43

One type of body net consists of a network of repoussé six-pointed stars connected by gold chains, worn like a tunic over an elegant dress (figs. 12.45, 12.46). Belts are sometimes made of decorated rectangles of silver or gold linked together by small rings to provide flexibility (fig. 12.47). Simpler belts may be fastened by repoussé gold or silver buckles (fig. 12.48).

Hand and arm ornaments include rings, bracelets, and broad armbands worn over the sleeves. Rings are usually worn on the third and fourth fingers. Gold is the preferred material (fig. 12.49). Rings may be made to match a pair of bracelets (fig. 12.50) or may be connected to a matching bracelet with a gold chain (fig. 12.51).

286 RELATED CEREMONIAL ARTS

12.47 Gilded silver belt with fifteen pieces of repoussé and cutwork, each with a finely crafted pair of birds, fastened together with pairs of gilded rings. A single large bird on a field of foliage adorns the buckle. Private collection.

12.47

12.48

12.49 Four gold rings with diamonds in a box setting. It is customary for a bride to wear a pair on the third and fourth fingers of each hand. It is not uncommon for a bride to adorn four fingers of each hand with rings. Private collection.

12.48 Two buckles made of gold with simple, uncluttered design in repoussé work surrounded by granulation. Collection of Yoebhaar Dt. Perpatih.

12.50 Pair of gold bracelets with matching gold ring shown on the wrist and hand of a young Minangkabau woman. Collection of H. Elly Azhar.

12.50

MINANGKABAU CEREMONIAL JEWELRY 287

12.51 Pair of gold bracelets (*galang ular*), one of which is attached to a gold ring by a gold chain. A serpent's head is featured on each bracelet, and one is adorned with small rubies. The other is a fine example of the use of granulation to decorate Minangkabau jewelry. Collection of H. Elly Azhar.

12.53 Detail of a woman's gold ceremonial bracelet crafted in filigree and openwork and set with small pearls. Collection of H. Elly Azhar.

Bracelets are often worn in pairs, one on each wrist. At her wedding, however, a bride may wear as many as eight or nine (fig. 12.52). Designs vary from elegant chains (fig. 12.53) to very large torroidal bracelets (figs. 12.54, 12.55). Some chains become very elaborate bracelets (figs. 12.56–12.58). The variety and intricacy of ceremonial bracelets attest to the great skill and artistry of Minangkabau jewelers (figs. 12.59–12.69).

12.51

12.53

12.52 Eight ceremonial bracelets (counterclockwise from the upper left corner): *maniak batapak*, *maniak rambai*, *maniak baranggo*, *maniak batapak*, *maniak baranggo*, *galang gadang*, *galang gadang*, and, in the center, *induik maniak*. Traditionally the bride wears rows of bracelets on both wrists. On her right arm she wears the larger *galang gadang*, *maniak batapak*, *induik maniak*, *maniak rambai*, and *maniak baranggo*. On her left arm she wears only three bracelets: *maniak batapak*, *maniak baranggo*, and the smaller *galang gadang*, set with rubies. Part of her left arm will be covered by her *salendang* (see figure 12.41). Private collection.

12.52

288 RELATED CEREMONIAL ARTS

12.54 Large ceremonial bracelet (*galang gadang*) from the village of Koto Gadang, approximately 15 centimeters in diameter, worn on the arm of a young Minangkabau woman. The bracelet is set with small rubies. Private collection.

12.55 Group of early twentieth-century Minangkabau women from the village of Sungai Puar dressed for a ceremony. Many wear very large bracelets no longer readily found in the area. All wear elaborate headdresses and multiple necklaces. Photograph courtesy Yayasan Dokumentasi dan Informasi Kebudayaan Minangkabau. Originally published in *Quer Durch Sumatra* (Berlin, 1904).

MINANGKABAU CEREMONIAL JEWELRY

12.56 Set of three gold ceremonial bracelets. The broad bracelet is made of gold ringlets in different sizes. The top five rows are ornamented; the other seven are plain. The lower chain is worn wrapped around the wrist, as shown in figure 12.57. Collection of H. Elly Azhar.

12.58 Gold ceremonial bracelet with exceptionally fine filigree and openwork. Collection of H. Elly Azhar.

12.56 above, 12.57 below

12.59

12.57 Gold chain bracelet wrapped on the wrist of a young Minangkabau woman. The bracelet combines granulation and openwork. Collection of H. Elly Azhar.

12.59 Gold bracelets of three different types in twisted rope design. Gold wires twisted into rope or spiral patterns were very popular in earlier times. The two upper bracelets, with overlapping twisted cords soldered side by side, have snake heads on one end and appliqué decoration on the other. Collection of Yoebhaar Dt. Perpatih.

12.60 The large gold bracelet (*galang gadang*) at top right has three cabochon stones in a box setting. The small bracelet at top left is a *galang ular*, a bracelet with a serpent's head. The bracelet draped in the form of a figure eight is called *induik maniak*. The multistrand bracelet is called *maniak batapak*. These four bracelets form a set for a bride. Collection of Lies Alwi.

12.61 Set of three gold ceremonial bracelets. The outer two are made in the form of coiled snakes set with rubies and fine granulation as decoration. Each bracelet was made in two parts that are joined by means of hinges and a screw. The center bracelet has two dragon heads, which join the two ends. Collection of H. Elly Azhar.

12.62 The center of this gold bracelet has a lattice decoration with granulation forming a floral pattern. With a pair of fish and a lion head surrounded by filigree ornamentation, it is a work of great beauty. Collection of Yoebhaar Dt. Perpatih.

MINANGKABAU CEREMONIAL JEWELRY

12.63 Large gold bracelet (*galang gadang*) made by the repoussé method from thin sheets of gold and decorated with small raised oval outlines and with rosettes produced by granulation on the center spine. The two halves are connected with gold pins. 11.4 x 8.6 x 6.4 cm. The Glassell Collection; photography courtesy of the Museum of Fine Arts, Houston.

12.64 Carved wooden bracelet covered in gold leaf. The design of the exterior surface is the same as that of the gold bracelet in figure 12.63.

12.65 Pair of large silver-gilt bracelets (*galang gadang*) beautifully executed in granulation and latticework and set with many small cabochon rubies. Private collection.

12.66 Large brass bracelet (*galang gadang*) with small rubies embedded in the latticework. Appliqué flowers and scrolls are added to conceal the hinge and the pin that join the ends of each piece. This bracelet is made of a brass that is nearly pure copper, the zinc component being less than 15 percent. Collection of Anna Chatab.

12.67 Gold bracelet made of two hollow sections, one inset into the other at one join and fastened with a gold pin at the other. Some of the fine raised-outline circles are enameled in the center; others are set with semiprecious stones. Collection of Miranda Crimp.

12.63

12.64

12.65

12.66

12.67

RELATED CEREMONIAL ARTS

12.68 Silver bracelet on the wrist of a young Minangkabau woman. The raised central portion of the bracelet is decorated with fine granulation; the remaining portion is done in latticework. Collection of H. Elly Azhar.

12.69 Three silver bracelets decorated principally by granulation. Collection of H. Elly Azhar.

Other Ceremonial Jewelry

A repoussé gold triangular ornament (fig. 12.70) is designed to fasten to the side of a bride's ceremonial tunic (*baju kuruang*). To make it flexible, it is made in three pieces hinged together. A bride also carries a beautiful purse (fig. 12.71), which may be decorated with gilded wood beads and dangles attached with gold chains. The purse contains *siriah* (betel leaf), which is given to members of the ceremonial party. It is also the leaf used to wrap the betel quid, often chewed at ceremonies.

European Influences

With the arrival of Europeans in the Minangkabau region, approaches to ornamentation changed. Women began to wear rings, bracelets, and earrings of simpler design—gold set with diamonds or colored precious stones—to dress up their ceremonial attire. One reason for the acceptance of these modern jewels by the Minangkabau is that they are lighter and therefore easier to wear than big, ornate traditional jewelry pieces. Adoption of European-style jewelry caused a decline in the old art of exquisitely crafted ornaments. Except for filigree work, elaborately decorated articles ceased to be made because there was no demand. Recently, however, there has been an attempt to revive silversmithing, a fast-disappearing art of a bygone era.

* * *

The author would like to express her gratitude to the individuals who allowed her to see their personal or family collections, especially Yoebhaar Dt. Perpatih, Mrs. Lies Agoes Alwi, the family of H. A. Sutan Madjo Indo of Bukittinggi and Balingka, and Yasina Effendi of Payakumbuh. The author is equally grateful to various friends who have contributed to this work. Special thanks and acknowledgment are due Anna Chatab, who patiently accompanied the author and encouraged her to pursue the recording of this aspect of our heritage.

12.70 Lavish gold ceremonial ornament from the village of Solok. It is fastened to the side of a bride's tunic (*baju kuruang*). The ornament consists of three separate embossed plates joined by hinges to make the ornament more flexible. Private collection.

12.71 Antique *siriah* purse carried by a bride so that she can offer the *siriah* (*Piper betle*) leaf to her guests. The bag is woven in supplementary weft with fish-scale motifs. Along the bottom are wooden beads that have been wrapped in gold foil. Velvet spacer disks with red silk fringe and silver dangles complete this bridal accessory. Private collection.

Glossary of Jewelry Terms

appliqué. Technique in which pieces are embossed separately, cut out, and soldered or sewn together on a background.

chasing. Method of working metal from the front using a tool with a rounded end so that the pattern is indented into the surface.

embossing. Decorative design produced from the back surface of a sheet of metal. On a bedding made from a substance that is firm yet yielding (e.g., resin), the goldsmith hammers out the desired pattern. Also called *repoussé* or *relief work*.

filigree. Decorative wirework twisted in spirals, tendrils, and lattices to produce delicate tracery, which is either applied and soldered to a metal background or fused into a complete pattern without additional support.

fire gilding. A technique in which gold dissolved in mercury is painted over a hard, shiny surface of silver or other metal and then fired.

gilding. A method in which a thin sheet of gold foil is pasted onto the surface of a less expensive metal in layers until the base metal is entirely covered with gold.

gold foil coating. The application of a thin sheet of gold foil onto a carved or chased wooden bead or other ornament.

granulation. Decoration consisting of minute spherical grains of metal soldered to a background to produce three-dimensional ornamentation.

niello. An alloy of sulfur with silver, copper, or lead. The alloy is used to fill designs that have been incised on the surface of a metal, usually silver. The black color of the niello provides a contrast with the silver. The term niello is also used to describe the final product (e.g., a niello buckle).

red hue or staining. The process of dipping gold ornaments in a solution of distilled water, salt, and alum, then in a solution of acid and sulfur. This produces a reddish hue on gold. The results are best on pure gold.

relief work. *See embossing.*

repoussé. *See embossing.*

OPPOSITE:
12.72 Participants in a Minangkabau ceremony. The two women wearing blue tunics and red tube skirts are wearing large gold earrings similar to those illustrated in figure 12.18. The woman facing the camera wears a headdress that is unique to the village of Padang Magek. She also wears elaborate necklaces and a gold or gilt belt.

Hanefi

13

TRADITIONAL MINANGKABAU MUSIC

The word *musik* (music) has not long been part of the vocabulary of traditional Minangkabau arts. The people of Minangkabau commonly call music *bunyi* (sounds). To the Minangkabau, there is no difference in meaning between the two terms. Because of developments outside the Minangkabau region, however, *musik* is becoming accepted as a replacement for the word *bunyi*, particularly by Minangkabau who live in towns or cities.

Bunyi is an integral part of every Minangkabau ceremonial procession, just as ceremonial garments are a part of every procession. *Bunyi* is also an integral part of traditional dance and of the nightlong performances in which age-old *kaba* are told and sung with instrumental accompaniment. As detailed in chapter 16, *kaba* celebrate and teach the tenets of Minangkabau adat. Some *kaba* tell stories of how certain practices came to be part of adat. Others speak of such matters as how a young man or woman should behave. The range of subjects is large; the number of *kaba* even larger. Ceremonial textiles and the musical presentations of the *kaba* perform similar functions for the Minangkabau. Just as the motifs of ceremonial textiles bring to mind adat sayings, so the narratives of *kaba* restate and refresh the viewers' understanding of adat teachings.

Because of the importance of traditional arts to the teachings of adat and because these rich and varied traditions were in danger of being lost, a group of Minangkabau established a training center for musicians and dancers. That center, the Akademi Seni Karawitan Indonesia (ASKI), in the village of Padang Panjang, is the only such school on the island of Sumatra. Archives are being organized there to document and preserve traditional arts, including tapes of musical performances (some of which have been published by the Smithsonian Institution; see Hanefi and Yampolsky 1994), choreography and detailed descriptions of traditional dances, and other activities at ASKI.

From a musical standpoint, the Minangkabau cultural area can be divided into two parts: the highland area (*darek*), which consists of the original Minangkabau settlements together with the southeast expansions into Solok and Sawahlunto/Sijunjung, and the coastal area, which includes several major settlements along the west central coast of Sumatra. Each of the two areas has its own distinct music, and even within the same area there are notable differences in musical styles and in forms of performance. That these differences are found is not surprising. For centuries villages existed as independent units, long recognized as *republik nagari*, or village republics (Naim 1984, 17). Although all Minangkabau share the same basic adat (the adat that does not crack in the sun or rot in the rain), some aspects of adat that govern music and performing arts have been changed by acts of the chieftains' councils of individual villages to meet the needs of those villages. So there are village-specific ceremonies, village-specific women's headdresses, and village-specific music.

In addition to the traditional Minangkabau music of the highland area and that of the west coast, music originating in the Islamic culture has found its way into almost every corner of the Minangkabau region.

Traditional Musical Instruments of the Minangkabau

Since traditional music is subject to adat, when this music accompanies an adat ceremony, only traditional Minangkabau instruments should be played. Minangkabau musicians distinguish three categories of musical instruments: (1) authentic Minangkabau (*Minangkabau asali*) instruments, (2) instruments that were originally

13.1 Musical group in the village of Pandan. Three of the musicians are beating on *tambua*, large cylindrical mosque drums of Islamic origin. The fourth, in the center, beats on his *tasa* with two thin drumsticks. 1994.

297

13.2 Musician playing *talempong*. He holds the two gongs in his left hand and strikes them with a short stick held in his right hand. This arrangement makes it possible for a *talempong* player to walk in the processions that are part of most Minangkabau ceremonies. The *talempong* player wears a red shirt (*baju*) ornamented with supplementary weft of gold-wrapped thread. His short tube skirt (*sisampiang*) is silk, woven by the Bugih on the island of Sulawesi. The musician's headdress (*deta*) is ornamented with gold-wrapped thread and silver blossoms. The red, yellow, and black banners hanging in the background indicate that a ceremony is in progress. The colors stand for the three original regions (*luhak nan tigo*) and also for courage (red), prosperity (yellow), and the Minangkabau adat (black). 1989.

Muslim or Arabic (*asa Arab*), and (3) instruments borrowed or adapted from the West (*asa Barat*). Within each of these three categories, Margaret Kartomi (1990, 225ff.) has identified the following six "ways of exciting sound ... as a taxonomy of Minangkabau instruments": beaten instruments (*bunyi-bunyian nan dipukua*), blown instruments (*bunyi-bunyian nan dipupuik*), plucked instruments (*bunyi-bunyian nan dipataik*), pulled instruments (*bunyi-bunyian nan ditariak*), bowed instruments (*bunyi-bunyian nan digesek*), and swung instruments (*bunyi-bunyian nan dipusiang*). Missing from this taxonomic scheme is the human voice, a very important instrument in much traditional Minangkabau music.

Unless otherwise noted, all instruments described below are *Minangkabau asali*.

Beaten Instruments

Beaten instruments include a variety of gongs, xylophone-like instruments, and drums.

Gongs

A *talempong* is a set of shallow bronze kettle gongs each about 18 centimeters in diameter and 9 centimeters deep. The individual gongs are similar in size and shape to gongs used by gamelan orchestras in Bali and Java, although the metallic plates of gamelan are not found among traditional Minangkabau instruments. A *talempong* musician holds two gongs in the left hand and strikes them with a stick held in the right hand (fig. 13.2). A common ensemble includes three *talempong* players. Their combined six gongs are pitched to a five-tone scale. When held in the hands, as described above, they are called *talempong pacik* and are readily portable, making them ideal instruments to accompany the many ceremonial processions that are part of traditional Minangkabau culture. Gongs may also be placed in one or more rows on racks on the floor and held in place by twine. When used in this form, they are called *talempong duduak* or *talempong rea* (*talempong* played by seated musicians) and are sometimes complemented by other instruments as accompaniment for dance or theater (*randai*; see chapter 14).

298 RELATED CEREMONIAL ARTS

13.3 *Talempong batu*, "gongs" made from large granite boulders, located in the village of Talang Anau, Limo Puluah Koto. This instrument is the legendary origin of the Minangkabau *talempong* tradition. The boulders are set on large tree trunks whose ends rest on a concrete base spanning a hollow resonating chamber. The granite boulders are played (sounded) by striking them with smaller granite rocks, one of which may be seen here resting on the fourth boulder from the front. 1996.

13.4 Three musicians playing the *talempong batu*. The boulders are arranged in the order shown here, so that the three players, each striking on two of the large stones, produce the combination of notes and the tonal quality of three musicians playing bronze *talempong*. 1996.

13.5 A burnt offering is required before the *talempong batu* may be played. Here one of the musicians is seen lighting the offering under one end of the largest of the six boulders. 1996.

The *talempong batu* (*talempong* in the form of granite boulders), said to be the original *talempong*, are located in the village of Talang Anau, in the regency of Limo Puluah Koto (fig. 13.3). Played by seated or standing musicians, the *talempong batu* consist of six large granite boulders ranging in length from about 1.5 to 2.5 meters. In order to allow the stones to vibrate freely, they are placed on two large tree trunks whose ends are set on concrete bases. The trunks suspend the boulders over a rectangular hole, which serves as a resonating chamber. *Talempong batu* are played by three musicians, each using small granite stones to strike two of the six granite boulders (fig. 13.4), paralleling in concept three musicians each playing a pair of bronze gongs. Sounds produced by the *talempong batu* are very close in tonality and sound quality to sounds produced by modern bronze *talempong*. The *talempong batu* are held in such high esteem that an offering is lighted under one end of the largest boulder before a performance may begin (fig. 13.5).

TRADITIONAL MINANGKABAU MUSIC

13.6 An ensemble with three *talempong* players in the front row. In the back row are two singers, one on each end. The musician second from the left is blowing a horn called a *pupuik batang padi*, which has a rice stalk for a mouthpiece and a conical horn of wrapped coconut palm leaves. The musician to his left is playing a *rabano*, a small tambourine-like drum. 1990.

13.7 Five male musicians in black garments in the middle of a ceremonial procession at the dedication of a palace in Limo Puluah Koto in 1989. Four are playing *talempong pacik*, and the fifth is playing a *gandang*, a two-headed drum, which is suspended from his neck by cords attached to the drum. The women at the front of the procession carry food trays on their heads. The mound of red, yellow, and green puffs atop the food platter identify the women as villagers from Padang Magek. The women at the rear of the procession also carry food trays on their heads; many of these trays are covered with special textiles (*tutuik*) heavily embroidered with silk and gold-wrapped thread.

Talempong Music: Tradition and Change

Adat ceremonies, though they vary in purpose and procedure, have three features in common: extensive traditional oratory (*pidato adat*), preparation of traditional foods, and playing of music by *talempong* ensembles.

Pak Islamida, a renowned *talempong* musician in West Sumatra, described *talempong* as an original form of traditional instrumental music in Minangkabau culture (conversation with authors, 1994). Kartomi (1990, 225–34) has described two main performance forms: (1) a sitting form, *talempong duduak* (literally, sitting *talempong*), in which musicians sit to play the instruments, which rest in a wooden stand or on a mat (figs. 13.6, 13.8, 13.9), and (2) a form in which the musicians hold the instruments in their hands (*talempong pacik;* fig. 13.7). In the sitting form, five or six *talempong* are played by two players, one called an accompanist (*paningkah*) and the other called a singer (*manyanyikan*) or melody maker (*mamelodikan*). In the second form, the musicians play while standing, squatting, or walking. Each holds one or two *talempong* in the left hand, striking them with a stick held in the right hand. The combined five or six gongs are pitched to a five-tone scale. The *talempong pacik* form is ideally suited to the processions that are an integral part of many adat ceremonies—for example, the procession from bride's to groom's house, or vice versa, in a wedding ceremony.

There is a general consistency from area to area in the *pacik* form of *talempong*, which employs an interlocking technique practiced in West Sumatran performances. This technique makes use of three pairs of *talempong* in an additive or cumulative fashion. One player starts a performance with a repetitive part. The

next player to enter builds on the first part, and the last player to enter blends with the other two parts to create a completed rhythmic and melodic construction. The end result is a very engaging and lively form of music that makes any performance or ceremony more enjoyable and festive. It is said that the interlocking of *talempong* is related to the rhythmic pounding of the *lasuang*, or rice-pounding trough.

The late Boestanoel Arifin Adam (1987, 86) wrote that he learned to play *talempong* from his mother, as did many of the older generation of musicians. Drawing on interviews collected from elders in the *luhak nan tigo*, he wrote: "In the past *talempong duduak* musical instruments could be found everywhere and every traditional house had a set of *talempong duduak*. It was used by girls and young women to fill their spare time because they weren't allowed to go outside" (Adam 1987, 30).

Many of the old women who knew how to play *talempong* have either stopped or died, leaving few young women to continue the tradition. Nonetheless, currently there are women *talempong* musicians performing both in the heartland and in the *rantau* (areas outside the heartland). Twelve women's *talempong* groups perform in the heartland. Most of these musicians are older women, however, and there is little doubt that males are now the principal *talempong* performers in many areas. Ibu Siyi Nurbaya, leader of the women's group in the village of Guntung, reported that none of the young women in her village plays *talempong*. She said that they are either not interested in learning or not clever enough to learn (conversation with the authors, 1994).

Today in West Sumatra several styles of *talempong* performance are practiced. For example, in the early 1970s at ASKI, the director, Boestanoel Arifin Adam, and his staff developed a form of *talempong* called *orkes talempong* (Kartomi 1979, 24). This ensemble utilizes an orchestration approach and an approximation of a Western diatonic scale to produce an ensemble comprising some thirty to forty *talempong* divided into ranges of low, middle, and high pitch and employing several performers divided by bass, accompaniment, and melodic function. The repertoire of this ensemble is taken mainly from popular songs and from *saluang* songs (songs accompanied by a bamboo flute) of West Sumatra and "is based to a degree on the artistic eclecticism of nationalism. Influences from international and Javanese musical ideas may be seen in the new music" (Kartomi 1979, 24).

—David and Vicki Salisbury

13.8 Four women musicians. At the center front is the *talempong duduak*, five *talempong* arranged in a rack and played from a seated (*duduak*) position by the musician in the center. Women seated on each side are playing *gandang*, double-headed drums, while the standing woman is playing *momongang*, a bronze drum suspended from a wooden frame. This group is called *Talempong Unggan*, named for the village of Unggan, in the regency of Sawahlunto/Sijunjung. Each of the musicians wears a headdress (*tangkuluak*) folded from a long textile ornamented with supplementary weft of gold-wrapped thread. The *gandang* player on the right is wearing a shirt (*baju*) normally worn only by a male chieftain. The others wear more traditional tunics over their tube skirts. 1994.

13.9 Group of male musicians, five playing *talempong duduak* with elaborate layouts of gongs, accompanied by two musicians playing *gandang*, the double-headed drum. Each of the musicians wears a headdress (*deta*) folded from a square cotton textile ornamented with supplementary weft of gold-wrapped thread. The red shirt and trousers of the leader of the group and the purple shirts and trousers of the other players are also decorated with bands of cloth ornamented with gold-wrapped thread. Spectators in the background are watching a ceremonial procession. 1994.

13.10 The *momongang*, or gong (shown here as no. 3), is usually suspended from a frame, but occasionally a musician will suspend it from his shoulder or from his neck. At the time this illustration was drawn, in the 1860s, the *momongang* was struck with a drumstick carved from a piece of bamboo wrapped in cloth and covered with Chinese paper (no. 4) to soften the tone of the gong. Today a simple wooden drumstick is used. Also shown on this drawing are two views of a *rabano*, a single-headed drum resembling a tambourine without attached jingles (nos. 1, 2); a *gandang*, a double-headed cylindrical drum (no. 5); and a flute called *saluang pauah* (no. 6).

13.11 Two musicians with a *dulang*, a brass or bronze tray held in one hand and struck with the other. The *dulang* is Islamic in origin. 1990.

The *momongan* is a suspended bronze gong (figs. 13.8, 13.10). It hangs either from a musician's shoulder or from a stationary rack, held by a cord fastened in two places on the back of the gong. When not in use, the racked gong is covered by a valuable textile, such as a silk patola.

The *dulang* (fig. 13.11) is a bronze or brass tray of Muslim origin held in one hand and struck by the other hand as accompaniment to singers. The Minangkabau use a number of other bronze gongs of various sizes, including *canang*, *aguang*, and *gandang tigo* (set of three gongs).

Xylophones

Similar to its Western xylophone counterpart, the *talempong kayu* (fig. 13.12) consists of a set of either five or six wooden bars, graduated in length, resting on a pair of supports. It is played by a musician holding one or more sticks. A variant on the *talempong kayu*, the *talempong batuang* is a xylophone-like instrument that, in place of the wooden bars of the *talempong kayu*, is made from sections of giant bamboo that have been cut in half lengthwise.

Drums

Gandang (fig. 13.10) and *adok* are double-headed drums generally used to accompany singers. The *katuak katuak* is a slit drum made from a section of large bamboo cut lengthwise to remove a narrow strip. It is carried by a cord attached at one end and is hung vertically from the musician's neck.

Rabano (figs. 13.10, 13.13) and *rapai* are tambourine-like drums without metallic jingles, carried by a musician and played in a sitting or kneeling position by striking the drum with the hand or fingers. The *rabano* is a highland (*darek*) instrument, and the *rapai* originates in the Pariaman area of the coastal region. Both are of Muslim or Arab origin. The *dol* is a large cylindrical two-headed kettle drum, probably of Indian origin.

The *tasa* is a drum made from a ceramic bowl or a circular wood frame across the open face of which is stretched a leather drumhead, most often goatskin. The drumhead is fastened to the bowl or frame with rattan strips. A cord attached to the drum makes it possible for a musician to suspend it from his neck and strike it with a pair of sticks. When the drumhead is tautly stretched, the drum can produce a loud, high-pitched sound (fig. 13.14). The *tasa* is an *asa Arab* instrument.

The *tambua* (fig. 13.1) is a large cylindrical mosque drum of Muslim origin used by musical groups in the Pariaman area. It reaches from shoulder to hip line when supported by a cord around the player's neck. When played, it is supported partially by one hand at its lower end and is struck with a stick held in the other hand.

The *sikatuntuang* consists of a block of wood about 10 centimeters high, 15 centimeters wide, and 120 centimeters long, supported on each end by a log. Frequently two or more such blocks of different lengths are aligned along the supporting logs and are struck with long poles, shorter sticks, or sometimes with both (fig. 13.15).

13.12 Woman in the village of Unggan playing a simple form of *talempong kayu*, a xylophone-like instrument with wooden "gongs" supported on two logs and played with a pair of drumsticks. 1994.

13.13 Three musicians playing *rabano*, a single-headed drum. Here the *rabano* is rested on the musician's foot, held at the top with one hand, and struck with the other hand. The *rabano* is Islamic in origin. 1990.

13.14 Musician in the village of Pandan taking advantage of an open fire to warm the head of his *tasa*, a single-headed drum, in order to tighten the drumhead. 1994.

13.15 Three young women in the village of Air Tabit playing the *sikatuntuang*, an instrument said to have been inspired by the rhythmic pounding of rice. They accompany a group of *talempong* players (not visible in photograph). 1994.

TRADITIONAL MINANGKABAU MUSIC

13.16 Musician playing a *saluang*, a 60-centimeter-long bamboo flute with five burned-in finger holes. The musician holds the *saluang* on a slant and blows diagonally into the tube. 1990.

13.17 Three flutes of assorted sizes and arrangement of finger holes. The largest of the three is a *sampelong*; the middle-sized flute in the illustration is a *saluang pauah*; the smallest, only 23 centimeters long, is a *bansi*. All have burned-in finger holes and are decorated with burned-on patterns. 1997.

13.18 Musician blowing a *pupuik batang padi* at a village festival in 1996. The *pupuik batang padi* is an instrument with a rice stalk as a mouthpiece attached to a horn made by wrapping coconut palm leaves into a cone. A *pupuik batang padi* rarely survives more than a day since all the materials wilt rapidly in the tropical heat. It is, however, a relatively easy task to make a new one, and the materials are readily available. The musician wears a *kupiah*, a fezlike hat, on his head. A striped cotton shoulder cloth (*salendang*) covers his black shirt (*baju*). Behind him, with a blue and white batik wrapped around his head, is another musician carrying a (barely visible) *talempong* in his left hand. His red shirt is decorated with supplementary weft of gold-wrapped thread. He is wearing a contemporary printed short tube skirt (*sisampiang*). The textile covering the upper arm and elbow of another musician at the right of the illustration is ornamented with silver-wrapped thread.

Blown Instruments
Bamboo Flutes

The *saluang* is a widely used instrument of the Minangkabau heartland. It is an open bamboo flute about 3 centimeters in diameter and 60 centimeters long with five finger holes toward its lower end. The finger holes are burned into the bamboo. The surface of the *saluang* is often decorated with burned-on designs such as florals, geometric motifs, or a striped tiger-skin pattern. A musician holds the *saluang* diagonally across his body and blows at an angle to the long axis of the flute (fig. 13.16).

The *sampelong* (fig. 13.17) is a five-tone flute, closed at the embouchure end. It is about 3 centimeters in diameter and 45 centimeters long with four burned-in finger holes, three near the center and one 15 centimeters from the open end. It has patterns burned onto the surface, similar to those on the *saluang*.

The *saluang pauah* (figs. 13.10, 13.17) is a bamboo flute, closed at the embouchure end, from around Pauah, in the coastal region. It is about 2.5 centimeters in diameter and 25 to 38

centimeters long with six burned-in finger holes extending from its center toward the open end. It also has patterns burned onto the surface.

The *bansi* (fig. 13.17) is a short bamboo flute, closed at the embouchure end, about 2 centimeters in diameter and 23 centimeters long. It has seven burned-in finger holes on the top surface and one on the bottom surface.

Other Blown Instruments

The *pupuik batang padi* (fig. 13.18), also called a *pupuik gadang*, is a horn with a mouthpiece made from a rice stalk. Young coconut leaves are wrapped into the shape of a cone, whose small end is attached to the mouthpiece. Because the materials are fresh vegetable matter, a *pupuik batang padi* has a short life. Replacement parts are readily available, however, and assembly is both easy and quick. The *sarunai* (fig. 13.19), an instrument of the southern part of the coastal region, is similar to the *pupuik batang padi* but with a longer straight stem of small bamboo and a smaller cone.

The *pupuik tanduak* (fig. 13.20) is a horn that is made from the horn (*tanduak*) of a water buffalo. It is sometimes patterned with carving on the wide end, presumably for decoration, not for sonic effects.

13.19 The *sarunai* (shown here as no. 4) is a variant on the *pupuik batang padi*. It has a rice stalk for a mouthpiece (not visible in this illustration). A bamboo stem with finger holes connects the mouthpiece to the horn shape, which is constructed of coconut palm leaves. Also shown in this 1860s drawing are a *rabab*, a three-stringed instrument (nos. 1, 2) that is played with a bow (no. 3), and three forms of bamboo flute (nos. 5–7).

13.20 This horn, called a *pupuik tanduak*, is made from the horn (*tanduak*) of a water buffalo. The water buffalo is dear to the hearts of the Minangkabau. Not only does it perform the hard work of plowing the rice paddies, it also provides milk and meat and represents wealth. The buffalo also reminds the Minangkabau of the legend that tells how they acquired their name (see chapter 2).

TRADITIONAL MINANGKABAU MUSIC

13.21 The *kucapi* is a zither used as an accompaniment to vocal music. It is most commonly played as part of *sijobang*, a traditional musical form in Limo Puluah Koto.

13.22 A *rabab*, a three-stringed instrument with the general shape of a banjo but played with a bow. The sounding bowl may be of wood or of a coconut shell covered with goatskin. The bow is a wood frame with horsehair stretched from end to end. The *rabab* is played upright by a musician seated or kneeling on the floor or ground. The three-string *rabab* is played in the coastal *rantau* areas. (For a version in use in the 1860s, see also fig. 13.19, nos. 1–3.)

13.23 A two-string *rabab*, similar in other respects to the three-string instrument illustrated in figure 13.22. This version of the *rabab* is played in the highlands.

Plucked Instruments

The Minangkabau play several plucked instruments, including the *kucapi* (fig. 13.21), which closely resembles a zither, and the *gambuih*, a lutelike *asa Arab* instrument with six strings.

Pulled Instruments

One pulled instrument is in use among the Minangkabau. The *genggong*, claimed to be an authentic Minangkabau instrument, is known in the Western world as a Jew's harp.

Bowed Instruments

The *rabab* is a three-string bowed instrument of the general shape of a banjo (figs. 13.19, 13.22). The sounding bowl was formerly made from a coconut shell covered with goatskin. One end of a bamboo tube was fitted to an edge of the bowl; the other end was equipped with three pegs, which were used to tighten the three strings to the desired pitches. The other ends of the strings were passed over a wooden bridge and fastened to the far end of the bowl. As with the bamboo flutes, the bamboo neck of the *rabab* had burned-in decorations along its length. Today the coconut-shell sounding bowl and bamboo tube have been replaced by similarly shaped wooden structures.

Although the *rabab* is primarily an instrument of the coastal region around Pariaman, a two-string version is used in the heartland (fig. 13.23), especially around the village of Payakumbuh. The bow is made of a wooden frame on which horsehair is stretched. The musician sits or kneels on the floor holding the *rabab* upright to play.

Biola is the Minangkabau name for a Western violin. In the coastal area it is sometimes played in the same posture as the *rabab*, that is, held upright while the player sits or kneels on the floor (fig. 13.24). When played in this fashion, the *biola* is called *rabab pasisia*, or coastal *rabab*.

13.24 A group of musicians. The musician on the left is playing a *biola*, the Minangkabau version of the violin. It is played vertically by a musician in a seated or kneeling position, as shown here, in the south coastal area (*pasisia*), where it is called *rabab pasisia* since it is played like a *rabab*. The *biola* is also played as Western musicians play the violin. The musician on the right is playing a *rabana*, a small drum. The musician in the center adds to the rhythm with a *giring giring* (rattle). 1990.

RELATED CEREMONIAL ARTS

Swung Instrument

The *gasiang* (bull-roarer) is "a piece of human skull threaded onto a string" (Kartomi 1972, 32), which is rapidly swung in circles above the head. It is a traditional Minangkabau instrument but is not used for what Westerners would consider musical events. It was part of a traditional tiger hunt. When a tiger was thought to have killed a person, a shaman and assistant went into the jungle to capture the guilty animal with a cage and a mixture of music and black magic. According to Kartomi, "it is believed that anyone who hears the sound of a bull-roarer, including a tiger, will become encrazed; and, in this state, the shaman is in complete control of his subject." Edwin Loeb (1972, 127) refers to the *gasiang* "as a means of magically abducting the soul of a woman. This instrument is swung by a jealous lover who has been repelled in making advances. Some hair of the victim is made use of in this charm, and it is thought that the demons will steal the soul of the owner and reduce her to a state of madness."

Traditional Music of the Heartland

Most music of the Minangkabau heartland is played using a five-tone scale. In the regency of Limo Puluah Koto, however, six- and seven-tone scales are also found. Coastal areas commonly use a seven-tone scale. Most traditional songs are sung within a range of only a few notes.

Dendang and *Saluang*

Dendang is a vocal melody sung to the accompaniment of the *saluang* (fig. 13.25). The musical tradition of *saluang* and *dendang* originated in the village (*nagari*) of Singgalang, located at the foot of Mount Singgalang. It then spread throughout the entire heartland (Adam 1980, 9).

Although the *saluang* is normally limited to five tones, a sixth can be sounded by overblowing. In addition, the *saluang* player can add vibrato to the tones in several ways (Adam 1980, 23): by rapid back-and-forth movement of the

13.25 A group in the Minangkabau heartland performing *saluang* and *dendang*, a musical tradition in which one or more musicians play the *saluang*, a bamboo flute, to accompany one or more singers. Their songs are often chanted versions of long epics (*kaba*) that relate the history of the Minangkabau and tenets of their traditional belief system (adat). This group also includes a musician playing a *gandang*, a double-headed drum. The musicians wearing red and black shirts and trousers all wear headdresses (*deta*) of various designs. Shirts, trousers, and *deta* are decorated with gold braid. The *saluang* player wearing the black *deta* also wears a red shoulder cloth heavily embellished with gold-wrapped thread. 1990.

TRADITIONAL MINANGKABAU MUSIC

13.26 Eight musicians, part of a 1996 ceremonial procession. The musician on the left carries a small bamboo flute. The next five play *talempong pacik*. On their left is a musician blowing a *pupuik batang padi*. The drummer on the right carries a *gandang* suspended from his shoulder and beats on it with both hands. (For a description of some of the garments worn by these musicians, see figs. 13.2 and 13.18.)

finger over the hole, much as a violinist vibrates a string on his violin with his left hand while bowing with his right hand; by vibrations of the player's tongue while he is blowing; by rapid movements of the player's head while he is blowing; or by shaking the *saluang* while blowing.

A type of *saluang* and *dendang* performance called *bagurau*—meaning joking, joyously celebrating, or having fun (Adam 1980, 67)—is held at night. The performance may take place anywhere—in a house, in a coffee shop, on the verandah of a shop, in a field, or in a formal performance space. The melody of the *saluang* and *dendang* has a certain power of attraction, but the text of the *dendang* is no less important as an attraction, especially in presenting, and involving the audience in, the meaning of the song. Most of these songs are based on traditional stories (*kaba*) that spell out, in story form, tenets of the Minangkabau adat.

Often a *bagurau* is performed for the purpose of raising money for some project, such as building a new mosque. In such performances the audience is allowed to determine the repertoire of the *dendang* (song) by bidding money for the project. Stiff competitive bidding often results, to the joy of the sponsor of the proposed project. A bidder can even stop a song that is being sung and bring about a change to another song by outbidding the previous bidder.

Songs for the *saluang* and *dendang* can be classified by mood as laments (*ratok*), happy (*gembira*), or half-happy (*satangah gembira*). Minangkabau are especially fond of songs that remind them of their native village (*lagu asa*). A song about one's ancestral village is taken as a sign pointing toward one's roots (Hanefi and Yampolsky 1994).

Bagurau with *saluang* and *dendang* is well loved by the people of the heartland in the villages as well as in the cities. It is also enjoyed by Minangkabau from other areas, although it is not their traditional music.

Talempong Ensembles

Many Minangkabau ceremonies include large processions of participants dressed in ceremonial costume, en route, for example, from bride's house to groom's house as part of a wedding ceremony. These processions are usually accompanied by a number of musicians, each playing *talempong* (*talempong pacik*). Often other musicians playing drums and blown instruments are part of the musical ensemble that either leads or follows the procession (figs. 13.26, 13.27). Composition of the musical group varies from village to village and is not the same for all ceremonies.

For parts of a ceremony that take place inside a building, the ensemble will be seated and can therefore include the *talempong duduak* or *talempong rea* (a seated ensemble), gongs hanging from frames (*aguang*), and other instruments too unwieldy to carry on long processions through the streets of the village (see fig. 13.8).

The *talempong pacik* is often played for *gotong royong* (mutual cooperation) activities in the villages, for festivities held by the people of the *nagari* to accompany the dances (*galombong*) for traditional ceremonies, and for other events.

Sijobang

Sijobang is a musical form, popular in the region of Limo Puluah Koto, in which a musician plays a *kucapi* (zither) to accompany a singer. According to Gérard Moussay (1995, 1061), the song tells of the adventures of a former king of Tiku Pariaman. The story is told in song, typically lasting all night. According to the people of this area, the complete story requires five full nights of performance. Formerly *sijobang* did not use an instrument; the rhythm was provided by the men in the audience, who would slap packages of matches against their thighs.

13.27 Ceremonial procession through a small village in Agam. The musician in front plays the *talempong pacik*; to his left is a musician blowing a *pupuik batang padi*. Four musicians in the rear are beating on *gandang*. 1990.

TRADITIONAL MINANGKABAU MUSIC

Salawaik Dulang

An interesting musical development in the heartland area is *salawaik dulang* music, which is vocal music accompanied by a *dulang*, a type of bronze tray. A *salawaik dulang* group consists of two musicians, each playing a *dulang* while singing (see fig. 13.11). *Salawaik dulang* music originated with Muslim performances of *Salawaik Nabi* (praise for the prophet Muhammad) conducted in communal buildings, in mosques, or even in homes. A *salawaik dulang* event is a competition involving two or three groups of musicians, who perform for the entire night. The texts of the songs take the form of *pantun*. This blending of traditional Minangkabau *pantun* with music provided by Muslim instruments is another metaphor for the successful merging of the traditions of the matrilineal Minangkabau adat with Islamic practices.

Each *salawaik dulang* group is given a chance to ask and answer questions. *Salawaik dulang* is very popular in heartland villages and has also started to develop in other areas of West Sumatra. Its popularity has been enhanced by the inclusion of Indonesian and Minangkabau pop music in its repertoire, with some modifications in the presentation.

Salawaik dulang groups have spread beyond the heartland to the villages of Solok, Sawahlunto, and several other highland areas. A village that has an auspicious event and hosts a *salawaik dulang* performance may invite two or three groups from different areas. Hence the groups become familiar with one another, and quarrels between them rarely occur, even though there are winners and losers in each competition.

TRADITIONAL MUSIC OF THE COASTAL REGIONS

In the coastal regions of the Minangkabau area—which includes the south coast, Padang, Pariaman, and the northwest coast all the way up to Air Bangis—a variety of traditional music can be found.

Rabab Pasisia

Rabab pasisia, which developed in the southern coastal area, consists of a melody played on a *rabab* accompanied by singing. A performance of *rabab pasisia* usually consists of two sections: first, the musical repertoire, which is joyful in nature, with *pantun* by young people (for example, *pantun* about love, involving humor, teasing, and so on), and, second, a story (*kaba*). The performance usually lasts all night. From about nine o'clock in the evening until midnight the *rabab* musicians play the cheerful musical repertoire with the young people's *pantun*. From midnight until about five o'clock in the morning they perform the story (*kaba*).

Traditionally *rabab pasisia* was performed by one musician; that is, the *rabab* player also sang. More recently, however, there has been a tendency to add a second musician, a drummer (*pamain gandang*), to accentuate the rhythmic power. The drummer may also sing. The *rabab*

13.28 A traditional musical group consisting of a *rabab* player in the center and a musician blowing a *saluang* on the right, accompanying a singer (with microphone) on the left. 1990.

used in this music has the shape of a *biola*, a local form of violin, and the playing technique is simple. Musicians are seated, and the *rabab* is held vertically, its base on the floor or ground. The music is full of variation and improvisation in the traditional style (see fig. 13.24).

Rabab pasisia is often performed at festive events, both those sponsored formally by the government and those sponsored by a family or a particular social group. Normally performances of *rabab pasisia* are viewed by a variety of age groups, from the very young to the old. The popularity of this musical form has spread to other areas in the Minangkabau region, and it is even quite well known in the *luhak nan tigo*.

Rabab Pariaman

Another form of traditional music from the coastal area, *rabab Pariaman* (fig. 13.28), is similar to *rabab pasisia*. It, however, is popular only in the area in which it emerged and developed, the regency of Padang Pariaman. It is not found as frequently as *rabab pasisia*, but in the area in which it receives popular support it is often performed by invitation at a variety of functions (ceremonies celebrating weddings, adoptions, or circumcisions or even parties held by the young people of a certain village) and at formal, government-sponsored events.

As is the case with *rabab pasisia*, a performance of *rabab Pariaman* has two sections: the repertoire featuring *pantun* for the young people and the repertoire featuring a story (*kaba*). The music, the *pantun*, and the *kaba* may be different, but the timing of the performance of each section is almost the same as that for *rabab pasisia*.

Gandang Tambua

In addition to music that is melodic in character, there is traditional rhythmic music called *gandang tambua*, which involves many *gandang* drummers. The group for *gandang tambua* includes several musicians; one is the director and plays the *tasa* (single-headed snare drum), while eight to ten additional musicians play the *tambua* (double-headed cylindrical drum).

Although *gandang tambua* is traditional music of the Padang Pariaman area, it is known throughout most of the Minangkabau region because of the role it plays in the Tabuik ceremony (the ritual ceremony commemorating the death of Husayn, grandson of Muhammad, in the field of Karbala). Because of the migration of the inhabitants of the Padang Pariaman area to cities of the heartland, the music of the *gandang tambua* has also developed in those highland areas, where it is not used in a ceremonial context. In the heartland *gandang tambua* has simply become music that can be performed for a variety of secular occasions. People originally from Padang Pariaman who have migrated to other regions often perform *gandang tambua* for Indonesian national holidays (such as Independence Day, August 17).

Music is a vital part of the rich ceremonial life of the Minangkabau. It also serves as a source of entertainment. Although *talempong* groups are the common musical component of ceremonial processions, flutes and drums with accompanying singing are a common musical form for dance, drama, and other ceremonial performances in the heartland and areas just south and east of there. Along the coast, however, singers are usually accompanied by stringed instruments, such as the *rabab* and the *biola*.

As has been pointed out in connection with virtually every aspect of Minangkabau society discussed in this book, practices are often village specific. Therefore, as one might expect, musical groups vary from village to village in combinations of instruments that are played together, in size and shape of instruments, and even in names given to instruments. What villages have in common is an abundance of music, instrumental and vocal. Whether in support of traditional ceremonies or in concert with the *kaba* that retell adat parables, musical performances keep the Minangkabau in touch with the tenets of their traditional belief system.

Indra Utama

TRADITIONAL DANCE IN MINANGKABAU: ITS ROOTS AND ITS FUTURE

Traditional Minangkabau dance and other ceremonial arts have grown and developed over the centuries as an integral part of the peoples' lives. Village pastimes, which were originally no more than simple folk games, developed and were refined into the arts of music, dance, and drama. As has been noted in previous chapters of this volume, the guiding principle in the lives of the Minangkabau is the adat, and it forms the basis of their arts as well. Traditional art is categorized as *adat berbuhul sentak*, an adat subcategory that is permitted to change and develop but only in accordance with current needs and with the consensus of the village chieftains.

The role of traditional art in Minangkabau society can perhaps best be understood from the saying:

Duduak bapamenan
tagak baparintang

Sitting has its games
standing has its diversions

This means when we Minangkabau sit or stand during moments of leisure, there are always "folk games" in which we can engage for our own pleasure. The term *pamenan* (from *bapamenan*, above) has a broader meaning than simply "folk games," however, and, in fact, these diversions may now often be classed among the arts. Within the category of *pamenan*, one finds many elements of play that incorporate positive values: brain teasers in the form of riddles; wordplay involving terms drawn from the local language; delivering and responding spontaneously to *pantun*, a short verse form—usually of four or six lines—which typically conveys trenchant sentiments regarding life, politics, or love. All of these activities contribute to a highly refined oral tradition.

For the Minangkabau, art must combine aesthetic beauty and moral value. These requirements are expressed in the traditional saying freely translated below:

Nan kuriak iolah kundi
Nan merah iolah sago
Nan baiak iolah budi
Nan indah iolah baso

Just as speckled things are spotty
And the sago palm is red
So good things have character
And beautiful things are attractive

To have *budi* (character) is to adhere to good moral principles, and to have *baso* is to display aesthetic value or beauty of a sort that attracts others. This beauty is the main condition required of the art form by the Minangkabau, but art must also embody *budi*, or values of goodness based on adat teachings, appropriateness, and practicality—values that do not conflict with the teachings of Islam.

Pancak silek, an art form from which the movements of traditional Minangkabau dance have evolved, combines *budi* and *baso*. As a folk game, it is considered to be more serious than most because it reflects the personal character of the Minang people as expressed in their everyday social interactions. Considered singly, the two words *silek* and *pancak* have very different meanings. *Silek* is a martial art, noted for beautiful yet restrained movements performed very seriously in the sometimes deadly practice of self-defense. *Pancak* is a type of game performed before large crowds as a popular entertainment. The movements of *silek* emerge spontaneously in response to the threat posed by an attacker; the movements of *pancak* are executed in a predetermined pattern.

14.1 The second erect stance adopted for traditional dance from the martial art known as *silek* (see fig. 14.5). The weight is on the left leg and the right leg crosses in front of the left at the knee so that it does not touch the ground. Los Angeles. 1997.

Silek and Pancak Silek

As the ultimate source of Minangkabau dance, the movements of *silek* deserve a detailed description. The philosophy of *silek* stresses that an enemy should not be sought; if one is encountered, however, it is forbidden to evade him. The intent of Minangkabau *silek* is not to destroy an opponent but rather to defeat an attack by temporarily disabling the attacker. *Silek* grounds the practitioner in the belief that it is far better to live in peace than to create conflict.

The Minangkabau say that their approach to thwarting attack through the performance of aesthetically pleasing movements illustrates their basic philosophy and character. They believe that to implement this defensive approach successfully, one must demonstrate a unity of mind and body and a belief in and devotion to Allah. A *silek* master (*pandeka*) is always sparing or careful with his movements. Sitting, standing, stepping, or moving any part of the body is always done with great caution. A master is also economical in his use of words, being unwilling to hurt someone's feelings or otherwise offend. Further, he must also be adept in the science of anatomy and in the lore of healing by means of traditional medicines.

According to Masrul Malik, the director of the Indonesian Pencak Silat Organization (IPSI) in Padang Panjang, a *silek* expert must act according to eight principles when facing an opponent. These principles, applicable to strategic planning in any confrontation, are:

Tagak:	Determine a good position if you feel there will be an attack from an opponent.
Tagun:	Maintain awareness of the position of your body at all times so that at any moment you can change to a more advantageous one.
Katak:	Plan the stages of your movement in the event that the dispute continues.
Garak:	Anticipate what your opponent may possibly do.
Garik:	Perform precise movements.
Jangko:	Estimate the distance that must be maintained between you and your attacker.
Pandang:	Evaluate your opponent's tactical and strategic abilities.
Kutiko:	Achieve the precise momentum required to reach a satisfactory conclusion with respect to your opponent.

There are two ways to stop an opponent's attack in *silek*. The first employs footwork, *sagayuang putuih*, in an attack on the legs that renders an opponent unable to move. The second is *tangkok mati*, the temporary disabling of appropriate joints of the assailant's body. Because joints are weak, disabling them is relatively easy and will usually prevent an attacker from continuing the assault.

Masrul Malik emphasizes that a *silek* expert must not be driven by his desires, nor should he allow himself to be provoked. He must not use *ilmu katak* (frog nature), meaning that he should not immediately jump if provoked. When a problem is encountered, it must first be considered calmly in hope that the appropriate or true solution will emerge. A traditional saying expresses the value the Minangkabau place on reasoning as a means of conflict resolution:

Pikia palito ati
Nanang sarugo aka
Lalok sakalok barasian
Bana kok dapek dalam mimpi

Thought is the lamp of the heart
Reflection is the height of intelligence
To have a dream as soon as falling asleep
For truth can be found in dreams

Most common sitting postures are comfortable (fig. 14.2), but they are not always amenable to the quick change of position required if one is to counter a sudden attack. A *silek* practitioner always sits in a state of caution with the right leg folded over the left leg (*baselo*; fig. 14.3). A quick move to a new position (*iduik sandiang*; fig. 14.4) is thus easily executed in the event of danger. Arranging one's position, taking appropriate steps, making changes in movements, attacking and defending, all are parts of the *batang* (trunk or stem), or essence of Minangkabau *silek*. Certain movements (*galuik*) executed during the opening phase of a dispute are not part of the *batang*: these deceptive movements, intended to free oneself from an attack, are considered ornaments of *silek*.

There are four basic positions in *silek*: the sitting posture shown in figure 14.3 and three standing postures. The general upright standing position is called *kudo-kudo* (horse stance). It consists of three different stances; the one the defender uses is based upon the tactics of the opponent. In the first standing stance, *tagak basitumpu, cancang balandasan*, the right leg is bent back behind the body at the knee and the

14.2 The author, dancer Indra Utama, posing in a comfortable sitting position. Los Angeles. 1997.

14.3 Dancer posing in the *silek* seated position that allows for a quick change to a defensive posture. Los Angeles. 1997.

14.4 Dancer in defensive posture struck from the seated position shown in figure 14.3. Los Angeles. 1997.

14.5 Dancer in the first of three upright or horse stances adopted from *silek* for traditional dance. This stance is known as *tagak basitumpu, cancang balandasan*. The weight is on the left leg, the right leg bends at the knee to go behind the body. Los Angeles. 1997.

14.6 Defensive pose, and dance movement, struck from the stance shown in figure 14.5. Los Angeles. 1997.

14.7 The third erect stance adopted from *silek* for use as a traditional dance movement. This stance is known as *tagak gantuang*. Los Angeles. 1997.

left leg supports the body's weight (fig. 14.5). A defensive position originating from this stance is shown in figure 14.6. In the second stance, *tagak itiak*, the *silek* practitioner continues to stand on the left leg, but the right leg wraps in front of the left at the knee (fig. 14.1). A third stance, *tagak gantuang*, puts the weight on the right leg (fig. 14.7).

Unlike *silek*, *pancak silek* is performed to entertain at special events or ceremonies. *Pancak silek* is considered to be a flowering of *silek*. Whereas in *silek* there are two ways to stop an opponent's attack, *sagayuang putuih* and *tangkok mati*, in *pancak* there is *sagayuang sambuik*, a leg movement that is parried or intercepted by another's hand, and *tangkok lapeh*, a grasp that is quickly released according to a pre-specified pattern (fig. 14.8). This quick release of a grasp in *pancak* is likened to the blossoming or opening of a flower. It contrasts with *silek* where a grasp is held and may be deadly. Movements as well as the timing of movements in *pancak* can be prearranged. Practitioners of *pancak silek* are called *anak silek* (children of *silek*).

TRADITIONAL DANCE IN MINANGKABAU

14.8 Children practicing *pancak silek* movements. The grasp that the girl in the foreground maintains on her opponent's leg and the thrust on the thigh of that leg will be held only momentarily before the circular *galombong* dance resumes. Pasia Putiah, Bungus Bay, Padang. 1985.

14.9 A view of the central area of the village of Pariangan taken from a hilltop at the edge of the village. The hillsides are too steep for roads or sidewalks to have been built to provide access to the village proper so the walkways are steps. This village is alleged to have been the first area settled when the Minangkabau ancestors descended from the top of Mount Marapi. Pariangan village. 1986.

Silek movements, as adapted for *pancak silek*, form the basis for movements found in all traditional Minangkabau dances—those of the coastal (*rantau*) area, as well as those of the heartland area in the highlands. Movements in traditional dance always follow the eight principles of *silek*. These principles, however, are developed and choreographed so that they are transformed into dance movements.

Preservation of Traditional Dance

Knowledge of the arts of Minangkabau has been passed down from one generation to the next orally. Thus it is possible that changes have taken place in the evolution of dance movements that we have no knowledge of today. To avoid this situation in the future, an effort is underway to document the movements of traditional dance as they are known today. An archive has been instituted at the Akadami Seni Karawitan Indonesia (ASKI) to house research and documentation concerning traditional dances. All such activity is undertaken with the aim that the heritage of Minangkabau dance be preserved.

As an example of ASKI's efforts, I was privileged to spend two years as leader of a team, consisting of four of my students, which was sent to learn and document the *tari sado*, a dance from the village of Pariangan (fig. 14.9). The only man who knew the dance was old and poor. He and his wife eked out a meager living by preparing *saté* in the late evening and selling it in the village the next day. From 10:00 P.M. until midnight they cut onions and beef and prepared marinade, so that the flavorful pieces of skewered meat could be barbecued in the morning and sold. The villagers, especially the young men, knew or cared little about this old man, Ahmed Sutan Rajo Madjo Anjuangek, but as the only living Minangkabau who knew the *tari sado*, he was essential to the mission of ASKI.

RELATED CEREMONIAL ARTS

The five of us walked from ASKI to Pariangan, a two-and-a-half-hour journey, every weekend for two years. We practiced the dance in a field in front of Ahmed's house. He taught us both its movements and its meaning. The first time no one came to watch. The second time, a few young men came to watch because our group included some attractive young women. One of the women approached these young men and said, "I come from outside this village, and I want to learn the *sado* dance. You are from this village. Why do you not learn this dance?" The boys seemed to be shamed by her question, and some of them joined us for the practice sessions. There are now two young men in Pariangan who know and perform the dance expertly.

Documenting the *sado* dance for future generations was not the only benefit of our prolonged study. We all helped the old couple to prepare *saté*, lightening their work and eventually becoming almost a part of their extended family. Some of the female students also worked with young villagers to clear a road and so helped to develop the village. Near the end of our study I choreographed a new dance based on the *tari sado*. The new dance was performed during an exhibition in Jakarta with Ahmed Anjuangek dancing the lead role. He was greatly surprised and pleased after the performance when he was given money; this was the first time he had ever been paid for dancing. The performance was telecast throughout Indonesia, and, as a result, villagers in Pariangan became aware of the value and the importance of their neighbor and of his special knowledge. They now take pride in his accomplishments.

An additional serendipitous result of the study was increased awareness among the village population of the value of their traditional heritage. With only five persons, we were able to increase the villagers' knowledge of and interest in traditional Minangkabau culture, and we were able to help develop that culture. Similar actions on the part of small groups in other parts of the nation could significantly influence the development of the arts of Indonesia and the country's awareness and appreciation of traditional aspects of those arts in the face of the onslaught of Western popular culture.

Of the many traditional dances that still exist and continue to develop in Minangkabau—and are now documented in the archives at ASKI—one of the most popular is the *tari piring*, or plate dance. In this dance, performers hold slightly dished plates in the palms of their hands (figs. 14.10–14.12) while they execute a series of movements said to mimic activities involved in rice farming. For example, the dancers mimic the act of walking along very narrow earthen dykes of irrigated rice fields to bring food to the workers by making their way across the performance area stepping cautiously from one small plate to the next (fig. 14.12). Sometimes the difficulty of this movement is increased by placing glass tumblers upside down on the plates so the dancers must step on even smaller areas representing the narrow dykes (fig. 14.13).

14.10 *Piring* dancer holding the plate in her hand. A cap on her finger is used to tap rhythmically on the plate. The plate is not fastened to the dancer's hand by any artificial means and may fall at some time during the strenuous dance. Shards of shattered plates are collected for use in later dances. Minangkabau highlands. 1994.

14.11 A group of six *piring* dancers performing the circular *galombong* dance at a private ceremony. Bukittinggi. 1995.

14.12 A dancer crosses the performance area by stepping on a series of small plates. This represents walking along the narrow dykes of wet rice fields to carry food to workers. Bukittinggi. 1995.

TRADITIONAL DANCE IN MINANGKABAU

14.13 A dancer negotiates her way cautiously across glass tumblers that have been set upside down on plates. This represents walking along the narrow dykes that control the flow of water through wet rice fields in order to bring food to those working there. Minangkabau highlands. 1994.

There is an aspect of magic involved in this dance. Shards of plates broken in falls from dancers' hands during previous dances are heaped in the center of the performance area. Barefoot dancers leap into this pile of sharp china fragments landing on their feet with full force (fig. 14.14). There is no blood. There are no cut feet. Dancers say they are protected by the spiritual powers of a colleague who is not part of their immediate performance and who has been assigned to protect them. It is said, however, that sometimes a person who wishes harm to one of the dancers may be stronger mentally than the assigned protector, and a dancer can thus be injured. A further example of such "magical" protection may be seen in the actions of a shirtless male dancer, who joins the performance with a flaming torch in each hand. Not only does he play the flames over his exposed skin with no evidence of being burned (fig. 14.15), he writhes on his back in the shards with no resulting visible injury (fig. 14.16).

The Influence of Traditional Dance on Contemporary Choreography

Although each traditional dance has its own village-specific traits, there are several general characteristics typical of traditional Minangka-

318 RELATED CEREMONIAL ARTS

14.14 A *piring* dancer jumps with full force into a pile of china shards. She experiences no injury claiming to be protected by a colleague who uses magic to assure her success in the maneuver. Bukittinggi. 1995.

14.15 A shirtless male *piring* dancer prays before playing fire across his bare chest. No visible burns appear on his body despite the contact with the flames. Bukittinggi. 1995.

14.16 After having bathed his upper body in flames with no resulting injury, the *piring* dancer writhes on his back in the china shards and emerges uninjured. Bukittinggi. 1995.

bau dance considered as a whole. These include a vocal element in the form of cries such as "*haaast!*" (delivered as a high shriek), "*ta!*" "*waaaast!*" "*hep!*" and "*hay!*"; there is hand clapping, thigh slapping, and slapping on the low-crotched pants that are also typically worn in the circular dance (*galombong*) performed in *pancak silek* (fig. 14.17). With each shift in movement, there is a lifting of the feet, and there is always a *gonjek*, a feigned or unexpected trick movement. Movements in traditional dance always convey an air of caution and a certain tension. A steady focus of the eyes lends the dancers an incisive, penetrating expression.

Knowledge of the elements of traditional dance impacts contemporary Minangkabau choreography. The choreographic process may often begin with a desire to develop a theme that has its origin in a creative work from the past. As a choreographer, I am concerned with the problem of how to transform that theme so that it continues to be meaningful within a

TRADITIONAL DANCE IN MINANGKABAU

contemporary context. An Indonesian choreographer today can escape neither the impact of tradition nor the influence of the modern world. Moreover, the responsible choreographer can never be free of the tension existing between Indonesian modern dance and traditional forms. No matter how much they study the art of dance, Indonesian choreographers will continue to be influenced by the traditions of their long-established subcultures, an influence that consciously or not will affect their compositions. From my point of view, this subcultural tie can be seen as a serious threat to creativity and to innovation, and especially to modern art, which requires individuality to achieve power and authority. The artist, in finding a unique creative voice must therefore be on guard against being a slave of tradition or being an uninspired imitator of Western culture.

There is some urgency to the need to incorporate the nuances of traditional Minangkabau dance in contemporary choreography. This need stems from the loss of much of the richness of the vocabulary of our traditional dance. Similar losses have already occurred in other parts of Indonesia, including Batak, Sunda, Java, Bali, Irian Jaya, Kalimantan, Mentawai, and elsewhere. What kind of culture will evolve if the wellsprings of modern Indonesian dance are not grounded in tradition? Some westernization of the art of choreography cannot be avoided, but complete westernization would remove this art completely from its culture. The pursuit of a totally modern idiom for Indonesian dance feels alien to contemporary creative artists whose spirits and feelings have been formed by tradition.

In Minangkabau attention must be given to achieving a real understanding of the eight principles of movement as applied in traditional dance. In development or exploration of movement for the purpose of creating a new work, the four basic movements and the eight principles should always be employed as guides and tools to provide a traditional context. Whatever form of movement is created during exploration, development carried out in the context of traditional movements should produce a new work that is a form of dialogue between traditional dance and contemporary dance.

The practice of deepening one's understanding of the power of tradition should be an ongoing activity. In-depth study of the four basic movements and the eight principles must be pursued at a time other than the period of choreography. At the time the creative process is taking place, the designer's thoughts and feelings are dominated by artistic problems—quality and vocabulary of movements, abilities of the dancers, lighting, costumes. Behind the freedom a choreographer experiences during the creative process lies a great responsibility. The requirements of choreography must be fulfilled in such a way that the newly created dance doesn't become merely a physical imitation of traditional dance, which is destructive. What is being created should renew or revitalize tradition, not destroy it.

Performers should also contribute traditional elements to a new composition. Dancers must be aware that they should as far as possible replicate the spirit and sensitivity of a master of *silek*, prepared to face any possibility that might arise. Dance practice carried out regularly with reference to the four basic movements and the eight principles is highly recommended. When this practice achieves its goal, expression in the dance takes shape on its own.

A modern Indonesian culture that reflects the style of a modern Indonesia economically, politically, and culturally has not yet been formed. We as artists have yet to find a strong, original position. By creating and working, an artist discovers his or her true self. The Indonesian people will follow a similar process to form their true identity as a nation of value in the modern world culture.

14.17 A young resident of the Bungus Bay area of Padang demonstrating how a loud sound is produced when he sharply claps the fabric of his large trousers (*sarawa gadang*) between his hands. The resulting sound is startling when a group of dancers clap at the same time as part of the *galombong*. Pasia Putiah, Bungus Bay, Padang. 1985.

Randai

The Minangkabau performance art called *randai* is a style of dance- and music-dominated theater often performed as an accompaniment to ceremonies. It combines drama; vocal, instrumental, solo, and ensemble musical performances; circular dance (*galombong*); and *pancak silek*, the aggregation of powerful body movements derived from the self-defense art of *silek* (fig. 14.18).

Randai is performed by a group of six to thirty-five players who are skilled actors, musicians, and dancers. Most village performances occur outside at night after the evening prayer and finish before daybreak. There may be as many as fifteen scenes in each production. A scene consists of three sections: *galombong* (a circle dance), *kaba* (a dramatic narrative), and *dendang* (song). Traditional *randai* may be performed in an open field, in a yard, or in a covered site. The stage must be level and at least six-meters square. The performance area is lighted either by electric lights or by bamboo oil lamps set inside the stage area. The audience sits or stands in a circle surrounding the performance area. This circular configuration is important to the intimate relationship between performers and audience. Honored guests are seated nearest the performers.

The audience is often called to a *randai* performance by the playing of a multiple-reed instrument made from a rice stalk and coconut leaves (*pupuik batang padi*). Then *talempong* musicians lead a procession of the cast to the performance area (fig. 14.19). One performer carries a ceremonial brass bowl (*carano*), which holds *siriah* and which is covered by a textile often embroidered in satin stitch or heavily embellished with couched gold thread. *Siriah* is offered to the production's director (*tuo randai*) and to one of the spectators who accepts it on behalf of the rest of the audience. This offering signals delivery of the introductory remarks, which include asking for forgiveness. Once the *siriah* is chewed, the *randai* can begin. Performers are commanded by a yell of "*hep-ta!*"; and they then form a *galombong* circle with graceful and precise *pancak silek* movements (fig. 14.20). Thus begins the first scene of *randai*.

The performers initially honor the audience in an introductory dance (*sambah barewai*). *Galombong* dancers form a circle and move toward and away from the center. The name for such dancing, *tari randai*, comes from the word *tari* (dance) and the word *rantai* (chain, referring to the circular movements of *galombong*).

14.18 *Pancak silek* performer receiving a blessing from the *ulama* (religious leader) before a competition during a ceremony celebrating the installation of a new *pangulu nagari*, or head of the geographic subdistrict. Minangkabau highlands. 1994.

14.19 Musicians using the loud clanging of the *talempong* to call people from the village to attend the performance. The man in the foreground is dressed as a female heroine. Traditionally women were not allowed to participate in *randai*, an exclusion that is now disappearing. Minangkabau highlands. 1994.

14.20 *Pancak silek* movements are the main constituents of the *tari randai* (circle dance) called the *galombong*. Minangkabau highlands. 1993.

14.21 The second part of a *randai* scene features actors enclosed in a circle of seated *galombong* dancers. These actors perform part of the narrative *kaba* drama. Minangkabau highlands. 1993.

Dancers may kick, clap their baggy black pants (see fig. 14.17), and lunge while singing. Their forceful *pancak silek* movements capture the audience's attention. All synchronized movements are signaled by a command from one of the circle dancers. One clap may signal the end of the dancing, two claps may be the signal to sit, and three claps begin every wave of movement. The *galombong* announces each change of scene.

This first part of a *randai* scene also contains a poetic prologue sung by the leader as a sign of respect to the audience. Next, in the spirit of musical folk poetry, a pair of singers performs a spontaneously improvised *pantun* that expresses feelings and thoughts. Often in *randai* a *pantun* is humorous, and its underlying meaning can express political or personal conflict. *Randai* has a long history as a means to communicate moral, political, and religious perspectives. Margaret Kartomi (1981, 23) has highlighted instances dating from the first half of the century through the 1980s where specific agenda—for example, anti-Sukarno, anti-Japanese, anti-feudal, anti-Communist, and prodevelopment sentiments—were promoted through narratives in *randai* performances.

When the *pantun* is completed, *galombong* dancers sit in a large circle in the center of the performance area, and the *kaba*, a dramatic narrative that usually includes a hero, a heroine, and some comic relief, begins. In times past the script of a *kaba* was taught orally. Today scripts are written. Spontaneous improvisation, however, is an important part of the dialogue, as is audience participation. Actors stand and deliver their lines from inside the *galombong* circle (fig. 14.21). In the past, all performers were male; even the role of the heroine was performed by a male dressed in woman's costume and made up to look as beautiful as possible. Often dark eyeglasses were worn to promote his disguise. Currently there is a trend toward allowing women to participate.

When the *kaba* segment finishes, *galombong* dancers, accompanied by a song (*dendang*), form a circle and commence the *pancak silek* movements again in order to begin the third section of the *randai* scene (fig. 14.22). The *dendang* music includes solo and ensemble vocalizing with instrumental accompaniment that includes a *talempong* ensemble, a thin bamboo flute about 70 centimeters long (the *saluang*), a drum called a *gandang*, and a tambourine-like instrument called a *rabano* (see chapter 13). This series, *galombong*, *kaba*, *dendang*, is repeated

for each scene until the story is finished. The audience is entertained between scenes by informal musical interludes (fig. 14.23). Upon completion of the story, *randai* performers repeat their introductory movements, again asking the spectators for pardon, usually accompanied by a *sapayaran* song, through which the performers express their hope that the audience is satisfied with the performance.

In some villages the leader of a *randai* group selects and organizes both play and players. Usually each group specializes in one *kaba* and often adopts the title of the story as the name of the group. Lead actors must be skilled at *pancak silek* movements and must be talented actors who can project dialogue. According to Leninio (1992), a lead actor must also have a strong spiritual force that can protect him during his acting, especially from his competitors who have black magic at their disposal. Leninio offers the following examples of disturbances caused by black magic: losing the ability to speak, sudden confusion or sickness, spirit possession, and causing or having an accident while using a knife or sword during the *pancak silek* portion of the performance. As seen in examples of traditional dance, protection from black magic may sometimes be provided by persons other than the performer.

Stories told as part of Minangkabau *randai* are narrated through *gurindam*, a type of free verse. They usually tell about heroism, love, or the evils of gambling or thievery. The script is adhered to loosely, and both improvisation and interaction with the audience are encouraged and viewed as skillful. For example, someone in the audience may yell out to the hero, "Hold her hand!" and he might answer, "I'm too shy." Stories convey moral messages about the lives of outstanding figures and about social behavior that is worthy of emulation. (See excerpt from the *kaba Rantjak diLabueh* in chapter 16.) They now also serve as venues for teaching Islamic laws and for dispensing political messages.

Randai is currently undergoing significant change. Participation of women can be seen in village performances as well as in professional theatrical groups. New *randai* scripts are concerned with contemporary social issues such as family planning and economic development. Scripts are being shortened so that performances no longer last into the early morning hours. Another significant change is adaptation to commercialized venues. In the past, performers traded food for the performance; today many groups charge admission.

With an increase in tourism to West Sumatra, *randai* theater has become a viable profession, especially for graduates of performing arts institutions. In the city of Bukittinggi, professional groups host tourist performances six nights a week in a public theater. *Randai* theater performed there is an abridged version with perhaps only one or two scenes. Other interesting changes adopted by some performing groups include increased numbers of *talempong* and nontraditional electronic instruments (Kartomi 1981, 25). Some scripts are now contemporary, and stories may be of recent vintage. In many regions *randai* has changed little, in others it has changed and adapted to suit new venues, foreign audiences, and contemporary issues. This expansion should be seen as a tribute to the dynamic creativity of the Minangkabau people.

—*David and Vicky Salisbury*

14.22 A circle of men performing the *galombong*, which is combined with chanting, yelling, and singing during the performance. Minangkabau highlands. 1994.

14.23 Musicians performing during an interlude between scenes. Minangkabau highlands. 1994.

14.22

14.23

Anas Nafis

PIDATO ADAT AND MINANGKABAU PROVERBS

The Minangkabau culture has been a largely oral one. The legends, myths, and values that sustain it are communicated orally from one generation to the next through sayings and narratives. Oral communication was and is so important to the Minangkabau that even after written language arrived with Islam in the sixteenth and seventeenth centuries, the oral form was retained in written records of origin myths and parables, traditions, and adat sayings.

Most ceremonies today follow tradition, but many follow it only partially. Some clothing, decorations, and music have forsaken traditional roots. Also, what were once all-night performances of *kaba*, narratives that promulgate cultural values or explain the cultural origins of certain customs, have often been shortened to last only two or three hours.

Among the varieties of traditional oral expression still in common use today are chieftain's orations (*pidato adat*). A Minangkabau chieftain (*pangulu*), in addition to being an expert in local adat, is expected to be highly skilled at oration. Unlike ordinary or everyday speech, orations contain many different types of traditional expressions, including *pantun* (stanzas, generally of four lines, whose last two lines usually carry the major import), *papatah-patitih* (aphorisms), *pameo* (slogans or proverbs), *petuah* (religious advice), *tamsia* (parables), *gurindam* (two-line aphorisms), *ibarat* (similes), and *talibua* (six-, eight-, ten-, or twelve-line *pantun*).

Pantun are especially rich in metaphors. The first two lines of the four-line poems and the first three lines of the six-line poems often contain metaphoric statements or descriptions that can be fully understood only after the last lines have been spoken. Careful examination of the first lines of the *pantun* rewards the reader with a deeper appreciation of the remarkable sophistication of the Minangkabau *pangulu*.

Orations are delivered in a special manner, much as a dramatic poet would read his poetry aloud. The more skillfully the chieftain delivers his oration, the more attentive and appreciative his audience becomes. At some ceremonies speeches may go on for hours, and it behooves the orator to be at least clever, if not brilliant, if he expects to hold his audience.

Usually *pidato adat* are delivered on such occasions as weddings, the installation of a new chieftain (*batagak pangulu*), funerals, or adoption ceremonies. At a wedding celebration, for example, the oration of a host (*sipangkalan*) is responded to energetically by a specially chosen guest orator (*alek*). The occasion becomes a competition, and an especially brilliant expression by one of the participants may bring forth cheers and applause from guests attending the ceremony.

Guests who are invited to take part in such a competition prepare themselves in a serious manner long before the event. This is not necessarily true for an experienced chieftain, however, because he is already a skilled orator and has become accustomed to participating in such events. Members of the clan of a chieftain who is a skilled orator are sometimes no less accomplished at oration than their chieftain himself.

Quite apart from *pidato adat*, it is usual for Minangkabau to slip examples of traditional sayings into their everyday speech. A person who isn't familiar with or who doesn't understand the meaning of such expressions is said not to know proper manners (*tidak tau di ereng dangan gendeng*) and furthermore is branded as someone who doesn't know tradition (*tidak tau adat*). The Minangkabau practice of using or referring to traditional sayings in ordinary conversation has become "everyday clothes." That often makes it difficult for non-Minangkabau to understand a conversation between Minangkabau. Consider, for example, traditional sayings in the *sunsang* (backward) format:

When you have it, do not eat it,
When you no longer have it, then you eat it.

When the passage is narrow, it passes through,
When the passage is wide, it gets stuck.

Or consider sayings such as:

Like a rice-pounding pole that is growing shoots.

For an interpretation of these and other examples of traditional sayings or proverbs, called *peribahasa*, refer to the final section of this chapter, where a small sampling of the many thousands of Minangkabau *peribahasa* are cited and explained.

Pidato Adat (Chieftain's Ceremonial Orations)

To provide a flavor of the rich poetic and allusive qualities of *pidato adat*, three examples are given below: a traditional oration delivered by the host at a wedding celebration, a traditional oration delivered by the preselected guest invited to deliver a competitive response to the host's oration at a wedding celebration, and an oration by the host at a celebration for a *pangulu*'s inauguration.

These chieftain's orations have been selected from among many that are common elements of Minangkabau ceremonies. The translations below are nearly verbatim from the original Minangkabau. A portion of the language is in four- or six-line *pantun* form, the first lines of which sometimes contain metaphors and in other instances do not add meaning. In addition to including frequent references to traditional adat aphorisms, the orations illustrate the well-known Minangkabau proclivity for indirection in speech. A few words, mostly names of local flora and fauna, remain in the original Minangkabau.

A Traditional Oration Delivered by the Host at a Wedding Celebration[1]

Wearing the batik hat, clad in garments
Woven by one from Batipuah,
Truly I stand here erect,
But my spirit is on the floor kneeling.

Woven by one from Batipuah,
Being worn in midday,
My spirit is kneeling,
My palms are together, asking your pardon.[2]

Forgive me, my honorable *pangulu*, great men with high prestige, all honorable *malin* and *ulama*,[3] being faithful and religious men, all *dubalang*[4] of the village, being brave and heroic men, as the pillars of the country, all *manti*[5] and officers, understanding the puzzle of village administration, playing the weights and balances. The small-minded will not be named, bigwigs will not be addressed, my deepest respect to everybody. Guests of this great party, allow me to speak, to describe what it is, to narrate everything in an orderly way.

Plume grass borders the forest,
Fruit to be taken from tree branches,
I am here with a question.
I stand with comments to make.

Back in the early ages, what was wished for by both parents, as said by *Melayu hadis* (Minangkabau tradition):

The ages before the ages before
The sky and earth have not existed,
Fruits have not had seed, therefore
Deep in the heart a promise hidden.

What was the request seriously asked of Allah? "Grant us a son or a daughter."

If a son is granted, let him be like a ring on the little finger, to be the host of celebrations, who chooses which guests shall come, who is as if a symbol in the village, who raises the soaked stem,[6] who picks up distant travelers, who challenges foreign worlds.

If granted a daughter, let her be the replacement for earrings and bracelets, as if *canggai*[7] on the little finger, like a flower in the garden, as the actress in the village, as said by *Melayu hadis*:

The bamboo is to be cut for a border enclosure,
To be cut nine fingers long.
Because the wish is seriously asked
It is the time to bring it to God.

Then they were granted a charming daughter, to be nursed and looked after, to be carried on the head like a crown, to be carried in one's hands like a magic stone, to be spoiled in the morning and evening, to be bought earrings and bracelets, to have belts and beads.

Since the daughter is grown up, become a young girl to be given guidance and knowledge, she knows and is able to feel, completed by

1. The host may be either the bride's father or her maternal uncle.
2. It is customary for Minangkabau performers or orators to beg forgiveness of their audience before they begin.
3. *Malin* and *ulama* are experts in religious matters.
4. *Dubalang* are men appointed to secure the village and to carry out orders of the *pangulu*. They are sometimes described as the bodyguards of the *pangulu*.
5. *Manti* are assistants to the *pangulu* for administration of the village.
6. Rice.
7. A long fingernail extension made of silver.

8. A *nagari* is a collection of small hamlets or villages that makes up the basic administrative unit of the province of West Sumatra.
9. The irrigation ditch, the water lifeline of the rice paddies.
10. A feeding trough for horses.
11. Refers to the ornately embellished textile covers, *dalamak*, placed over the *carano*, which holds the elements of betel quid, including slaked lime.
12. Consensus. Refers to the chieftains' council hall deliberations, which must result in unanimous decisions.
13. A beautiful red cloth, named for its famous designer, Dewangga.
14. A patterned *siriah* cover, usually exquisitely embroidered with silk and metallic thread.
15. Refers to the elevated sections (*anjuang*) at the ends of the Koto Piliang style of house, where the highest-ranked *pangulu* in this hierarchical system sits during ceremonies. The implication is that the bridegroom is such a fine man that he is worthy of becoming not just a *pangulu*, but a chief *pangulu*.
16. Gold ornament resembling a seahorse. The symbol is thought to have been adopted from China.
17. Minangkabau spelling of Garuda, mythical bird and mount of Vishnu.

morals and politeness, living traditionally in the village, staying traditionally in the *nagari*,[8] following traditional ways with in-laws, to be taught courtesy, a traditional-marriage person, as said by *Melayu hadis*:

> A variety of plants grow in the ditch[9]
> Bearing fruits with the leaf fallen off.
> A young lady perfectly educated
> Like paddy rice fully filled out.

Then the plans came, the request appeared, from the mother and father, uncles and village elders, complete with design and balance, in order to consider asking for marriage, to find a partner to be a fiancé.

Trying to make an agreement, after consideration to be returned, to choose among the choices, to be negotiated and compared, like an aphorism of our elders:

> Seeing bran in the *paruku*[10]
> No need to keep them together.
> Seeing daughter and son-in-law,
> Like lime and its cover.[11]

Discussed thoroughly to reach agreement:

> Lime in the midst of the council hall
> Grow varieties of grass.
> Varieties of expectation
> To have only one aim.[12]

Having found what was sought, the interested one now appears; having been examined, both were ready; after being measured, both were of the same weight. The brave man in the battlefield, the strong man in the village, coming from a noble family, it is time for Allah to make it happen. The joints and knuckles matched, the same length bamboos become ladders, so appointment was made, looking for good days and finding suitable times. The date to be conveyed.

Then the people of the village to be gathered, the in-laws to be collected, those living far to be brought nearby, those scattered to be congregated, those separated to be brought together.

Heavy work is thought to be light; no water, the bamboo be cut, no firewood, the stairs be chipped, because the vows are very big, because the wish is very strong. Then the big house was decorated, curtains were hung on the ceiling, Indian seat cushions were brought out, paper lanterns and oil lights were flamed on, the *dewangga*[13] curtain was required, complete with a big pillow, ornamented with golden thread, it looks very beautiful, where the bridegroom sits with crossed legs.

So, the *siriah* leaf and areca nut were delivered to all close friends, all people in the village, across the region as well.

The bridegroom is now picked up, a big *carano* is now carried, covered with beautiful *dalamak*.[14] The bridegroom parades with many people.

> Golden garments now glitter,
> The village will receive a great gift,
> A man is bringing his glory,
> Fitting to sit at the top of the *anjuang*.[15]

Being bestowed with yellow rice, being welcomed by the host, being carried on the back, honorable man in the village, being wealthy and rich, to the crown of the house, who receives grandeur and honor, who covers disgrace with politeness, as said by *Melayu hadis*:

> He is not for washing and pushing along
> Just for wall and for wickerwork.
> Although he is our in-law
> He is like the elders and our uncle.

Then the bride was beautifully adorned, complete with lovely clothes, wearing a glorious shoulder cloth patterned with motifs of bamboo shoots, made in Agam Balai Gurah. Wearing a silky long tunic, wearing a fluttering headdress, wearing a *saruang* made of silk patola cloth, knotted in scroll-like form.

Bracelets are wound around her wrists, earrings dangle from her ears, she is ornamented with beads hung with the *gajah menong*.[16] Flowers in the knot of her hair flutter like honeybees, attracting *garudo*[17] in the skies. Displays of gold jewelry from *singingih* mines, made by young gold craftsman, brightly shine in the house, a performance by mother and father.

The vow is announced, as said by *Melayu hadis*:

> The groom with his virgin bride,
> Like a tray with its cover,
> Being far from risk, being spared from danger,
> The glow becomes brighter and brighter.

> The groom with his virgin bride,
> *Siriah* box and pouch kept together,
> Being far from bad luck, spared from danger,
> A sound like the voice of the turtledove.

> The groom with his virgin bride,
> Like the handle and the chain of a *siriah* purse,
> Being far from bad luck, spared from danger,
> Much gold, a garden of children.
>
> The virgin bride with her groom,
> Like lime and its container,
> A twist of yarn not separated,
> The fertile garden grows forever.

Words will break if made too long; brief words will be kept.

> Those from Padang brought gold thread to the weaving trade,
> To be wound on a shuttle and woven,
> To be woven to be in thirds,
> Just to make a speech long,
> Everything I can say has been said,
> Anything left to say is for everyone to say.
>
> Japanese gun from Bengkulu
> For shooting pelicans at the border
> Forgiveness is asked from *pangulu*
> *Pidato adat* asks for an answer.

A Traditional Oration Delivered by a Designated Guest at a Wedding Party

> At first the net must be spread,
> In order to capture *kelari*,[18]
> Before the oration is delivered,
> Palms must be together asking for forgiveness.

I beg pardon and ask for forgiveness from those four honorable leaders of the village: *pangulu*, *malin*, *manti*, and *dubalang*. I beg the pardon of all the intellectuals, the wise men, the meal servers, the respectable ladies of the house, the wealthy men from whom the poor hope for charity, who overcome the crises of the village, and to all of the guests. In addition to that, I wish to pay my respects to the host, the givers of the party, those who carry this party forward.

> To *jirak*[19] a butterfly has flown,
> Flying to the roof to cover its trace,
> Fluttering down onto the ground.
> The small-minded will not be announced,
> Bigwigs will not be addressed.
> Honor is due to everyone.

While climbing the stairs of the adat house and knocking, see the high doors are pitch black, the door frames carved by beetles, spangled with pieces of silver, ornamented with golden flowers,[20] the bell of the door key tinkling.

> In the marsh thorny pandanus,
> On the dam the *silayu*[21] have grown,
> Being pulled out together with roots.
> Tradition endures for the rich,
> Those invited are already drawing near,
> Those to be picked up have already been brought.

Then, into the center of the house, every eye will be gratified, observing the glorious decorations.

> What is not found in the forest?
> Probably *katari*[22] and rattan.
> What is not for the rich?
> Probably the moon and the sun.

Draperies have been hung from the ceiling, elaborately dyed carpets have been spread out, unrolled in the center of the room, the pillars are covered with yellow cloth, with a large red and golden cloth whose upper and lower ends are ornamented. The value is inestimable.

A short mat has also been rolled out, made of pandanus fiber plaited by young ladies, which is very fine and delicate, which has never before been used, a place to sit with crossed legs.

Then is brought in a fine *carano* made with a perforated bowl, inlaid, and with pendants, covered with a *dalamak*, containing the complete betel quid, to welcome the bridegroom, as *Melayu hadis* says:

> Separate shrimps from fish,
> Going to the beach
> To catch dolphin and mackerel.
> The *siriah* vines smile, the areca nuts shimmer
> Welcoming the bridegroom and all the guests.
> That is the height of courtesy.

Looking to the other side of the room, some pillows lie side by side, shining and glittering, embroidered with gold thread. The Indian seat cushion has been brought out, its ends ornamented with golden thread, where the bridegroom sits cross-legged, accompanied by his advisers, wearing the required clothing, as said by *Melayu hadis*:

> Wearing a silken-fringed waist tie,
> Wearing a belt wrapped around,
> A good man with noble character,
> Where to hope outwardly and inwardly.

18. A fish.
19. A tea bush of the genus *Eurya*.
20. Refers to short, fringed textiles hung at the top of a doorframe to make a room look festive.
21. Indonesian plants.
22. A type of plant.

23. It is customary for Minangkabau men to position the kris they wear tucked in their belts in such a way that it must be repositioned before it can be drawn for use. This adverse placement is deliberate; it gives the owner time to consider whether he really wants to draw the weapon.
24. This refers to the ceremonial kris, which is richly ornamented with filigreed silver but has a piece of wood instead of a knife blade fastened to the hilt.
25. A medicinal plant.
26. A tree whose bark is used as medicine.
27. Plumbago plant.
28. A tree with a yellow blossom.
29. In these *pantun* the speaker explains that he was asked by the host to welcome the guests. The speaker modestly introduces himself as one young and inexperienced in performing this task. He asks the leader of the guests to introduce him and mention his name and his adat title.

> Wearing a belt wrapped around
> A small knife adversely tucked.[23]
> Where to hope outwardly and inwardly.
> The inner chamber is tightly locked.
>
> The small knife is adversely tucked
> As used by our young men.
> The inner chamber is tightly locked
> As the custom of our in-laws.
>
> Young men's clothing,
> A hilt without its knife,[24]
> Embellished with twisted and overlaid silver,
> As the custom of our in-laws.
> Carrying candles with shellac,
> Carrying costus with kalanchoe.

How cheerful the hosts are, what was hoped has come true, fulfilling their vows to achieve the ideal. How splendid the village is.

Continuing the view to another side, pillows are stacked in orderly fashion in the *palaminan*, the oil light is flaming, yellow gold is shining, shining like fireflies. The bride and bridegroom sit side by side, like the moon and the sun. Their rings are shining, making house lizards fall crazily. How pleasant the feeling is, finding suitable marriage partners. Encircled by bridesmaids, filled with politeness and courtesy, the honorable and respectable gentleman born from a noble offspring, who manages in profitable ways, who has great wisdom, a pool of intelligence, and an ocean of morals. Being cognizant of teasing allusion, being cognizant of final words, knowing how to turn back words. Being able to get along on nothingness, being able to move in narrowness. A bit of oil in the frying pan for cooking a buffalo rump. Its taste remains delicious, as said by *Melayu hadis*:

> Wild betel grows at the edges of the forest,
> Tie the vines up tightly in a bunch.
> They are to dry on the side of the estuary.
> The strong road that he made,
> Everything's perfect with no defect
> They are all entirely wonderful.

Regarding the leader and director, extremely wise and knowledgeable, light-footed and dexterous. He sees the long view and points out the short view. Capable of both designing and distributing, there is no one to compare with him.

> In the channel *pugaran*[25] was planted,
> Its shoots will never change.
> Being closely linked, father and bride,
> His smile will never change.

Nothing is improper, askew, or oblique; no violation of the adat; everything is in the right place. The guests sit cheerfully, with joyful hearts, as said by *Melayu hadis*:

> The *siriah* leaf to be torn,
> He grates the poisonous areca nut.
> Its essence rises to the face.
> The bride and bridegroom
> Are like a design painted on a plate.
> The image never fades; it lasts forever.

The word breaks if it is too long; the short word will be kept, kept with great respect.

> The hornbill has been trapped
> To be shot, its feathers fall off
> As it falls and dies on the beach.
> All I know has been reported.
> What I feel has been said.
> What remains is for the clever to add.

A Traditional Oration Delivered at a Celebration of the Inauguration of a *Pangulu*

> Pounded bamboo and *malapari*[26]
> The *sitako*'s[27] shoot and the betel's roots.
> Even though I am standing here,
> It doesn't mean I am a clever man.
>
> The *sitako*'s shoot and betel's roots,
> The *limpato*'s[28] stem to be broken,
> It doesn't mean I am clever.
> The words' origins are forgotten.

In addition to that, I am still very young, as expressed by the following *pantun*:

> The nutmeg sap has ripened,
> Falling down into the garden,
> Pick up and divide in two.
> I am very young and inexperienced,
> Very active and diligent,
> Always asked to do any job.
>
> Pick up the falling nutmeg, divide in two.
> A piece falls into the garden.
> Always asked to do any job,
> Always agree without comment to follow any instructions.[29]

I wish your forgiveness, my *pangulu* sitting

at the corner, and those sitting at the center, meaning that all *pangulu* inherited their grandeur from Katumangguangan and Parpatiah nan Sabatang,[30] the center of the fish net, where the fishes are concentrated, the stem of words, and the central power of the village. I wish your forgiveness, all *dubalang*, being brave and heroic men, being great and honorable, cannot be challenged by anyone, as the backbone of the country, the ditch and hedges of the village. Forgive me, all of the respectable *manti* and officers, the wise and knowledgeable men, able to enlighten and clarify. My respectful greetings to *malin* and *ulama*, the torch of the village, the big well in the town, whose water is made pure with mossy sands. And also to the youth of the village, having clear faces and sweet hearts.

> Climbing a mountain that's cloudy
> To the forest, the source of teak,
> The big trees being fruitful,
> Mixed with *kamat* trees.
> I tell and report it nervously
> Many powerful *pangulu*
> Many big men magically forceful
> Many *malin* sacred and holy[31]

> *Kasumbo*[32] in cubic measure
> Pried up with nails,
> Prying up the *kasumbo* while running.[33]
> Even though the faces of the guests can be seen
> I do not know their names and adat titles,
> So I kneel and beg your forgiveness.[34]

Allow me all of the guests, to tell and to report, to describe and to elucidate. As sugarcane is being stamped out, rice is dried on a wide mat, a big buffalo is shown in the field, those scattered will be collected, those spilled out will be picked up, the light ones have been carried in, the heavy ones have been shouldered. Having consulted with village people, so the hill is pierced, the field is plowed, because the elder aphorism has said:

> The adat house has a high stair,
> The veranda is for the chair,[35]
> The betel tree can grow wild or can be supported by a pole,
> The chicken's family exists because of the hen.[36]

The vows and wishes now appear, on the side of the rainy and treed field, becoming illusion during the day, becoming dreams during the night. The soaked stem will rise up, the folded clothes will be worn, wishing to promote the great *pangulu*, to be sovereign in the village, to whom the nephew and niece pay respect, who holds the scales of justice, who supplies what is lacking, where to ask permission when leaving, where to report when coming back, who takes hold of the leadership from the previous village elder. So the *siriah* leaf and areca nut are delivered, to call the great *pangulu*, high *imam khatib*, grand *ulama*, the officers and *dubalang*. All people of the village, receiving great praise together, receiving high praise together, in order to cheer this celebration, as said by *Melayu hadis*:

> As the irrigation ditch is being made
> To make water able to flow,
> The great chieftain is to be raised
> To be the umbrella over the world.

> To make water able to flow
> To irrigate the rice field on the hills,
> As an umbrella over the world,
> Where to find shelter from rain and sun.

The ceremonial garments are now worn, wearing the black shirt, wearing the Aceh-woven *saruang*, wearing Batipuah-designed trousers as well as an heirloom kris.

> *Pugaran*[37] grows on the fern,
> Growing behind the *limpato*[38] trees,
> Requirement is for the *pangulu*'s garments
> To be loose, to be like heirloom garments.

Meaning that he is a big tree in the field, its roots stuck in the earth, the top leaves reach to the skies. The roots are a place to sit, the trunk is a place to lean, the branches are a place to hang, a place for shelter when it is raining, a place to hide when it is sunny.

> Coconut shell is put on the drying rack,
> Beef is grilling in the earthen cooking pot,
> Heavy rain followed by the storm,
> He does not want to be silent, he is always active.[39]

Consistently stands for right, tightly holds to the straight, tends to command for goodness, tends to prohibit evil, keeps the line on the line, using what's suitable and proper, who weighs with the same weight, who measures with the same length, as said by *Melayu hadis*:

> The coconut tree stands tall,
> Having two branches with fruit,
> The law is just, tradition holds,
> It is the beginning of consensus.

30. See chapter 16 for a discussion of the role of these two *datuak* in Minangkabau history.
31. This *pantun* has the same meaning as the one that follows immediately.
32. *Kasumbo* is identified only as a plant that produces red dye. It is probably *Morinda citrifolia* (*kombu* in Indonesian). Its root bark is used throughout Indonesia to provide a deep red dye. The surrounding soil must be dug out from the roots to make the bark accessible. To prevent the tree from dying, only a small portion of the bark is harvested at any one time. It may take years to gather enough bark to dye a textile.
33. These lines have no relevant meaning, but serve as an introduction to the last three lines.
34. The posture is that of sitting with the legs folded back and to one side with the hands held, palms together, in front of the face.
35. This may refer to the *anjuang*, or elevated platform end of the Koto Piliang house, where the *pangulu* who is head of the hierarchy sits during ceremonies.
36. In this *pantun* the betel supported by a pole and the chicken with her egg are metaphors for the family or tribe or for adat communities. The adat society exists and is secure under a leader elected by its members. Here the pole and the hen are metaphors for the clan leader.
37. A plant used as medicine.
38. A tree with yellow blossoms.
39. The meaning of this *pantun* is that the adat leader should be brave enough to take action in any situation (i.e., despite heavy rain or storms). He must help and protect his people. He must be fair, honest, and wise in making decisions.

40. The meaning of these two *pantun* is that if a tribe, village, or society has a strong leader, it will be content, prosperous, and famous.
41. This is a proverb that means that all occasions are good for making oneself useful.
42. The meaning of the *pantun* is that the adat title exists always. When a clan leader dies, he will be replaced by a younger man. This tradition is perpetual.

If Allah gives luck, then prestige starts to grow, then light starts to shine.

> Off to the valley to shoot,
> Finding young pelicans.
> It brings happiness and joy.
> The village now becomes famous.

> Having the young pelicans
> Is a game to play all day long.
> The village is famous,
> The earth is pleased, the rice paddy is growing.[40]

In addition to that, on the site of the rainy and wooded field, having intention in the heart, seriously request to Allah.

> Rice winnowing sites in the middle of the field,
> Rice to be cut and then fall.
> Consulting at the big tree
> To be protected from sunshine and rain

> Rice winnowing sites in the middle of the field,
> Rice to be cut and then fall.
> To live where the village is an area
> That undertakes sound activities.

Strongly holds the job, strongly keeps the law, to protect nephew and niece, able to lead the followers, combining the work and the job, finding the path and the work.

Standing to examine booty, sitting to tend the traps,[41] protecting the village and country, as said by *Melayu hadis*:

> The road turns to the forest
> Many places to sit in the forest.
> The field is attractive because of hedges,
> The plant is grown up because of fertilizer.

> Many places to sit in the forest,
> Having fruits without flowers.
> The livestock is fat because of food,
> The herdsman then becomes famous.

Words will break if lengthened; brief words will be kept.

> Twist one knot in a string
> Twist it again and again, fold it in three
> One vanishes, one grows
> The heirloom is always in its place

> Twist and fold it by three,
> Let it be rolled up.
> One vanishes, one grows,

Leadership of a clan is always regenerated.[42]

> The undergrowth is being burned out
> So rice paddies can be planted.
> Everything I can say has been spoken,
> Anything omitted is to be pardoned.

PERIBAHASA (MINANGKABAU PROVERBS AND SAYINGS)

Throughout this book the reader has encountered references to and citations of traditional Minangkabau sayings. As stated at the start of this chapter, they are "everyday clothes" for the Minangkabau. These sayings, sometimes called *kato adat* (literally, "adat words") or *papatah-patitih* (aphorisms), are best known as *peribahasa*. They are short statements, most often one-liners, that set forth rules of behavior, statements of the consequences of one's actions, and advice. To a non-Minangkabau these statements are difficult to understand because of the Minangkabau tendency to speak indirectly or metaphorically. Orality in Minangkabau society and the reasons for its persistence are discussed in some detail in chapter 1.

There follows a small sampling of the literally thousands of *peribahasa* that have been published. Each of the *peribahasa* included here is given first in Minangkabau. Then follows a nearly literal translation into English. Lastly, in brackets, there is an interpretation of the meaning. To almost all Minangkabau the meaning is obvious.

Angguak anggak geleang amuah, unjuak nan indak babarikan.
Nodding but does not want, shaking head but actually wants, offers but does not give.
[Describes hypocritical behavior.]

Tarapuang tak anyuik, tarandam tak basah.
Floating but not moved by current, soaked but not wet.
[A metaphor for something being considered for which the whole situation is still vague; it is not clear what is what, which is which.]

Aia tanang maanyuikan.
Still water sweeps (away).
[A person who does not say much very often has great ability.]

Samuik tapijak indak mati, alu tataruang patah tigo.
When an ant is stepped on, it does not die. When *alu* is stepped on, it breaks into three pieces.
[*Alu* is a piece of wood about 1.5 meters long and 7 centimeters in diameter used to husk rice or to pound it into flour. This proverb describes the wisdom of a person or leader whose decisions do not adversely affect the common people (ants) but do affect threatening opponents, no matter how strong, who could be crushed (broken into three pieces).]

Ingek-ingek nan di ateh, kok nan di bawah nan ka manimpo.
Be mindful, those of you who are up above. Who knows, those who are below might come down on you.
[Leaders, "those who are up above," are cautioned to be mindful of the common people, "those who are below," who might bring them trouble or bring about their downfall.]

Indak buruak nan tak elok.
No bad that cannot be good.
[No conflict for which there is no mutually acceptable solution.]

Nandapek labiah bak kailangan.
Gaining is worse than losing.
[Refers to gaining something that brings more difficulties (e.g., being given a position of greater responsibility in which any advantages gained are outweighed by the additional responsibility).]

Duduak surang basampik-sampik, duduak basamo balapang-lapang.
Sitting alone is crowded; sitting together is spacious.
[When there is nobody to talk with, one feels hemmed in or crowded by one's unexpressed thoughts. When one is with friends, however, one feels the release or freedom that comes with getting something "off one's chest" or with exchanging views.]

Dibilang ganok, dipapakan ganjin.
When you count, it appears even; when you put it on the table, it turns out odd.
[This expression is used to describe situations where one may think one has gained but where one has in reality suffered a loss.]

Sairiang batuka jalan, saiyo batuka sabuik, sarantak balain dagam.
Same direction but different route; same opinion but different expression; same rhythm but different beat.
[Refers to actions or policies that may appear the same but that differ in practice.]

Kutiko ado jan dimakan, lah tido baru dimakan.
When you have it, do not eat it; when you no longer have it, then you eat it.
[You should dig into your savings only when other options are not available. Do not dig into your savings unless you really have to.]

Sarik kaji di urang malin, sarik pitih di urang kayo.
Difficult proof religious teacher, difficult money rich man.
[A person knowledgeable in religious matters does not easily dispense with religious rulings, just as a rich person does not easily part with his money.]

Bapauik tak batali, bapanggang tak barapi.
Tied without a rope, grilled without fire.
[Describes a situation in which a husband simply walks out on a wife, neither divorcing her nor giving her any sustenance.]

Tarandam tak basah, tarampai indak nyo kariang.
Soaked in water, not getting wet; hung for drying, not getting dry.
[Refers to a person who is very sly, not easily defeated or cheated, or to a situation whose status is not yet clear.]

Sampik lalu, lungga batokok.
When the passage is narrow, it passes through; when the passage is wide, it gets stuck.
[Refers to the ironic situation in which some people enjoy good living while their resources are scarce, while others live miserably, as if in poverty, while their resources are abundant.]

Sumpik panuah indak barisi.
The full sack has nothing in it.
[We think that the sack is full of good rice, but in actuality it contains only empty rice husks. Refers to a person who seems well-to-do on first impression but is actually poor or to a person who appears to be knowledgeable but in reality is not.]

Tampak kaki ula.
Appearing to be a snake's foot.
[We saw a snake that appeared to have no feet, but we found out that it really did have feet. This expression describes the realization that someone whom we thought was good actually has hidden vices, vices we did not know about and only now realize.]

Manariak bapanjang tangan, mambaia basingkek tangan.
When collecting, the arm is long; when paying, the arm is short.
[Describes a person who borrows easily but has difficulty paying back.]

Bak cando alu bapucuak.
Like a rice-pounding pole that is growing shoots.
[Refers to a situation in which a person ties some leaves at one end of a rice-pounding pole and cries, "Now the pounding pole has grown shoots!" This expression is a reminder to be careful of a person making outrageous claims.]

Sabaiak-baiak untuang taniayo, saburuak-buruak untuang maniayo.
The best of fate is to be inflicted with injustice by others; the worst of fate is to inflict gross injustice on others.
[It is better to be treated unjustly than to treat other people unjustly.]

Gantuangan disangko buaian.
Thinking that the gallows is a swing.
[Describes a situation in which someone enjoys himself thinking that he is doing something good but is actually destroying himself; for example, a person who is involved with drug abuse or uncontrolled sexual activities, activities that give immediate gratification but are harmful in the long run.]

Kok ka sawah pangkua balabiah, tibo mairiak piriang kurang.
Going to the rice paddy to prepare the field for sowing; separating the rice grain from the stalk.
[In the former group, there would be fewer volunteers than the number of hoes available; in the latter, there would be more people at the table but not enough food for all. This expression refers to a person who normally tries to avoid hard work but is the first to come when good food or benefits are available.]

Kato si gadang sagala io, kato si ketek sagalo bukan.
Words of a powerful person are right; words of a lesser person are not.
[Whatever a powerful person says must be followed, while what a lesser person says can be ignored. An English equivalent is "Might makes right."]

Arun samarabak baun malo.
Nice fragrance of decomposed corpses.
[Refers to the act of praising deeds that are carried out through contemptible means, such as contributions made from gains obtained through corrupt practices.]

Indak puji nan manganyang, indak upek nan mambunuah.
Praise will not fill our stomach; blame will not kill us.
[Praise and slander should not be taken at face value because neither is of much use.]

Puji nan mambunuah, upek nan maiduiki.
Praise kills; criticism gives life.
[A reminder that continually seeking praise will only get you into trouble. If you are criticized justly and act positively on that criticism, however, you will grow.]

Patah kapak batungkek paruah.
When the wing is broken, use the beak as a crutch.
[One need not despair just because a particular thing that one requires is missing. Be ready to make use of a close substitute. Be creative, innovative.]

Bialah kapalo bakubang, asa tanduak lai makan.
It does not matter if one's head is dipped into the mud as long as one's horn hits its target.
[Accept sacrifice as long as it will bring desired results.]

Kecek balauak-lauak, makan jo samba lado.
Talk is about fish and meat dishes, but when it comes to eating, there are only hot chilies.
[Describes a person who talks big but doesn't deliver.]

Kok indak takuik ka mati, indak nan salamak parang. Kok indak takuik ka kalah, indak nan salamak sabuang.
If not for fear of death, nothing would be more pleasurable than war; if not for fear of losing, nothing would be more pleasurable than watching and betting on a cockfight.
[A reminder that although some like to wage war or watch or bet on a cockfight, the consequences can be disastrous.]

Bana lai, picayo tidak.
It is right, but one should not easily believe completely.
[This is advice not to have full confidence even if what is said appears at first to be true. One should remain skeptical until fully convinced.]

Indak talok tanduak, talingo dipuleh.
When action against the bone has no effect, one should try to wring the ear.
[When we cannot take direct action against the strong, we can target their weak points, such as vulnerable family members.]

Mansiang baru ka bacari, tapi kampianyo alah salasai.
The grass is still being sought, but the bag has already been woven.
[Refers to a situation in which negotiations have yet to begin but decisions have already been made.]

Kok bakarajo anyo indak bapaluah, kok makan anyo bapaluah.
When working, he does not perspire; when eating, he perspires.
[Refers to a person who likes to eat but does not like to work.]

Jalan baduo andak ditangah.
When walking in twos, he wants to be in the middle.
[Describes a person who is egotistical and insists on what suits him only.]

Padi samo tumbuah jo siangan, adat samo tumbuah jo sangketo.
The rice grows together with the weeds; customs grow together with conflicts.
[A reminder that good things are often accompanied by problems.]

Kok puntuang indak basilang dolaw tungku, tantu api indak manyalo, nasi ditanak indak masak.
If the logs in the stove are not crisscrossed, the fire will not burn well and the rice will not be cooked.
[Differences of opinion are necessary to produce good solutions.]

Throughout this book the reader has encountered references to adat sayings and to the Minangkabau predilection for indirect communication. The chapter, by offering many examples of traditional oral expression in ceremonies and in daily conversation, provides insight into how extensively indirection enters into the life of the Minangkabau. Indirect oral communication, though clear and understandable to most Minangkabau living in West Sumatra, remains an enigma to Westerners and even to Minangkabau whose families have lived away from the homeland for a generation or two. But the *peribahasa* and other *kato adat* serve the important dual purpose of teaching youth about the time-tested Minangkabau culture and keeping the traditions of adat constantly at the forefront of Minangkabau consciousness.

The author hopes that this excursion into the oral culture will help the reader to better understand the role of Minangkabau ceremonial textiles, with their complex visual expression and proliferation of motifs that refer to *kato adat*—motifs that are as pervasive in textiles as traditional expressions are in oral communication.

16

Taufik Abdullah

TAMBO, KABA, AND HISTORY: TRADITION AND THE HISTORICAL CONSCIOUSNESS OF THE MINANGKABAU

Tambo

Tambo (from the Sanskrit, meaning "origins") is the traditional historiography of Minangkabau. There are three types of *tambo*. The first is usually known as the history of the Minangkabau World (*tambo alam Minangkabau*), which recounts the history of the Minangkabau; the second, called *tambo adat*, delineates the origins of many adat regulations. Quite often these two types are treated as parts of the *tambo alam Minangkabau*. The third or, if one prefers, the second, can perhaps be called a "local *tambo*." It describes the history of a certain locality or prominent family. The unmodified word *tambo*, however, generally refers to the *tambo* that describes the genesis of the Minangkabau World (Alam Minangkabau), the earliest process of the formation of Minangkabau adat communities, the origins of adat regulations, and the formulation of Minangkabau adat philosophy. It is in this sense that the word *tambo* is used in this essay.

There is no doubt that *tambo* was originally rendered orally. It was tradition handed down from generation to generation. Most likely, knowledge of *tambo* was required for any future adat chief, or *pangulu*, a matrilineally ascribed position. He was expected to memorize the "history" and the adat expressions and formulas. There is a very strong indication that the genesis of the known *tambo* can be traced back at least to the early sixteenth-century period of Islamization. Written versions of *tambo* became available only after the end of the Padri War (1821–1837)[1]—the war that, on the one hand, brought the Minangkabau region under Dutch control but, on the other, enlarged the scope of Islamic influence in the Minangkabau social fabric and strengthened the force of Islam in social consciousness.[2]

Tambo may also be seen as the locus of the first attempt to place the Minangkabau in the Islamic fold. It is therefore understandable why the *tambo* not only Islamized itself but also, in its turn, gave religious and historical sanctions to any adat regulations that might contradict Islamic doctrine (explaining why, for example, one's sister's children, instead of one's own children, inherit one's property). In addition, the *tambo* describes certain mythical events that can be read as supporting the sanctity of the matrilineal inheritance law. Unlike other traditional Indonesian historiographies, such as the Javanese *babad*, the Buginese-Makasarese *lontara*, or the Malay *hikayat* or *sejarah*, *tambo* does not describe the process of Islamization of Minangkabau. It does, as interpreted by quite a number of adat theoreticians,[3] provide many signs pointing to the institutionalization of monarchy, such as the crowning of Adityawarman, a Majapahit prince. But the Islamization of the Minangkabau is simply taken for granted. The Minangkabau World, as the *tambo* describes it, has been Islamized since its very inception. The written *tambo* only strengthens an already obvious Islamic aura.

There are a number of written versions of the *tambo*, but the core remains the same. Some versions begin with the Minangkabau cosmogony, which states that before anything else existed adat already existed—"that is adat which is truly adat." Others commence with the Islamic mystical cosmology of "the light of Muhammad" as being "the beginning of the beginning." But they all deal with questions of how the world was created and how the Minangkabau World emerged and expanded. With this cosmogony treated as an introduction, the *tambo* can then be divided into two major parts. The first is a "genealogical history," which describes a gradual emergence of the Alam Minangkabau. The second part deals with the formation of the Minangkabau cultural world.

The "genealogical history" begins with the

story of the three children of Iskandar Zulkarnain (Alexander the Great),[4] one of whom later became the founder of the Minangkabau World itself and the first king of Minangkabau. He was called Maharaja Diraja (king of kings), while his brothers became the kings of Turkey (Benua Ruhum) and of China. It was Maharaja Diraja who laid the foundation of a Minangkabau monarchy. But it was two legendary adat formulators, Datuak Katumangguangan and Datuak Parpatiah nan Sabatang, who, through their teachings, really made Minangkabau society what it was—a monarchy that consisted of relatively independent village regions (*nagari*), under the leadership of their respective councils of adat chiefs (*pangulu*). The two legendary adat formulators were half brothers. The father of Datuak Katumangguangan was Sultan Sri Maharaja Diraja, who was (depending on the version of *tambo*) either the youngest son of Iskandar Zulkarnain and the first king of Minangkabau or his direct descendant. The father of Datuak Parpatiah nan Sabatang was Cati Bilang Pandai, a commoner, a wise man (a "culture hero" of the Minangkabau), who was, again, either the person who accompanied the son of Iskandar Zulkarnain to Minangkabau, or that person's descendant. The mother of the two legendary adat formulators was Indo Jati, the widow of Sri Maharaja Diraja, who later married Cati Bilang Pandai. She was the mythological earth goddess of Minangkabau (Bundo Kanduang). Her brother—hence the maternal uncle, or *mamak*, of the adat formulators—was Datuak Suri Dirajo, a wise man. The two fathers, the mother, and the uncle of the two adat formulators symbolize the ideal family background of a Minangkabau, as stated by an adat saying: "The father is rich, the mother is revered, and the uncle is highly respected." These personages are symbols of harmony and continuity. While others may come and go, they remain entrenched in *tambo*.

Despite their differences, the two legendary adat formulators complement each other. So do the two nonroyal Minangkabau political traditions: the relatively more "democratic" tradition of Parpatiah nan Sabatang (Bodi Caniago) and the relatively more "aristocratic" tradition of Katumangguangan (Koto Piliang).[5] The highly valued "Minangkabauness" of a Minangkabau is very much determined by adherence to the adat teachings of the two adat formulators.

As *tambo* describes it, the formation of the Minangkabau World was completed when the areas of the three original regencies (*luhak nan tigo*)—Tanah Datar, Limo Puluah Koto, and Agam—had been settled and organized. These three areas are traditionally considered to be the heartland (*darek*) of the Minangkabau World. But the Minangkabau continued their exploration, and new areas were added. New areas were called the *rantau*, meaning "abroad" or "foreign country." Although the village regions (*nagari*) in the three original *luhak* were ruled by the council of their respective *pangulu*, or adat chiefs, the *rantau* territories were under the jurisdiction of the king: "*Luhak* has its *pangulu*; *rantau* has its raja." The Minangkabau World can be seen as a convergence of a static *luhak* and the ever-expanding *rantau*. It is also a world that embraced the political traditions of *pangulu*-ship and of kingship. This seeming dichotomy was bridged by the coexistence of the Bodi Caniago and Koto Piliang political traditions. The former considers all *pangulu* as equals; the latter recognizes a hierarchy of *pangulu*.

The Minangkabau World, as *tambo* suggests, is a world based on recognition that "adat is based on *syarak* (religious law), and *syarak* is based on the *Kitabullah* (Quran)." It is a world where "*syarak* regulates, adat applies"; that is, religious law tells what to do; adat tells how to do it. The permanent essence of Minangkabau adat, as a very famous adat proverb puts it, is the adat that "neither cracks in the sun nor rots in the rain." Everything else may and indeed can change; as another proverb says, "Once a flood comes, the bathing place moves." Essential adat, however, remains the same.[6]

History as told by *tambo* is necessarily a reconstruction of past events. *Tambo* history reflects cultural assumptions about what past events should have been. It may not recount historical truth, but it reveals historical fairness. Some versions of *tambo*, for example, describe a sea battle off the coast of Pariaman between the Dutch armada and the Minangkabau fleet under the leadership of the two legendary adat formulators. The battle supposedly began because the Dutch insulted the Muslims and the Islamic religion. They had to pay for this insult. According to *tambo*, they were defeated by the Minangkabau and converted to Islam. *Tambo* can indeed transform what was military defeat in empirical reality into victory in cultural imagination. This interpretation of events (i.e., finding a way to interpret defeat as victory) is crucial to an understanding of postindependence Minangkabau history as discussed later in this chapter.

Because *tambo* is the historicization of Minangkabau structural arrangements and the

mythologization of its cultural foundation, it is also a book of ethics that postulates a foundation for a Minangkabau system of action. An action can be undertaken only if it fulfills two criteria: it should be ethically proper, or *patuik*, and logically possible, or *mungkin*.[7] Or, to put it in a social perspective, an action should be dependent not only on one's own wish; it should also be agreeable to the community.

Kaba

Tambo mythologizes the Minangkabau cultural sense of propriety and historicizes Minangkabau structural arrangements. *Kaba* (story), however, relies on an imaginatively constructed narrative to present the social and personal consequences of either ignoring or observing ethical teachings and the norms embodied in the adat system of action.[8] The storyteller (*tukang kaba*)—accompanying himself on a *rabab*,[9] a two-string violinlike musical instrument—recites in poetic rhyme or lyrical prose, and his performance typically lasts all night. Through his choice of *kaba*, he may emphasize either rewards or punishments. So many *kaba* exist that it is simply impossible to count them, and even today new *kaba* are being created.

Whether a *kaba* is a love story, a farce, or a melodrama, the main concern is teaching the maintenance of social harmony. For example, the classic and semi-legendary *kaba* known as the *Kaba Tjindua Mato* is not only a Minangkabau state myth and an important source of traditional wisdom, it also presents the consequences of a failure to heed ethical teachings.[10] Another renowned ethical story is the *Kaba si Malin Kanduang*, known primarily for its depiction of a rebellious son whose mother sacrificed greatly to raise him. The son leaves his mother behind and goes to the *rantau* to seek his fortune. When he returns home a rich merchant and finds that his mother is only a poor old woman, he deliberately rejects her. As a result, he is condemned and transformed into stone.

Kaba also quite often address issues of change—not only the all-too-familiar problems that occur during rapid social change but also change emanating from within. A famous poetic *kaba* embodying this theme—arguably one of the most beautifully written of all *kaba*—is the *Kaba Rantjak diLabueh*.[11] Composed by an influential adat theoretician, Datuak Paduko Alam, this *kaba* tells the story of a mother preparing her children for life as Minangkabau. In a short passage excerpted from a translation by Anthony Johns (see p. 337), she gives her son advice about how to interact with others. In so doing, she communicates that no change is so priceless that one should abandon "propriety and appropriateness."

In some *kaba*, constructed dilemmas occur. A case in point is the *Mustiko adat alam Minangkabau*, which is actually an adat book written in *kaba* form. It is a fictionalized account of the problems of maintaining adat in changing times written by a prominent pre–World War II adat theoretician, Datuak Sangguno Diradjo. This story begins with a meeting of the adat leaders at the adat hall (*balai*). In accordance with the changing situation they have met to discuss, they decide to alter the adat regulations. Although an old adat leader who has not attended the meeting thinks that the decision is unwise, the changes are made in accordance with adat procedure after all participants in the meeting have given their agreement. The story then goes on to illustrate why the assessment of the absent adat leader is correct. After his death, he is replaced by his nephew, who is also determined to maintain the inherited adat. The story ends with the death of the new adat leader, who has no nephew to replace him. The story poses the question of whether the future of adat should simply be entrusted to members of the younger generation, who may have scant knowledge of its inherent greatness.[12]

Both *tambo* and *kaba* begin with the tacit assumption that change is unavoidable. The question is how to master change so that it does not undermine the sanctity of the Minangkabau world. Both genres are also very much concerned with the relationship of the permanency of the *luhak nan tigo*—the heartland of the Alam Minangkabau—to the ever-expanding *rantau*. The "inner" *rantau* may still be part of the Minangkabau world, but the "outer" *rantau* is a strange world that has to be domesticated culturally. Many *kaba* glorify the success of the Minangkabau migrant or sojourner (*parantau*) in domesticating the *rantau* and making it like his home village, albeit temporarily. The glorification becomes complete the moment the *parantau* comes home wealthy and wise and revives the grandeur of his family and his *nagari*. This concept of space (*luhak* and *rantau*) also reflects the traditional Minangkabau understanding of history: it moves, progresses, makes curves, yet never deviates from its origin. A proper history moves as if tracing an ever-widening gyre.

A Selection from *Kaba Rantjak diLabueh*

tjaliek nan usah dipatinggi,
pandanglah urang lalu lintéh;
nan patuik anak salam maaf,
nan patuik bujueng tague sapo.
Kok duduek djo nan tuo,
banjaklah rundieng djo paparan,
banjak pitua nan kalua,
papatah banjak diuraikan
salah sabuah kok tapakai;
bauntueng gadang anak disanan:
dapék pitua sadang duduek,
indak mandjalang rumah guru
—bilalang dapék dék manuai
ikan dapék dék basieng.
O, 'nak dénai Rantjak diLabueh,
kok tumbueh anak barakanan,
bakabie samo gadang,
djanlah tjando mantjandokan:
arék-arék mamagang satia,
tagueh mamagang djandji,
buatan usah diubahi.
Kok malu samo satuntuik
maro nan samo ditulakkan
—bak itu urang samo gadang.
Usah basombong djo baduto,
sakali budi kadapatan
saumue iduik urang tak patjajo,
takuikkan budi katadjua,
rusueh kan paham Katagadai.
Dangakan bana, O, 'nak kandueng,
nan mudo élok dikasihi:
kok batama djo nan mudo,
pabanjak garah djo kutjikak
sambiekan djuo dalam ati
dalam sapulueh ado duo
nasihaik untuek dipakainjo,
paréso nasihaik dipakaikan.
Paliékkan muko nan manih,
paturuikkan nan diatinjo
bagai maélo tali djalo:
raso katagang dikanduekan
agak kandue ditagangi,
nak diam injo sadang élok,
bak itu urang babitjaro:
'Mangabék padi djo daunnjo,
mangabék manusie djo akanjo.'
Bak itu kasieh nan mudo,
injo diélo djo banang,
bukan diégang djo dandan.
O, 'nak dénai, Rantjak diLabueh,
kalau tapakai nan bak itu,
baban nan barék djadi ringan,
barang nan djaueh djadi ampieng:
diimbau, injo lakéh datang,
disurueh injo lakéh pai.

don't just look high in the air,
Take notice of passersby:
where it is fitting, greet them
and where fitting, address them.
When you sit with older people
much will be said and much explained;
much good advice will come out,
many of the proverbs will be expounded.
—something at least for you to follow.
You will gain a lot there:
good advice while just sitting
and no need to visit a teacher!
—amid harvesting catching crickets,
while rinsing *padi* catching fish.
O, my boy, Rantjak diLabueh,
when with people of your own age
in close company with them,
never take part in gossip.
Be true to your word,
don't break an agreement,
don't alter the traditional pattern.
If one is slighted, feel slighted too,
if in danger, share in averting it
—that's how to behave with your companions.
Do not act proudly, or lie,
for once people see you cannot be relied on
as long as you live, no one will trust you
fearing your sense of goodness can be sold
or your understanding pawned.
Listen carefully, O my dear son:
the young you should love.
And if you meet anyone young
have plenty of jokes to amuse him,
at the same time taking care
that of ten jokes there shall be two
that have advice worth following,
and these will be noticed and followed.
Mind you look friendly,
and follow them in their whims
just as a casting-net cord should be handled:
if taut, let it go slack a little
then draw it in again
so that their feelings are not hurt.
For, just as people say:
bind up *padi* with its blade,
bind up mankind through their wits.
This is how you should love the young,
leading them gently on a thread,
not dragging them by a rope.
O, my boy, Rantjak diLabueh,
if you put this into practice
the heavy burden will be lightened
and the distant brought near.
People when called, will come quickly,
or if asked, will go at once.

[Johns 1958, 35–36]

The Minangkabau Role in the Struggle for Independence

From the early 1920s until the early 1930s the Minangkabau region was one of the centers of a radical nationalist movement. A temporary lull in this activity occurred in 1927 following an ill-fated "communist" rebellion, but at the end of the decade the region had once again become a hotbed of nationalist agitation. By that time, however, the controversy over "Minangkabau nationalism" versus "Greater Indonesia (Indonesia Raya) nationalism"[13]—a controversy that had deeply influenced Minangkabau intellectual life in the late 1910s and early 1920s—had been transformed. The controversy was now centered on whether Indonesia Raya nationalism should be based on Islam, on loyalty to the nation, or on a combination of the two.[14] The Struggle between "Islamic nationalism" and "secular" nationalism and attempts to combine the two orientations are major themes within the history of the Indonesian struggle for independence. A number of Minangkabau intellectuals and nationalist leaders have figured prominently in the attempts to resolve these issues, which in a slightly different form, persist even today.

Much less openly debated during the early decades of the twentieth century, however, were questions of cultural understanding raised in response to the newly formulated concept of a transethnic community, the "nation" of Indonesia. Although the idea of Indonesian nationalism was securely established, the notion of social harmony and the traditional values of "propriety and appropriateness" expounded by *kaba* were being seriously challenged by novels of protest written in Indonesian, primarily by Minangkabau school teachers and intellectuals among the *parantau*.[15] By asserting the right to form relationships based on romantic love instead of arranged marriage, these novels demanded not only freedom for youth to choose their own destinies but also freedom to promote transethnic relationships and to repudiate traditional social status.

As early as 1918 Minangkabau and other Sumatran students who were pursuing their studies in Batavia (present-day Jakarta) established an association of Sumatran youths, the Jong Sumatranen Bond. These Western-educated youths began to entertain the need to establish a new community that they could share with other ethnic groups. Claiming to be the "builders of a new nation," they, along with other youth organizations and incipient nationalist political parties, began to "imagine"[16] a new community, without, as it were, undermining the old one. The climax of this search was reached in October 1928 at the Second Youth Congress, when several youth organizations disbanded and reunited to form an all-Indonesia youth organization. At that time they also took the now-famous Youth Oath, pledging to belong to one nation and to recognize one national language. With this oath, symbolically, a new nation was born. Indonesia became a new social, political, and cultural sphere in which all citizens would retain both their ethnic affinities and their national sense of unity.

The rapid spread of Indonesian nationalism in the still largely agrarian Minangkabau region can hardly be explained solely on the basis of this understanding of Indonesian nationalism. Leaving aside colonial domination and its impact on the society and the long tradition of opposition to colonial rule, the strong attraction of Indonesia Raya nationalism should also be seen in light of the Minangkabau (*tambo*) view of history: an ever-enlarging *rantau* and an ever-increasing perimeter of the historical spiral. This perspective underlay the participation of some rural *pangulu* in the propagation of nationalism. The custodians of Minangkabau adat and other literati were able to conceive the notion of Indonesia as an enlargement of their "inner" *rantau*—different possibly, yet capable of being domesticated culturally.

The end of World War II in August 1945 set the stage for a declaration of independence and the five-year war to drive the Dutch from Indonesia. In 1978 a number of prominent Minangkabau veterans published a book intended to provide a Minangkabau perspective on the war of independence: *Sejarah Perjuangan Kemerdekaan R.I. di Minangkaba / Riau, 1945–1950* (A history of the struggle for the independence of the Republic of Indonesia in Minangkabau and Riau, 1945–1950). In 1992 the second volume of the second edition of this massive work appeared.[17]

The last chapter of the book, which is admittedly highly subjective in its stance, emphasizes that the revolution was the culmination of the lengthy struggle for Indonesian independence in the Minangkabau area. It records the succession of local religious, adat, and "Western-educated" leaders who were instrumental in nurturing the idea of nationalism. It is obvious that the authors are proud of the history of the struggle for Indonesian independence and of the nationalist movement that arose in Minangkabau. Recorded history easily confirms the basis of

their pride.[18] As the authors characterize it, the modern history of Minangkabau can be seen as an unending struggle toward independence, be it through modern and religious education or through the formation of a nation.

The authors emphasize the important historical role played by the Minangkabau during the war of independence with the Dutch. The Minangkabau region, for example, served as the constitutionally established center of the Emergency Government of the Republic of Indonesia after the fall of Yogyakarta in December 1948. They point with pride to the contributions of many Minangkabau to the struggle for Indonesian independence and to the relatively high profiles of a number of Minangkabau *parantau* intellectuals in the new national leadership.[19] The book gives the region a special place in the history of the creation of the multiethnic national state of Indonesia.

Minangkabau Adat and the Republic of Indonesia

Even as the Minangkabau people played an important role in the struggle for independence, so has Minangkabau philosophy—especially through the precepts of adat—influenced the concepts of the Republic as formulated after the 1945 Proclamation of Independence.

The *tambo* view of history reached its clearest manifestation in the national revolution. The formation of a transethnic nation-state was, in the traditional Minangkabau view of history, a new manifestation of an ever-expanding *rantau*, which could be, conceptually speaking, domesticated. The Proclamation of Independence and the establishment of the republican apparatus and all things that characterize a modern state might, to the Minangkabau, have been logical consequences of the desire to establish a new community that would be neither ethnically specific nor colonial, but civic and independent. But the Minangkabau attachment to the ideals of this community was very much dependent on their traditional adat concepts of propriety and appropriateness and a system of action based on the right balance between these concepts and what is possible (*mungkin*)—all of this being finally based on truth (*nan bana*) handed down by Allah. Radjo Penghulu (1970) in one of the first books on adat published after the 1965 downfall of Sukarno, the first president of the republic, shows the close affinity between the philosophy of Minangkabau adat and the state ideology known as *pancasila* (five principles), a concept that encompasses a key tenet of Minangkabau adat—governing and decision-making by consensus.

A serious reevaluation of the *tambo* concept of history was initiated in 1960 when the national army crushed a Minangkabau armed rebellion against the central government in Jakarta. The Minangkabau region was practically occupied by an army dispatched by the central government. Yet, despite defeat, the attendant humiliation, and the ongoing reevaluation, Minangkabau belief in the principles of adat persisted, in part because of the continued acceptance of *pancasila* as part of the ideological framework of the new government and in part because of the *tambo* teaching of the importance of *rantau*. Jakarta, it had been argued, might be the national center that controlled and distributed the limited sources of power, but to the Minangkabau it was also *rantau*, which could be domesticated. As it turned out, the *rantau* that the Minangkabau thought they could control culturally was simply too strong to be domesticated politically.

Suddenly the formerly taken-for-granted *rantau* had demanded that its presence be taken seriously. More than that, it had also threatened to *rantau*-ize, so to speak, the essential foundation of the Minangkabau World, which was believed to "neither crack in the sun nor rot in the rain." The harsh reality of empirical history had finally demanded a change of historical (*tambo*) view of a Minangkabau World at the center of a continually expanding *rantau*.

After a traumatic period of social and political adjustment, the Minangkabau story has a happy ending. West Sumatra became the third province to receive the presidential award for the province that had carried out the five-year plan most successfully. It is also one of only two provinces to have twice won this highest national award, being the only province outside of Java to have ever garnered such national honors. A host of additional national accolades could be cited. The numerous national awards, however politically motivated they may be, speak for themselves.

The process of reexamination is still going on, but in the meantime the cultural strategy of the young prewar Western-educated *parantau* intellectual in imagining a new community—Indonesia—without undermining the old one—Minangkabau—has become a reality. The Minangkabau region, now the national province of West Sumatra, has emerged economically viable and culturally intact.

NOTES TO THE TEXT

The literature on Minangkabau abounds with mixed usage of two languages, Indonesian and Minangkabau. In an attempt to establish a consistent usage, the editors of this volume have chosen to use Minangkabau words rather than Indonesian words and have gone to considerable effort to accomplish that goal. A glossary of the Minangkabau terms used in the text appears at the end of this volume.

CHAPTER 1

1. Prany Sananikone, conversation with authors, 1994.
2. Islam was first established in Sumatra at the end of the thirteenth century in Aceh, at the northern tip of the island, but did not take hold in the region of Minangkabau until much later. The west coast port city of Tiku, which handled most of the trade with Muslims from Gujarat, India, was the first Minangkabau city to embrace Islam. It had become somewhat Islamized by the second decade of the sixteenth century. Other coastal villages followed. As late as 1761, however, Islam seems to have been limited to commercial brokers and their families in the port cities. Coastal peasants continued to retain their animistic beliefs. Conversion in interior regions of Minangkabau proceeded even more slowly. First to embrace Islam (because of commercial advantage to their extensive and lucrative dealings with Muslim courts) were the royal families. By the mid-seventeenth century heartland villages involved with gold trade or gold traders had converted. Adoption of Islam took place more slowly in predominantly agricultural villages. As late as the early nineteenth century there were some villages with no Muslim adherents (Dobbin 1983, 119–20).
3. The name Padang is misleading because this style of food originated in the Minangkabau highlands and is still prevalent there.
4. See chapter 12 for a longer discussion of Minangkabau jewelry, once the third most important measure of wealth of a Minangkabau family, after land and cattle.
5. *Adat* is an Indonesian word assumed to have been taken from the Arabic, meaning "custom" or "tradition." In the Minangkabau language the comparable word is *adaik*. Because it is so much more widely used and understood than the Minangkabau word *adaik*, the term *adat* is used throughout the text. To the Minangkabau, adat is the whole structure of their society and encompasses all that is implied in an anthropological definition of culture (see chapter 3).

CHAPTER 2

1. This saying is a variant on the aphorism cited earlier: "Adat is based on *syarak* (Islam); *syarak* is based on adat."

CHAPTER 3

This chapter was first drafted by Khaidir Anwar. Following his death, Imran Manan, at the editors' request, made necessary editorial revisions to the original text.
1. *Datuak* is a title given to a chieftain at the time of his elevation to that position.
2. The word *role* here signifies the sum total of culturally prescribed duties, characteristics, and rights expected of and granted to the incumbent of a particular position.
3. Literally, "Truth becomes the king."

CHAPTER 4

1. Datuak Pangulu H. Muhammed Thamrin Basa, conversation with Anne and John Summerfield, 1994.

INTRODUCTION TO PART 2

1. Textile arts of the coastal regions are not included in this report per se. For centuries coastal areas of the province played host to and were even governed by other nationalities and other cultural groups, which resulted in cultural differences from the highland peoples.
2. The highland area measures some 125 kilometers long by 100 kilometers wide. The main area from which the textiles in this chapter are drawn is smaller. It encompasses part of the *luhak nan tigo* and part of the original highland frontier area, about 2,500 square kilometers.
3. Jambi, beginning in the seventh century, was the center of one of the great Southeast Asian Hindu kingdoms. Ruins of early temple compounds are located not far from the provincial capital.

CHAPTER 5

1. A *pangulu* tries first to settle family disputes as an arbitrator between the two disputants. If that fails, he includes senior members of the matrilineage in the discussion. He next goes to the extended families of both participants. And finally, if all else fails to resolve the dispute, he takes it to the village council, a group of fellow *pangulu* who meet regularly in the village council hall (*balai*).
2. For the location of regencies (*kabupatan*) and villages (*nagari*), refer to the map of the Minangkabau heartland (p. 22–23).
3. Although the raja currently has no official status in the Republic of Indonesia, descendents of the original raja are still honored in their villages and are addressed by the title of raja. They receive minimal support from the government, and many live in poverty. They wear their titles and heirloom ceremonial garments with great dignity.

4. In the sixteenth and early seventeenth centuries the Acehnese controlled ocean trade along the west coast of Sumatra and exercised considerable control over the west coast Minangkabau port of Pariaman, leading to the Treaty of Painan in 1663 (Kathirithamby-Wells 1967). It is probably through this long-standing relationship that the *sarawa gadang* became part of the Minangkabau adat costume.
5. Adapted from Ibrahim 1986, 27–90.

CHAPTER 6

1. This positive-negative patterning device is common in Middle Eastern textiles and rugs. The rugs were regularly traded into Minangkabau by Arab traders and could have been seen or even owned by a weaver. Other possible relationships of Minangkabau motifs to motifs commonly found in the Mideast are discussed briefly in chapter 7.
2. Couching consists of making a pattern by laying pattern threads in the appropriate design on the surface of an already woven fabric and fastening them there with small, delicate stitches.
3. For example, textiles embroidered with satin stitch were buried in the Han dynasty (206 B.C.E.–220 C.E.) tombs of western China (Shih 1977, 308–11).

CHAPTER 7

1. This refers only to the embellishments of the textile per se and not to any additional meanings assigned to its use as a garment, such as the responsibilities of male leadership assigned to various aspects of chieftains' ceremonial wear (see chapter 5).
2. Translation from "About Sumatra," an unpublished paper by Anas Nafis (1990).
3. This practice was not found in the Koto Nan Gadang area of Limo Puluah Koto in 1980–1981 (Ng 1987, 1:166ff.). It is likely, however, that the practice did exist there at an earlier time. First, the region was initially settled by persons from Tanah Datar, where the practice was common. Second, motifs catalogued by Cecelia Ng from the textiles that formed the basis of her study were heavily oriented to figurative, nonindigenous forms typically found in European pattern books, indicating that more recently adopted motifs could have gradually displaced indigenous motifs and thus their adat significance to the community. Motifs found in existing older Koto nan Gadang textiles tend to support this view.

Certain other ritual practices, namely, exchanges of supplementary weft cloths, also were not known to Ng in Koto nan Gadang in the 1980s. Reports of late nineteenth-century visitors to the area, however, make it clear that these practices were active at the time of their visits (Ng 1987, 174).
4. The Bugih are a highly skilled seafaring people. At one time they were known as the fiercest pirates in the South Seas. Originally from the island of Sulawesi, they helped to make the city of Makassar, now Ujung Pandang, a wealthy port. With the advent of the Dutch East India Company in Sulawesi in the mid-seventeenth century, the Bugih were forced to immigrate to other Indonesian and Malaysian areas. As a result of this diaspora, Buginese arts were spread throughout the archipelago. Even today certain textiles, motifs, and intricate weaving techniques carry the name of the Bugih. It is alleged that their piratical exploits in the South Seas led to the coinage of the Western expression the "bogeyman."

5. *Rebuang* is an Indonesian word. The Minangkabau word is *rabuang*.
6. See chapter 12 for a description of the process and ceremonial role of making *galamai* for a wedding in a small village in the regency of Tanah Datar.
7. This information comes from H. Elly Azhar (conversation with author, 1988), who was provoked by skeptical clients to go to the village of Batu Sangkar to study why the variety of motifs found in Batu Sangkar ceremonial textiles was much greater than that found in textiles from Limo Puluah Koto or from Agam.
8. This information is contained in the written version of the *tambo* (Anas Nafis, correspondence with author, 1986).
9. None of the many Minangkabau in the highlands with whom we discussed this textile in detail remembered hearing about where it was dyed or woven. They all agreed that it was very old. Most extant examples are in shreds. The format and motifs are typical of Batu Sangkar, but the technique used for dyeing is puzzling. It could have been weft ikat, technically, but there is general agreement that ikat dyeing was not used as a patterning technique in the region of the three *luhaks*, only in the village of Silungkang. See chapter 8 for a full discussion of the dyeing of this textile.
10. This motif also appears on an imperial silk saddle rug woven in the sixteenth century in Ningxia, western China (from a monastery in Northern Tibet); in a floor carpet depicted in a miniature in the Shah Namah; in the Crivelli Turkish carpet in the Iparmüveszeti Muzeum in Budapest; and is illustrated in Gantzhorn 1991, 159, fig. 230.

CHAPTER 8

1. It is difficult to determine how old "old" textiles really are. It is commonly said that the tropical climate and insects limit the life of Indonesian textiles and that therefore any Indonesian textile in reasonably good condition cannot have been made before the late seventeenth or eighteenth century. Recent work by Ruth Barnes at the Ashmolean Museum at Oxford has, however, cast doubt on that traditional wisdom. Barnes carbon-dated a large complete Indian cotton textile that had been kept as an heirloom and ceremonial cloth on the island of Sulawesi and judged by knowledgeable textile professionals to date to about 1800. The textile had been maintained under conditions nearly identical to those in the Minangkabau heartland. Carbon-dating showed that the Indian textile dated from c. 1400 (Barnes 1996, 2). This suggests that some old Minangkabau textiles might be older than heretofore thought possible. A carbon 14 study of old Minangkabau ceremonial textiles is sorely needed.
2. To make enough bark cloth to construct pants and shirts, longer pieces of tree trunk or branch must be debarked. Because the beater can work on only one meter of bark at a time, it is common practice to work on a length of bark over many weeks, letting the material dry between sessions.
3. The word *ikat* (*ikek* in the Minangkabau language) means "to tie."
4. The dyeing technique used for this textile is puzzling. Several textiles from Tanah Datar, of which Batu Sangkar is a part, are made with zone-dyed warps. Our informants agreed that zone dyeing of warps was probably accomplished by dipping warp ends into dye. Careful examination shows that the line of demarcation is not precise, suggesting that the warps were "dunked" into the dye and not tied

before dyeing. The same technique could have been used for dyeing wefts. It is clear from close examination of the textile that the color of the warps and wefts that are all red is darker than the red in those warps and wefts that are red and white. We infer from this that the silk for the single-color red warps and wefts was purchased already colored and that the two-color warps and wefts were dyed in the village, or at least in the heartland. No wholly satisfactory explanation of how or where this weaving was dyed has been advanced as yet.

CHAPTER 9

For various aspects of the analytical work or for supplying scanning microscopy data, thanks to R. J. Koestler and M. Wypysky, Objects Conservation Department, Metropolitan Museum of Art, New York; Professor M. Ellis, Conservation Center, Institute of Fine Arts, New York University; D. Montegut, Fashion Institute, State University of New York; and Mary Ballard, Conservation Analytical Laboratory, Smithsonian Institution, Washington, D.C.

CHAPTER 10

1. How the Minangkabau have melded their practice of Islam with the practice of their adat, including matriliny, has long been a subject of study, both by visiting scholars and by the Minangkabau themselves (see chapter 3).
2. The reference to pumpkin alludes to the adat saying that the pumpkin seed, though tiny, contains the world and the sky. The reference to earrings alludes to the silver metallic finials that decorate the tips of the horn-shaped sections of the roof.

CHAPTER 11

This article is based on research undertaken in the Minangkabau highlands in 1986–1988, which has been presented in greater detail in a doctoral dissertation for the University of Pennsylvania (Klopfer 1994). Research was funded by a Fulbright-Hays Doctoral Research award under the auspices of the Indonesian Institute of Science (LIPI) and the sponsorship of Andalas University. The author is grateful to these institutions as well as to the people of Sungai Patai.

1. For more about Padang restaurants, see Naim 1987 and Klopfer 1993.
2. Cookbooks and even folklore collections of Minangkabau traditional practices, such as the inventory of Minangkabau foods by Zaidan et al. (1985), are often based on the assumption that there is a single Minangkabau cuisine. It is quite likely that, in the course of a nationwide effort to construct ideal ethnic types for each Indonesian region, a Minangkabau type has been or will be defined. Village practices found not to conform may be dismissed as backward or as deviations from the ideal rather than being seen as significant and potentially very interesting variations. In this author's view, a rigorous comparative study of Minangkabau adat in different villages is sorely needed.
3. For studies on Minangkabau migration, see Naim 1987, Kato 1982, Persoon 1983, and Chadwick 1991.
4. The hajj is the pilgrimage to Mecca that is required of all Muslims who can afford to go without burdening their families. Many Minangkabau villagers gradually accumulate money for decades in the hope of going once in their lifetime.
5. In this case, "female relatives" is used rather loosely and may include women who feel close to the family, members of the same matrilineage as the bride, possibly close relatives on her father's side (aunts or cousins), and also possibly women married to her brothers or perhaps to her mother's brothers.
6. For a fuller discussion of the meanings the Minangkabau attach to aspects of the environment, to items in their daily life, and so on, see chapter 1, especially the section "Minangkabau as an Oral Culture."
7. Some Minangkabau say that goat curry should not be served with other curries because the black pepper and red chili pepper are opposed (*lawan*) and should not be eaten together. Nonetheless, at some weddings both kinds of curry are served.
8. According to Khaidir Anwar (personal communication, 1987), in some parts of West Sumatra a wooden model of a fish is used. In the village where the research for this chapter was done, the fish was merely saved for the final evening wedding feast and then eaten along with the other foods with no special ceremony.
9. The elaborate headdresses currently used by Minangkabau brides seem to be an innovation from roughly a century ago, possibly of Chinese origin. Before the late nineteenth century brides seem to have worn cloth headdresses and gold jewelry.
10. It has been suggested that this symbolizes the return of cloth given at a wedding. It may have at one time, but today the exchange of cloth at weddings is no longer common.

CHAPTER 13

Initial work on this chapter was done by Boestanoel Arifin Adam shortly before his death, and some additional material has been supplied by the editors.

CHAPTER 15

The original Minangkabau manuscript was translated into English at Andalas University, Padang, West Sumatra, and the English translation was checked for accuracy by Professor Lukman Ali of the University of Indonesia, Jakarta. The editors have taken the liberty of retranslating occasional bits of information about textiles that eluded the original translators. Consul J. S. Philliang of the Indonesian consulate in Los Angeles provided special help in translating and interpreting *pantun* quoted in the third of the three orations printed here. Consul Philliang is a Minangkabau chieftain.

CHAPTER 16

1. For the most comprehensive philological study of the *tambo*, see Djamaris 1991.
2. On the concepts of "scope" and "force" of religious influence, see Geertz 1967.
3. See, for example, Sango 1955; Radjo Panghoeloe 1971.
4. The myth of Iskandar Zulkarnain may have come to the archipelago around the fourteenth century. This can be taken as a proof of the great influence of the trading relationship between the archipelago and the Gulf of Persia. A Persian myth, it may also indicate that some of the people who brought Islam were the followers of Syiah (Shiite Muslims). If the Portuguese traveler Tomé Pires was right in reporting in his *Suma Oriental* that in the early sixteenth century Islam had just come to Minangkabau, we can assume that the myth came to Minangkabau along with the spread of Islam. A seventeenth-century Minangkabau king, Sultan Ahmad Syah, wrote a letter to Batavia in which he identified himself as "Paduka Seri Sultan Ahmad Syah, a true descendant of king Iskandar Zulkarnain, under the [as a] Shadow of God... God gave to Sultan Iskandar Zulkarnain three crowns and staff which he divided and handed over to his three sons the emperor of Turkey, the king of

China, and the king of Minangkabau" (*Daghregister*, vol. 17 [1666–1667], 296ff.; cited by Drakard 1993, 92). Written *tambo*, it should be noted, claims that Iskandar Zulkarnain inherited only one crown. It fell into the sea. Cati Bilang Pandai managed to recover it, but instead of returning it directly to the three sons, he made two exact replicas. Then he gave the three similar crowns to the princes. But the question of who owned the original remained open.

5. On the questions of competing yet complementary Minangkabau political traditions, see Josselin de Jong 1952.

6. On the question of change in Minangkabau historical thought, see Abdullah 1972, 190–92.

7. In the jargon of modern social science, one can also suggest that an action is taken when it rationally makes sense and is emotionally pleasing or it depends on the affinity between "world view" and "ethos." See Geertz 1975, 142–69.

8. See, for example, Junus 1984.

9. The *rabab* is a two-string instrument in the Minangkabau highlands (*darek*) but a three-string instrument in coastal areas (see chapter 13).

10. On this very famous "classical" *kaba*, see Abdullah 1970, 1–22.

11. It has been beautifully translated into English; see Johns 1958.

12. See Diradjo 1921. See also an interesting analysis by Umar Junus (1988), 55–68.

13. These terms are used by Hendrik Bouman (1949).

14. See Abdullah 1971.

15. *Parantau* refers to Minangkabau living in an area away from the heartland. See, among others, Teeuw 1972; see also Freidus 1977.

16. On the concept of "nation" as an "imagined community," see Anderson 1983.

17. Husein et al. 1991–1992. The contributors to the second edition were Ahmad Husein, Kasymir Sutan Muntjak, Sjoe'ib, Jahja Djalil, Syaflar S. H., Bakri Abbas, M. A., Arief Amin, and Djohan. The first edition had a different group of authors, namely, S. M. Rasyid, Dahlan Ibrahim, Abdul Halim, Ahmad Husein, Eny Karim, Syoeib, and Mulkan. These individuals played more prominent roles in the revolution than the compilers of the second edition.

18. See, for example, Abdullah 1971.

19. Those who know the history of the Indonesian revolution will recall that the first vice president of the republic, Mohammad Hatta, was a Minangkabau; so were the first prime minister, Sutan Syahrir; the chairman of the KNIP (a provisional parliament), Assaat; the third foreign minister, Haji Agus Salim, known as the "grand old man of the republic"; the third minister of information; and many others. The most prominent opposition leaders, Tan Malaka and Mohamad Yamin, were also Minangkabau.

GLOSSARY

This glossary contains an illustrative sample of common Minangkabau words used in this book—words relating to textiles and their motifs, to ceremonial arts, and to the adat or traditional system of belief. Some words in Minangkabau and Indonesian languages are identical, many differ slightly, and some are completely different. The only comprehensive lexicon of the Minangkabau language now available is Gérard Moussay's two-volume Minangkabau-French encyclopedic dictionary (1995).

MINANGKABAU	INDONESIAN	ENGLISH
adaik; adat	adat	traditional law; the culture
aguang	gong	cymbal; gong
ajik	wajik	ceremonial cake
aka cino	aka cina	Chinese root; name of motif
alek	jamu; helat	guest
alek	pesta	festival; ceremony
anak	anak	young boy or girl
antimun	ketimun	cucumber
anyam	anyam	braid
api api	kilatan api	match
bada mudiak	teri mudik	small sea fish (going upstsream); name of motif
baju	baju	blouse; shirt
baju cino	baju cina	Chinese-design shirt
baju itam	baju hitam	chieftain's black shirt
baju kuruang	baju kurung	tunic; closed blouse
bakaruik	berkerut	man's pleated hat
bakatak	berkerut	man's pleated hat
bako	keluarga geris ibu pihak ayah	father's matrilineal family
balah kacang	belah kacang	split peanut; name of motif
balai	balai	village council hall
balapak	berdepak	full (of metallic thread)
baludu	beludru	velvet
barantai	berantai	chain
basahan itam	basahkan hitam	a black-dyed cloth
baso	basa	aesthetic attraction
batabua	bertabur	scattered
batagak pangulu	menegakkan penghulu	ceremony to elevate a chieftain
batang	batang	tree trunk; stem
batang pinang	batang pinang	trunk of areca palm tree; name of motif
bateh	batas	border
batu	batu	stone
bijo	biji	seeds
biku biku	biru biru	zigzag; name of motif
budi	budi	character
Bugih	Bugis	seafaring ethnic group originally based on Sulawesi
bunyi	bunyi	sounds
cacak	cicak	house lizard
cadiak pandai	cerdik cendekia	intellectuals; scholars
carano	cerana	*siriah* bowl
cincin	cincin	ring
cubadak	nangka	jack fruit
dalamak	kain tutup	cover for *siriah* set or for food
darek	darat	interior
datuak	datuk	title for a chieftain
deta	destar	man's pointed headdress
deta bakaruik	destar berkerut	Limo Puluah Koto chieftain's headdress
dindiang	dinding	wall
dubalang	hulubalang	chieftain's bodyguard and assistant
duduak	duduk	to sit
dukun	dukun	sorcerer; spiritualist
gaba	kain gabar	type of shoulder cloth worn by married women in Limo Puluah Koto; also festoon
gadang	besar	large
galamai	gelamai	cake made of rice, sugar, and coconut
galang	gelang	bracelet
galombong	gelombong	circular dance
gambia	gambir	flavoring used in betel quid
gandang	gendang	drum
godok	godok	deep-fried dumplings
gulo jawa	gula java	palm sugar
gunuang	gunung	mountain
hukum	hukum	law
ieh	hias	decoration; design
ikek pinggang	ikat pinggang	man's belt or waist tie
Induak Padi	Induk Padi	Rice Mother
itiak pulang patang	itik pulang petang	ducks going home in the afternoon; name of motif

344

janang	jenang	assistant; mediator
kaba	cerita; hikayat	history; legend
kabau	kerbau	water buffalo
kabupatan	kabupaten	regency
kain	kain	cloth
kain balapak	kain berdepak	textile completely ornamented with metallic thread
kain panutuik janazah	kain penutup jenazah	shroud
kaluak	keluk	curved
kaluak paku	keluk paku	fern tendril; name of motif
kaluang	kalong	flying fox
kaluang	kalung	necklace
kambang cino	kembang cina	Chinese flower; name of motif
kampia	kampil	pouch
kampuang	kampung	village
kapalo	kepala	head; main decorative panel of a sarong
karih	keris	kris (small ceremonial dagger)
kato adat	kata adat	traditional saying
katupek	ketupat	container woven of coconut leaves and used for boiling rice
kayu	kayu	wood
kodek	sarung	skirt woven on *kodek* loom
koto	kota	fortified town
kubang	ondeh ondeh	pastry of rice, sugar, and coconut
kulik kayu	kulit kayu	bark thread (literally, "skin of wood")
kunang kunang	kunang kunang	fireflies; name of motif
kuniang	kuning	yellow
kupiah	kopiah	man's fezlike cap
kuruang	kurung	enclosed; caged
labu	labu	gourd or squash
laka	lekar	braided
lamang	lemang	rice cooked in bamboo cylinder
lambak	sarung	underskirt or tube skirt
lapek	lepat	rice dish wrapped in banana leaf
lidi	lidi	thin bamboo rod
luhak	wilayah	administrative region
luhak nan tigo	wilayah nan tiga	the three original Minangkabau regions
mairiak	mengirik	separating rice from hull
malin	malim	religious leader
mamanggia	memanggil	to call a meeting
manang	menang	to win or conquer
mandi	mandi	bath
manggih	manggis	mangosteen fruit
manti	pembantu penghulu	administrative assistant to a *pangulu*
manyanyikan	menyanyikan	singer
marantau	merantau	to migrate from the heartland
marawa	tunggul; panji panji	banner
merah	merah	red
mualim	mualim	religious leader
mukena	mukenah	woman's Islamic prayer robe
nagari	negeri	village region
nikah	nikah	Muslim wedding ceremony
niniak mamak	ninik mamak	a group of clan chieftains
pacik	pegang	to hold
padi	padi	wet rice field
paga	pagar	fence
pakaian	pakaian	clothing
palaminan	pelaminan	wedding alcove
pamenan	permainan	games
pancak silek	pencak silat	dance form based on martial arts movements
pangulu	penghulu	clan chieftain
panjang	panjang	long
pantun	pantun	poem, usually of four lines
parantau	perantau	Minangkabau living away from the heartland
parkawinan	perkawinan	wedding
pasisia	pesisir	coastal
pidato adat	pidato adat	traditional speech
pinang	pinang	areca palm
pucuak rabuang	pucuk rabung	bamboo shoot; name of motif
pupuik	puput	flute
putiah	putih	white
ragi	ragi	fermenting agent similar in action to yeast
ramin	rami	a type of *boehmeria*; source of bast fiber
randai	randai	type of theatrical performance
randang	rendang	meat dish cooked with coconut milk and spices
rangkiang	lumbung padi	rice barn
rantau	rantau	settlement away from the heartland
rumah	rumah	house
rumah gadang	rumah besar	adat house
sagun	segun	rice cake made with sugar and coconut
saik galamai	sayat gelamai	slice of cake; name of motif
salapah	tempat tembakau	tobacco box
salempang	selempang	man's tubular shoulder cloth
salendang	selandang	shoulder cloth
saluak	saluk	chieftain's hat
saluak laka	seluk lekar	interwoven rattan; name of motif
saluang	seruling	bamboo flute
sambuaran	semburan	sprinkles (noun, plural)
sapatu	sepatu	woman's sandal
sapik udang	sepit udang	shrimp claws; name of a Padang Magek tube skirt
saputangan	saputangan	handkerchief or small square cloth

sarawa	celana; seluar	man's trousers
sarawa gadang	celana besar	man's voluminous trousers
saruang	sarung	tubular skirt
saruang banta	sarung bantal	pillowcase
sawah	sawah	rice field; paddy
silek	silat	martial arts
siriah	sirih	leaf of the betel vine
siriang	siring	fish fins
sisampiang	samping	man's short tube skirt
sisiak ikan	sisik ikan	fish scales; name of motif
sisiak tanggiliang	sisik tenggiling	anteater scales; name of motif
songket	songket	patterning with supplementary weft
songkok	songkok	man's fezlike hat or a cover
suku	suku	clan
sumando	semanda	husband of one member of a matrilineage
sunek rasua	sunat rasul	circumcision ceremony
suntiang	sunting	bridal headdress
tagak	tegak	to lift or to hold upright; erect
talak tujuah	talak tujuh	textile with red and gold bands separated by seven white stripes
talakuang	telekung; mukenah	headdress in the form of a veil
talempong	telempong	percussion instrument
tambo	riwayat dahulu kala	origin history
tampuak manggih	tampuk manggis	mangosteen calyx; name of motif
tanduak	tanduk	horn (of an animal)
tangkuluak	tengkolok; tengkuluk	folded or tied headdress
tarewai	selendang mempelai	shoulder cloth
tari	tari	dance
tarimo kasiah	terima kasih	thank you (literally, "accept love")
tarompa	terompah	man's sandal
tinggi	tinggi	high
tirai	tirai	curtain
titian	jembatan; titian	bridge
tuah	tuah	power
tungkek	tongkat	walking stick
tuo rarak	tua lerak	long shoulder cloth used for carrying
turun	turun	to go down or to dismount
turun ka sawah	turun ke sawah	ceremony at start of work in rice paddy
turun mandi	turun mandi	ceremony for baby's first washing
tutuik	tutup	cover
ulama	ulama	religious leader
ulek tantadu	ulat cencadu	parading caterpillar; name of motif
uncang	dompet	purse; cloth bag
urang	orang	person; people
wajik	wajik	ceremonial cake

BIBLIOGRAPHY

ABDULLAH, TAUFIK
1966 "Adat and Islam: An Examination of Conflict in Minangkabau." *Indonesia* 2: 1–24.
1970 "Some Notes on the *Kaba Tjindua Mato*: An Example of Minangkabau Traditional Literature." *Indonesia* 9: 1–22.
1971 *Schools and Politics: The Kaum Muda Movement in West Sumatra, 1927–1933*. Ithaca, N.Y.: Modern Indonesia Project, Cornell University.
1972 "Modernization in the Minangkabau World: West Sumatra in the Early Decades of the Twentieth Century." In Holt 1972b, 179–245.
1978 "Identity Maintenance and Identity Crisis in Minangkabau." In *Identity and Religion: International, Cross-Cultural Approaches*. Edited by Hans Mol, 151–67. London and Beverly Hills, Calif.: Sage.
1985 "Islam, History, and Social Change in Minangkabau." In Thomas and Benda-Beckman 1985, 141–56.

ACHJADI, JUDI
1976a "Traditional Costumes of Indonesia." *Arts of Asia* 6 (5): 74–79.
1976b *Pakaian daerah wanita Indonesia / Indonesian Women's Costumes*. Jakarta: Penerbit Djambatan.

ADAM, BOESTANOEL ARIFIN
1980 *Salueng dan dendeng di luhak nan tigo Minangkabau, Sumatera Barat: Leloren penelitian*. Padang Panjang: Akademi Seni Karawitan Indonesia.
1987 *Talempong: Musik tradisi Minangkabau*. Padang Panjang: Akademi Seni Karawitan Indonesia.

ADHYATMAN, SUMARAH, AND REDJEKI ARIFIN
1993 *Manik-manik di Indonesia / Beads in Indonesia*. Jakarta: Penerbit Djambatan.

AGTHE, JOHANNA
1979 *Arm durch Reichturn Sumatra*. Frankfurt: Museum für Völkerkunde.

ALAM, SYAMSIR
1984 *Tenun tradisional desa Pandai Sikek dan Kubang di Sumatera Barat*. Padang: Proyek Pengembangan Permuseum.

ALI, LUKMAN
1994 *Unsur adat Minangkabau dalam sastra Indonesia, 1922–1956*. Jakarta: Balai Pustaka.

ALIAS, AIDA
1991 "The Architecture and Symbolic Motifs of Three Indonesian Curved Ridgepole Housetypes and Their Relevance to the Rituals and Beliefs of the Groups That Built Them." M.A. thesis, Northern Illinois University, De Kalb.

AMRAN, RUSLI
1981 *Sumatera Barat hingga plakat Panjang*. Jakarta: Penerbit Sinar Harapan.

ANDAYA, BARBARA WATSON
1989 "The Cloth Trade in Jambi and Palembang Society during the Seventeenth and Eighteenth Centuries." *Indonesia* 48: 27–47.
1993 *To Live as Brothers: Southeast Sumatra in the Seventeenth and Eighteenth Centuries*. Honolulu: University of Hawaii Press.

ANDERSON, BENEDICT
1983 *Imagined Communities: Reflections on the Origin and Spread of Nationalism*. London: Verso.

ANWAR, KHAIDIR
1980 "Language Use in Minangkabau Society." *Indonesia Circle* 22: 55–63.
1987 *Kata-kata Minangkabau (Specific Minang Vocabulary)*. Padang: Yayasan Pengkajian Kebudayaan Minangkabau.
1988 *Kolokasi dan ungkapan bahasa Minang (Minangkabau Collocations and Expressions)*. Padang: Yayasan Pengkajian Kebudayaan Minangkabau.

ARAGON, LORRAINE V.
1990 "Barkcloth Production in Central Sulawesi: A Vanishing Textile Technology in Outer Island Indonesia." *Expedition* 32 (1): 33–48.

AZAR, SYAMSUL
1988 *Minangkabau Culture*. Bukittinggi: N.p.

BACHTIAR, HARSJA W.
1967 "*Negeri* Taram: A Minangkabau Village Community." In *Villages in Indonesia*. Edited by R. M. Koentjaraningrat, 348–75. Ithaca, N.Y.: Cornell University Press.

BAHAR, SAAFROEDIN, ED.
1993 *Minangkabau*. Jakarta: Yayasan Gebu Minang.

BAKAR, JAMIL
1979 *Kaba Minangkabau*. 2 vols. Jakarta: Pusat Pembinaan dan Pengembangan Bahasa.

BARNES, RUTH
1996 *Oxford Asian Textile Group Newsletter*, no. 3.

BATUAH, AHMAD DT., AND A. DT. MADJOINDO
1956 *Tambo Minangkabau dan adatnya*. Jakarta: Penerbit Dinas Balai Pustaka.

BELLWOOD, PETER
1985 *Prehistory of the Indo-Malaysian Archipelago*. Sydney: Academic Press.

BENDA, HARRY J.
1962 "The Structure of Southeast Asian History: Some Preliminary Observations." *The Journal of Southeast Asian History* 3 (1): 106–38.

BENDA-BECKMANN, FRANZ VON
1979 *Property in Social Continuity: Continuity and Change in the Maintenance of Property Relations through Time in Minangkabau, West Sumatra*. The Hague: M. Nijhoff.

BENDA-BECKMANN, KEEBET AND FRANZ VON
1978 "Residence in a Minangkabau Nageri." *Indonesia Circle* 15: 6–17.

BODROGI, TIBOR
1972 *Art of Indonesia*. Greenwich, Conn.: New York Graphic Society.

BOUMAN, HENDRIK
1949 *Enige beschowingen over de ontwikkeling van het Indonesisch nationalisme op Sumatra's westkust*. Groningen: J. B. Wolters.

BOURDIEU, PIERRE
1977 *Outline of a Theory of Practice*. Trans. R. Nice. Cambridge: Cambridge University Press.

BOWEN, JOHN R.
1991 *Sumatran Politics and Poetics: Gayo History, 1900–1989*. New Haven: Yale University Press.

BÜHLER, ALFRED, AND EBERHARD FISCHER
1979 *The Patola of Gujarat*. Basel: Krebs.

CASEY, MARGARET
1987 "Female Work Patterns in Silungkang, West Sumatra: Preliminary Observations." *Indonesia Circle* 43: 41–49.

CHADWICK, RICHARD J.
1976 "*Merantau*: Aspects of Outmigration from a West Sumatran Village." M.A. thesis, University of West Australia, Perth.
1991 "Matrilineal Inheritance and Migration in a Minangkabau Community." *Indonesia* 51: 21–45.

CORTESÃO, ARMANDO, ED.
1944 *The Suma Oriental of Tomé Pires: An Account of the East, from Red Sea to Japan*. London: Haklyut Society.

DAWSON, BARRY, AND JOHN GILLOW
1995 *Traditional Indonesian Architecture*. London: Thames and Hudson.

DHAVIDA, USRIA
1992 *Pakaian penganten daerah Koto Gadang Kabupatan Agam*. Padang: Museum Negeri Provinsi Sumatera Barat Adhityawarman.
1996 "Malay Dress and Its Minangkabau Variants." *Citra Indonesia* 2 (9): 24–30.

DIRADJO, SANGGUNO
1919 *Kitab tjurai paparan adat lembaga alam Minangkabau*. Fort de Kock: Agam.
1921 *Mustiko adat alam Minangkabau*. Jakarta: Perpustakaan Perguruan Kementarian P. P. dan K.

DJAMARIS, EDWAR
1991 *Tambo Minangkabau*. Jakarta: Balai Pustaka.

DOBBIN, CHRISTINE
1974 "Islamic Revivalism in Minangkabau at the Turn of the Nineteenth Century." *Modern Asian Studies* 8 (3): 319–46.
1977 "Economic Change in Minangkabau as a Factor in the Rise of the Padri Movement, 1784–1830." *Indonesia* 23: 1–38.
1983 *Islamic Revivalism in a Changing Peasant Economy: Central Sumatra, 1784–1847*. Scandinavian Institute of Asian Studies, Monograph Series, no. 47. London and Malmö: Scandinavian Institute of Asian Studies.

DRAKARD, JANE
1993 "A Kingdom of Words: Minangkabau Sovereignty in Sumatran History." Ph.D. diss., Australian National University, Canberra.

EERDE, J. C. VAN, ED.
1920 *De volken van Nederlandsch Indië*. Vol. 1. Amsterdam: Elsevier.

EFFENDI, NURAN
N.d. *Penulisan awal kerajaan Pulau Punjung*. Sawahlunto/Sijunjung.
N.d. *Penulisan awal kerajaan Jambu Lipo*. Sawahlunto/Sijunjung.

EFFENDI, RUSTAM
1977 *Pertumbuhan dan perkembangan dendeng di kecamatan Saso*. Padang Panjang: Akademi Seni Karawitan Indonesia.

EMERY, IRENE
1980 *The Primary Structures of Fabrics.* Washington, D.C.: Textile Museum.

ERMA
1991 "Fungsi kerbat dalam upacara batagak penghulu di Minangkabau studi kasus: Di desa Tabek kecamatan, perwakilan Sungai Puar kabupaten Agam." Thesis, Fakultas Sastra, Universitas Andalas, Padang.

ERRINGTON, FREDERICK K.
1984 *Manners and Meaning in West Sumatra: The Social Context of Consciousness.* New Haven: Yale University Press.

ESDE, ERNI
1994a *Pakaian penganten daerah Pasaman.* Padang: Museum Negeri Provinsi Sumatera Barat Adhityawarman.
1994b *Pakaian penganten daerah Pesisir Selatan.* Padang: Museum Negeri Provinsi Sumatera Barat Adhityawarman.

ESTRADA, CRISTINA, VALERIE GREGGAINS, AND SABINE SCHOUTEN, EDS.
1979 *Aspects of Indonesian Culture: Java-Sumatra.* Jakarta: Ganesha Society.

FISCHER, H. TH.
1964 "The Cognates in the Minangkabau Kinship Structure." *Oceania* 35: 96–110.

FISCHER, JOSEPH, ED.
1979 *Threads of Tradition: Textiles of Indonesia and Sarawak.* Berkeley: Lowie Museum of Anthropology, University of California.

FISHER, ROBERT E.
1993 *Buddhist Art and Architecture.* London: Thames and Hudson.

FONTEIN, JAN
1990 *The Sculpture of Indonesia.* Washington, D.C.: National Gallery of Art; New York: Harry N. Abrams.

FOX, JAMES J., ED.
1993 *Inside Austronesian Houses.* Canberra: Australian National Museum.

FRASER-LU, SYLVIA
1988 *Handwoven Textiles of South-East Asia.* Singapore: Oxford University Press.

FREIDUS, ALBERTA JOY
1977 *Sumatran Contributions to the Development of Indonesian Literature, 1920–1942.* Honolulu: Asian Studies Program, University of Hawaii.

FREY, EDWARD
1988 *The Kris: Mystic Weapon of the Malay World.* 2d ed. Singapore: Oxford University Press.

FREY, KATHERINE STENGER
1986 *Journey to the Land of the Earth Goddess.* Jakarta: Gramedia.

GANTZHORN, VOLKMAR
1991 *The Christian Oriental Carpet.* Cologne: Benedikt Taschen.

GEERTZ, CLIFFORD
1967 *Islam Observed.* Chicago: University of Chicago Press.
1975 "Ethos, World View, and the Analysis of Sacred Symbols." In *The Interpretation of Cultures.* New York: Basic Books.

GEERTZ, HILDRED
1963 "Indonesian Cultures and Communities." In *Indonesia.* Edited by Ruth T. McVey, 24–96. New Haven: Southeast Asia Studies, Yale University.

GILLOW, JOHN, AND BARRY DAWSON
1992 *Traditional Indonesian Textiles.* London: Thames and Hudson.

GITTINGER, MATTIEBELLE
1980 "Indonesian Textiles." *Arts of Asia* 10 (5): 108–23.
1990 *Splendid Symbols: Textiles and Tradition in Indonesia.* 2d ed. Singapore: Oxford University Press.
1992 "An Examination of Tai Textile Forms." In Gittinger and Lefferts 1992, 29–58.

GITTINGER, MATTIEBELLE, ED.
1980 *Indonesian Textiles: Irene Emery Roundtable on Museum Textiles, 1979: Proceedings.* Washington, D.C.: Textile Museum.
1989 *To Speak with Cloth: Studies in Indonesian Textiles.* Los Angeles: Museum of Cultural History, University of California.

GITTINGER, MATTIEBELLE, AND H. LEEDOM LEFFERTS JR.
1992 *Textiles and the Tai Experience in Southeast Asia.* Washington, D.C.: Textile Museum.

GRAVES, ELIZABETH E.
1971 "The Ever-Victorious Buffalo: How the Minangkabau of Indonesia Solved Their 'Colonial Question.'" Ph.D. diss., University of Wisconsin, Madison.
1981 *The Minangkabau Response to Dutch Colonial Rule in the Nineteenth Century.* Monograph Series, no. 60. Ithaca, N.Y: Cornell Modern Indonesia Project, Southeast Asia Program, Cornell University Press.

GRAYSTON, GRAHAM, ED.
1992 *Cultures at Crossroads: Southeast Asian Textiles from the Australian National Gallery.* Canberra: Australian National Gallery.

HALL, KENNETH R.
1976 "An Introductory Essay on Southeast Asian State-craft in the Classical Period." In *Explorations in Early Southeast Asian History: The Origins of Southeast Asian Statecraft.* Edited by Kenneth R. Hall and John K. Whitmore, 1–24. Ann Arbor: Center for South and Southeast Asian Studies, University of Michigan.
1981 "The Expansion of Maritime Trade in the Indian Ocean and Its Impact upon Early State Development in the Malay World." *Review of Indonesian and Malayan Affairs* 15 (2): 108–35.
1996 "The Textile Industry in Southeast Asia, 1400–1800." *Journal of the Economic and Social History of the Orient* 39 (2): 87–135.

HAMKA
1951 *Kenang-kenangan hidup.* Jakarta: Bulan Bintang.
1968 "Adat Minangkabau dan harta pusakanya." In *Menggali hukum tanah dan hukum waris Minangkabau.* Edited by Mochtar Naim, 19–48. Padang: Center for Minangkabau Studies Press.

HANEFI AND PHILIP YAMPOLSKY
1994 *Night Music of West Sumatra.* Smithsonian Folkways. SF 40422.

HANSSEN, LINDA
1995 "Ceremonial Cloth of the Minangkabau: Textile as Metaphor for Social Organization." M.A. thesis, University of Utrecht.
1996 "Heirloom Cloth and Social Organization: The Ceremonial *Kain Sandang Gobo* of the Minangkabau, West Sumatra." In *Sacred and Ceremonial Textiles: Proceedings of the Fifth Biennial Symposium of the Textile Society of America.* [Minneapolis]: Textile Society of America.

HARDJOWARDO, R. P.
1966 *Adityawarman.* Jakarta: Bhratara.

HARIMANSYAH
1993 *Fungsi upacara perkawinan adat pada masyarakat Padang Magek, kacamatan Rambutan kabupaten Tanah Datar.* Padang: Universitas Andalas.

HEIDER, KARL G.
1991 *Landscapes of Emotion: Mapping Three Cultures of Emotion in Indonesia.* Cambridge: Cambridge University Press.

HELMI, F. KUNANG
1991 "Minangkabau 'Cloth of Gold.'" *Arts of Asia* 21 (2): 157–61.

HITCHCOCK, MICHAEL J.
1985 *Indonesian Textile Techniques.* Aylesbury: Shire Publications.
1991 *Indonesian Textiles.* New York: Harper Collins.

HODDER, IAN, ED.
1989 *The Meanings of Things: Material Culture and Symbolic Expression.* London: Unwin Hyman.

HOLT, CLAIRE
1972a "Dances of Minangkabau." *Indonesia* 14: 73–78.
1972b *Culture and Politics in Indonesia.* Ithaca: Cornell University Press.

HOOP, A. N. J. TH. VAN DER
1949 *Indonesische siermotieven / Ragam-ragam perhiasan Indonesia / Indonesian Ornamental Design.* Batavia: K. Bataviaasch genootschap van kunsten et wetenschappen.

HOWARD, MICHAEL C.
1994 *Textiles of Southeast Asia: An Annotated and Illustrated Bibliography.* Bangkok: White Lotus.

HUSEIN, AHMAD, ET AL.
1991– *Sejarah perjuangan kemerdekaan R.I. Minangka-*
1992 *bau/Riau, 1945–1950.* 2 vols. 2d ed. Jakarta: Badan Pemurnian Sejarah Indonesia-Minangkabau.

IBRAHIM, ANWAR
1986 *Pakaian adat tradisional daerah Sumatera Barat.* Padang: Departemen Pendidikan dan Kebudayaan, Proyek Inventarisasi dan Dokumentasi Kebudayaan Daerah.

INDICTOR, NORMAN, AND M. BALLARD
1989 "The Effects of Aging on Textiles That Contain Metal: Implications for Analysis." In *Conservation of Metals: Problems in the Treatment of Metal-Organic and Metal-Inorganic Composite Objects: International Restorer Seminar, Veszprém, Hungary, 1–10 July 1989.* Edited by Márta Járó, 67–76. Veszprém: I. Eri, 1990.

INDICTOR, NORMAN, AND C. BLAIR
1990 "The Examination of Metal from Historic Indian Textiles Using Scanning Electron Microscopy-Energy Dispersive X-Ray Spectrometry." *Textile History* 21 (2): 149–63.

INDICTOR, NORMAN, AND R. J. KOESTLER
1986 "The Identification and Characterization of Metal Wrapping in Historic Textiles Using Microscopy and Energy Dispersive X-Ray Spectrometry: Problems Associated with Identification and Characterization." *Scanning Electron Microscopy* 2: 491–97.

INDICTOR, NORMAN, R. J. KOESTLER, C. BLAIR, AND A. WARDWELL
1988 "The Evaluation of Metal Wrappings from Medieval Textiles Using Scanning Electron Microscopy-Energy Dispersive X-Ray Spectrometry." *Textile History* 19 (1): 3–22.

INDICTOR, NORMAN, R. J. KOESTLER, AND R. SHERYLL
1985 "The Detection of Mordants by Energy Dispersive X-Ray Spectrometry, Part 1: Dyed Woolen Textile Fibers." *Journal of the American Institute for Conservation* 24: 104–9.

INDICTOR, NORMAN, R. J. KOESTLER, M. WYPYSKY, AND A. WARDWELL
1989 "Metal Threads Made of Proteinaceous Substrates Examined by Scanning Electron Microscopy–Energy Dispersive X-Ray Spectrometry." *Studies in Conservation* 34 (4): 171–82.

JESSUP, HELEN IBBITSON
1990 *Court Arts of Indonesia*. New York: Asia Society Galleries and Harry N. Abrams.

JOHNS, ANTHONY H., ED. AND TRANS.
1958 *Rantjak diLabueh: A Minangkabau Kaba*. Ithaca, N.Y: Southeast Asia Program, Department of Far Eastern Studies, Cornell University.

JOSSELIN DE JONG, P. E. DE
1952 *Minangkabau and Negeri Sembilan: Socio-Political Structure in Indonesia*. The Hague: M. Nijhoff.
1960 *Minangkabau and Negeri Sembilan: Socio-Political Structure in Indonesia*. Djakarta: Bhratara.
1980 *Two Essays on Minangkabau Social Organization*. ICA Publication no. 8. Leiden: Institute of Social and Cultural Studies, Leiden University.

JUNUS, UMAR
1984 *Kaba dan sistem sosial Minangkabau: Suata problema sosiologi sastra*. Jakarta: Balai Pustaka.
1988 "'Mustiko adat alam Minangkabau': Fiction or an Account of Minangkabau *Adat*?" In *Time Past, Time Present, Time Future: Perspectives on Indonesian Culture: Essays in Honour of P. E. de Josselin de Jong*. Edited by David S. Moyer and Henri J. M. Claessen. Dordrecht: Foris Publications.

KADIR, HANDRA
1993 "Teknik interloking dalam gaya permain talempong Minangkabau di desa Kubang Pipik kecamatan Agam propensi Sumatera Barat." Thesis, Fakultas Sastera Jurusan Etnomusikologi, Universitas Sumatera Utara.

KAHIN, G. MCTURNAN
1952 *Nationalism and Revolution in Indonesia*. Ithaca, N.Y.: Cornell University Press.

KAHLENBERG, MARY HUNT
1977 *Textile Traditions in Indonesia*. Los Angeles: Los Angeles County Museum of Art.

KAHN, JOEL S.
1974 "Economic Integration and the Peasant Economy: The Minangkabau (Indonesia) Blacksmiths." Ph.D. diss., University of London.
1980 *Minangkabau Social Formations: Indonesian Peasants and the World Economy*. Cambridge Studies in Social Anthropology, no. 30. Cambridge: Cambridge University Press.
1992 *Constituting the Minangkabau: Peasants, Culture, and Modernity in Colonial Indonesia*. Providence, R.I.: Berg.

KARTIWA, SUWATI
1979 "The Social Functions of the *Kain Songket* Minangkabau." In Gittinger, ed., 1980.
1984 "Adat Weaving in West Sumatra," M.S. thesis, University of Pennsylvania, Philadelphia.
1986 *Kain Songket Weaving in Indonesia*. Jakarta: Penerbit Djambatan.
1987 *Tenun ikat (Indonesian Ikats)*. Jakarta: Penerbit Djambatan.

KARTOMI, MARGARET J.
1972 "Tiger-Capturing Music in Minangkabau, West Sumatra." *Sumatra Research Bulletin* 2 (1): 24–41.
1979 "Minangkabau Musical Culture: The Contemporary Scene and Recent Attempts at Its Modernization." In *What Is Modern Indonesian Culture?* Edited by Gloria Davis, 19–36. Athens: Ohio University Center for International Studies.
1981 "Randai Theater in West Sumatra: Components, Music, Origins, and Recent Change." *Review of Indonesian and Malayan Affairs* 15: 1–44.
1985 *Musical Instruments of Indonesia: An Introductory Handbook*. Melbourne: Indonesian Arts Society.
1986 "Muslim Music in West Sumatra." *The World of Music* 3: 13–32.
1990 "Taxonomic Models of the Instrumentation and Regional Ensembles in Minangkabau." In *On Concepts and Classifications of Musical Instruments*, 225–34. Chicago: University of Chicago Press.

KATHIRITHAMBY-WELLS, J.
1967 "Achenese Control over West Sumatra up to the Treaty of Painan, 1663." *Journal of Southeast Asian History* 10 (3): 453–78.

KATO, TSUYOSHI
1977 "Social Change in a Centrifugal Society." Ph.D. diss., Cornell University, Ithaca, N.Y.
1982 *Matriliny and Migration: Evolving Minangkabau Traditions in Indonesia*. Ithaca, N.Y.: Cornell University Press.

KEAH, JOHN
1991 *The Honourable Company: A History of the English East India Company*. New York: Macmillan.

KHAN MAJLIS, BRIGITTE
1984 *Indonesische Textilien: Wege zu Göttern und Ahnen: Bestandskatalog der Museen in Nordrhein-Westfalen*. Cologne: Rautenstrauch-Joest-Museum für Völkerkunde.
1991 *Gewebte Botschaften: Indonesische Traditionen im Wandel*. Hildesheim: Roemer-Museum.

KIM, KHOO KAY
1972 *The Western Malay States, 1850–1873: The Effects of Commercial Development on Malay Politics*. London: Oxford University Press.

KLOPFER, LISA
1993 "Padang Restaurants: Creating 'Ethnic' Cuisine in Indonesia." *Food and Foodways* 5 (3): 293–304.
1994 "Confronting Modernity in a Rice-Producing Community: Contemporary Values and Identity among the Highland Minangkabau of West Sumatra, Indonesia." Ph.D. diss., University of Pennsylvania, Philadelphia.

KOENTJARANINGRAT, R. M.
1967 *Villages in Indonesia.* Ithaca, N.Y.: Cornell University Press.
1975 *Introduction to the Peoples and Cultures of Indonesia and Malaysia.* Menlo Park, Calif.: Cummings.

KOOIJMAN, SIMON
1959 *Ornamented Bark-Cloth in Indonesia.* Mededelingen van hat Rijksmuseum voor Volkenkunde, no. 16. Leiden: E. J. Brill.

KRÄMER, AUGUSTIN
1927 *West-Indonesien: Sumatra, Borneo, Java.* Stuttgart: Franckh'sche Verlagshandlung.

KROESKAMP, HENDRIK
1931 *De westkust en Minangkabau, 1665–1668.* Utrecht.

LANGEWIS, LAURENS, AND FRITS A. WAGNER
1964 *Decorative Art in Indonesian Textiles.* Amsterdam: C. P. J. van der Peet.

LARSEN, JACK LENOR
1976 *The Dyer's Art: Ikat, Batik, Plangi.* New York: Van Nostrand Reinhold.

LEBAR, FRANK M., ED.
1972 *Ethnic Groups of Insular Southeast Asia.* Vol. 1, *Indonesia, Andaman Islands, and Madagaskar.* New Haven: Human Relations Area Files Press.

LEE, SHERMAN E.
1994 *A History of Far Eastern Art.* 5th ed. New York: Harry N. Abrams.

LEEUW, HENDRIK DE
1931 *Crossroads of the Java Sea.* Garden City, N.Y.: Garden City Publishing Company.

LEIGH, BARBARA
1989 *Tangan-tangan trampil / Hands of Time.* Jakarta: Penerbit Djambatan.

LENINIO
1992 *Kesenian tradisional randai dan berberapa perubahannya.* Padang: Universitas Andalas.

LEWIS, BERNARD, ED.
1976 *The World of Islam: Faith, People, and Culture.* London: Thames and Hudson.

LOEB, EDWIN M.
1972 *Sumatra: Its History and People.* Vienna: Institute Für Völkerkunde der Universität Wien, 1935. Reprint, Singapore: Oxford University Press.

LUBUK SATI, DT. B.
1971 *Uraian menurut sepanjang adat bagunan.* Padang: Istana Pagaruyung.

MACK, JOHN
1989 *Malagasy Textiles.* Aylesbury: Shire Publications.

MAKMUR, ERMAN
1981a *Rumah gadang Minangkabau.* Padang: Proyek Pengembangan Permuseum.
1981b *Pakaian penghulu Minangkabau.* Padang: Proyek Pengembangan Permuseum.
1982 *Tenun tradisional Minangkabau.* Padang: Proyek Pengembangan Permuseum.
1984a *Adat musik tradisional Minangkabau.* Padang: Proyek Pengembangan Permuseum.
1984b *Pelaminan.* Padang: Proyek Pengembangan Permuseum.
1985 *Tutup kepala tradisional Minangkabau.* Padang: Proyek Pengembangan Permuseum.
1995 *Mengenal 65 benda koleksi Museum Negari Propinsi Sumatera Barat Adityawarman.* Padang: Proyek Pengembangan Permuseum.

MANAN, IMRAN
1984 "A Traditional Elite in Continuity and Change: The Chiefs of the Matrilineal Lineages of the Minangkabau of West Sumatra, Indonesia." Ph.D. diss., University of Illinois, Urbana-Champaign.

MANSOER, M. D., ET AL.
1970 *Sedjarah Minangkabau.* Jakarta: Bhratara.

MARJO, Y. S.
1996 *Peribahasa Minangkabau Indonesia.* Bandung: Pustaka Setia.

MARSDEN, WILLIAM
1986 *The History of Sumatra.* 3d ed. 1811. Reprint, Singapore: Oxford University Press.

MARTAMIN, MARDJANI
1976 *Ragam ukiran rumah gadang Minangkabau.* Padang: Jurusan Sejarah, Fakultas Keguran Pengetahuan Social, IKIP.
1978 *Ukiran rumah gadang adat Minangkabau dan artinya.* Padang: Jurusan Sejarah, Fakultas Keguran Pengetahuan Social, IKIP.

MAXWELL, ROBYN
1990 *Textiles of Southeast Asia: Tradition, Trade, and Transformation.* Melbourne: Oxford University Press.

MENG, HO WING
1984 *Straits Chinese Silver: A Collector's Guide.* Singapore: Times Books International.

MIKSIC, JOHN
1990 *Old Javanese Gold.* Singapore: Ideation.

MILGRAM, LYNNE, AND PENNY VAN ESTERIK, EDS.
1994 *The Transformative Power of Cloth in Southeast Asia.* Toronto: Museum for Textiles.

MONTEGUT, D., NORMAN INDICTOR, AND ANNE AND JOHN SUMMERFIELD
1996 "Technical Examination of Metal Threads in Some Indonesian Textiles of West Sumatra." *Textile History* 27 (1): 101–14.

MOREHOUSE, BRIAN
1996 *Yastiks: Cushion Covers and Storage Bags of Anatolia*. Philadelphia: Eighth ICOC.

MOUSSAY, GÉRARD
1981 *La langue minangkabau*. Paris: Association Archipel.
1995 *Dictionnaire minangkabau-indonesien-français*. 2 vols. Paris: L'Harmattan.

MUCHTAR, AKMAR
1982 *Adat penanti tamu di Minangkabau*. Padang: Proyek Pengembangan Permuseum.

MULYADI, SYAFRIL
1992 *Pakaian penganten daerah sungai rotan-cupak*. Padang: Museum Negeri Provinsi Sumatera Barat Adhityawarman.

NABHOLZ-KARTASCHOFF, MARIE LOUISE, RUTH BARNES, AND DAVID J. STUART-FOX, EDS.
1993 *Weaving Patterns of Life: Indonesian Textile Symposium, 1991*. Basel: Museum of Ethnography.

NAERSSEN, FRITS HERMAN VAN, AND R. C. DE IONGH
1977 *The Economic and Administrative History of Early Indonesia*. Leiden and Cologne: E. J. Brill.

NAFIS, ANAS
1970 "About Sumatra." Working paper.
1996 *Peribahasa Minangkabau*. Jakarta: Penerbit Djambatan.

NAIM, ASMA M., AND MOCHTAR NAIM
1975 *Bibliografi Minangkabau*. Singapore: Institute of Southeast Asia Studies.

NAIM, MOCHTAR
1984 *Merantau pola migrasi Minangkabau*. Yogyakarta: Gajah Madja University Press.
1987 *Jurus manajemen Indonesia: Sistem pengelolaan restoran Minang*. Jakarta: Yayasan Obor Indonesia.

NAIM, MOCHTAR, ED.
1972 *Merantau dan pengaruhnya terhadap pembangunan daerah di Sumatera Barat*. Padang: Center for Minangkabau Studies Press.

NASRUN, M.
1957 *Dasar filsafah adat Minangkabau*. Jakarta: Penerbit Pasaman.

NAVIS, ALI AKBAR
1980 *Adat dan kebudayaan Minangkabau*. Kayutanam: Ruang Pendidikan INS.
1984 *Alam terkembang jadi guru: Adat dan kebudayaan Minangkabau*. Jakarta: Penerbit PT Grafiiti Pers.

NEILL, WILFRED T.
1973 *Twentieth-Century Indonesia*. New York: Columbia University Press.

NEWMAN, THELMA R.
1977 *Contemporary Southeast Asian Arts and Crafts*. New York: Crown Publishers.

NG, CECILIA
1984 "Symbols of Affinity: Ceremonial Costumes in a Minangkabau Village." *Heritage* 7: 22–38.
1987 "The Weaving of Prestige: Village Women's Representations of the Social Categories of Minangkabau Society." Ph.D. diss., Australian National University, Canberra.
1993 "Raising the House Post and Feeding the Husband-Givers: The Spatial Categories of Social Reproduction among the Minangkabau." In *Inside Austronesian Houses*. Edited by James J. Fox, 116–39. Canberra: Australian National University.

NUSYIRWAN, A.
1980 *Pakaian adat wanita daerah Payakumbuh*. Padang: Proyek Pengembangan Permuseum.
1982 *Ragam hias songket*. Padang: Proyek Pengembangan Permuseum.

O'FERRALL, MICHAEL A.
1986 *Threads of Gold: Minangkabau Textiles*. Perth: Art Gallery of Western Australia.

OKI, AKIRA
1977 "Social Change in the West Sumatra Village, 1908–1945." Ph.D. diss., Australian National University, Canberra.
1979 "A Note on the History of the Textile Industry in West Sumatra." In *Between People and Statistics: Essays in Modern Indonesian History*. Edited by Francien van Anrooij, 147–56. The Hague: M. Nijhoff.

ORTHNER, SHERRY
1973 "On Key Symbols." *American Anthropologist* 75: 1338–45.

OWEN, SRI
1992 *The Best of Indonesian Cooking*. London: Centurion Books.

PELLY, USMAN
1983 "Urban Migration and Adaptation in Indonesia: A Study of Minangkabau and Mandailing Batak Migrants in Medan, North Sumatra." Ph.D. diss., University of Illinois, Urbana-Champaign.

PERSOON, G.
1983 *Wij met elkaar (awak samo awak): De Minangkabau di Jakarta*. Leiden: Institute of Cultural and Social Studies.

PETSOPOULOS, YANNI
1979 *Kilims: Flat-Woven Tapestry Rugs*. New York: Rizzoli.

PHILIPS, NIGEL
1981 *Sijobang: Sung Narrative Poetry of West Sumatra*. London: Cambridge University Press.

RADJO PANGHOELOE, M. RASJID MANGGIS DT.
1971 *Minangkabau: Sefarah ringkas dan adatnya*. Padang: Penerbit Sri Dharma.

RADJO PENGHULU, I. H. DT.
1970 *Pokok-pokok pengetahuan adat alam Minangkabau*. Vol. 1. Padang: Sekretariat LKAAM Sumatera Barat.
1994 *1000 pepatah-petitih, mamang, bidal, pantun, gurindam*. Bandung: Ramaja Rosdakarya.

RAFFLES, SOPHIA
1835 *Memoir of the Life and Public Services of Sir Thomas Raffles*. London: James Duncan.

REENEN, JOKE VAN
1996 *Central Pillars of the House: Sisters, Wives, and Mothers in a Rural Community in Minangkabau, West Sumatra*. Leiden: Research School CNWS.

REID, ANTHONY
1969 "Sixteenth-Century Turkish Influence in Western Indonesia." *Journal of Southeast Asian History* 10 (3): 395–414.
1988 *Southeast Asia in the Age of Commerce, 1450–1680*. Vol. 1, *The Lands below the Winds*. New Haven: Yale University Press.
1993 *Southeast Asia in the Age of Commerce, 1450–1680*. Vol. 2, *Expansion and Crisis*. New Haven: Yale University Press.

RICHARDSON, MILES
1989 "The Artefact as Abbreviated Act: A Social Interpretation of Material Culture." In Hodder 1989.

RICKLEFS, M. C.
1993 *A History of Modern Indonesia since c. 1300*. 2d ed. Stanford: Stanford University Press.

RODGERS, SUSAN
1985 *Power and Gold: Jewelry from Indonesia, Malaysia, and the Philippines*. Geneva: Barbier-Müller Museum.
1995a *Weaving Life, Weaving Wealth: Sumatran Textiles in Transition*. Worcester, Mass.: Iris and B. Gerald Cantor Gallery, College of the Holy Cross.

RODGERS, SUSAN, ED. AND TRANS.
1995b *Telling Lives, Telling History: Autobiography and Historical Imagination in Modern Indonesia*. Berkeley and Los Angeles: University of California Press.

ROSS, HEATHER COLYER
1981 *The Art of Bedouin Jewellery: A Saudi Arabian Profile*. Fribourg: Arabesque.

ROTH, H. LING
1977 *Studies in Primitive Looms*. McMinnville, Ore.: Robin and Russ Handweavers.

SANDAY, PEGGY R.
1984 "The Vitality and Revitalization of Minangkabau Culture." In *Seminar Budaya Minangkabau*. Padang: Panitia Pekan Budaya dan Pameran Pembangunan Sumatera Barat.
1997 "Eggi's Village: Reconsidering the Meaning of Matriarchy." *Expedition* 39 (3): 27–36.

SANDAY, PEGGY R., AND SUWATI KARTIWA
1984 "Cloth and Custom in West Sumatra." *Expedition* 26 (4): 13–29.
1991 "Value in and of Minangkabau Songket." In *Indonesian Textiles: Symposium 1985*. In Völger and Welck 1991, 87–91.

SANGO, DATUAK BATUAH
1955 *Kitab tambo alam Minangkabau*. Payakumbuh: Limbago.

SCHNITGER, F. M.
1964 *Forgotten Kingdoms in Sumatra*. Leiden: E. J. Brill.

SCHRIEKE, B. J. O.
1955 "The Causes and Effects of Communism on the West Coast of Sumatra." In *Indonesian Sociological Studies*. The Hague and Bandung: W. van Hoeve.

SEN, S. P.
1962 "The Role of Indian Textiles in South-East Asian Trade in the Seventeenth Century." *Journal of Southeast Asian History* 3 (2): 92–110.

SHEARES, CONSTANCE
1970 "Patterns and Patternmaking Techniques in the Traditional Textiles of Southeast Asia." Thesis, University of Singapore.
1984 "Trade in Indian Textiles in Southeast Asia." *Heritage* 6: 39–48.
1987 "Southeast Asian Ceremonial Textiles in the National Museum." *Arts of Asia* 17 (3): 100–107.

SHIH, HSIO-YEN
1977 "Textile Finds in the People's Republic of China." In *Studies in Textile History*. Edited by Veronika Gervers, 305–31. Toronto: Royal Ontario Museum.

SIREGAR, SUSAN RODGERS
1981 *Adat, Islam, and Christianity in a Batak Homeland*. Papers in International Studies, Southeast Asia Series, no. 57. Athens: Ohio University Center for International Studies.

SOEDARSONO
1974 *Dances in Indonesia*. Jakarta: Gunung Agung.

SOELAIMAN, H. B. CHATIB
1995 *The World of Minangkabau Custom: The Great Tradition*. Jakarta: Ikhwan.

SOLYOM, GARRETT, AND BRONWEN SOLYOM
1984 *Fabric Traditions of Indonesia*. Pullman: Washington State University Press.

STEINBERG, RAFAEL
1970 *Pacific and Southeast Asian Cooking*. New York: Time-Life Books.

SULEIMAN, SATYAWATI
1977 *The Archaeology and History of West Sumatra*. Jakarta: Pusat Penelitian Perbukala dan Peninggalan Nasional.

SUMMERFIELD, ANNE
1996 "Symbolic Meanings in Minangkabau Ceremonial Cloths." Paper presented at the International Symposium on Indonesian Textiles, Jambi.

SUMMERFIELD, ANNE, AND JOHN SUMMERFIELD
1990 *Trailing the Tiger to Golden Cloths of Sumatra's Minangkabau*. Exhibition guide. Washington, D.C.: Textile Museum.
1991a *Fabled Cloths of Minangkabau*. Santa Barbara, Calif.: Santa Barbara Museum of Art.
1991b "On Culture's Loom." *Aramco World* 42 (4): 20–28.

SUMMERFIELD, JOHN
1996 Metallic Elements in Indonesian Textiles." Paper presented at the International Symposium on Indonesian Textiles, Jambi.

SURYADI, ED.
1993 *Rebab pesisir selatan: Zamzami dan merliani*. Jakarta: Yayasan Obor Indonesia.

SWEENEY, AMIN
1987 *A Full Hearing: Orality and Literacy in the Malay World*. Berkeley and Los Angeles: University of California Press.
1997 "Memoirs from Sumatra." *Indonesia and the Malay World* 73: 270–80.

SYAMSUDDIN, ED.
1993 *Rebab pesisir selatan: Malin kundang*. Jakarta: Yayasan Obor Indonesia.

TANNER, NANCY
1969 "Disputing and Dispute Settlement among the Minangkabau of Indonesia." *Indonesia* 8: 21–67.
1974 "Matrifocality in Indonesia and Africa and among Black Americans." In *Women, Culture, and Society*. Edited by Michelle Zimbalist Rosaldo and Louise Lamphere, 129–56. Stanford: Stanford University Press.

TAYLOR, PAUL MICHAEL, ED.
1994 *Fragile Traditions: Indonesian Art in Jeopardy*. Honolulu: University of Hawaii Press.

TAYLOR, PAUL MICHAEL, AND LORRAINE V. ARAGON
1991 *Beyond the Java Sea: Art of Indonesia's Outer Islands*. Washington, D.C.: National Museum of Natural History, Smithsonian Institution; New York: Harry N. Abrams.

TEEUW, A.
1972 *Modern Indonesian Literature*. Vol. 1. The Hague: M. Nijhoff.

THAHAR, AGUSMAN
1991 *Deskripsi tari alang suntiang pangulu*. Padang: Depdikbud.

THOMAS, LYNN L., AND FRANZ VON BENDA-BECKMAN, EDS.
1985 *Change and Continuity in Minangkabau: Local, Regional, and Historical Perspectives on West Sumatra*. Athens: Ohio University Center for International Studies.

TIM, A.
1992 *Tengkuluak balenggek: Pakaian pengenten wanita daerah lintau—buo*. Padang: Museum Negeri Provinsi Sumatera Barat Adhityawarman.

USMAN, IBENZANI
1985 "Seni ukir tradisional pada rumah adat Minangkabau: Teknik, pola dan fungsinya." Ph.D. diss., Institut Teknologi, Bandung.

USMAN, ZUBER
1985 *Orang talang mama*. Jakarta: Penerbit Wijaya.

VETH, PIETER JOHANNES
1881 *Midden-Sumatra: Reizen und onderzoekingen der Sumatra-expeditie, uitgerust door het Aardrijkskundig genootschap, 1877–1879*. 4 vols. Leiden: E. J. Brill.

VOICE OF NATURE
1990 January issue devoted to West Sumatra and the Minangkabau.

VÖLGER, GISELA, AND KARIN VON WELCK, EDS.
1991 *Indonesian Textiles: Symposium, 1985*. Ethnologica, n.s., 14. Cologne: Rautenstrauch-Joest-Museum für Völkerkunde.

WAGNER, FRITS A.
1959 *The Art of Indonesia*. Baden-Baden: Holle.

WALLACE, ALFRED RUSSEL
1902 *The Malay Archipelago: The Land of the Orang-utan and the Bird of Paradise: A Narrative of Travel, with Studies of Man and Nature*. 1869. Reprint, London: Macmillan.

WARMING, WANDA, AND MICHAEL GAWORSKI
1981 *The World of Indonesian Textiles*. Tokyo: Kodansha International.

WASSING-VISSER, RITA
1982 *Weefsels en adatkostuums uit Indonesie*. Delft: Volkenkundig Museum Nusantara.

WEINER, ANNETTE B.
1992 *Inalienable Possessions: The Paradox of Keeping while Giving*. Berkeley and Los Angeles: University of California Press.

WEINER, ANNETTE B., AND JANE SCHNEIDER, EDS.
1989 *Cloth and Human Experience*. Washington, D.C.: Smithsonian Institution Press.

WELLS, J. K.
1976 "Indrapura Sultanate: The Foundation of Its Rise and Decline from the Sixteenth to the Eighteenth Centuries." *Indonesia* 10: 65–84.

WHALLEY, LUCY ANNE
1993 "Virtuous Women, Productive Citizens: Negotiating Tradition, Islam, and Modernity in Minangkabau." Ph.D. diss., University of Illinois, Urbana-Champaign.

WIERINGA, EDWIN
1997 "The *Kaba Zamzami jo Marlaini:* Continuity, Adaptation, and Change in Minangkabau Oral Story Telling." *Indonesia and the Malay World* 73: 235–51.

WOLTERS, O. W.
1967 *Early Indonesian Commerce: A Study of the Origins of Srivijaya.* Ithaca, N.Y.: Cornell University Press.

YOUNG, KENNETH R.
1980 "The Late-Nineteenth-Century Commodity Boom in West Sumatra." *Indonesia Circle* 22: 64–69.
1982 "Minangkabau Authority Patterns and the Effects of Dutch Rule." In *The Malay-Islamic World of Sumatra: Studies in Politics and Culture.* Edited by John Maxwell, 63–74. Melbourne: Monash University.

YUNUS, MAHMUD
1960 *Sejarah pendidikan Islam.* Jakarta: Pustaka Mahmudiah.

YUSRUL, ABRAR, ED.
1997 *Tokoh yang berhati rakyat: Biografi Harun Zain.* Jakarta: Yayasan Gebu Minang.

ZAIDAN, NUR ANAS, ET AL.
1985 *Makanan, wujud, variasi, dan fungsinya serta cara penyajiannya, daerah Sumatera Barat.* [Jakarta]: Departemen Pendidikan dan Kebudayaan, Proyek Inventarisasi dan Kebudayaan.

ZAIN, SUTAN MUHAMMAD
1960 *Kamus modern bahasa Indonesia.* Jakarta: Penerbit Grafika.

ZED, MUSTIKA, EDY UTAMA, AND HASRIT CHANIAGO
1995 *Sumatera Barat di panggung sejarah, 1945–1995.* Padang: Bidang Penerbitan Khusus Peringatan 50 tahun R. I., Sumatera Barat.
1997 *Somewhere in the Jungle (Pemerintah darurat Republik Indonesia: Sabuah mata rantai sejarah yang terlupakan).* Jakarta: P. T. Grafiti.

ZULKARNAIN, H.
1989 "Upacara khitan, dan peranan kaum kerabat didalamnya serta fungsi upacara tersebut." Thesis, Fakultas Sastra, Universitas Andalas, Padang.

ILLUSTRATION CREDITS

Cover	Don Cole, © FMCH	1.31	Barbara Belle Sloan	5.12	H. A. Sutan Madjo Indo
Back cover	Don Cole, © FMCH	1.32	H. A. Sutan Madjo Indo	5.13	Yayasan Dokumentasi dan Informasi Kebudayaan Minangkabau
p. 1	Don Cole, © FMCH	1.33	Anne Summerfield		
p. 2	Anne Summerfield	1.34	Anne Summerfield		
p. 3	Background: Don Cole, © FMCH; Inset: Hendri Azhar	1.35	Anne Summerfield	5.14	Don Cole, © FMCH
		1.36	Don Cole, © FMCH	5.15	Photography courtesy of the Museum of Fine Arts, Houston
pp. 4–5	Anne Summerfield	2.1	Anne Summerfield		
pp. 6–7	Anne Summerfield	2.2	Anne Summerfield		
pp. 8–9	Barbara Belle Sloan	2.3	Anne Summerfield	5.16	Yayasan Dokumentasi dan Informasi Kebudayaan Minangkabau
p. 11	From Alfred Russel Wallace, *The Malay Archipelago* (1902)	2.4	Anne Summerfield		
		2.5	Anne Summerfield		
		2.6	Anne Summerfield	5.17	Don Cole, © FMCH
p. 21	Anne Summerfield	2.7	Anne Summerfield	5.18	Don Cole, © FMCH
pp. 24–25	Anne Summerfield	2.8	Anne Summerfield	5.19	Don Cole, © FMCH
p. 27	Hendri Azhar	2.9	Anne Summerfield	5.20	Barbara Belle Sloan
pp. 74–75	Hendri Azhar	2.10	Anne Summerfield	5.21	Don Cole, © FMCH
pp. 181–85	Drawings by H. A. Sutan Madjo Indo	3.1	H. A. Sutan Madjo Indo	5.22	Don Cole, © FMCH
		3.2	Anne Summerfield	5.23	Don Cole, © FMCH
		3.3	Anne Summerfield	5.24	Don Cole, © FMCH
p. 238–39	Edy Utama	3.4	Anne Summerfield	5.25	Don Cole, © FMCH
pp. 363–68	Anne Summerfield	3.5	H. A. Sutan Madjo Indo	5.26	Don Cole, © FMCH
		3.6	Yayasan Dokumentasi dan Informasi Kebudayaan Minangkabau	5.27	Don Cole, © FMCH
Figures:				5.28	Don Cole, © FMCH
1.1	Anne Summerfield			5.29	Don Cole, © FMCH
1.2	John Summerfield	3.7	Yayasan Dokumentasi dan Informasi Kebudayaan Minangkabau	5.30	Don Cole, © FMCH
1.3	Anne Summerfield			5.31	Don Cole, © FMCH
1.4	Anne Summerfield			5.32	H. A. Sutan Madjo Indo
1.5	Anne Summerfield	3.8	Anne Summerfield	5.33	Don Cole, © FMCH
1.6	Anne Summerfield	3.9	Anne Summerfield	5.34	Don Cole, © FMCH
1.7	Anne Summerfield	3.10	Anne Summerfield	5.35	Don Cole, © FMCH
1.8	John Summerfield	3.11	Don Cole, © FMCH	5.36	Gene Akers, © Anne and John Summerfield
1.9	E. B. Urban	4.1	Barbara Belle Sloan		
1.10	Anne Summerfield	4.2	David Salisbury	5.37	Don Cole, © FMCH
1.11	Anne Summerfield	4.3	David Salisbury	5.38	Don Cole, © FMCH
1.12	Anne Summerfield	4.4	David Salisbury	5.39	Don Cole, © FMCH
1.13	Anne Summerfield	4.5	David Salisbury	5.40	Don Cole, © FMCH
1.14	Anne Summerfield	4.6	David Salisbury	5.41	Don Cole, © FMCH
1.15	Anne Summerfield	4.7	John Summerfield	5.42	Don Cole, © FMCH
1.16	Anne Summerfield	4.8	David Salisbury	5.43	H. A. Sutan Madjo Indo
1.17	Anne Summerfield	4.9	H. A. Sutan Madjo Indo	5.44	Museum of Fine Arts, Boston
1.18	Anne Summerfield	4.10	David Salisbury		
1.19	John Summerfield	4.11	David Salisbury	5.45	Don Cole, © FMCH
1.20	Anne Summerfield	5.1	H. A. Sutan Madjo Indo	5.46	Don Cole, © FMCH
1.21	Anne Summerfield	5.2	Rina Junus	5.47	Mary Jane Leland
1.22	John Summerfield	5.3	H. A. Sutan Madjo Indo	5.48	H. A. Sutan Madjo Indo
1.23	Anne Summerfield	5.4	Don Cole, © FMCH	5.49	H. A. Sutan Madjo Indo
1.24	H. A. Sutan Madjo Indo	5.5	H. A. Sutan Madjo Indo	5.50	H. A. Sutan Madjo Indo
1.25	Don Cole, © FMCH	5.6	Gene Akers, © Anne and John Summerfield	5.51	Don Cole, © FMCH
1.26	Anne Summerfield			5.52	Anne Summerfield
1.27	Anne Summerfield	5.7	Don Cole, © FMCH	5.53	Don Cole, © FMCH
1.28	Anne Summerfield	5.8	Don Cole, © FMCH	5.54	Don Cole, © FMCH
1.29	H. A. Sutan Madjo Indo	5.9	Don Cole, © FMCH	5.55	Don Cole, © FMCH
1.30	Gene Akers, © Anne and John Summerfield	5.10	Rina Junus	5.56	Don Cole, © FMCH
		5.11	Anne Summerfield	5.57	Don Cole, © FMCH

5.58	Rina Junus	6.53	Don Cole, © FMCH	6.117	Anne Summerfield
5.59	Anne Summerfield	6.54	Gene Akers, © Anne	6.118	Anne Summerfield
5.60	Don Cole, © FMCH		and John Summerfield	6.119	Don Cole, © FMCH
5.61	Don Cole, © FMCH	6.55	Don Cole, © FMCH	6.120	Photograph courtesy of
5.62	Anne Summerfield	6.56	Don Cole, © FMCH		Mien Soedarpo
5.63	Photography courtesy of the Museum of Fine Arts, Houston	6.57	Don Cole, © FMCH	7.1	Anne Summerfield
		6.58	Don Cole, © FMCH	7.2	Don Cole, © FMCH
		6.59	Don Cole, © FMCH	7.3	Don Cole, © FMCH
5.64	Don Cole, © FMCH	6.60	Don Cole, © FMCH	7.4	Anne Summerfield
5.65	Anne Summerfield	6.61	Don Cole, © FMCH	7.5	Don Cole, © FMCH
6.1	Don Cole, © FMCH	6.62	Don Cole, © FMCH	7.6	Anne Summerfield
6.2	Anne Summerfield	6.63	Don Cole, © FMCH	7.7	Don Cole, © FMCH
6.3	H. A. Sutan Madjo Indo	6.64	Don Cole, © FMCH	7.8	Anne Summerfield
6.4	Hendri Azhar	6.65	Gene Akers, © Anne and John Summerfield	7.9	Anne Summerfield
6.5	J. D. Ungerer			7.10	Don Cole, © FMCH
6.6	Don Cole, © FMCH	6.66	Don Cole, © FMCH	7.11	Anne Summerfield
6.7	Don Cole, © FMCH	6.67	Don Cole, © FMCH	7.12	H. A. Sutan Madjo Indo
6.8	Don Cole, © FMCH	6.68	Don Cole, © FMCH	7.13	Anne Summerfield
6.9	Don Cole, © FMCH	6.69	Don Cole, © FMCH	7.14	Don Cole, © FMCH
6.10	Yayasan Dokumentasi dan Informasi Kebudayaan Minangkabau	6.70	Photograph courtesy of H. A. Sutan Madjo Indo	7.15	H. A. Sutan Madjo Indo
				7.16	Don Cole, © FMCH
		6.71	Don Cole, © FMCH	7.17	Don Cole, © FMCH
6.11	Don Cole, © FMCH	6.72	Don Cole, © FMCH	7.18	Anne Summerfield
6.12	Yayasan Dokumentasi dan Informasi Kebudayaan Minangkabau	6.73	Rina Junus	7.19	Anne Summerfield
		6.74	Don Cole, © FMCH	7.20	Anne Summerfield
		6.75	H. Elly Azhar and H. A. Sutan Madjo Indo	7.21	John Summerfield
6.13	H. A. Sutan Madjo Indo			7.22	Anne Summerfield
6.14	Anne Summerfield	6.76	Don Cole, © FMCH	7.23	Anne Summerfield
6.15	Anne Summerfield	6.77	Anne Summerfield	7.24	Anne Summerfield
6.16	Don Cole, © FMCH	6.78	Don Cole, © FMCH	7.25	Anne Summerfield
6.17	Don Cole, © FMCH	6.79	Anne Summerfield	7.26	Don Cole, © FMCH
6.18	Rina Junus	6.80	Anne Summerfield	7.27	Don Cole, © FMCH
6.19	Don Cole, © FMCH	6.81	Don Cole, © FMCH	7.28	Don Cole, © FMCH
6.20	Don Cole, © FMCH	6.82	Don Cole, © FMCH	7.29	Don Cole, © FMCH
6.21	Gene Akers, © Anne and John Summerfield	6.83	Don Cole, © FMCH	7.30	Anne Summerfield
		6.84	Anne Summerfield	7.31	Anne Summerfield
6.22	Don Cole, © FMCH	6.85	Don Cole, © FMCH	7.32	Anne Summerfield
6.23	John Summerfield	6.86	Gene Akers, © Anne and John Summerfield	7.33	Anne Summerfield
6.24	Don Cole, © FMCH			7.34	Anne Summerfield
6.25	Don Cole, © FMCH	6.87	Don Cole, © FMCH	7.35	Anne Summerfield
6.26	Don Cole, © FMCH	6.88	Don Cole, © FMCH	7.36	Anne Summerfield
6.27	Don Cole, © FMCH	6.89	Don Cole, © FMCH	7.37	Anne Summerfield
6.28	Gene Akers, © Anne and John Summerfield	6.90	Don Cole, © FMCH	7.38	Anne Summerfield
		6.91	Don Cole, © FMCH	7.39	John Summerfield
6.29	Yayasan Dokumentasi dan Informasi Kebudayaan Minangkabau	6.92	Don Cole, © FMCH	7.40	John Summerfield
		6.93	Don Cole, © FMCH	7.41	Gene Akers, © Anne and John Summerfield
		6.94	Don Cole, © FMCH		
6.30	Anne Summerfield	6.95	H. A. Sutan Madjo Indo	7.42	Don Cole, © FMCH
6.31	Anne Summerfield	6.96	Don Cole, © FMCH	7.43	© 1992 The Metropolitan Museum of Art
6.32	Don Cole, © FMCH	6.97	Gene Akers, © Anne and John Summerfield		
6.33	Yayasan Dokumentasi dan Informasi Kebudayaan Minangkabau			7.44	Osman Mawardi
		6.98	Don Cole, © FMCH	7.45	Gene Akers, © Anne and John Summerfield
		6.99	Don Cole, © FMCH		
6.34	H. A. Sutan Madjo Indo	6.100	Don Cole, © FMCH	7.46	Anne Summerfield
6.35	Anne Summerfield	6.101	Yayasan Dokumentasi dan Informasi Kebudayaan Minangkabau	7.47	Sothebys, London
6.36	Don Cole, © FMCH			7.48	Anne Summerfield
6.37	Don Cole, © FMCH			7.49	Anne Summerfield
6.38	H. A. Sutan Madjo Indo	6.102	H. A. Sutan Madjo Indo	7.50	Sothebys, London
6.39	Don Cole, © FMCH	6.103	Don Cole, © FMCH	7.51	Sothebys, London
6.40	Don Cole, © FMCH	6.104	Don Cole, © FMCH	7.52	Anne Summerfield
6.41	Don Cole, © FMCH	6.105	Don Cole, © FMCH	7.53	© 1982 The Metropolitan Museum of Art
6.42	Don Cole, © FMCH	6.106	Don Cole, © FMCH		
6.43	Don Cole, © FMCH	6.107	Gene Akers, © Anne and John Summerfield	7.54	Anne Summerfield
6.44	Don Cole, © FMCH			7.55	Anne Summerfield
6.45	Don Cole, © FMCH	6.108	Don Cole, © FMCH	7.56	Anne Summerfield
6.46	Don Cole, © FMCH	6.109	Don Cole, © FMCH	7.57	Anne Summerfield
6.47	Don Cole, © FMCH	6.110	Don Cole, © FMCH	7.58	Don Cole, © FMCH
6.48	Don Cole, © FMCH	6.111	Hendri Azhar	7.59	Anne Summerfield
6.49	© 1999 The Metropolitan Museum of Art	6.112	Anne Summerfield	7.60	Don Cole, © FMCH
		6.113	Don Cole, © FMCH	7.61	Anne Summerfield
6.50	Don Cole, © FMCH	6.114	Don Cole, © FMCH	7.62	Brian Morehouse
6.51	Don Cole, © FMCH	6.115	Don Cole, © FMCH	7.63	Anne Summerfield
6.52	Don Cole, © FMCH	6.116	Anne Summerfield	7.64	Brian Morehouse

7.65	Anne Summerfield	8.60	Anne Summerfield	11.22	Lisa Klopfer
7.66	Anne Summerfield	8.61	Anne Summerfield	11.23	Lisa Klopfer
7.67	Anne Summerfield	8.62	R. J. Veth	11.24	Lisa Klopfer
7.68	Anne Summerfield	9.1	Don Cole, © FMCH	11.25	Lisa Klopfer
7.69	Anne Summerfield	9.2	Don Cole, © FMCH	12.1	Photography courtesy of the Museum of Fine Arts, Houston
7.70	Anne Summerfield	9.3	Don Cole, © FMCH		
7.71	Photograph courtesy of the Los Angeles County Museum of Art	9.4	John Summerfield		
		9.5	John Summerfield	12.2	Don Cole, © FMCH
		9.6	Norman Indictor	12.3	Don Cole, © FMCH
7.72	Don Cole, © FMCH	9.7	Norman Indictor	12.4	Lies Alwi
7.73	Anne Summerfield	9.8	Anne Summerfield	12.5	Redjeki Arifin
8.1	Don Cole, © FMCH	9.9	John Summerfield	12.6	Don Cole, © FMCH
8.2	John Summerfield	9.10	John Summerfield	12.7	Redjeki Arifin
8.3	Don Cole, © FMCH	9.11	Anne Summerfield	12.8	Redjeki Arifin
8.4	Norman Indictor	9.12	Don Cole, © FMCH	12.9	Redjeki Arifin
8.5	Norman Indictor	9.13	Norman Indictor	12.10	Redjeki Arifin
8.6	John Summerfield	9.14	Norman Indictor	12.11	Redjeki Arifin
8.7	John Summerfield	9.15	John Summerfield	12.12	Redjeki Arifin
8.8	Anne Summerfield	10.1	Anne Summerfield	12.13	Barbara Belle Sloan
8.9	John Summerfield	10.2	John Summerfield	12.14	H. A. Sutan Madjo Indo
8.10	John Summerfield	10.3	Ibenzani Usman	12.15	Yayasan Dokumentasi dan Informasi Kebudayaan Minangkabau
8.11	Anne Summerfield	10.4	Anne Summerfield		
8.12	Anne Summerfield	10.5	Ibenzani Usman		
8.13	Anne Summerfield	10.6	Ibenzani Usman	12.16	Anne Summerfield
8.14	Anne Summerfield	10.7	Ibenzani Usman	12.17	Don Cole, © FMCH
8.15	Anne Summerfield	10.8	Ibenzani Usman	12.18	Don Cole, © FMCH
8.16	Anne Summerfield	10.9	Anne Summerfield	12.19	Redjeki Arifin
8.17	Anne Summerfield	10.10	Ibenzani Usman	12.20	Redjeki Arifin
8.18	Anne Summerfield	10.11	Ibenzani Usman	12.21	Anne Summerfield
8.19	Anne Summerfield	10.12	Ibenzani Usman	12.22	Redjeki Arifin
8.20	Anne Summerfield	10.13	Ibenzani Usman	12.23	Redjeki Arifin
8.21	Anne Summerfield	10.14	Ibenzani Usman	12.24	Redjeki Arifin
8.22	Anne Summerfield	10.15	Ibenzani Usman	12.25	Redjeki Arifin
8.23	Anne Summerfield	10.16	Ibenzani Usman	12.26	Redjeki Arifin
8.24	Anne Summerfield	10.17	Ibenzani Usman	12.27	Don Cole, © FMCH
8.25	Anne Summerfield	10.18	Ibenzani Usman	12.28	Don Cole, © FMCH
8.26	Anne Summerfield	10.19	Anne Summerfield	12.29	Redjeki Arifin
8.27	Anne Summerfield	10.20	Ibenzani Usman	12.30	Don Cole, © FMCH
8.28	Anne Summerfield	10.21	Ibenzani Usman	12.31	Don Cole, © FMCH
8.29	Anne Summerfield	10.22	Don Cole, © FMCH	12.32	Don Cole, © FMCH
8.30	Anne Summerfield	10.23	Don Cole, © FMCH	12.33	Redjeki Arifin
8.31	Anne Summerfield	10.24	Don Cole, © FMCH	12.34	Redjeki Arifin
8.32	Anne Summerfield	10.25	Ibenzani Usman	12.35	Don Cole, © FMCH
8.33	Anne Summerfield	10.26	Ibenzani Usman	12.36	Redjeki Arifin
8.34	Don Cole, © FMCH	10.27	Ibenzani Usman	12.37	Redjeki Arifin
8.35	R. J. Veth	10.28	Don Cole, © FMCH	12.38	Redjeki Arifin
8.36	Anne Summerfield	10.29	Anne Summerfield	12.39	Don Cole, © FMCH
8.37	Anne Summerfield	10.30	Anne Summerfield	12.40	H. A. Sutan Madjo Indo
8.38	Anne Summerfield	10.31	Don Cole © FMCH	12.41	Lies Alwi
8.39	Anne Summerfield	10.32	Ibenzani Usman	12.42	Redjeki Arifin
8.40	Anne Summerfield	10.33	Ibenzani Usman	12.43	Redjeki Arifin
8.41	Anne Summerfield	11.1	Gene Brandzell	12.44	Redjeki Arifin
8.42	Don Cole, © FMCH	11.2	Lisa Klopfer	12.45	Anne Summerfield
8.43	John Summerfield	11.3	Lisa Klopfer	12.46	Anne Summerfield
8.44	Anne Summerfield	11.4	Lisa Klopfer	12.47	Don Cole, © FMCH
8.45	John Summerfield	11.5	Lisa Klopfer	12.48	Redjeki Arifin
8.46	Yayasan Dokumentasi dan Informasi Kebudayaan Minangkabau	11.6	Lisa Klopfer	12.49	Redjeki Arifin
		11.7	Lisa Klopfer	12.50	Anne Summerfield
		11.8	Lisa Klopfer	12.51	Redjeki Arifin
8.47	Don Cole, © FMCH	11.9	Lisa Klopfer	12.52	Redjeki Arifin
8.48	John Summerfield	11.10	Lisa Klopfer	12.53	Redjeki Arifin
8.49	Anne Summerfield	11.11	Lisa Klopfer	12.54	Anne Summerfield
8.50	John Summerfield	11.12	Lisa Klopfer	12.55	Yayasan Dokumentasi dan Informasi Kebudayaan Minangkabau
8.51	Don Cole, © FMCH	11.13	Lisa Klopfer		
8.52	Don Cole, © FMCH	11.14	Lisa Klopfer		
8.53	Don Cole, © FMCH	11.15	Lisa Klopfer	12.56	Redjeki Arifin
8.54	Don Cole, © FMCH	11.16	Lisa Klopfer	12.57	Redjeki Arifin
8.55	Don Cole, © FMCH	11.17	Lisa Klopfer	12.58	Redjeki Arifin
8.56	John Summerfield	11.18	Lisa Klopfer	12.59	Redjeki Arifin
8.57	H. A. Sutan Madjo Indo	11.19	Lisa Klopfer	12.60	Redjeki Arifin
8.58	Don Cole, © FMCH	11.20	Lisa Klopfer	12.61	Redjeki Arifin
8.59	John Summerfield	11.21	Lisa Klopfer	12.62	Redjeki Arifin

12.63	Photography courtesy of the Museum of Fine Arts, Houston
12.64	Don Cole, © FMCH
12.65	Don Cole, © FMCH
12.66	Redjeki Arifin
12.67	Don Cole, © FMCH
12.68	Anne Summerfield
12.69	Anne Summerfield
12.70	Redjeki Arifin
12.71	Redjeki Arifin
12.72	Hendri Azhar
13.1	David Salisbury
13.2	Hendri Azhar
13.3	John Summerfield
13.4	John Summerfield
13.5	Anne Summerfield
13.6	Hanefi
13.7	Hendri Azhar
13.8	David Salisbury
13.9	David Salisbury
13.10	Yayasan Dokumentasi dan Informasi Kebudayaan Minangkabau
13.11	Hanefi
13.12	David Salisbury
13.13	Hanefi
13.14	David Salisbury
13.15	David Salisbury
13.16	Hanefi
13.17	John Summerfield
13.18	Hendri Azhar
13.19	Yayasan Dokumentasi dan Informasi Kebudayaan Minangkabau
13.20	Edy Utama
13.21	Hanefi
13.22	Hanefi
13.23	Hanefi
13.24	Hanefi
13.25	Hanefi
13.26	Hendri Azhar
13.27	Gene Brandzell
13.28	Hanefi
14.1	Anne Summerfield
14.2	Anne Summerfield
14.3	Anne Summerfield
14.4	Anne Summerfield
14.5	Anne Summerfield
14.6	Anne Summerfield
14.7	Anne Summerfield
14.8	Anne Summerfield
14.9	Anne Summerfield
14.10	David Salisbury
14.11	Barbara Belle Sloan
14.12	Barbara Belle Sloan
14.13	Edy Utama
14.14	Barbara Belle Sloan
14.15	Barbara Belle Sloan
14.16	Barbara Belle Sloan
14.17	Anne Summerfield
14.18	David Salisbury
14.19	David Salisbury
14.20	Edy Utama
14.21	Edy Utama
14.22	David and Vicki Salisbury
14.23	David and Vicki Salisbury

CONTRIBUTORS

TAUFIK ABDULLAH received his doctoral degree in Southeast Asian history from Cornell University, Ithaca, New York. He has held visiting professorships at the University of Indonesia, the University of Wisconsin, the State Institute of Islamic Studies in Yogyakarta and Jakarta, Cornell University, and McGill University Institute of Islamic Studies. He has been a research fellow at the University of Chicago, the Netherlands Institute for Advanced Studies, the University of Kyoto, and the Australian National University. Abdullah is currently research professor at the Indonesian Institute of Sciences and professor of history at Gadjah Mada University in Yogyakarta, Java. A few of his many publications devoted to the Minangkabau are included in the bibliography of this volume.

The late KHAIDIR ANWAR received his doctoral degree in applied linguistics at the University of London and subsequently taught there for ten years before returning to Padang, where he was professor of sociolinguistics at Andalas University. He published two books under the auspices of a private foundation in Padang, *Kolokasi dan ungkapan bahasa Minang* and *Kata-kata khusus Minangkabau*, which provide trilingual (Minangkabau, Indonesian, and English) explanations not readily available elsewhere of Minangkabau words and expressions.

REDJEKI ARIFIN has played an active role in Indonesian art and culture since 1974, when she founded a volunteer group in the ethnographic section of the Museum Nasional in Jakarta. She has been active in the Ceramic Society of Indonesia, serving as board member and vice president. Since 1980 she has been assistant curator of the Adam Malik Museum in Jakarta. She is the coauthor of *Kain Adat*, the first catalogue of the holdings of the Museum Tekstil in Jakarta, and of *Manik-manik di Indonesia / Beads in Indonesia*. She frequently lectures on the subject of antique beads.

HANEFI was educated at the University of Northern Sumatra, Medan, with a major in ethnomusicology. Among his publications is the booklet that accompanies the Smithsonian/Folkways recording *Night Music of West Sumatra*. Hanefi teaches music and musical composition at the Akademi Seni Karawitan Indonesia in Padang Panjang, West Sumatra.

NORMAN INDICTOR received his doctoral degree in chemistry at Columbia University. Following a brief industrial career as a research chemist, he joined the chemistry faculty of Brooklyn College, where he was appointed professor in 1972 and department head in 1997. He has served as visiting scientist and adjunct professor at New York University's Institute of Fine Arts and as consultant at the Metropolitan Museum of Art's Department of Objects Conservation. Indictor has been a fellow of the American Institute for Indian Studies. He is author or coauthor of numerous publications on metallic threads and other topics.

LISA KLOPFER received her doctoral degree in anthropology at the University of Pennsylvania. Her doctoral dissertation—"Confronting Modernity in a Rice-Producing Community: Contemporary Values and Identity among the Highland Minangkabau of West Sumatra, Indonesia"—included an extensive analysis of the role of ceremonial food in Minangkabau weddings. She has produced a number of publications and lectures on the Minangkabau. Klopfer is currently employed at the University of Michigan, where she is pursuing additional graduate work in the field of information sciences.

H. A. SUTAN MADJO INDO is a recognized authority on the meaning and significance of motifs woven into Minangkabau textiles and carved on walls of adat houses. His expertise derives from his extensive studies and his many years as an antiques dealer and collector in Bukittinggi, West Sumatra. Portions of his collection of Minangkabau textiles have been displayed in Perth, Australia; in Singapore; and in Santa Barbara, California, where he has lectured on the Minangkabau culture and its ceremonial textiles.

IMRAN MANAN received his doctoral degree in anthropology at the University of Illinois, Urbana-Champaign. Following completion of his dissertation—"A Traditional Elite in Continuity and Change: The Chiefs of the Matrilineal Lineages of the Minangkabau of West Sumatra, Indonesia"—he engaged in postdoctoral studies at Ohio State University and the University of London. Manan is dean of the Faculty of Education and Social Sciences at the Institute of Teacher Training and Educational Sciences (IKIP), Padang; head of the anthropology department at Andalas University, Padang; and a special faculty member of JAIN Imam Bonjol, Padang. He is the author of numerous publications on education and on Minangkabau culture.

ANAS NAFIS was educated at Gadjah Mada University in Yogyakarta, Java. He is a writer and musician who has written screenplays for three films broadcast on TVRI (Television, Republic of Indonesia). As executive secretary of the Yayasan Dokumentasi dan Informasi Kebudayaan Minangkabau (Foundation for Documentation and Information Concerning Minangkabau Culture), he assembled from worldwide sources a vast database of photographs and written material dealing with Minangkabau arts and culture. This collection is now housed in an adat house built for the foundation, the Pusat Dokumentasi dan Informasi Kebudayaan Minangkabau, in Padang Panjang, West Sumatra. Nafis is the author of *Peribahasa Minangkabau*, a collection of some thirty-five hundred traditional sayings of the Minangkabau.

DAVID SALISBURY received his master's degree in ethnomusicology from San Diego State University. He is completing work on his doctoral dissertation in ethnomusicology at Monash University in Melbourne, Australia, based on fieldwork in West Sumatra during 1994. In addition to his teaching experience in the United States and Australia, he is a songwriter, composer, and arranger, with 165 songs and compositions to his credit.

VICKI SALISBURY received her master's degree from Monash University in Melbourne, Australia. In addition to her work as a professional musician and composer, she has conducted an anthropological inquiry into women's roles within Minangkabau social systems and the emergence of women as *talempong* musicians. She is currently working with a program to fund preventive health care in remote indigenous communities in Australia.

ANNE AND JOHN SUMMERFIELD received their doctoral degrees in physics and economics, respectively, from the University of California, Berkeley. After separate careers in academia, government, and business, they combined their talents in 1977 in a joint project to study Indonesian textiles. By 1985 they had decided to concentrate on the ceremonial weavings of the Minangkabau and on the culture that produces them. Two earlier exhibitions, in 1990 and 1991, and a small publication, *Fabled Cloths of Minangkabau*, laid the groundwork for the present volume and the exhibition that it accompanies.

The late IBENZANI USMAN received his doctoral degree from the Institute of Technology, Bandung, Java. His dissertation—"Traditional Carving on Minangkabau Adat Houses: Technique, Design, and Function"—grew out of his teaching in the plastic arts department of the Institute of Teacher Training and Educational Sciences (IKIP) in Padang. He was a talented painter who had solo exhibitions in Padang and Jakarta. His musical compositions won several competitions. He is remembered by his students as a talented and beloved teacher.

INDRA UTAMA studied dance and choreography in Surakarta, Java, and at the Akademi Seni Karawitan Indonesia (ASKI) in Padang Panjang, West Sumatra, where he has since taught movement and choreography. He has participated in a number of international choreography workshops in the United States and Australia. He is currently on leave from ASKI and is pursuing graduate studies at Gadjah Mada University in Yogyakarta, Java.